Music/Video

Histories, Aesthetics, Media

EDITED BY
GINA ARNOLD,
DANIEL COOKNEY,
KIRSTY FAIRCLOUGH, AND
MICHAEL GODDARD

Bloomsbury Academic
An imprint of Bloomsbury Publishing Inc

BLOOMSBURY
NEW YORK · LONDON · OXFORD · NEW DELHI · SYDNEY

Bloomsbury Academic

An imprint of Bloomsbury Publishing Inc

1385 Broadway	50 Bedford Square
New York	London
NY 10018	WC1B 3DP
USA	UK

www.bloomsbury.com

BLOOMSBURY and the Diana logo are trademarks of Bloomsbury Publishing Plc

First published 2017

Library of Congress Cataloging-in-Publication Data
Names: Arnold, Gina editor.
Title: Music/video : histories, aesthetics, media / edited by: Gina Arnold, Daniel Cookney, Kirsty Fairclough-Isaacs, Michael Goddard, and Benjamin Halligan.
Description: New York : Bloomsbury Academic, 2017. | Includes bibliographical references.
Identifiers: LCCN 2017003348 (print) | LCCN 2017021641 (ebook) |
ISBN 9781501313929 (ePDF) | ISBN 9781501313936 (ePUB) |
ISBN 9781501313912 (pbk. : alk. paper)
Subjects: LCSH: Music videos–History and criticism.
Classification: LCC PN1992.8.M87 (ebook) |
LCC PN1992.8.M87 M885 2017 (print) | DDC 780.26/7–dc23
LC record available at https://lccn.loc.gov/2017003348

ISBN:	HB:	978-1-5013-1390-5
	PB:	978-1-5013-1391-2
	ePub:	978-1-5013-1393-6
	ePDF:	978-1-5013-1392-9

Cover design: Louise Dugdale and Daniel Cookney
Cover image © Photo taken by Paula Harrowing. Used with permission by FKA Twigs

Typeset by Integra Software Services Pvt. Ltd.

Music/Video

Histories, Aesthetics, Media

CONTENTS

LIST OF FIGURES

ACKNOWLEDGEMENTS

The editors would like to thank Benjamin Halligan, who was a co-initiator of this project, did substantial work on the original proposal, and had a strong influence on the shape of the volume. We would like to thank Paul Hegarty, who, in addition to contributing a chapter, also did invaluable editing work on two of the other chapters in this volume for which we are extremely grateful. We would also like to thank all our contributors who remained committed to this project over a longer than usual, or wished for, development period. We would like to thank Susan Krogulski and Leah Babb-Rosenfeld at Bloomsbury, along with Ally Jane Grossan, who initially approved the project. Permission to use images from Björk's videos was given by One Little Indian. Permission to use Test Dept images was given by the group themselves, and the same applies to the use of stills from Laibach videos. Finally, we also want to thank Paula Harrowing, who contributed the image that was the basis of the cover of the book, taken from FKA twigs's 'Pendulum' video (2015).

NOTES
ON CONTRIBUTORS

Dr Gina Arnold is a visiting professor at the Evergreen State College in Washington. A former rock critic, she is the author of three books – *Route 666: On the Road to Nirvana* (St. Martin's/Picador), *Kiss This: Punk in the Present Tense* (St Martin's/Picador), and *Exile in Guyville* (Bloomsbury). She is a former fellow at Stanford's Center for the Comparative Study of Race and Ethnicity, where she received her Ph.D. in 2011, and has a forthcoming book entitled *Millions Like Us: Rock Crowds and Power,* which is part of the University of Iowa Press's New American Canon series.

Dr Vera Brozzoni holds a PhD in Music Composition and Performance from Newcastle University and a MA in Popular Music from Kingston University. Her PhD thesis focused on vocal sacred music, mysticism and female sexuality. Her academic and life interests span from opera history and vocal performance history, to electronic music, to feminist and gender studies to sexuality in horror cinema. She performs as an avantgarde vocalist with the stage name of Vera Bremerton, and as a techno industrial act with the stage name of Viy.

Dr Andrew Burke is an associate professor in the Department of English at the University of Winnipeg, where he teaches critical theory, screen studies, and cultural studies. His most recent publications have been on topics ranging from the films of the pop group Saint Etienne to the cultural history of the Moog synthesizer to the gallery installations of Douglas Coupland. He is currently completing a book titled *The Past Inside the Present: Cultural Memory and 1970s Canadian Film and Television.*

Dr José Cláudio Siqueira Castanheira is assistant professor and coordinator of Film Program at Universidade Federal de Santa Catarina (UFSC), Brazil. He is researcher in the areas of music, sound studies and cinema, and currently develops research on the constitution of different listening models in cinema and their relationship with technology and social practices. He is one of the contributors to the anthologies: *Reverberations: The Philosophy, Aesthetics and Politics of Noise* (2012), edited by Michael Goddard, Benjamin Halligan,

Paul Hegarty; and *Small Cinemas in Global Markets: Genres, Identities, Narratives* (2015), edited by Lenuta Giukin, Janina Falkowska, and David Nasser.

Dr Daniel Cookney is a lecturer on the BA (Hons) Graphic Design course at the University of Salford. His transdisciplinary research and practice work has explored a number of areas of communication design, although a notable specialism is identity – particularly within the music industry. As a writer, he has additionally written for a number of print and online publications, contributed to *Reverberations: The Philosophy, Aesthetics and Politics of Noise* (Continuum/Bloomsbury), and co-edited *Extremity and Excess* (University of Salford Press).

Dr Greg de Cuir Jr is the managing editor of the online journal NECSUS and series editor of Eastern European Screen Cultures, both published by Amsterdam University Press. His writing has been featured in *Cineaste, Jump Cut, Festivalists, Art Margins, Politika*, and other publications. De Cuir lives and works in Belgrade, Serbia, as an independent curator, writer, and translator.

Dr Kirsty Fairclough is Senior Lecturer in Media and Performance and Director of International School of Arts and Media at the University of Salford. Kirsty's research lies in the analysis of popular culture, chiefly celebrity and gender representations. Kirsty is the co-editor of *The Music Documentary: Acid Rock to Electropop* (Routledge), *The Arena Concert: Music, Media and Mass Entertainment* (Bloomsbury), and author of the forthcoming *Beyoncé: Celebrity Feminism in the Age of Social Media* (I.B. Tauris). She is also co-editor of two journal issues on the return of *Twin Peaks*, one published by *Senses of Cinema* and a second a section of the journal *Series*. Kirsty has lectured internationally on popular culture and feminism, most recently at Second City, Chicago; Columbia College, Chicago; Middle Tennessee State University; the Royal College of Music, Stockholm; and Bucknell University, Pennsylvania.

Dr Michael Goddard is Senior Lecturer in Film, TV and the Moving Image at the University of Westminster. He has published widely on Polish and international cinema and media culture as well as cultural and media theory and he recently published a book, *Impossible Cartographies*, on the cinema of Raúl Ruiz. He has also been doing research on sonic cultures including both popular music focusing on groups such as The Fall, Throbbing Gristle, and Laibach, as well as free and guerrilla radio stations and culminating in editing two books on noise, *Reverberations* and *Resonances*. He is currently

completing a research project, *Guerrilla Networks,* examining radical media ecologies in film, TV, radio, and radical politics in the 1970s from a media archaeological perspective. Most recently, his research focuses on contemporary audiovisual popular culture and urban space. He is also co-editor of two journal issues on the return of *Twin Peaks*, one published by *Senses of Cinema* and a second a section of the journal *Series.*

Dr Benjamin Halligan is Director of the Doctoral College of the University of Wolverhampton. Publications include *Michael Reeves* (Manchester UP, 2003), *Desires for Reality: Radicalism and Revolution in Western European Film* (Berghahn, 2016), and the co-edited collections *Mark E. Smith and The Fall: Art, Music and Politics* (Ashgate, 2010), *Reverberations: The Philosophy, Aesthetics and Politics of Noise* (Continuum, 2012), *Resonances: Noise and Contemporary Music* (Bloomsbury Academic, 2013), *The Music Documentary: Acid Rock to Electropop* (Routledge, 2013), and *The Arena Concert: Music, Media and Mass Entertainment* (Bloomsbury Academic, 2015).

Dr Paul Hegarty teaches on visual and audio cultures in University College Cork. His last book, *Rumour and Radiation: Sound in Video Art* came out on Bloomsbury in 2015. He has just completed *Peter Gabriel: Global Citizen*, for Reaktion Press, and this is due out in 2017. He has two new music projects – Rural Slave and Maginot (with Romain Perrot).

Dr Jaap Kooijman is Associate Professor of Media Studies and American Studies at the University of Amsterdam. His articles on American pop culture have been published in journals such as *The Velvet Light Trap, The Journal of American Culture, Post Script, Journal of International Education, GLQ, Celebrity Studies,* and *[in]Transition: Journal of Videographic Film & Moving Image Studies.* Kooijman is the author of *Fabricating the Absolute Fake: America in Contemporary Pop Culture* (revised and extended edition, 2013), editor of *European Journal of Cultural Studies,* and co-founding editor of *NECSUS: European Journal of Media Studies.*

Dr Julie Lobalzo Wright is a Teaching Fellow in the Film and Television Studies Department at the University of Warwick. Most of her research is concerned with crossover stardom, particularly male popular music stars in British and American cinema. She has recently co-edited, with Lucy Bolton, *Lasting Screen Stars: Images That Fade and Personas That Endure* (Palgrave), has published on David Bowie's film stardom, and has her own monograph, *Crossover Stardom: Popular Male Music Stars in American Cinema,* forthcoming (Bloomsbury).

Dr Dean Lockwood is Senior Lecturer in Media Theory in the School of Film and Media at the University of Lincoln. He researches and publishes in the fields of digital culture, sonic culture, and media ecologies, with a particular interest in horror and dark media. He is the author, with Rob Coley, of *Cloud Time* (Zero Books, 2012) and *Photography in the Middle: Dispatches on Media Ecologies and Aesthetics* (Punctum Books, 2016).

Dr Sunil Manghani is Reader in Critical and Cultural Theory and Director of Doctoral Research at the Winchester School of Art, University of Southampton. He is an Associate Editor for *Theory Culture and Society* and *Journal of Contemporary Painting*, and author/editor of numerous books and volumes, including *India's Biennale Effect: A Politics of Contemporary of Art* (Routledge, 2017); *Image Studies* (Routledge, 2013); *Image Critique & the Fall of the Berlin Wall* (Intellect, 2008); *Painting: Critical and Primary Sources* (Bloomsbury, 2015); and *Farewell to Visual Studies?* (Pennsylvania State University Press, 2015). He was co-curator of 'Barthes/Burgin', at the John Hansard Gallery, and co-author of the accompanying book, *Barthes/Burgin* (Edinburgh University Press, 2016).

Prof Michael Saffle took his Ph.D. at Stanford University, where he taught before moving to Virginia Tech; since 1993, he has served at Tech as Professor of Music and Humanities. During 2000–2001 he held the Bicentennial Fulbright Distinguished Professor of American Studies at the University of Helsinki. In Spring 2008 he held the Au Yeung King Fong Research Fellowship in Hong Kong.

Dr Fabricio Silveira holds a PhD in Communication Sciences from Unisinos, Brazil. On two occasions he was invited as researcher and visiting professor at the Universidade Autônoma de Barcelona, Spain. In 2015, he completed Postdoctoral Senior stage (CAPES, case no. 5939-14-3) at the University of Salford.

Sarie Mairs Slee has been working in the messy territories between dance and theatre for the last fifteen years, exploring links between the embodied experience of our humanity and the significatory power of the body in performance. She is a Lecturer in Dance at the University of Salford and works as an artist/academic across choreography, devising and writing. From 2010–2013, her work focused on collaboration with Studio Matejka, a performance laboratory ensemble in permanent residence at the Grotowksi Institute in Wroclaw, Poland. Since 2013, Slee has explored approaches to interdisciplinary collaboration with poet Scott Thurston and composer Alan Williams, interrogating the performers' and audiences' embodied experiences with performance settings within these two collaborative relationships.

Introduction

The Persistence of the Music Video Form from MTV to Twenty-First-Century Social Media

Gina Arnold, Daniel Cookney,
Kirsty Fairclough, and Michael Goddard

The music video has been a problematic and controversial media entity, for as long as the genre, or phenomenon, of such videos to promote, accompany, or illustrate music has existed. In the 1980s, these three and a half minutes were understood by some arbiters of popular taste to usher in everything from the death of authenticity and undermining of the artistic worth of popular music to the eradication of its human element altogether. Yet the synaesthetic combination of music and moving images has a considerably longer and more diverse history than that of music television, and certainly of MTV, a diversity that is beginning to be increasingly recognized in the emergent field of contemporary audiovisual studies.

This volume will be making the case that music video plays a key role in this field, as confirmed by such recent high-profile volumes as *The Oxford Handbook of New Audiovisual Aesthetics* (Richardson et al. 2015) and

Digital Music Videos (Shaviro 2017), but also through a range of recent projects that attest to the fact that, as Vernallis puts it in another key text, *Unruly Media*: 'At one time we knew what a music video was but no longer [...] We used to define music videos as products of record companies, in which images were put to recorded pop songs in order to sell songs. But no longer' (2013: 10, 11). The evolution from Vernallis's unashamed celebration of music video aesthetics as a distinct format a decade earlier in *Experiencing Music Video* (Vernallis 2004) is clear in *Unruly Media*'s discussion of the music video in the context of the 'mixing board aesthetic' (2013: 4ff) of YouTube clips and new digital cinema which for her have become inseparable from music video itself. Nevertheless, as contributors to this current volume show, the net needs to be cast wider still, not only in terms of connections with broader histories and practices from high art video to global popular culture, but also in terms of an 'audiovision' or 'audiovisuology' that has the capacity to destabilize what we thought we knew about music video, even in its 'classic' MTV period.

MTV began broadcasting in August 1981 and soon became a dominant mechanism for the promotion and circulation of popular music. Radio, in this paradigm shift, was considered unable to deliver the full payload, commercial or cultural, of music, and so this audio-only culture was expected to wither away. And, it was commonly feared, musicianship, musicality, and even live performance would be rendered redundant. The visual would ultimately therefore demand the reinvention of the sonic and, in the domination of vision over sound, could be read as a survival mechanism or life-support system: only by completely transplanting popular music to the domains of the visual, no matter what damage would entail, would popular music continue to exist as an essential component of popular culture. With the paradigm shift in the music business in the wake of models of digital distribution, however, such hard-hitting promotion, which had been predicated on a limited number of outlets, became redundant, coinciding with the obsolescence of music charts. MTV began to manage its decline by a progressive disengagement with music while the commercial importance of live music was revived.

From today's perspective, however, another dimension needs to be considered: the technology of analogue video itself, by means of which music video was given its characteristic material support and aesthetic texture. Certainly film antecedents, as with Bob Dylan nonchalantly despatching cue cards for 'Subterranean Homesick Blues', or the film/music clips of Queen, David Bowie, and Abba, pioneered later music video tropes. At the same time, the music video has also seemed to segue seamlessly into emergent digital modes of production and, more recently, distribution. Nevertheless, paying attention to the arrival of the music video in its emergent and now-classic 1980s form inevitably becomes a form of media archaeology: the investigation of a now-obsolete technology and its associated practices.

Analogue video is an archetypically 'in between' electronic technology: between analogue cinema and photography and digital special effects, rendering and processing. It is also situated between relatively stable cinematic genres and digital fluid pastiche, as well as between stable television formats and the multi-channel free-for-all of satellite TV and, ultimately, YouTube. Significantly, in perceptual terms, the electronic video image is produced via entirely distinct mechanisms to both photographic and digital images, leading Sean Cubitt to speculate in the early 1990s that 'video media need to be thought in terms of relationships first, and of representations only second' (Cubitt 1993: 202), an approach that is still a useful corrective to representationalist approaches to music video in terms of identity politics that have dominated and continue to dominate academic research in the field.

Early work on the music video was inevitably located on a series of fault lines between music and sound and the visual, between high and popular culture, and between dominant and alternative representations. While E. Ann Kaplan's early and influential *Rocking Around the Clock* (1990) very much analysed music video in visual terms derived from film studies, Andrew Goodwin (1992) argued for the centrality of music in music video, an approach also informing *Sound and* Vision, the co-edited reader he produced with Simon Frith and Lawrence Grossberg (1993). Yet the fixation on MTV and its representation of cultural identities, as well as the paradigm of postmodernism that was perhaps unavoidable in these early works, obscure as much as they reveal about these synaesthetic objects, their multiple histories, and their functions in a rapidly developing media sphere on the cusp of the implantation of digital technologies. With hindsight, the music video appears as a kind of chameleon and catalyst of media change, one that would soon discard its commercial disguise as a mere MTV product, in favour of a more multifarious, if no less ambiguous, existence.

The analogue music/video therefore represents a world of technical and creative passage, situated between art and commerce, the mere illustration and documentation of musical performance, and visual creativity and imagination. Certainly it may be closer to us and less exotic than some of the technologies researched in the field of media archaeology. Nevertheless, in its creative exploitation of the resources of the denigrated technology of analogue video, with its unnatural and lurid colours ('video green'), tendencies towards deterioration, and cheap-looking special effects, the music video of its first period belongs just as much to a forgotten technical and aesthetic world, even if it is a world that has strongly conditioned contemporary digital aesthetics.

We will now present some of the key areas that will be covered in this volume beginning with revisions of the multiple histories of the music video, and then proceeding onto the close relationships between music

video, celebrity performance, gender, and sexualized bodies. From this point we will be addressing the more recent turn to music video as an aesthetic form both in its own right and in proximity to a range of new audiovisual aesthetic practices, before situating contemporary music video in its contemporary digital, mobile, and social media contexts.

Music video histories in, outside, and beyond MTV

Many histories of music videos – foremost Andrew Goodwin's *Dancing in the Distraction Factory* (1992) – yoke them to the American television station MTV; they analyse them as short films, and place them in the context of advertisements. Although that methodology may have been correct prior to the turn of the century, new technologies of dissemination have removed them from that era. Unyoked from distribution on cable television, unyoked from the financial necessity of major label sponsorship, and unyoked from bulky, expensive filming processes, the genre is in need of new theoretical frameworks. In 1936, Walter Benjamin's essay 'The Work of Art in the Age of Mechanical Reproduction' charted the way that the advent of the moving picture changed not only our understanding of but also the uses for visual art as a whole. Cinema, he claimed, changed art's status, its aesthetics, and its political usefulness; exploding what he deemed 'the prison-world' of still photography, 'so that now, in the midst of its far-flung ruins and debris, we calmly and adventurously go traveling' (Benjamin 1969 [1936]: 236). In many ways, the advent of the Internet has had the same effect. Music videos have been similarly infused with a new spirit of understanding, both political and aesthetic.

Unfortunately, given the volume of music videos in the world, this book is not, and cannot be, an exhaustive history of what might now be termed the 'music video turn'. Instead, it tries only to capture a few of those effects to point to a larger whole. Just as cameras brought art and images to the masses in ways that allowed casual viewers a far wider experience of the world, so too does the music video expand the reach of popular music. By so doing, it has added to its original purpose (promotion) a number of other ones. As well, the industry of music video has built a vast new edifice of use-values for musicians, artists, videographers, actors, and technologies to live inside. Compared to the massive transformation needed for the world to go from still to moving picture, music video's innovative qualities may at first seem comparatively trivial. And yet, despite its lowly beginnings as a marketing tool, it marks another way-station *en route* from consumer to creator.

Another way that the productive qualities of music video mirrors that of cinema is that, just as the invention of the camera left the work of art

itself not only intact, but redolent of aura and authenticity, so too does the music video, *qua* music. *Music* is still the single, signature note at the heart of all these endeavours. At the same time, there is no doubt that the wide dissemination and reach of the music video, and the technological advances that have occurred in cameras, videography, digital compression, and the Internet, have changed both how they are made and who can make them, altering forever the way that popular music is actually experienced. If, in a paraphrase of Althusser, ideology is construed by our imagined relationship to the real conditions of our existence, then music video has an even more magical quality, transforming an imagined relationship into sonic reality. As with ideology, that imagined relationship is fixed; it is the real conditions (of sound, of existence) that are fluid.

Neil Postman has said, following the words of Thoreau, that new technologies make us into the 'tool of our tools' (Postman 1992: 9). The many affordances of the music video have created a state where some listeners now listen to music by looking at it. Adding this layer has allowed artists to add new nuance, new depth, new ways to convey their messages, but it has also, as Postman warned us that technologies will, taken something away: as he said, 'every technology is both a burden and a blessing, not either-or but this-and-that' (4–5). The burden that the music video carries forward is that it has perhaps desensitized some listeners to music as a purely aural pleasure – a defect which many would argue is definitively negative. We respond to that claim herein by examining the work of artists whose videos not only haven't detracted from their musical impact, but which, we argue, have instead proven to be drivers towards new innovation, new fans, new music, new vocabularies of meaning.

In short, it is our contention here that, considered as either a new genre or addendum to music itself, the music video adds more than it takes away. To begin our study, we examined some early examples of this opening out in the works of Grandmaster Flash, of David Bowie, and of New Order – all artists whose use of the video has had a profound and lasting influence on the way it has subsequently developed, as well as at broader categories, like YouTube and Disney. We tried to capture this range in the essays herein, beginning with a chapter on methodologies which looks at music videos in all these realms, travelling through the history of rap to see the kind of impact the music video can have not only on music but on culture and its spread, all the way through to the world of television (specifically, on the Disney cartoon 'Phineas and Ferb') where its qualities have been put to work in reverse – a job, one might say, closer to its early incarnation as a marketing tool.

Of course, most music videos are still marketing tools, and are produced and paid for and circulated for that purpose alone. That they can simultaneously also be art is both the great achievement of the form and an acknowledgement of the conquest of capitalism over art. Capitalism

can force art to do its bidding, but art can inject its own messages, via music video; the process is an abject illustration of hegemony (the struggle to control meaning) in action. Michel de Certeau has suggested that 'everyday life invents itself by *poaching* in countless ways on the property of others' (de Certeau 1984: xii, emphasis in original); music video also poaches on foreign terrain, borrowing both its visual language and (as we try to capture here) its actual significance from a number of different disciplinary territories.

Music video, celebrity performance, and sexual embodiment

When it comes to celebrity performance and issues of gender and sexual embodiment, the music video is no less complex. As previously discussed, the music video no longer remains coupled to the financial base of major music labels and with this shift, a diffuse and complex audiovisual landscape has emerged. The form remains a vehicle for the presentation of packaged celebrity and commercialized femininity, but equally it presents a contemporary counter to these traditional and often regressive approaches and representations.

The emergence of this volume appears at a time where limited and stereotyped representations of gender and sexuality in the popular media are being challenged through social media platforms as never before. Hashtags such as #Yesallwomen and #Everydaysexism have highlighted how women are routinely presented in the media in narrow and regressive ways. Feminist activity is weaving its way into popular culture, forcing a cultural conversation that in years past would have remained largely locked in the academy. This conversation extends to celebrity performance and representations of gender and sexuality in music video. The mainstream music video has long been criticized for its limited and regressive representations which have sought to promote overtly sexualized images of women in particular.

This phenomenon peaked recently when the video for US R and B star Robin Thicke's 'Blurred Lines' appeared in 2013. 'Blurred Lines' was seen by many as promoting rape culture, a misogynistic attitude towards sex and troubling issues surrounding sexual consent. The video depicts three naked women dancing for three fully-dressed men whilst the lyrics repeat 'I know you want it', and T.I. raps 'I'll give you something big enough to tear your ass in two.' It is no surprise that it widely received a negative public response. Thicke attempted to defend the video by suggesting that it is absolutely degrading to women, but is more complex. In an interview with GQ he said, 'We tried to do everything that was taboo. Bestiality, drug

injections, and everything that is completely derogatory towards women. Because all three of us are happily married with children, we were like, "We're the perfect guys to make fun of this"' (Thicke in Phili: 2013).

What underlies this statement is a troubling view that is visible throughout popular culture that suggests if men respect women, it is then also legitimate to demean them. Given this context, when VH1 and Thicke's publicity team promoted the hashtag #AskThicke as a live Twitter Q&A, it grew into an altogether angrier publicity beast with Thicke receiving a barrage of calls to explain what was perceived to be rampant misogyny in his lyrics and imagery. Thicke's case highlighted not only the apparent misjudgement on the part of a celebrity, but how the public sought to challenge such negative representations of women and sexual embodiment through social media. As a consequence, Thicke's career has never recovered. Celebrity performances in music video exist to attract attention, but it is a fine line to tread in terms of representations of sexuality and the limits of acceptability.

Music video as a vehicle for celebrity performance is intrinsic to its existence. As a promotional tool, it functions to launch, reinforce, and maintain the celebrity persona, presenting revamped aesthetics, bodies, and imagery as fast as the celebrity machine will allow. Celebrity artists use music video in a range of ways, as platforms to bolster their personas, comment upon celebrity culture, and air their political views. More recently, contemporary popular female musicians stage controversies regarding body image issues and their implied power relations through various means in their music videos. Artists such as JLo, Nicki Minaj, Lily Allen, and Mariah Carey use various tactics to directly comment on, and often challenge, contemporary body image ideology.

Miley Cyrus's 2013 performance in 'Wrecking Ball' presents a case where all of these issues crystallize. It divided opinion, not least due to her prior entrance into the entertainment industry as a Disney child star. While Cyrus's music video is by no means the only one that portrays the female body near-naked, and arguably not even among the most explicit ones, the fact that Cyrus had risen to fame as a child actor at least in part explains the polarizing effect that 'Wrecking Ball' had on audiences. From 2006 to 2011, Cyrus had starred in the Walt Disney-produced TV series *Hannah Montana*, in which she played a schoolgirl who leads a double-life as a successful singer. In line with the family-friendly orientation of Disney, Cyrus was marketed as an average teenager. Towards the end of the show's run, Cyrus had begun to modify her public persona towards a more rebellious and provocative one, a development that culminated in the look evident in 'Wrecking Ball'.

Parallel to this change in Cyrus's public persona from conformist to provocateur, the difference between innocence and sexuality is visualized through the use of the colours red and white in 'Wrecking Ball', and the

disparity between Cyrus's new, sexually self-confident public persona and the more innocent one that had made her famous added to the media outcry. Many fans took no issue with the highly eroticized imagery and perceived the video as a step of detachment, if not liberation from Cyrus's previous celebrity persona as a role model for teenagers. Others were less enthusiastic of the direction of Cyrus's career. One of the most prominent voices was singer Sinéad O'Connor. In in an interview with *Rolling Stone* magazine, Cyrus had explicitly cited O'Connor's video for her 1990 hit 'Nothing Compares 2 U' as an inspiration for 'Wrecking Ball'. O'Connor's contribution to the debate constituted a discursive space in which two female artists from different generations articulated their views on the meaning of feminism and its artistic expression. O'Connor criticized Cyrus's artistic choices and furthermore cautioned her not to be exploited by record industry executives. O'Connor stressed the point that the decision to perform nearly naked in order to promote one's music does not lead to empowerment, but rather objectifies the female body and may lead to quite contrary results. This was no less complex as O'Connor's advice to Cyrus could be seen as perpetuating a traditional model of feminist generations or waves in the sense that an established feminist artist like O'Connor problematizes contemporary conceptions of feminist expression as demonstrated by Cyrus. The pairing of empowerment and the use of eroticized imagery has a long history in feminist discourse, and continues to be both problematic and unresolved, as the case of 'Wrecking Ball' video exemplifies.

The chapters in the second section of this book address these issues and present alternate discourses that challenge these critiques. Railton and Watson in their analysis of music video and the politics of representation argue that feminist writing on music video consistently critiques images in which women are negatively represented or not represented at all. It also celebrates more positive images of women, in their words, 'images deemed valuable in promoting a broader range of possibilities, opportunities and capabilities for women' (Railton and Watson 2011: 19). There are increasing examples of these types of music videos which have presented far more diverse representations that challenge patriarchal hegemony. Since the 1990s body of audiovisual work by Madonna, who openly challenged the music industry and its tendency to present women as objects rather than subject of sexual desire, there has been a counter to mainstream regressive images of women. Arguably this challenging body of work has seen its most challenging expression in Beyoncé's recent *Lemonade* visual album, which not only calls into question dominant modes of sexual and racial representation, but also develops a sophisticated audiovisual language that calls into question the very concept of the music video via the format of the 'visual album'; the rapid and intensive critical response to *Lemonade*

as a phenomenal audiovisual event testifies to how far the music video has come from its role as mere promotion of music and celebrity personae. In several chapters of this volume, the authors therefore seek to provide fresh understandings of the complex representations of celebrity, gender, and sexual embodiment in audiovisual culture.

In the examples analysed in the second section of this volume, we see much broader and more complex representations by female artists who have managed to traverse the complexities of the music industry on terms that have been negotiated by themselves and whose work presents a range of representational moments that challenge, reframe, and conform normative stereotypes. From Nicki Minaj to FKA twigs and Björk, these chapters present analyses of music videos that step outside and poke fun at the countless music videos that represent dead eyed women as objects of the male, patriarchal gaze.

The music video and/as video art

This collection also comes at a time when the long-forgotten/fondly remembered music videos of the late twentieth century have become widely available online, as so many instances of popular media archaeology. YouTube represents a vast 'anarchive' of music video that radically expands the 'product' associated with bands. At the same time, the democratization of digital media, and its freeness (as begun with MySpace), has allowed for an influx of 'home-made' music videos: the video is now seen as essential to the song in terms of viral dissemination. In some respects, this has returned music videos to their DIY origins – the delightfully shambolic and cheap videos that baffled early MTV viewers before record companies began to capitalize on the medium.

This viral dissemination of the music video via digital technologies signals beyond the limits of MTV narratives to minor traditions of the avant-garde and the amateur that subtended them. This is not to say that there was always an openly acknowledged kinship between highbrow video art and the more popular and commercially tainted practices of making music videos. There was indeed often a strenuous effort on the part of gallery video artists to distinguish their activities from that of commercial music video. This was true even if, in terms of actual practices and work, the lines were more fluid. Hence an experimental filmmaker like Derek Jarman, who was also an early experimenter with video, found himself directing videos for groups like The Smiths. Even more interesting crossovers between the worlds of art and music videos can be found in the 1980s practice known as 'Scratch Video' that remixed popular culture and television, often with explicitly political content. In the less populist regions of popular music,

such crossovers were very frequent. Industrial music, for example, was frequently accompanied by experimental film and video, and featured practitioners adept at mixing both forms. But this is no less the case of 'The Replacements' 'non-videos' for several of the tracks form the *Tim* album; these often single-take videos where nothing happens other than a framed-from-the-neck-down band member eating take-out, or a speaker cone vibrating only to be kicked over at the end of the video ('Bastards of Young'), there is a minimalism and medium reflexivity worthy of Michael Snow or Chantal Akerman. Taken together these tendencies constitute part of a complex 'video culture' to use Sean Cubitt's term (Cubitt 1991: 1–20), ranging from the most commercialized popular culture to avant-garde aesthetics, and profoundly affecting contemporary technologized late capitalist subjectivities and modes of life.

In this regard, a more arresting legacy of the music video is apparent and remains relatively unexplored. The music video has remained suspended between two distinct poles: on the one hand, as the visual sheen of late capitalism, at the intersection of celebrity studies and cultural identities and on the other hand, as art, looking to a prehistory of avant-garde filmmaking while perpetually pushing forward the digital frontier with a taste for anarchy, controversy, and the integration of CGI into a form designed to be disseminated across digital platforms. Virally, therefore, the music video re-engenders debates about high art and low culture in a transformed digital and social media context. This collection is hardly the first to raise these issues, since in addition to Vernallis's already mentioned work there is also the significant collection edited by Beebe and Middleton, *Medium Cool: Music Videos from Soundies to Cellphones* (2007), that was an earlier attempt to develop the more heterogeneous understanding of the music video that we are also proposing. Nevertheless, digital production, circulation, and distribution have advanced rapidly since then, as chapters in the last section of this book attest, not only transforming what the music video is and does today, but also understandings of what it has been in the past.

Music video and the contemporary digital context

Critics who highlight the death of the music video transmission as triggered by MTV's high-profile transition from an acronym-appropriate 'music television' to a successful scheduler of 'reality TV' productions should investigate the proliferation of cable/satellite channels that are still devoted to nothing but music. If solely observing UK offerings, MTV has diversified its music video provision via MTV Music, MTV Base, MTV Hits, MTV Dance, MTV Rocks, and MTV Classic at the time of writing. These options

compete with other providers such as Viva, VH1, KISS, 4Music, Magic, Chart Show TV, Scuzz, Kerrang!, Chilled TV, CS Summer, Flava, NOW Music, Clubland TV, Channel AKA, Heart Summer, Capital TV, and even Keep It Country which includes such segments as 'Live Laugh Linedance'. Yet the music video as it relates to much of this broadcasting is but a replica of the audio song's relationship to radio. This type of programming – based on playlists where a 'VJ' (video jockey) might replace the DJ – doesn't really foster and encourage the 'unification and involvement' that McLuhan might view as a requirement of modern media (1967: 10). For that we might look to The Box: a channel with most influence in the 1990s that eschewed the carefully constructed menus of music video staples MTV and VH1 while instead relying on viewers to request videos by telephone. While more democratically motivated, this audience-prompted activity would notably often lead to haphazard results involving back-to-back repeat plays or actual gaps in programming. A more current version of this interactive approach would be the MMS/text message-operated Starz TV with its promise of 'some slammin tunes' and the urging of viewers to 'request your fave vids or get your face on-screen by sending us a pic … you control the show!'.

Control, it seems, remains a driver behind the evolution and diversification of the music video's platform and format. While the CD-ROM may have once allowed for a different kind of interactivity when adopted for the later career audiovisual experimentation of musicians like Sting, David Bowie, and Peter Gabriel, mainstream fans appeared to be more interested in simply being able to defy the elusive, random, and transient nature of playlist content and access a music video at their convenience. The VHS recorder initially assisted in the way it had for the home taping of radio broadcasts and would allow the amateur compiler the ease in which to return to their 'fave vids'. But, eventually, official label-issued physical products (whether VHS, Laserdisc, or DVD) would capitalize of this demand for audiovisual output. This compiling/cataloguing as a physical commodity, in turn, opens up a new perspective on music consumption where that rather passive, fleeting chance encounter alternatively becomes a more active, permanent, and readily available experience. Yet the nature of the various formats that facilitate this interaction are significant through their understandings as physical products. As such, these need consideration beyond their communicative – as in 'playable' – properties and should also be addressed as curated tangible objects; objects that also become tied up with notions of collecting and, relatedly, with ideas surrounding self-identity. As Baudrillard explains:

> Apart from the uses to which we put them at any particular moment, objects in this sense have another aspect which is ultimately bound up with the subject: no longer simply material bodies offering a certain resistance, they become mental precincts over which I hold sway, they

become things of which I am the meaning, they become my property and
my passion. (1996: 91)

However, these 'objects of a passion' (1996: 91) do start to resemble archaic
time capsules when compared to the more recent emergence of web-based
streaming services.

Fred Deakin of music production duo Lemon Jelly underestimated the
most popular of these platforms, YouTube, as 'just twenty-first-century
MTV with a horrible window around it full of chat from morons telling
me how awesome/lame the track is' (2010: 55). The 'horrible window'
itself is designed in such a way that it is possible to view YouTube content
without even visiting YouTube. The proliferation of much of the platform's
content – particularly that which is said to have 'gone viral' – is through
the ability for this window to be shared and embedded across Internet
sites including all major social media. Subsequently, the music video exists
on YouTube (and other video sharing sites like Vimeo and Dailymotion)
as a more flexible entity than it would have through MTV playlisting. In
fact the music video clearly serves its primary purpose as a promotional
device once dispersed through these practices of sharing. Additionally,
the use of 'chat' (or, more accurately, 'comments') that will appear on
a particular video upload's web page is but one way that an audience
can further their interaction with the music video. Since video editing
technology first became ubiquitous across web-enabled electronic devices,
YouTube's user-generated content has arguably been as important as
Vevo: the multinational collaboration between Sony Music Entertainment
and Universal Music Group which is responsible for a large amount of
'official' music video on YouTube. The user-generated material may
actually include more official record label content – with descriptions of
these uploads including hastily drafted disclaimers pleading for protection
given the evident copyright-infringement. Alternatively, the music video
provides a format to explore for aspiring directors: 'a new generation
of artists, not ordained by TV and radio [...] mixing image and sound'
(Houplain 2010: 57). The culmination of this exhaustive, varied work
has subsequently turned YouTube into a 'collide-oscope' (McLuhan 1967:
10): a platform where styles and eras are juxtaposed and the music video
dilettante and expert vie for attention.

This collection is addressed to this contemporary, complex, and hybrid
context where the music video has not only survived the demise of MTV
and music television as the primary locus of its dissemination, but has
transformed its qualities and operations. Paraphrasing the Vernallis quote
with which this intro began, we no longer know neither what the music video
was and is, nor what its functions are, in the transformed media ecologies
of digital and social media, especially if we hold on to narrow ideas of the

music video as merely a music promotion commodity. The diverse chapters in this volume suggest otherwise, that the music video was always a more complex audiovisual entity than this, a complexity that has only become fully describable in the contemporary period and that calls for the renewed appreciation that this volume, along with other recent publications, aims to contribute to.

Music Video Histories in, outside, and beyond MTV

Introduction

Most histories of the music video begin in 1981, with the advent of MTV, the American cable network that brought a stream of song-length clips to music lovers in a package that somehow eluded the notion that they were in fact advertisements for the records on offer. And while that's as good a place for any to start a book on music video, the chronological (and business) story is not the one we are telling here. Suffice to say that MTV preceded the widespread sale of CDs by six years, the World Wide Web by ten, and the invention of YouTube (and its affordances) by twenty-three. Today music video, as a category, exists well beyond the confines of MTV and even television: this section grapples with how it has reached beyond its nominal beginnings into many other areas of art and life.

The history of the music video is certainly partly about technological advancements in communication, but this portion of the book focuses instead on the history of the video's cultural work, beginning with an overview of the ways that the advent of music video in the MTV age has not only transformed the landscape of pop, but may well have been part of a larger artistic project. Indeed, in this section, we suggest that, to paraphrase the words of Sunil Manghani, whose chapter on the cultural status of the music video frames the book, videos have become a new site of cultural production. Rather than merely emphasizing how music was disseminated, Manghani argues that music videos are a distinct cultural product, with different uses and abuses. To Manghani, the music video is now an empty visual product (relegated to source material, and often for the purposes of comedy and parody). In its place, a new video form – which he calls the Internet video – has emerged as a means for a younger generation to communicate and experiment with the forming of identities and social connections.

As Manghani implies, individual rock bands and artists are not the only people to benefit from music video as a marketing device. Michael Saffle's chapter shows how another musical genre, that of musical comedy, has been able to expand and thrive thanks to the affordances inherent in the form. Using the example of the children's cartoon *Phineas and Ferb*, which is produced and shown by the Walt Disney Company on the Disney cartoon network, Saffle describes how music videos have allowed for new uses of cartoons, creating yet another dimension that has changed how both a genre and a product can be circulated, consumed, and, inevitably, reproduced.

Providing a different take on reproduction, Greg DeCuir looks at the music video in the world of hip-hop, tracing its influence from the song 'The Message' to the present day to better understand its – and hip-hop's – astonishingly powerful effect on culture. By decoding the samples, cues, and the lyrics used in the original video for 'The Message' and carrying them forward to subsequent hip-hop offerings that bounce off its initial breaks and beats, DeCuir reframes the song's ultimate meaning. As he says, 'at its worst hip hop can offend and harm, and at its best it can change the world – and this can often occur in the space of the same lyrical verse, or break beat, or graffiti mural'. Considering its message through 'The Message' is therefore a vital exercise.

Concluding this section, Julie Lobalzo Wright on Bowie, and Andrew Burke on New Order, respectively, discuss how these two differing musical acts' early adoption of the form helped transformed its role; both were massively influential in how we understand artists through their videos, and both used film directors who were able to add significantly to the canon of groundbreaking early music video imagery. Wright focuses on David Bowie, whose unexpected demise during the conception of this book shaped in part how she approached the topic: she argues here that his music videos were not just a vital part of his own artistic output, but also important in showing the world new uses for the medium as part of the star making machinery. Lobalzo Wright's chapter makes a great case for the idea that the prescient topic of his final video 'Lazarus' – death – may not have been as eerily intentional as it seemed at the time of its release. It was simply a continuation of a lifelong artistic exploration.

Burke, also, explores how a single artist's use of the medium allowed it to become more adventurous and aspirational. In a series of increasingly abstract music videos, the band New Order, he posits, broke open the possibilities of the form itself. Freed from both the constraints of time and the demand that it serve above all as a vehicle for the manufacture and maintenance of pop stardom, New Order was able to situate and affiliate themselves, through their videos, with a whole history of high cultural visual arts production, from the legacy of the modernist European avant-garde to the emergence of American postmodern provocateurs. The three videos which he analyses here – 'Perfect Kiss', 'Bizarre Love Triangle', and 'True Faith' – not only

revealed the pop promo as a form through which band, brand, national, and cultural identity is worked through and over, but one in which the visual signifiers of 1980s postmodernism 'converge and coalesce'. The subjects and artists engaged within this section on histories and prehistories really represent only a very partial glimpse of the music video turn, but they do give an idea of the scope of the transformation at work. To follow the example of McLuhan (and to paraphrase DeCuir), if the medium is the message, then music video is telling us to pay close attention.

CHAPTER ONE

The Pleasures of (Music) Video

Sunil Manghani

This chapter traces something of the rise and fall of the music video over the course of its forty-year history. However, any purported demise of the form has come about only with the emergence of the online environment that has actually increased the opportunity to view and share videos (more broadly defined). The argument to be made, then, is not that the music video is necessarily lost from view, but that it is out of time. It could be suggested the music video has always been a *spectral* medium, always slightly out of step: it is not quite a film (it is too short and visually repetitive); it is made for television, yet only as a plugin; and crucially it is not the music, but its supplement. Nevertheless, since becoming mainstream in the 1980s there has been no let up in its production. Indeed, the music video looks set to remain an ubiquitous cultural product. What has changed is its reception. Amidst a wash of video now available online, the aesthetic of the music video appears anachronistic. It bears all the hallmarks of having been made through the official channels and sites of production, and generally mobilized to represent (and sell to) a young audience as an oppositional cultural group. This was all very well in an environment in which the means of production was controlled and broadcast channels were extremely limited in scope and choice. The music video appeared then as alternative and challenging. Today, digital production and Internet technology have dramatically altered the landscape.

The term 'music video' is often used interchangeably with phrases such as 'pop video' and 'pop promo', referring to a short film or video made to *accompany* an existing music track. Writing in the early 1990s, Goodwin (1992: 45) points out that '[m]usic video is not primarily a

commodity form but a promotional one'. The period of the 1980s leading up to when Goodwin was writing is arguably the most creative period for its production, which we would perhaps most readily associate with prominent rock and pop acts such as Michael Jackson, Madonna, Queen, Grace Jones, Duran Duran, and U2. The music videos made at this time would generally not be available for individual purchase, acting purely as promotional material. At that time, in the context of ubiquitous domestic video recording, it was common for music videos to be taped for repeated consumption, a mode of consumption that perhaps adds to the definition of the music video *as* video. Today, it is still common to see relatively high-budget music videos, at least with high-profile artists such as Beyoncé, Katy Perry and Taylor Swift. Beyoncé's album *Lemonade* (2016) was promoted as her second 'visual album' (being accompanied by a sixty-minute film). An artist of Beyoncé's stature allows for a degree of confidence in releasing a so-called concept album, but nonetheless the incorporation of visual material can still be seen as a loss leader, merely helping to market the album. It is still largely the case that music video operates as a promotional tool, and is not purchased in the same way as music tracks. Yet, contrary to Goodwin's remark which highlighted the music video's use value rather than its exchange value, the commodity value of the music video became readily more apparent with the advent of dedicated commercial TV channels, and more recently with the rise of an online commercial infrastructure, with platforms such as YouTube and Vevo. Indeed, from the perspective of critical visual culture *all* looking is in fact a form of labour, a means of commercial exchange (Beller 2006; Mirzoeff 2009). As Mirzoeff puts it:

> Advertising, television, film and the other visualized media that comprise everyday life in today's commodity culture demand your looking to generate value for someone else. [...] That value may be monetized when you pay to get into a cinema; or generate advertising revenue by clicking on a web ad; or it may be the value that a successful art gallery show creates by raising the status of the artist. (Mirzoeff 2009: 8, 9)

Within this context, the music industry is inevitably still wedded to the idea that selling music requires a visual component. In part this is due to the growth in music television channels over the last few decades, and a broader shift towards a visual culture that has meant an ever-greater circulation of images. As Railton and Watson (2011: 6) note, the computer screen has added a whole new complexity to the distribution and redistribution of music. They argue for a dual process. Looked at one way, the Internet has provided a highly effective new platform for broadcasting music videos, which are now available on demand. Yet, the same technology has provided a means for consumers to redistribute

music videos according to their own needs and interests. Their argument is a layered one, which is as follows:

> In selecting from the general catalogue of music videos which specific works are to be fed back into the system – that is to say, simultaneously re-circulated and archived – the relationship between video and song is reversed. For this enterprise implies that it is the video itself which has become the primary product, something which is valuable on its own terms. The significance of this is not simply to do with the fact that, like popular music, music videos now have a life outside of their official institutional existence. It also has to do with their cultural longevity. Put simply, music videos now no longer, if they ever did, come and go with the release schedule of the song they promote. Indeed, the new and the old, the classic and the contemporary, increasingly circulate, and are re-circulated, alongside one another in the present moment of the screen. (Railton and Watson 2011: 6)

This chapter is certainly sympathetic to such a reading, yet it takes a different view about the currency and 'pleasures' of the music video. In short, this chapter suggests the importance of the 'music video' as a distinct cultural product has receded, while the medium of video (understood as a broad category) has re-emerged as a notable site of production. It is not that the consumption of music itself has diminished, though the digital revolution in the music industry has significantly restructured its commercial prospects. Railton and Watson, for example, are not able to account for the streaming of music, which allows for a new distribution of music that further diminishes the role of the accompanying video and attributes greater commercial value to music's transience. In effect, music streaming seems to evoke the radio more than television. Yet, for a young audience today, Internet video production appears to assume a role that pop and rock music formerly held. It is 'video' (in a variety of forms, but typically 'unofficially' made) that offers the potential of a 'temporary autonomous zone' (Hakim Bey 1991); meaning the forming or informing of a sociopolitical tactic to create temporary spaces or systems of representations that sit outside of formal power structures. Arguably, then, Railton and Waston's laudable aim to restore critical aesthetic value to the music video fails to address the wider media ecology in which music video is now placed. Instead, the consumption of 'music-video' (as an ephemeral compound of image and sound) is now more likely to occur from snippets circulating on social media, via machinima, or through subscriptions to vloggers and YouTubers.[1] The three-minute pop song and its accompanying video (or extended video typical of the 1980s) are now subsumed into a more dynamic circulation of music-video, typically found via Facebook, Twitter, Vine, or Instagram, but equally on websites, blogs, television programmes, and mobile phone apps, and which can include official and unofficial footage of artists 'behind the

scenes', celebrity news, the reporting of live performances, and of course parody (a phenomenon that in the UK has led to a new law giving much greater latitude to the parody of copyrighted work). Thus, video remains an important cultural form, while the music video perhaps returns to a position of secondary interest (or, in the context of YouTubers, a secondary *source*). In many respects video today begins to look – finally perhaps – like the medium and mode of the late 1980s and early 1990s, which Cubitt, in his book *Timeshift* (1991), argued offered the *potential* of a new democratic form.

Music video as remediation

Broadcast TV, approaching its half century, has just developed its only original art form – rock video or MTV. Its originality lies in three dimensions – the foregrounding of the signifier over the signified, the 'openness' of its textural structure and its popularity for a non-conventional possibly oppositional audience. Its analysis is the delight of the post-structural.

(Fiske 1986: 74)

The first dedicated music channel, MTV, began broadcasting in 1981 in America (and MTV-Europe launched in 1987). The first video to be broadcast on the channel was The Buggles' 'Video Killed the Radio Star', which was originally released in 1979. It was the record label's first number one single, yet it was made by a short-lived duo, Geoff Downes and Trevor Horn (who went on to be a feted producer of the 1980s). They never performed live and really only existed on record. The video is considered to have been innovative for the time (Larkin 1993: 207), yet today we would generally regard it fairly static and even humorous for its surreal theatricalism. It includes a strange, ethereal character suspended in a transparent tube and a child who is drawn to a large wireless (presumably representing the idea of a shifting generation). However, in the main it is a band video, with the musicians surrounded by numerous pieces of music and televisual technology, both old and new. There are some neat edit points where the musical phrasing is carried by different frames within the video. So, for example, the vocalist is seen singing as if 'live', but then their image shifts to a television screen situated within the main set. Similarly a drumbeat is accentuated by multiple edit points. These techniques of montage and frames within frames, which were clearly novel at the time (and much copied ever since), play well to Fiske's account of the open structure of the music video.

Yet the real significance of 'Video Killed the Radio Star' is as a piece of music rather than as video. While seemingly a modest pop song, it is at the level of musical composition and recording that the post-structural,

intertextual qualities come through. The record has a standard disco beat, a catchy melody, and fairly straightforward instrumentation. Yet, as Warner's (2003: 41–49) analysis reveals, there is a great deal of subtlety. A lyrical reference to 'jingles' is matched with a passing sound of a jingle, while the words 'Second Symphony' lead out to a Baroque trumpet flourish. This is clearly a synthesized sound, which is underlined by the lyric 're-written by machine on new technology'. The lyrics are conceptually unusual for a pop song, and even just its title evokes 'a range of images, from the philosophical/political slogan to "whodunit", and as neither the gender nor the particular nature of the radio star's talent are ever made explicit, the lyrics shrewdly offer the listener's imagination the widest range of possibilities' (Warner 2003: 44). A key quality, however, is the *recording* of the vocals, which for the male voice makes use of extreme compression and equalization. 'The resultant sound', Warner explains, 'is reminiscent of an early radio broadcast and is in marked contrast to the "contemporary" clarity of the female voices that interject in the verse and sing the chorus' (46). He also points out the use of different accents, with the male mid-Atlantic accent, reminiscent of British radio singers of the 1950s (captured with the line 'I heard you on my wireless back in '52), juxtaposed with the strong New York accents of the female singers:

> These elements provide timbral contrast but also imply historical contrast: the male voice sounds old-fashioned, whereas the female voices sound modern, through timbre, accent and implied (but illusory) variations in recording techniques. It is not surprising, then, that the verse text expresses nostalgic sentiments while the chorus does not. (Warner 2003: 46)

Thus the song is not only about nostalgia, but as much infused with techniques to evoke sounds old and new. We might take 'Video Killed the Radio Star' to be a metapicture of the music video, whereby it uses the medium of pop and music video to analyse itself and, in this case the shift to a visual culture.[2] And, as such, it is an example of remediation, as defined by Bolter and Gusin (2000), which significantly combines both senses they outline of remediation. It presents the 'immediacy' of the artist, the 'radio star' who is still cutting through the apparatus of the video. But hyper-mediation is also evident, through its combined use and foregrounding of differing technologies of mediation. The song establishes the music video as a lament, as a space of inferiority, and as temporary – it is a stop-gap, in lieu of the real thing. As such it claims the music video as a form of seduction and manipulation. While less obviously metapictures in this way, similar layers of nostalgia can be seen in the video for The Boomtown Rat's 'I Don't Like Mondays' (1979) and Aha's 'Take On Me' (1985). The former incorporates an upright piano (central to the music composition) in all of the scenes of its video, which show the band (a group of modern 'new romantics') inhabiting

the mise-en-scene of a school and home of the 1950s. The latter makes excellent use of rotoscoping, which allows the combination of pencil-sketch animation and live-action (the same technique used in the film *Who Framed Roger Rabbit*, 1988). The shift between drawing and live action within the same representational space foregrounds its own mediation, and the style of the drawings harks back to cartoons and illustrated books of a yesteryear. Also, the main theme of the video is a romantic fantasy narrative, which further heightens its sense of nostalgia.

Of course, the idea that video might kill the radio star is a playful conceit. In fact the symbiotic relationship between sound and vision goes back to the 1930s. Oscar Fischinger, for example, experimented with abstract synchronization of music and image. He produced *Komposition in Blau* (1935), and some of his work included end-titles directly advertising music, with slogans such as 'Get it at your local record store'. He was also hired to work for Disney in 1938 and his influence can be seen in the acclaimed *Fantasia*, released in 1940. British filmmakers also experimented with music-based work. Len Lye's *A Colour Box* of 1935 (produced for the GPO Film Unit) remains a vibrant work in comparison to music and animation video today. Films showcasing popular artists also started to be shown as part of cinema programming. These films were made available more widely via the Panarom – a form of video jukebox popular between around 1939 and 1946. Weighing around two tons, these machines could be found in bars and cafes and its contents were generally unregulated so allowing for material that might be sexually suggestive or politically sensitive. A follow-up machine, the Scopitone, was developed in France. It could show colour films and provided means to both play and rewind film – which arguably begins to foreground the plasticity of the medium (as is later considered, for example, in Cubitt 1991). By the mid-1960s the Scopitone had become popular in both France and the United States. During this time music-based films started to appear, including Elvis Presley's *Jailhouse Rock* (1957) and Cliff Richards's *The Young Ones* (1961) and *Summer Holiday* (1963). And perhaps more significantly for the development of the music video, The Beatles turned to the use of film as a response to the difficulty of being heard over the screams of their own fans. *A Hard Day's Night* (1964) adopts a documentary mode, which is also notable with Bob Dylan's *Subterranean Homesick Blues* (1965). The idea of using film to offer a more up-close, intimate picture of the artist is significant, and remains an important role for contemporary music video.

The real growth in music video comes, of course, with the advent of weekly TV programmes dedicated to pop music. Inevitably the promo film became necessary to stand in for performers when they were not available. However, it is also advances in music recording itself that prompts greater use of film. The Beatles' *Sergeant Pepper* (1967) album, for example, marks a turning point, a shift from the touring band to the studio recording artist.

The surreal and Dadaist film and animation techniques that we start to see accompanying The Beatles' music is in part a reflection of certain visual trends of the time, but equally offers a visual equivalent to the complex, layered sounds in their recordings. This aesthetic was further pushed and made mainstream by *The Monkees*, a US band and television series created to rival The Beatles. It is no real coincidence that it was Mike Nesmith, a former member of *The Monkees*, who pitched to Warner Brothers the idea of *Pop Clips* as a dedicated music programme. This went on to become MTV – the round-the-clock broadcast channel for the music video we are familiar with today. Thus, by the time we reach this watershed moment, key elements of the music video aesthetic (surrealism, jump cuts, comedy, band performances, use of repetition, documentary modes, etc.) were already well established, and based on various forms of audiovisual mediation. The idea that video killed the radio star is clearly revealed a fiction, but the ease with which The Buggles' track constructs this 'narrative' through its music and video equally highlights the very malleability of the pop video form. It is able to evoke, inhabit, and self-critique various techno-aesthetic conditions.

At the height of music video production in the 1980s, there was a tendency in some quarters to want to secure the pop video as something closer to cinematic art. Emphasis was placed upon lavish narrative elements and increasingly large budgets. The role of the video director also takes on greater significance. Many directors went on to have careers in cinema or at least aspired to, and notable directors of the time were also drawn to make music videos. Michael Jackson's 'Thriller' (1984) was directed by John Landis. It made extensive use of special effects, costume, and prosthetics in a fourteen-minute-long music video. As supplement, a documentary of the video was released to help offset its costs and proved highly popular itself. Following this, Martin Scorsese directed the video for Jackson's 'Bad' (1987), and his later release 'Black or White' (1991) was again directed by John Landis, and was also premiered *simultaneously* in twenty-seven countries, attracting the highest ever audience for a music video with around 500 million viewers. The end of the video includes a polished execution of 'morphing' – a visual effect created by Pacific Data Images that allows one image to seamlessly cross over into another, and which at the time had only previously been used in films such as *Willow* and *Terminator 2* (although a similar *non-digitized* effect can be seen in Godley and Crème's video for 'Cry' released in 1985).

The high degree of confidence within the music industry during the 1980s meant that it was a particularly creative and experimental period for the development of the music video. The former rock duo Godley and Creme turned their attention to directing music videos for artists such as Ultravox, The Police, Duran Duran, and Frankie Goes To Hollywood, creating some of the most evocative and provocative productions of the time. These British acts also took advantage from the fact that MTV was keen to gain

more material to fill its extensive airtime. As a result video airplay could often come *in advance* of radio play, which in turn helped these acts break into the American market. Duran Duran's stylish and glamorous videos, shot on location, are a good example of the confidence of the period. However, Godley and Creme also experimented with creating music in the form of video. In other words they reversed the process: individual edits contained elements of sound, which when edited together became a music track. This collage approach to music echoes some of the early experiments of the 1930s, noted above, but also pre-empted developments in digital production, epitomized by the work of The Art of Noise, the 'avant-garde' synth-pop group formed in the early 1980s. Another important backdrop to the development of the music video was the emergence of video art, stemming from the pioneering work of Nam June Paik in the mid-1960s, and later, from the 1970s onwards, other notable artists such as Andy Warhol, Martha Rosler, and Bill Viola. In connection to this, and of particular significance for the choreography of music video, is the work of Merce Cunningham – the pioneering modernist dancer and choreographer.

Cunningham famously did not take 'inspiration' from a piece of music, but instead focused directly on questions of movement in time and space. He was interested in chance as a way of mapping out sequences or phrases in dance, and as such sought to find new ways of moving that did not rely on habit or intuition (Vaughan 1990: 81). Crucially, he forms the idea that each dancer is the centre of the space he or she occupies:

> This notion of a multiplicity of centres could be called a Zen concept [...] it is also analogous to the organisation of the pictorial space in much contemporary painting. Cunningham himself says that where he found confirmation was in Einstein's statement, 'There are no fixed points in space'. (Vaughan 1990: 82)

It is perhaps not too much of a stretch to consider a similar sense of space – of multiple centres – in most music videos. The camera work, editing techniques, and performances of singers and dancers found in music video create a complex pictorial space, in which continuity is often eschewed and focal points are quite fluid. Cunningham, himself, was interested in the intersection of camera and dance space. As Vaughan (1990: 87) notes: 'He recognised in his first tentative experiments that the space seen by the camera differs from that seen by the spectator in a theatre: a triangle that widens from the camera aperture as opposed to a rectangle that narrows.' *Beach Birds for Camera* (1991), made in collaboration with John Cage, is a good example of Cunningham's use of the camera as interacting *relatively* with space and body movements. In this work the dance group appears to move in highly individual ways, yet there is also a sense of shared space and spacing between one another – the work is of a *flock* of dancers that both works together yet through individual movements.

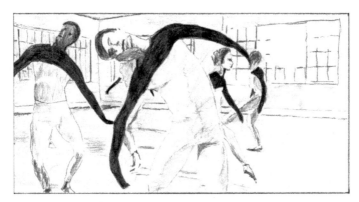

FIGURE 1.1 *From Merce Cunningham's* Beach Birds for Camera *(1991). Illustration: Manghani.*

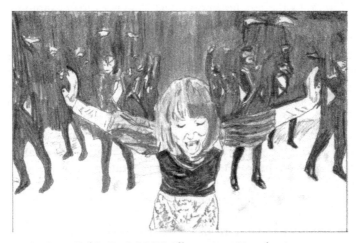

FIGURE 1.2 *From Yuki's 'Joy' (2005). Illustration: Manghani.*

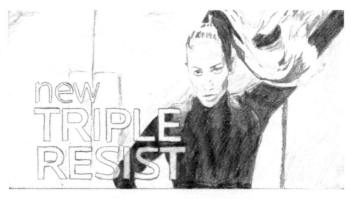

FIGURE 1.3 *From L'Oréal Paris 'Elvive Triple Resist' TV advertisement, featuring Jennifer Lopez. Illustration: Manghani.*

Cunningham's work is, of course, understood (and consumed) through the discourse of modern and avant-garde art, which is at odds with the low cultural status of the pop music video. His disassociation of movement and music is also difficult to relate to the often highly mechanized relationship in music video. Yet, his consideration of the stage as a non-hierarchical space (i.e. with a multitude of equal viewpoints and positions), which has been likened to cubism and abstract expressionism, provides one way of thinking about the construction of movement in music video. While inevitably undercut by the main singer as focal point, music videos frequently display idiosyncratic and asymmetrical elements. A further correlation is Cunningham's openness to free expression, which again allows for a simultaneity of equal events among those dancing. Such freedom of expression is a vital ingredient of the music video, and again relates to its role in displaying a certain intimacy of the artist or band. The music video for 'Joy' (2005) by the Japanese pop singer Yuki is a direct example of how we might relate *Beach Birds for Camera* to the pop video. Yuki dances in front a troupe of dancers with bird-like faces. Most of the dancing is tightly choreographed and regimented, yet the camera often intervenes in the space to interrupt its flow, and crucially, Yuki, while echoing the bird-like gestures of the dance routine, expresses herself in free form. Her video for センチメンタルジャーニー [Sentimental Journey] (2003) is another fascinating example that foregrounds the mediation of the camera, but in this case through the repetition of the body itself. A line of women who all look like Yuki, and are all dressed the same, stand in a line for the video. They are all in same space, yet each hold a separate pose of movement that appears as if sequential, as if we looking at separate frames of a film. It is a very simple device, with the camera slowing panning in a single take along the line of bodies as the music plays. The video appears almost a form of animation yet all of the movement is held static on a single plane.

The shift suggested here from the high art of Cunningham's modernist dance, to the 'low' art of pop music and music video, makes better sense if we dispense with the high/low distinctions and instead focus on systems of communication. As Hebdige (1988) defined in his classic study of subcultures we can understand subcultural styles as art, when understood 'as art in (and out of) particular contexts; not as timeless objects, judged by the immutable criteria of traditional aesthetics, but as "appropriations", "thefts", subversive transformations, as *movement*' (Hebdige 1988: 129). What is particular to the music video as *form* is its ability to appropriate other forms and signs. So while there is such a 'thing' as the music video (something we can select to watch), its definition as a *form* is more fluid. We might think here of Roland Barthes's (1977) distinction between the *work* (e.g. a book we can take from the shelf) and the *text* as its place in a network of meaning, as a form of reading. In this respect the music video presents an inherently post-structural and postmodern system of

signification. As 'style', as a symbolic form of resistance, it can present a challenge to dominant ideology, hegemony, and social normalization. It can challenge the doxa of high art as much as prevailing dominant mores. Yet, of course, as Hebdige shows, such resistance is held momentarily, because eventually it is commodified. In the example here of Cunningham, his work (as reified 'art') is subsumed into the pop promo, which in turn is easily commodified as pure advertisement. Elements of dance and gesture, combined with the interface of the camera, can as much be found in a shampoo advertisement for L'Oréal Paris Elvive Triple Resist, featuring Jennifer Lopez (c.2012). Through a series of jump cuts, she is seen to strike various dancerly poses. Overall, the advertisement creates a mesh of interconnecting 'texts' of movement, texture, and voice. In a 'behind the scenes' video, Lopez jokes about her role: 'They always make me dance', and then affecting the voice of a producer she adds: 'We have Jennifer today, just dance around. Just do whatever you want. No, Jennifer, just dance. Just tell her dance over there. We'll just shoot it whatever'.[3] Again, here is an instance of remediation: an advertisement posing as avant-garde dance, and which also incorporates the celebrity of Jennifer Lopez, enabling avant-garde practices to be ably subsumed within the mainstream.

Video pleasure

Fiske's account of the music video suggests of a play of oppositional and disruptive forces, which operates at the level of style. He explains style as 'a recycling of images that wrenches them out of the original context that enabled them to make sense and reduces them to free-floating signifiers … and thus able to enter the world of pleasure where their materiality can work directly on the sensual eye, running the boundary between culture and nature, between ideology and its absence' (Fiske 1987: 250). However, as the preceding account shows, the music video in most cases is the result of a *construction* of signifiers and that the medium itself is bound up with a series of interrelated modes of mediation. Cubitt is critical of Fiske, arguing that he overlooks structures of power and contestation. Picking up on Fiske's reference to Madonna, for example, Cubitt suggests Fiske's account of pleasure too readily allows him to 'remove the image of Madonna from the voyeuristic mechanisms of the patriarchal gaze'. Instead, Cubitt argues, 'Madonna's videos do not subvert bourgeois taste, they reconfirm it by tinkering at the edges of the permissible [...] What is in operation here is the containment of the potential of populist disruption, not its irruption into an unwilling system' (Cubitt 1991: 56).

Both Fiske and Cubitt are writing after the fact of Laura Mulvey's groundbreaking essay on the male gaze (1975). For all the potential of the

music video as a site of experimentation in the visual arts, it nonetheless has to be recognized for its formulaic mode of visual pleasure and consumption. The editing of the *gendered* body, as associated with Mulvey's notion of the male gaze, has arguably become the most prevalent and recognizable characteristic of the pop video aesthetic, aided and abetted by a penchant for fast editing (in keeping with the beat) and the 'empty container' in which the videos are frequently set. The basic tenets of Mulvey's account, of the female body as being looked at (often broken up and fetishized through montage etc.), and of the predominance of the male protagonist (who we get to see *move through* cinematic space and act) are sadly all too often on display. Indeed, structurally speaking, very little has changed, particularly in terms of the music video's mode of address – with artists being tracked as if in a riffle-range or bearing down on the lens. Writing in the early 1990s, for example, Cubitt's comparison with television news is still pertinent:

> pop on TV relies on novelty, on the elimination of analysis in favour of sensation, on the dominance of the soundtrack over the images (one bombed city, one guerrilla, is much like another till we learn that they are Beirut or Belfast, terrorists or freedom-fighters). Eye-contact is a crucial mode of address for both. Like news events, pop acts are criticised for preparing themselves for the camera, for using the media, for irrationality and abnormality – the very qualities that make them newsworthy. 'Sexy' is a term applied commonly to news stories and videos. Like news, pop TV uses the mechanism of marginalisation to void the present of its historical formation, to indicate the boundaries within which normality can be expected to continue to perform in the indefinite present, to homongenise. Alternatively: everybody has a different living room, but they are all living rooms. (1991: 49)

Cubitt's account of the music video as the spectacle of the 'event' remains a useful way of understanding the allure of its image. Although his closing reference to the 'living room' is now out of date, with spectatorship much more fragmented due to the Internet and mobile technologies.[4]

A more critical consideration of the 'pleasure' of the music video requires a less celebratory account of the signifier. In Barthes's *The Pleasure of the Text* (1975) an underlying concern is to persuade critics on the left to allow for a notion of pleasure within the theory of the text. It is to counter a form of iconoclasm of pleasure and the image that pervades through critical writing. Barthes seeks to show there is no contradiction between social and political engagement, or, as it were, the ideology of the text and its energy or pleasure. He refers, for example, to an 'amorous' investment into an object, as a means of engagement. Railton and Watson's much more recent attempt to re-position the music video as an object worthy

of serious examination is in fact a very similar gesture. There is a need to engage directly with the object itself – for all its allure and pleasure – if we are to understand its ability to enter into the wider systems of signification. In doing so, we might do well to recall Barthes's account of two different pleasures of the text:

> Text of pleasure: the text that contents, fills, grants euphoria; the text that comes from culture and does not break with it, is linked to a *comfortable* practice of reading, Text of bliss: the text that imposes a state of loss, the text that discomforts (perhaps to the point of a certain boredom), unsettles the reader's historical, cultural, psychological assumptions, the consistency of his tastes, values, memories, brings to a crisis his relation with language. (Barthes 1975: 14)

Barthes's reference to a 'crisis' in one's own language or discourse sets a rather higher bar than we might glean from Fiske's reading of the post-structural. In most cases, the music video is likely to appeal as a pleasure of comfort. It is an object borne of the culture industry, and with the key purpose of selling us music. Yet, the fluidity of form that the music video presents does allow for the potential of a more contestatory object: the music video as a text of discomfort and of challenge to the *doxa*.

FIGURE 1.4 *From David Bowie's 'Ashes to Ashes' (1980). Illustration: Manghani.*

A comparison of David Bowie's 'Ashes to Ashes' (1980) and Michael Jackson's 'Black or White' offers one way of navigating Barthes's pleasure of the text. Bowie's 'Ashes to Ashes' is an iconic pop record, much remembered for its innovative video (which Bowie himself co-directed). Reportedly being the most expensive video made around that time (costing £250,000), it is notable for its use of solarized colour in contrast to stark black-and-white. This kind of experimentation was not readily found elsewhere, at least not within popular cultural forms. Michael Jackson is another good example of an artist innovating through music video (notably with the examples cited above of 'Thriller' and 'Black or White'). Yet, when we look at the two videos today by David Bowie and Michael Jackson, we might be inclined to see them as examples of *contrasting* accounts of pleasure. Ever the entertainer, and self-confessed fan of films and musicals, Michael Jackson demonstrates a very intuitive form of visual intertextuality. But, just like the popcorn-eating fan we see in the video for 'Thriller' Jackson tends to assume an euphoric, playful, and comfortable practice of reading. The video for 'Black or White' opens with a cameo scene from Macaulay Culkin (the star of the *Home Alone* franchise). Once the song properly starts we see Jackson dancing in various culturally specific tableaux. In one, Jackson mirrors the movement of a surrounding group of dancing African hunters. Similar scenes show Jackson dancing with traditional Thai dancers, Plains Native Americans, an Odissi dancer from India, and a group of Russians dancing Hopak. For the final verse, Jackson appears as if on the torch of the Statue of Liberty, prior to which he was seen at other famous world sites including The Giza Sphinx, Hagia Sophia, Pamukkale, The Parthenon, Taj Mahal, St. Basil's Cathedral, Pyramids of Giza, Golden Gate Bridge, Big Ben, and the Eiffel Tower. This kind of intertextuality is fun and celebratory, but also only trades in stereotypes. Given the lyrics of the record, it espouses a comfortable, optimistic notion of harmony and multiculturalism, not too different to the problematic advertising campaign of the 'United Colors of Benetton' popular at the time (Lury 2000). By contrast, the video for David Bowie's 'Ashes to Ashes' – to this day – remains visually ambivalent. It incorporates relatively easy-to-read signifiers, such as the harlequin, a priest, a dentist chair, and a modern kitchen, yet in their combination and the fog of the solarized colour they become uncertain, even unsettling. Somewhat akin to a Rauschenberg flatbed painting, we can grasp its various elements, but our sense of perspective is unsettled through their spatial (and narrative) flattening. We are brought to a crisis in relation to our own orbit of signifiers and order.

Nevertheless, if we re-examine Jackson's 'Black or White' it is perhaps not entirely fair to assert such a contrast. The end sequence of the video is often forgotten, largely because it was removed following complaints. After the previously mentioned morphing sequence, which offers a celebratory

multicultural morphing of 'difference', Jackson is seen to leave the studio not as himself but as a black panther (which in recent American history is a loaded activist symbol regarding black rights). Through a play of shadows the panther is seen to morph back into Jackson himself, who then presents a demanding dance sequence that is both sexually suggestive (with Jackson repeatedly holding his crotch, and zipping up his trousers) and violent, with Jackson smashing windows, destroying a car, and causing an explosion. Video networks ended up removing these last four minutes of the video (which are not set to music). An altered version was later produced which includes graffiti messages within the scene, concerned with racism (with slogans such as 'prejudice is ignorance'), as an attempt to make more sense of the vandalism and violence. Here again, is an example of discomfort and a collapse in regular discourse that music video seems well placed to affect. We could say the main music video itself is not of this order, but like a Trojan Horse, it is the carrier of a 'loaded message'. With regards the sexual content of Jackson's video, a more contemporary example of such discomfort might be Miley Cyrus's 'Wrecking Ball' (2013), which featured the singer in the nude swinging from an industrial wrecking ball. However, in terms of its political content a more obvious example is Beyoncé's 'Formation' (2016). The song itself is strident in its references to black culture and history. It even includes a provocative line about Michael Jackson's youthful look (an artist she has expressed much admiration for), thus she sings: 'I like my baby heir with baby hair and afros/I like my negro nose with Jackson Five nostrils'. However, the video is even more obvious as a political statement. Beyoncé is seen lying on top of a New Orleans police car sinking in water, a clear reference to Hurricane Katrina of 2005, the aftermath of which revealed a stark racial divide in those affected. The video also includes a young black boy dancing in front of riot police, who put their hands up before cutting to graffiti that reads: 'Stop shooting us'. And a dance sequence is shot in a car park, which is filmed to replicate an amateur video. It is a clear reference to the sort of mundane sites in which various shootings of black men by police officers have taken place. It also echoes something of the Rodney King beating in 1992, which again was captured on amateur film. On one level this is a direct example of the challenge to the dominant discourse that Barthes refers to as a so-called text of bliss, or *jouissance*. Yet, perhaps more importantly we have to understand this sense of oppositional 'text' as the *movement* between various representations, and the passage of intertextuality that they allow. Thus we view Beyoncé's 'Formation' *in relation to* (and in opposition to) other texts, which include Jackson's 'Black or White', among numerous other sources and reference points. This requires an understanding of the music video less as a discrete cultural product and more as a medium and being made up of multiple iterations.

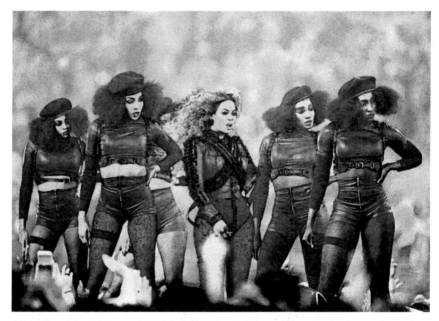

FIGURE 1.5 *From Beyoncé's live Super Bowl 50 performance of 'Formation' (2016). Illustration: Manghani.*

Internet killed the video star

The significance of Beyoncé's 'Formation' goes far beyond the official video and has much more to do with how it swiftly circulated within news and social media networks. The release of the song came somewhat out of the blue, and just twenty-four hours after its release Beyoncé performed the song at the half-time break of the Super Bowl 50 (2016), which is the culminating American football game for the National Football League with a reported average television audience of over 111 million (and with a base rate for a thirty-second advertisement of $5 million – a record high price for a Super Bowl advertisement). Beyoncé's tribute to Michael Jackson was made very clear in the costume she wore, but more striking were the costumes of the backing dancers who were clad in black leather and wearing black Panther-style berets. This homage to the Black Panthers marked fifty years since their formation, and which had its roots in Oakland, less than 50 miles from where the Super Bowl took place. Given the visual prominence of this event and a flawless execution of a powerfully choreographed display, Beyoncé inevitably became the story of the night. Crucially the performance was pegged to the hashtag #blacklivesmatter – a social movement for which, only the day before, Beyoncé's husband, Jay-Z, had announced a donation of $1.5m. Thus, Beyoncé's 'Formation' can be viewed as something beyond

a music video, even beyond its music. It becomes a combined 'object' of music-video-news as it forms and reformulates through social media, news networks, and print journalism.

Beyoncé is, of course, a particularly high-profile artist, which makes such an event possible. However, there was spontaneity to the release of the record that is unusual for an artist of her stature, which gives a more contingent quality to the song and certainly it is a good example of how the music video is superseded by the Internet. Other than for those attending the event itself, the 'spectacle' of Beyoncé at the Super Bowl is not captured in any one broadcast or from a single authorial position. Instead it is made up of official and unofficial 'feeds'. It is the medium of the Internet that is important here, and that allows for a new kind of networked artist. While The Buggles' 'Video Killed the Radio Star' offered a space of lament, of nostalgia, the contemporary context of digital music, downloads, and streaming and video platforms such as YouTube have come to offer a new space of both commercial consolidation and creative freedom (including a notable DIY aesthetic). In effect the Internet has killed the video star. Given the decreasing margins on the sale of music (due to digital distribution) and the fragmentation of television audiences, the music video has lost its space within a broader media ecology. Taking its place, in many respects, is the emergence of music video as snippets and of more significance online videos made by vloggers and YouTubers.

Eva Gutowski, who posts videos as 'mylifeaseva', has over 5 million subscribers. She is a 21-year-old American university student who began making videos about fashion and make-up, but has developed a loyal audience interested in all aspects of her life. She tours with other YouTubers, has published a book, and sells various merchandize. She cites her love of parody videos as an initial prompt into making YouTube videos herself, and in fact she has produced a slick, but tongue-in-cheek record (available on iTunes) called 'Literally, my life'. While bearing none of the subtly of 'Video Killed the Radio Star', the song offers something of a metapicture for the current 'video' landscape. The video offers an upbeat representation of her life with her friends (as if life is an eternal party), yet the lyrics describe the lifestyle of the video-uploader as insular and self-deceiving. She sings: 'Inside my sheets/With the screen lighting up my face/I've got my life/Laid out in a visual space'. Of course the irony is that her life as a YouTuber is much more obviously networked and vibrant. Similarly, Zoe Elizabeth Sugg, known by her YouTube username Zoella, has over 10 million subscribers. She is a British-based fashion and beauty vlogger, YouTuber, and author; her waxwork is featured in Madame Tussaud's, London. Her debut novel, *Girl Online* (2014), broke the record for highest first-week sales of a first-time novelist since Nielsen BookScan began compiling records in 1998. When comparing with the gold and platinum discs awarded to music artists for selling half a million or a million records, these YouTube artists are regularly

receiving views on their individual videos that far exceed a platinum disc (even in cases a diamond disc, equivalent to 10 million views).

On first view, the kinds of videos posted by these 'artists' can seem inane and self-obsessed. Theirs is an unfiltered and uncritical account of the world that is typically oriented towards consumerism and individualism. Yet, in reference back to the quote by Mirzoeff at the start of this chapter, the vlogger and YouTuber gives a new lilt to the idea of the labour of looking, since they end up earning money for the way in which they look at their lives. Furthermore, there is a candid nature to the video work that suggests rather than being self-obsessed; there is an ease and frankness with one's own body, gestures, and clothing. Vloggers and YouTubers frequently make fun of themselves and the videos are generally crudely edited (indeed they are made swiftly and prolifically). It is a 'clean' punk aesthetic. There is also a lot of humour and quite complex performances of (shifting) identity, which can be quite insightful or cutting. In this vein, Miranda Sings is a particularly interesting example.

Created in 2008 by an American comedian, actress, and YouTube personality Colleen Evans, Miranda Sings began as a satire of bad singers who use YouTube to try to break into the music business. Today she has over 6 million subscribers to the YouTube channel, and individual videos regularly receive over 10 million views. A spoof video of Taylor Swift's 'Shake It Off' has over 45 million views. Badly dressed, and with overly applied lipstick (as a trademark), Miranda is a talentless, narcissistic character. She often provides inept 'tutorials' in various elements of stagecraft. In a video in which she reacts to the video of Ariana Grande's 'Focus' (2015) she claims

FIGURE 1.6 *Miranda Sings, 'Reacting to Ariana Grande – Focus', YouTube video (9,725,717 views at time of writing, on 6.3.16). Illustration: Manghani.*

to be Grande's vocal coach of many years and feigns a maternal concern over the singer, who she feels is not being looked after properly. As the video comes to an end Grande falls to the ground as the music fades, at which point Miranda Sings gasps in horror as if Grande has collapsed. It is an amusing sequence, which metaphorically suggests of the collapse of music video itself, and is replaced (and critiqued) by an artist such as Colleen Evans.

The alternative forms and imagery once unique to the music video is now seen in all kinds of video work on the Internet. In the 1980s and early 1990s there were numerous community spaces providing access to film and video production. In the UK, the BBC maintained a highly successfully unit called Video Nation, which enabled ordinary people to make films from their own perspective and typically about their own lives. These were the precursors to the YouTube generation. Yet the requirement to distribute through the dominant channels and gatekeepers meant that the community-based movement was relatively short-lived. The online environment has undoubtedly changed things and in effect given rise to a new aesthetic. Cubitt's account of video in the late 1980s and early 1990s was critical yet considered video, through its ability to 'timeshift' and edit the moving image, to offer the *potential* for a set of practices and possibilities of a new democratic form. As we reflect back, the power of the image formerly associated with the music video begins to recede. Today, 'video', as a catch-all term, and as a more pervasive set of practices is now significant for its shifting status within not just time, but the very compression of time-space. This is to evoke David Harvey's (1990) account of the condition of postmodernity that was published almost concurrent to Cubitt's *Timeshift*. Key to Harvey's argument is that time has been privileged over space in modernist, theoretical accounts. However, space becomes more significant under certain social conditions. Harvey's account of the production of space through social practices and of the flattening out of knowledge remains pertinent, not least with the World Wide Web as a compression of time-space, as a historically flat and culturally smooth 'space' (and that offers both 'representations of space' and 'spaces of representation'). This is problematic in many ways. It is notable, for example, that YouTubers are generally almost all middle-class, upwardly mobile young people (though this is equally true of most pop musicians over the years). For the music video the compression of time-space leads to the demise in its significance vis-à-vis the broader image 'ecology' in which it now exists, certainly with respect to the dominant forms of production (the star system, the record labels, the advertising corporates, and the entertainments industry more broadly). Indeed, the traditional music video is now an empty visual product (relegated to source material, and often for the purposes of comedy and parody). In its place, a 'new' video form has emerged that began with parody, but has

led to a new sensibility and artistry, underscored by the D.I.Y. aesthetic of vloggers, YouTubers, and Internet performance artists. Nonetheless, the *continuity* between the music video and the Internet video is that both provide a means for a younger generation to communicate and experiment with the forming of identities and social connections – a process which still typically concerns itself with the 'pleasures' of fashion and the body within a limited political purview.

CHAPTER TWO

From Broadway to *Phineas and Ferb*: The Rise of Music(al Comedy) Videos

Michael Saffle

Considering the technological changes that have transformed publications, live performances, and televised music, it is scarcely surprising that musical comedy, that most old-fashioned of genres, is changing too. Traditional musicals are still presented in theatres by living actors, even though Hollywood long ago began recasting staged musicals as full-length feature films as well as producing new, exclusively filmed musicals. As the smash hit and Pulitzer Prize–winning musical *Hamilton* (2015) has shown, 'legitimate' musical comedy continues to thrive, while film versions of *Into the Woods* (2014) and *Les Miserables* (2013) have also achieved success. Today, too, musicals are not only televised but made for television, and excerpts from televisual offerings, together with clips from live productions and movie musicals, (re)appear by the thousands on the Internet. These excerpts include portions of animated TV programmes, some of which embody a few – or, in certain cases, many – of the tropes associated with stage and screen musicals. Today, digitalized, serialized, and televised musical comedy is closely associated with two interrelated distributers: the Walt Disney Company and the Internet.

For most of a century, no audiovisual empire has produced more commercially successful musical-comedy material than the Walt Disney Company.[1] During the 1990s, for example, only the Disney studios 'could be relied on to release a [filmed] musical every year or two' (Miller 2000: 46).

Nor has the Company ignored TV. As early as 1937 Walt Disney himself foresaw 'the power and potential of television as a medium'; decades later, *The Mickey Mouse Club* (originally 1955–1959) 'helped pave the way for an even bolder, more ambitious development – the company's move into cable television' (Telotte 2004: 3, 82). More recently Disney has all but cornered the market on TV musicals aimed at 'tweens': boys and girls between the ages of nine and fourteen (see Prince and Martin 2012; Seidman 2009). The Company's musicalized television series, including *Hannah Montana* (2006–2011), have proven as popular with twenty-first-century youngsters as *Cinderella* (1950), *Mary Poppins* (1964), and *The Little Mermaid* (1989) did with their parents and grandparents.

The pages that follow deal with both subjects identified above: Disney's ongoing contributions to televisual musical comedy, and the continually expanding re-presentation online of those contributions in the form of new music videos. A genre originally associated with cable television, the 'music video' – defined as a 'short film paid [for] by the music industry to be shown by TV channels' (Sibilla 2010: 225) – became a staple of MTV (Music Television) programming as early as August 1981 and quickly made the network famous. A few of MTV's videos have been criticized for their sexual content and violence (see Baxter 1985) as well as for narrational incoherence associated with building stories around songs that have nothing to do with each other (Kinder 1985: 5). At the same time early music videos have won praise for their 'integrity as an expressive form' within 'miniature film', and for subsuming 'the function of the [1950s TV] variety show in disseminating popular music to vast audiences' via television (Allan 1990: 1, 13, 14).

During and after the late 1990s, MTV reduced music video airplay, replacing much of it with reality show[s] (Brayton 2016). Currently, early MTV videos survive on television almost exclusively in retrospective compilations as well as a few documentaries broadcast on other channels; they also survive on the Internet. Today, MTV and MTV2 broadcast more coherent but less influential videos advertising electric, rap, and hip-hop performers.[2] Largely replacing MTV's 1980s and 1990s offerings today, at least for many viewers, are online audiovisual posts of every imaginable kind, ranging in musical content from professional recordings of lengthy classical performances to home-made footage of three-chord guitar solos. Occasionally these posts, like MTV's products, have been 'conflated, and confused, with the context of [their] distribution' (Railton and Watson 2011: 44). Furthermore, 'music videos' as a genre continues to be defined exclusively in terms of pop styles, even when 'art' is invoked as a genetic category (Railton and Watson 2011: 51–55). But context matters, and so does content. More than a few musical-comedy YouTube posts, for instance, have been devoted to amateur performances. Others, representing the work of talented camerapersons and sound engineers, re-

present portions of Broadway theatricals. One typical example, complete with two call-backs and enthusiastic audience applause, preserves a live performance by Lee Wilkof and Michael Mulheren of 'Brush Up Your Shakespeare' from the 1999 Broadway revival of Cole Porter's *Kiss Me Kate*.[3]

Blaine Allan is correct in suggesting that 'attempts at critical inquiry into the music video may be fated to remain provisional' (1990: 3), which is why questions about precisely what music videos have often been or should be continue to be raised.[4] Allan's suggestion that videos in some sense pose a threat to the survival of musical comedy, however, seems less plausible (Allan 1990; Grant 2004: 4). Nor was this last suggestion noteworthy, even in 1990, when Allan published it, since the idea that worthwhile musical comedies are dead or dying has circulated for decades. Replacing them in certain circumstances are 'McMusicals': unimaginative and often recycled shows churned out by teams of chorographers and producers instead of independent, theatre-savvy writers (Grant 2004: 309). Here Disney has also led the way, and by the early 2000s the Company 'had become Broadway's most powerful and successful producer of [McM]usicals by tapping its reserve of pre-sold animated feature films and remarking them for the stage' (Singer 2004: 161).

Perhaps staged and filmed McMusicals – also known as 'jukeboxicals', 'popxicals', and 'revisicals' – have 'played out their string' (Grant 2004: 314). Or perhaps not. *Jersey Boys*, based on 1960s recordings by the Four Seasons, is but one of many jukeboxicals to achieve box-office success; in 2006 it won two Tony awards. Revivals of classic musicals also continue to attract audiences, and recently a few innovative productions have achieved worldwide acclaim. Both *Hamilton* and *The Book of Mormon* (2011), Broadway's biggest hits in years, are the creations not of choreographers or directors, but of writer-composers Lin-Manuel Miranda (for *Hamilton*) and Trey Parker, Robert Lopez, and Matt Stone (for *The Book of Mormon*). The changing face of musical comedy thus appears to undermine Mark Grant's assertion that the 'only way American musical theater can regerminate is if vital and inspired writers...turn to [live, book-based productions] rather than to movies *or television*' (Grant 2004: 314; italics added). In fact, we argue here that the opposite is true. Indeed, among many other musicalized diversions, Disney's animated *Phineas and Ferb* (2007–2015) series suggests that TV and the Internet may be musical comedy's next best places.

In contradistinction to Disney's own McMusicalized output, *Phineas and Ferb* exemplifies a highly innovative form of postmodern musical comedy – one that simultaneously incorporates, transforms, and in certain respects transcends aspects of older book-based shows such as *Oklahoma!* (1943) as well as newer shows such as *Follies* (1971), *Cats* (1981), and Disney's own animated *Aladdin* (1992 film, 2014 stage). Furthermore, *Phineas and Ferb* challenges a number of familiar assumptions about

musicals themselves. Even the Company's more predictable *Teen Beach Movie* (2013) and *Teen Beach 2* (2015), as well as the *High School Musical* series mentioned below, represent exceptions to Jack Harrison's rules that 'serial musical[s]…[have] almost never been successful', and that 'even in film and on stage, musical sequels have almost always flopped' (2012: 259).

Musical comedy is anything but an antiquated or static genre. Even its (meta)narrational focus seems to be shifting. During the early 1980s Thomas Schatz coined the terms 'rites of integration' for (re)acceptance narratives, and 'rites of order' for stories about eliminating dangers, often of a less than intellectual kind (1981: 34). For Schatz, musicals deal with romance or 'reacceptance' rather than escapes from danger. However, *Phineas and Ferb*'s speculative scientific content – dubbed the 'best science fiction on television today' (Padnick 2012) – as well as its avoidance of erotic entanglements challenge Schatz's categories.

On the other hand, Schatz himself admits that genres of every kind, including musicals, are never in and of themselves 'blindly supportive of the cultural status quo'. Instead, a great many generic creations *renegotiate* cultural ideologies rather than simply accept them (Schatz 1981: 35; italics in the original). This last claim would seem to undermine the Company's long-standing reliance on 'such all-American traits as conservatism, homophobia, Manifest Destiny, ethnocentricity, cultural insensitivity, superficiality', and 'lack of culture' (Wasko 2001: 224). But times change, and decades ago Disney began changing with them. As early as 1991, the Company formally instituted a non-discrimination policy based on sexual orientation at its theme parks (Griffin 2005: 131). More recently, Disney's production teams have begun, albeit somewhat intermittently, to address environmental issues as well as ethnic and gender stereotypes. Biases linger, but some argue that many of the most stinging assaults on recent Disney productions may only be 'knee-jerk' reactions from conservatives and leftists alike (Wasko 2001: 225).

Every Disney product, of course, is precisely that: a product. Nor is *Phineas and Ferb* an exception. A family-friendly show aimed at mainstream audiences, each episode revolves around the suburban antics of the series' eponymous half-brother stars. Phineas and Ferb are mechanical geniuses who spend each day of summer vacation inventing or building something amazing: a roller coaster, a super-computer, a giant, remote-controlled bowling ball, and so on. Candace Flynn, the boys' insecure fifteen-year-old sister, desires above all to 'bust' her brothers for their audacious behaviour, but she never succeeds, usually because one of Dr Heinz Doofenschmirtz's evil inventions somehow gets in the way. (Doofenschmirtz, also known as 'Doof' and 'Dr. D.', wants to rule the imagined Tri-State Area, where the series is set, but he invariably fails to seize command for long.) Other characters include Linda Flynn, also known as Mom (and the biological mother of Phineas and Candace), and Lawrence Fletcher, also known as

Dad (and the biological father of Ferb). A favourite with children is the family's pet platypus Perry – who, unknown even to Phineas and Ferb, is actually Agent P: an animal spy who spends part of each episode foiling Doof's nefarious plans.

These and other characters are associated throughout Disney's series with three interlocking plot lines: the boys' inventions, Candace's attempts at 'busting', and Perry's struggles with Doof. Scientific speculation, action and adventure sequences, moments of young love (chastely represented), and a variety of extra-musical visual and textual references are offset by at least one musical number in almost every episode.[5] More than a few of these numbers are unmistakably musical-comedic in style. Doof's show-stoppers, for instance, suggest the first-act finales of such Broadway successes as Porter's *Anything Goes* (originally 1934), while Candace calls to mind Kim McAfee of *Bye Bye Birdie* (1960 stage, 1963 film) and Sandy of *Grease* (1971 stage, 1978 film). References to past or passing phenomena include vacuum tubes, Parisian fashions, and glam rock. For these reasons *Phineas and Ferb* appeals to small children (who love Perry and the show's action sequences), 'tweens' as well as teens (who may identify with Candace, her cell-phone obsession, and her crush on a neighbourhood boy named Jeremy), younger adults (who can laugh at the show's jokes and enjoy its tunes), and older adults (who may recognize its many references to the past).

Phineas and Ferb also reflects the Company's possibly grudging but nevertheless more up-to-date depictions of ethnic diversity and gender stereotypes. It is easy to unpack the principal assumptions that underline the series as well as almost everything else the Disney studios have produced. America's economic prosperity (although not necessarily its global military and industrial superiority) is one, heterosexual love as healthy and normal another, the social importance of the nuclear family a third. Certain exceptions exist, however. As a series, *Phineas and Ferb* includes such incidental characters as Baljeet (a star student of South Asian descent), Isabella Garcia-Shapiro (of mixed Hispanic and Jewish ancestry), and the anything-but-girly Fireside Girls. Ferb himself speaks at least a little Japanese, and neighbourhood bully Buford not only speaks French but occasionally cross-dresses. The Flynn-Fletchers' mixed marriage, Doof's status as a divorcé and his socially destructive schemes, and Buford's outbursts make the series livelier as well as a little more relevant to twenty-first-century audiences, helping them 'teas[e] out the relationship between representation and reality' (Stempel 2012: 603). Details like those identified above momentarily encourage suspension of disbelief, even as the series' ritualized plot elements and continuously recycled mantras remind viewers – adults especially, but even many children – of its artificiality. In these and other ways, including moments of adventure, scientific speculation, and cultural awareness, *Phineas and Ferb* overturns long-standing assumptions about musical comedies as well as the political and social conservatism of Disney's

corporate output. The 'almost sonnet-like' precision of its interrelated narratives and the 'fusillade of repeated motifs' also support its 'radical vision of childhood as a time of unsupervised independence' (Nussbaum 2012: 114).

Understanding how animated and serialized TV programming can be transformed into musical comedy requires a grasp of the conventions associated with 'classic' musicals. Stephen Banfield's discussion of narrational, organizational, and performative traditions common to almost all late nineteenth- and earlier twentieth-century operettas and musical shows begins with story lines that foreground 'the triumph of youth and beauty over impediments to a marriage laid down by age, authority or economics' (2005: 295). For Banfield, each show comprises 'a whole evening's entertainment, divided into two or three acts' and introduced by 'a medley overture' (2005: 294). After an opening ensemble number, 'spoken dialogue, always in the audience's own language, alternates with songs', and each song comprises 'a succession of quadratic (e.g. thirty-two bar) units' (2005: 294, 297). Expressive contrasts are also important, as are 'overall setting and color', and musical variety often depends upon 'the art of arrangement' (i.e. accompaniment) as well as 'stylistic updates' (2005: 296, 298). Banfield also mentions both the impact of film on musical comedy and 'the rock revolution' that arrived on Broadway during the 1960s 'and is still with us' (2005: 298).

Often, but by no means invariably, *Phineas and Ferb* draws upon many of the tropes Banfield identifies, including opening ensembles that foreground beautiful girls, the use of polyphonic vocal numbers, and multicultural musical-stylistic variety as well as a few nods in the direction of famous shows. 'I Know What We're Going to Do Today' which opens 'Rollercoaster: The Musical' (2011; Season 2, episode 63), visually references *Fiddler on the Roof* (1964), *Singin' in the Rain* (1952), and *The Phantom of the Opera* (London 1986; Broadway 1988) as well as other well-known stage and screen musical offerings. The song itself, however, belongs only to the series. 'Ferb Latin', from the episode of the same name (2011; Season 3, episode 26), is constructed in the form of a contrapuntal chorus, with Phineas, Ferb, Isabella, Baljeet, and Buford gradually adding their voices to create a polyphonic climax.

For Banfield, musical variety is often achieved by references to a cultural 'Other,' often located geographically east and/or south of other numbers. In *West Side Story* (1961), for instance, the other is represented by Puerto Rican rhythms. Several episodes of *Phineas and Ferb* feature Central European-themed numbers associated with Drusselstein, an imaginary nation stuck mostly in the Middle Ages and the native land of Dr Doofenschmirtz, who returns home once or twice for visits. In fact, musical contrasts referencing distant places and other cultures appear in many *Phineas and Ferb* episodes. In 'Summer Belongs to You', Candace, Isabella, and the boys stop in Tokyo,

the Himalayas, and Paris during an around-the-world adventure. In two of these places, 'exotic' music is foregrounded: J-pop in Tokyo, for instance, as well as a Bollywood song-and-dance spectacular set somewhere in an imagined northern India.

Other episodes draw upon older, less exotic musical styles. In 'Don't Even Blink' (2009; Season 2, episode 9), a quiet, tick-tock back beat reminiscent of Joseph Haydn's 'Clock' Symphony introduces an emphatic chorus reminiscent of 1970s jazz-rock fusion. In 'Norm Unleashed' (2012; Season 3, episode 54), Doof's unhappy robot performs a vigorous and rather ominous military march. And in 'Chez Platypus' (2009; Season 2, episode 9), Dr D. whistles, sings, and accompanies himself on the ukulele in 'Happy Evil Love': a song tantalizingly similar to 'It's Only a Paper Moon', recorded in 1933 by Clifton 'Ukulele Ike' Edwards.[6]

Still another trope familiar to every musical-comedy fan is the reprise. *Phineas and Ferb* has its own theme song, several times reworked, and 'Gitchee Gitchee Goo', its first pop-style offering, reappears in a half-dozen episodes and styles. Perry too has his own signature tune, and even Doof has a sort of radio call signal – 'Doofenschmirtz Evil, Incorporated!' – that plays whenever an establishing shot of his high-rise corporate headquarters appears on screen.

At the same time, *Phineas and Ferb* ignores many of Banfield's conventions. Not even its hour-long specials comprise 'an entire evening's entertainment'; many of its more or less self-contained episodes last no more than eleven minutes. There are few references to courtship and marriage, although infatuation plays a slowly evolving role throughout the series, with Isabella attracted to Phineas, Candace to Jeremy, and Ferb to Vanessa, Doof's slightly naughty teenage daughter. Instead of a medley overture, each episode opens with an almost unvarying title sequence. Acts, if they can be said to exist, are excuses for commercials, and the ads themselves provide the closest thing to *entr'acte* music. 'Rollercoaster: The Musical', however, is 'a show about putting on a show' – a well-established plot line or narrative 'ploy' (Banfield 2005: 297). Isabella's 'City of Love' song from 'Summer Belongs to You' (2010; Season 2, episode 54) is all about 'reflection, nostalgia, and loss' (2005: 295). Finally, 'harsher musical idioms, including rock' (2005: 298), are employed in a great many episodes, including disco in 'Put that Putter Away' (2008; Season 1, episode 36), punk in 'The Baljeatles' (2009; Season 2, episode 21), and rap in 'Brain Drain' (2010; Season 2, episode 63).

Gender issues are frequently foregrounded in *Phineas and Ferb*, and female characters often come out ahead. Isabella is ready for any adventure; she and the other Fireside Girls hike, climb, and swim to earn merit patches for their uniform sashes. Once or twice Isabella even takes on Buford and manages to defeat him. Male characters, on the other hand, often get the worst of it. Linda may be a housewife today, but she used to be a rock star known as Lindana, and in several episodes she again performs to

wild applause. Only with his sons' support, however, is Lawrence able to approximate his wife's successes – and then only once: as lead vocalist with a counterfeit 1980s ensemble called Max Modem and the Mainframes (2010; Season 2, episode 58).

Phineas and Ferb is by no means the only musicalized series on television today, nor is it invariably the most popular. Episodes of *The Simpsons* (1989–) and *South Park* (1997–) also animated, have been given over to 'all singing, all-dancing' specials; one *Simpsons* episode even bears that title (1997; Season 9, episode 11). Instalments of real-life dramas, including *Glee* and *Scrubs* (2001–2010), have also featured musical episodes, and so has the more facetious *Flight of the Conchords* (2007–2009). 'My Musical' (2007; Season 6, episode 6), the prize-winning *Scrubs* episode about a woman suffering from delusions who imagines she's in the middle of a musical production, proved so successful that in 2014 a staged adaptation was being prepared for Broadway (Niles). Nor should we forget that more conventional musical comedy long ago made a place for itself on TV. In 1957 Richard Rodgers and Oscar Hammerstein II's *Cinderella* became American television's first 'original' musical.[7] Only in 2013 did Rodgers's and Hammerstein's show make it to Broadway, where it has again achieved success.

Except for a very few fart jokes and veiled references to excrement, *Phineas and Ferb* avoids *South Park*'s vulgarity as well as its political commentary. In spite of its episodic happy endings, it also avoids a little of Disney's old-fashioned sweetness and light. Put it another way: *South Park* calls to mind Greek Old Comedy, full of sex and politics. *Phineas and Ferb* is closer to Roman New Comedy (Banfield 2005: 295): a less explicitly satirical form of entertainment. Yet, although *Phineas and Ferb* is gentler than *South Park*, it is also more sophisticated than many earlier Disney entertainments and more consistently musicalized than any other animated TV series. Netflix's innovative *Unbreakable Kimmy Schmidt* (2015–) series also features Broadway numbers, albeit somewhat inconsistently – and this in spite of claims that music is the series' 'DNA […] much as it was on [Tina Fey's and Robert Carlock's] previous collaboration, *30 Rock* (2006–2013) (Zuckerman 2015). Unlike *Kimmy* and *30 Rock*, *Phineas and Ferb*, as well as *Crazy Ex Girlfriend* (2015–) – the last with its greater appeal for adult audiences – incorporate one, two, three, or even four original musical numbers in almost every episode.

Neither *Kimmy* nor *Crazy* is animated. *Family Guy* (1999–), on the other hand, *is* animated and also references musical-comedy tropes in many episodes. Yet *Family Guy* relies much more heavily than *Phineas and Ferb* on pre-existing numbers, including borrowings from Gilbert and Sullivan's Savoy Operas as well as stage and screen successes such as *The Music Man* (1957 stage, 1962 film) and *My Fair Lady* (1956 stage, 1964 film). Furthermore, *Family Guy* mostly employs its musical numbers for satiric

and frequently semi-obscene purposes, although one adaptation – 'The Shapoopi' from *The Music Man* – is presented complete in 'Patriot Games' (2006; Season 4, episode 20), with a few new words but most of the 1962 film version's choreography intact.

Family Guy creator Seth McFarlane has composed original numbers for the series and also expressed a preference for older, more conventional musical comedies (McFarlane). Perhaps for this latter reason *Family Guy* is far more dependent than *Phineas and Ferb* than on pre-existing musical sources. Disney's series regularly recalls and suggests existing numbers but never simply copies them. 'Disco Miniature Golfing Queen' from 'Put that Putter Away' may have been inspired by ABBA's 'Dancing Queen' of 1975, but duplicates neither its melody nor lyrics.

The strikingly modern content in *Phineas and Ferb* reflects many of the important changes that have taken place since the 1980s and earlier in terms of marketing and distributing musical comedy, changes that technology has made necessary. For decades before its theme parks opened, Disney depended almost entirely on two sources of income: movie-theatre ticket sales and licensing fees paid by merchandise manufacturers. The Company's more recent and more conventional musicals have reaped profits, however, thanks to repeated cable-TV broadcasts and direct-to-disk sales as well as occasional theatrical releases. Consider the televisual *High School Musical* series (2007–2009) – a series parodied in *South Park*'s 'Elementary School Musical' (2008; Season 12, episode 13). All three *High School Musical*s have been broadcast and re-broadcast on the Disney Channel and Disney XD. In addition, *High School Musical 3* was screened in theatres, and a spin-off entitled *Sharpay's Fabulous Adventure* (2011) and starring Ashley Tisdale (who voices *Phineas and Ferb*'s Candace) went directly to disk in the form of Blu-ray/DVD combination packs.

Surprisingly, only a few *Phineas and Ferb* episodes have been released on DVDs, but – as we shall see below – literally hundreds of excerpts and even entire episodes have been posted to the Internet, many of them by the Company itself. At the same time, a number of real (rather than virtual) *Phineas and Ferb* products have been licensed and marketed, among them a series of graphic novels, three of which – *Wild Surprise* (Mayer 2009), *Runaway Hit* (Bergen 2009), and *Speed Demons* (Jones 2009) – have proven especially popular as library purchases.[8] Other items include plush toys in the shapes of Phineas, Ferb, Candace, Perry, and Ducky Momo – the last a fictional plaything of Candace's early childhood and, in several episodes, a source of rare collectibles. These real-life toys are mostly intended for very young children and are available from Disney's own stores, Toys 'R' Us, and online vendors. *Phineas and Ferb* board games also exist; so does *Quest for Cool Stuff*, a videogame that can be played on Nintendo's DS and Wii as well as on XBOX 360. Products manufactured with older children in mind include Phineas and Ferb FUNtainer thermos bottles (illustrated with

images of Perry) and Disney Phineas and Ferb Slumberbags (sleeping bags that also feature Perry's image).

Licensing, however, is fading in comparison with the ubiquitous appeal of audiovisual Internet posts created for profit by corporations as well as by well-meaning fans, posts that represent the twenty-first century's emerging take on old-fashioned music videos. Disney continually (re)commodifies *Phineas and Ferb* through the excerpts it presents 'officially' on YouTube. These excerpts have little or nothing to do with selling sound recordings, of course; declining LP and CD sales contributed decades ago to the decline of MTV-style music videos as advertisements for albums and the conglomerates that manufacture and distribute them. Nor do the Company's posts follow the 'relatively rigid stylistic schema' of old-fashioned music videos in which 'shots of the band members (performing or not)', 'excessive cinematography', and 'rapid editing' helped illustrate pre-existing 'lyric-based songs' (Butler 2010: 96). *Phineas and Ferb* features *original* songs cast both as plot-based musical-comedy numbers and as 'miniature films' (albeit animated ones), and Internet posts of these songs unquestionably disseminate the Company's music to vast audiences. So, of course, do TV broadcasts of series material. The 'Christmas Vacation!' special broadcast on 7 December 2009 garnered 2.62 million viewers, up to that time the most watched telecast in Disney XD's history (Cable ratings).

Phineas and Ferb is not just an example of how musical comedy has found its way into new forums. It also helps us understand how the affordances of YouTube and the Internet work to transform musical comedy itself. Decades ago the only way to replay televised music videos would have been to record them on magnetic tape. 'Vidding' – analogue editing of existing film footage – was possible as early as the 1970s, but vids could not be distributed then as easily as digital material can now (Freund 2011). Today's YouTube posts can be accessed from almost anywhere in the world and paused as well as replayed, edited, altered, and reposted online. These possibilities provide opportunities not only for almost unlimited access to *Phineas and Ferb* numbers, but also for discovering 'Easter Eggs' – hidden messages – in Internet posts taken from individual episodes as well as the episodes themselves. In other words, in order to watch everything Disney's series has to offer, viewers need to be able to watch it on a hand-held device, which is precisely where it is most often advertised, enjoyed, and discussed.

One example of an Easter Egg must suffice: In 'You're Going Down', a 1960s-style girl-group number sung by Candace together with Stacy and Jenny, two of her virtual friends, and presented near the beginning of 'Rollercoaster: The Musical', we see Candace imagining punishments inflicted on her brothers that include a seventeenth-century pillory and a modern jail cell. We also get a glimpse of an old-fashioned school room, with Candace as teacher, ruler in hand, and her brothers as naughty students wearing dunce hats and standing in the room's corner. This last glimpse lasts

less than a second, so it is impossible in real time to decipher what's written on the virtual blackboard. Digital devices, however, allow viewers to pause at this point and read the words 'I will not build cold fusion re[actors]'. The same devices also allow viewers to search 'cold fusion' online and confirm its presence in 'Run Away Runway' (2008; Season 1, episode 9). This last episode provides no more than a glimpse of the invention in question, with Ferb working on a reactor in the family's backyard, but the two 'Eggs' are enough to tie the episodes together.

Internal references like these are not only fun to uncover; they also encourage small-screen enthusiasts to watch more of *Phineas and Ferb*, thereby enlarging Disney's audience base and the show's appeal to advertisers. Apparently the Company has never posted 'You're Going Down' to YouTube, but several independent viewers have. One of them even added the lyrics as subtitles to an extended version of that number, while other users posted word-only clips that omit Disney's visuals but preserve its music (PhineasFan11). All these developments contribute to the *serialization* of musical comedy: a form of virtual entertainment in which each animated character or group of characters – Phineas, Ferb, Candace, and so on – is given an opportunity, sooner or later, to perform alone or as part of an ensemble. These developments also make possible the creation of postmodern music videos, available on YouTube rather than MTV, and supported by corporate sponsorship as well as the consumers, or some of them, who embrace its products.[9]

Phineas and Ferb, then, is a microcosm of a trend in which television today is increasingly perceived as a palimpsest upon which references to its own history as well as to other media are continually (re)inscribed and rarely altogether erased. Many Americans have embraced televised musicals in part because they embody familiar performative gestures and styles as well as explicit references to previous stage and screen shows. *Phineas and Ferb* exemplifies aspects of this ongoing development. More even than *Family Guy, South Park*, and *Unbreakable Kimmy Schmidt*, Disney's series exploits a wide range of cultural references, especially musical styles ranging from Busby Berkeley spectaculars to Cab Calloway-style blues, hard-edged Chicago blues, and 1950s rock 'n' roll. By so doing, it appeals strongly to adults with a fondness for wit and irony; it also incorporates a few gestures in the direction of ethnic and gender equality; and even on TV screens it frequently opens the fourth wall separating programmes from viewers.

Re-presented online, *Phineas and Ferb* musical clips have helped bring a new form of music videos into existence. Like many of Disney's previous song successes, each of these videos 'advance[s] plot or delineate[s] character' as semi-independent segments of a serialized, animated, and digitalized musical, thereby linking Broadway productions of the past with multi-mediated present and future possibilities (Miller 2000: 47). Instead

of selling something else, sound recordings, as early MTV videos mostly were intended to do, the new videos sell themselves. Moreover, they sell the televisual series from which they are excerpted and the industry that creates those series. As such, they more firmly establish metonymic rather than primarily metaphoric links between producers and consumers. Every *Phineas and Ferb* clip is part of a larger whole, not simply an advertisement for an ensemble, performer, or composer. Disney's series is neither violent, offensively sexualized, nor incoherent, and as a consequence it possesses far broader audience appeal. Family friendly, the show reflects the attitudes of creators Dan Povenmire and Jeff 'Swampy' Marsh, who based the series 'on the freedom, creativity and sense of exploration' they experienced in their own childhoods (Anonymous 2010).[10] In all these ways *Phineas and Ferb* episodes and excerpts exemplify a new kind of music video: virtual rather than real, serialized rather than occasional or isolated, industry-sponsored but multi-mediatized for a variety of distribution venues, and enjoyable – safe, even, as well as stylistically variegated. They represent products that the 1980s corporate executives of the Music Television network never imagined, but ought to be delighted with – as should connoisseurs of musical comedy, who should see in it a route towards the genre's longevity.[11]

CHAPTER THREE

'The Message' Is the Medium: Aesthetics, Ideology, and the Hip Hop Music Video

Greg de Cuir Jr

When hip hop is at its best, it is a method for social critique and engagement, one of the most powerful, democratic, and versatile artistic methods in the contemporary world. Todd Boyd has written that 'hip hop is an unrivaled social force, a way of being', also that it is 'a new way of seeing the world' (2003). Tricia Rose posited the idea that 'hip hop is cultural, political, and commercial form, and for many young people [...] the primary cultural, sonic, and linguistic window on the world' (1993: 19). In broad terms, hip hop was created in the South Bronx in New York City in the 1970s and is characterized by the elemental actions of graffiti writing (visual art), b-boying (dance), DJing (music), and MCing (poetry). Hip hop means many different things to its various practitioners and adherents, and indeed it has spread across the globe quickly in its relatively short lifespan.

As a method hip hop has been used by many to carry out a variety of ends. The song 'The Message' (1982), by Grandmaster Flash and the Furious Five, is positioned in this study as an *ur*text that has served as the basis for expressing important shifts in hip hop culture throughout the late twentieth century. The politics of some of the key songs that have been constructed from this foundation as well as the music videos that visualized these shifts in expressive manners are evidence of the importance of its message. This essay will also trace the development of a feature-length, dramatic cinematic impulse in hip hop music videos and

how it intersects with shifts in aesthetics and ideology in hip hop culture. As Rose writes, the 'music video is a collaboration in the production of popular music; it revises meanings, provides preferred interpretations of lyrics, creates a stylistic and physical context for reception; and valorizes the iconic presence of the artist' (1993: 8, 9). Charting the major shifts in twentieth-century hip hop style through videos by Grandmaster Flash and the Furious Five, Ice Cube, and Puff Daddy and Mase, and also through the musical composition they are based on, allows us to lay bare the nature of hip hop as a method.

It can be said that hip hop first gained a conscience in 1982 with the release of the song 'The Message' by Grandmaster Flash and the Furious Five. Popular hip hop songs before that, such as 'Rapper's Delight' (1979) by the Sugarhill Gang or 'Planet Rock' (1982) by Afrika Bambaataa and the Soulsonic Force, featured themes of partying and other trivial endeavours and misadventures. We might go so far as to say that 'The Message' represented the birth of what would become a golden age in hip hop, when the musical form matured in terms of style and content. 'The Message' was written and performed by Furious Five group members Melle Mel and Duke Bootee. This fact attests to the moment in which the MC or lyricist came to the forefront of hip hop music, superseding the DJ or turntable artist. Indeed, Grandmaster Flash was a pioneering DJ, among the hip hop holy trinity of DJs along with Kool Herc and Afrika Bambaataa as those who were key in creating and spreading the culture in the 1970s. Still, Flash had practically no involvement in making 'The Message'. After this moment it would be rare for a DJ to headline a hip hop group, where before it was *de rigueur*.

FIGURE 3.1 *Grandmaster Flash in* Wild Style *(O'Hearn, 1983).*

'The Message' is characterized by the content of its message: tales of urban strife and hard living in the inner city. In writing about the song, Cynthia Fuchs said it 'exposed street realities as such' (Fuchs 2007: 293). As Boyd also wrote, 'hip hop is significant because it gives voice to those who tend to occupy the lowest rungs of the American social ladder' (2003). In essence, this is what 'The Message' does. The iconic opening line of 'The Message', spoken by Melle Mel, is 'broken glass everywhere', accompanied by the corresponding sound effect. This could be read as a break with the nascent tradition of hip hop music as it was then practised. Melle Mel reflects the realities of ghetto life but also smashes that reflection with the force of his rhetoric and the anger and pain he channels. Social reflection is often the defence claim made when hip hop is attacked by its critics. While this may be valid, it is also not enough to make hip hop fulfil its artistic potential and the social promise it contains. As Frantz Fanon warned, methods must serve ends other than those internal, lest they consume themselves (1986: 14).

The sound effect of the broken glass also introduces another distinguishing trademark of this important song. The lyrics have a visceral, cinematic quality. There are multiple narrative threads spun in this song, most notably in the final verse when Melle Mel tells the tale of 'a child born with no state of mind, blind to the ways of mankind'. This sort of evocation of the visual and the narrative was rare in early hip hop lyricizing, which was more often an abstract and improvisational flow full of metaphors, similes, and various non-sequiturs. 'The Message' is in fact a genre pastiche, if we indeed think of it in a cinematic manner. Documentary is utilized in its lyrics, as are melodrama, crime stories, even science fiction/horror hybrids, such as when in something of a brief surreal turn Duke Bootee describes reassembled body parts and reincarnation. The cinematic aesthetic that this song employs leads us to the music video and how it amplifies hip hop culture.

The hip hop music video had developed even before the hip hop film in the mid-1980s, making something of a template to follow and expanding the form's reach into visual culture.[1] The video for 'The Message' was created at the time when MTV first appeared (in 1981), though before the channel actually started showing hip hop music videos, and before the heyday of the mainstream music video when clips were signed with the director's name in an authorial and very cinematic gesture. As such, we do not know who it was that directed the video for 'The Message'. It would be tempting to venture the guess that Sylvia Robinson produced and directed the video. Robinson has been called the 'Mother of Hip Hop', as she was the founder and CEO of Sugar Hill Records, which was the first hip hop music label. Robinson also co-wrote and co-produced 'The Message', so she can be considered one of the architects of hip hop music in general and a strong businesswoman that drove the culture in new directions (Stoever, forthcoming).

The video for 'The Message' was shot with low-grade video technology, on location, with natural lighting and performances. It almost appears as a home movie, and indeed the musical group is captured in their natural habitat: the South Bronx in New York City, which is also the birthplace of hip hop culture. For many, this video would be their first glimpse into the South Bronx as something of an iconic and representative site of urban blight. The fact that the video aspires to the 'real' through its aesthetic in turn helps to create a strongly mediatized image of what the reality of urban living is. As Boyd writes, 'one of the biggest misconceptions about hip hop is that it is literal [...] it may be real, but it is certainly not literal, and there is a difference' (2003). We may critique the video for the accuracy of its representation and also recognize a foundational moment when the line between performance and reality become blurred in hip hop. The reflective broken glass that is shattered in Melle Mel's lyrics finds a correlative in the video – metaphorically, in the lens that captures these images as well as the television screens they are broadcasted on, and also practically in the video transition effects that often break up the image or affect it in other ways.

The opening image of the video features two men walking down the street, one of them holding a large radio. They are framed in a continuous long shot and as integral parts of the surrounding environment. As they slowly approach the camera we can see that they are dressed in early hip hop gear, which announces their affinities and sends a very clear message to the viewer. Fashion is one of the underappreciated elements of hip hop culture, and indeed each region in the United States has unique styles of dress and speech that mark and code their hip hop citizens. A documentary realism governs the entire feel of this video, and this is also something of a message that is sent, emphasizing the importance of street-level reportage and placing hip hop in a unique position to deliver such information. The documentary realism in 'The Message' video extends to shots of cars, buildings, and streets, painting an accurate picture of New York City in the late stages of the twentieth century, at a moment when Ronald Reagan dominated American politics and its effects on day-to-day life. These effects included the introduction of crack cocaine into the ghetto, also the widening gap between the greedy, predatory rich and the suffering poor (mostly of colour) in locations such as the South Bronx.

The South Bronx as a hip hop city in this video is a 'concept', just as Michel de Certeau described (1984: 93). As a concept it stands for something that expresses identity, because locale is crucial in hip hop culture. Rose writes that 'identity in hip hop is deeply rooted in the specific, the local experience, and one's attachment to and status in a local group or alternative family' (1993: 34). Not only that, but within hip hop culture, depending on what city you are from or what section of a particular city and being able to be identified with it can place one in a dangerous struggle for survival.[2]

The city as concept, calculated by a 'strategy' that emanates from political institutions of power, sets the stage for the dramatic conflict in some hip hop videos. Dangerous city streets become a trap, as recent hip hop slang literalizes it – a diabolical trap from which escape is difficult.[3] In this sense the city space is an enclosed space. Vilém Flusser writes that 'we were thrown into civilization [...] without anyone asking us for our permission' (2011: 172). This concept exemplifies the fate of so many urban residents, particularly those of the hip hop generation and their struggle with forces beyond their control, their struggle against the supra-structure foisted upon them by institutions of power. As de Certeau notes, '[i]ncreasingly constrained, yet less and less concerned with these vast frameworks, the individual detaches himself from them without being able to escape them and can henceforth only try to outwit them, to pull tricks on them, to rediscover, within an electronicized and computerized megalopolis, the "art" of the hunters and rural folk of earlier days' (1988: xxiii–xxiv). Indeed the city space ultimately offers the possibility of confinement and little more in the video for 'The Message', as the trap closes in on the group when they are boxed in by a police car, shoved into the back seat by suspicious officers, and driven away to an unknown destination.

Though the urban city is often an expansive space, ironically, it still functions as an effective trap. Writing on 'non-places', Marc Augé elaborates this point by stating the following: '[w]e could start by saying – again somewhat paradoxically – that the excess of space is correlative with the shrinking of the planet' (1995: 31). This paradox lies at the core of the trap that the hip hop artist finds himself enclosed in. Again, relating this idea to the notion of a trap, Augé writes, '[t]his spatial overabundance works like a decoy, but a decoy whose manipulator would be very hard to identify (there is nobody pulling the strings)' (1995: 32). But, of course, someone is always pulling the strings, as one cannot be prey without a hunter and vice versa. If the hip hop artist is trapped in the urban space like a rat in a maze, as Melle Mel describes in 'The Message', from the ground level it is very difficult indeed to ascertain the identity of the trapper, as Augé notes. In a larger sense this is where hip hop has gone astray – by focusing its energy on trying to outwit the framework rather than leveling an attack on those who set its parameters, although they are difficult to flush out. This search for the door – not to the exit of the trap but rather its very control room – will make hip hop a really revolutionary method.

Be that as it may, the aesthetic of the video for 'The Message' is minimalist. Lyrics are delivered in static medium shots as direct camera addresses. Cutting is very judicious, preserving the integrity and authenticity of the various performances on display. Simple video effects are used, but sparingly. Multiple frames fly around each other, images appear in stuttering motion, pixilated transitions delineate sequences. This raw visual honesty echoes the embryonic state of early hip hop, when emphasis was placed on

technique and the practice of craft. Still, a shift could be foreseen on the horizon even then. Duke Bootee rhymes, 'It's all about money, ain't a damn thing funny.' The party was almost over, metaphorically speaking, and hip hop would soon begin taking itself deadly serious as it evolved into big business. Furthering notions of representing reality, the final action in the video is a police car rolling up to the hip hop crew on a street corner. They are promptly harassed and arrested while they protest that they are doing nothing wrong. 'We're down with Grandmaster Flash and the Furious Five', one of them pleads. An officer retorts, 'What is that, a gang?' This is the final message of the song and the video, which ends on a downbeat note.

The message was indeed a message: one delivered visually, auditorily, and allegorically – and it was received as such. As a postmodern art form, hip hop has often made use of pastiche to further its effects. In musical terms this means borrowing structures and motifs from other genres and remixing and assembling them into new creations. This repurposing extended to other elements of the culture, such as graffiti artists turning trains and buildings into canvases, or b-boys and b-girls turning cardboard boxes into stages for dance. The very essence of early hip hop music was the excerpting of 'breaks' – the rhythm-heavy mid-section of song compositions – from old records as backdrops for performances of all sorts. However, some early hip hop music was characterized by original composition, like 'The Message' with its mix of keyboards, guitars, and percussion-based funk. As the musical form matured, hip hop artists began to look inward to hip hop itself as a source for sampling. This practice extended to both beats and lyrics. If you want to learn a great deal about any hip hop artist, pay attention to the musical cues that he or she samples. Those cues are coded keys to unlocking their influences and ideology, as well as the nuance of the messages they want to send.

As a foundational song in hip hop culture, 'The Message' has been referenced countless times by many artists. The music is among the most familiar tunes in all of hip hop and the lyrics are legendary, such as the hook 'don't push me, 'cause I'm close to the edge' and 'it's like a jungle sometimes, it makes me wonder how I keep from going under'. These are sacred scriptures for multiple generations of hip hoppers, and many cities in hip hop videos have been depicted as dangerous jungles.[4] As stated in the introduction, certain commonalities in hip hop culture have been used to carry out a variety of ends. In 1993 the artist Ice Cube wrote the song 'Check Yo Self (The Message Remix)'. Cube had already been a successful solo artist for a few years after gaining a reputation as one of the founders of West Coast gangster rap while a member of the legendary hip hop supergroup NWA. He recorded an alternate version of 'Check Yo Self' for his album *The Predator*, but when it was time to release the song as a single, as the parenthetical subtitle indicates, Cube took the opportunity to remix 'The Message' and stake his claim to its heritage while also extending

its aesthetic. Cube's message in this instance was a warning to all those who may want to do him harm, as he states in the opening verse: 'You better check yourself before you wreck yourself, 'cause I'm bad for your health'. As Rose wrote, 'hip hop is very competitive and confrontational; these traits are both resistance to and preparation for a hostile world that denies and denigrates young people of color' (1993: 35, 36). This sort of attitude heard in Cube's lyrics was indicative of the shift in power in hip hop in the early 1990s to the West, particularly the state of California and its artists. West Coast gangster rap continued with the ruthless focus on reality that Grandmaster Flash and the Furious Five had practised, but it added a particularly brutal and even nihilistic edge as well as an explicit handling of language and imagery.

The video for 'Check Yo Self' was directed by F. Gary Gray, who worked with many West Coast artists in the early 1990s and would eventually make his feature film debut directing *Friday* in 1995, which was written by and starring Ice Cube. Gray also directed the video for Cube's hit single 'It Was a Good Day', also from the album *The Predator*, and the video for 'Check Yo Self' was positioned as a sequel to it. This is just one of many instances in which cinematic and narrative tropes are utilized, bringing the music video in line with more complex forms of visual expression. Indeed, Gray had a strong visual sense and clear ambitions to working on a larger scale. Since Cube had already acted in the celebrated hip hop film *Boyz n the Hood* (John Singleton, 1991), which was named after a famous song by NWA, he also had further ambitions for large-scale cinema production. The opening of the video takes place at night with the aforementioned police manhunt for Ice Cube. As noted, this opening is a continuation from the end of the video 'It Was a Good Day', which actually details a charmed twenty-four hours in the life of a boy in the hood – something like a gangster fairy tale, with nothing but positive notes struck. In 'Check Yo Self' we return to the darkness and violence that is common of gangster rap, as Cube descends into the hell of Los Angeles County Jail – perhaps one circle below the hell of the hood. It could be said that this video is also a continuation of the video for 'The Message', while evidencing a shift from the exterior to the interior, and from a collective experience to an individual one. The earlier video ended with the police rounding up Grandmaster Flash and the Furious Five off a street corner and ostensibly taking them to jail. Cube is also pursued and arrested in his video, the city still functioning as a trap, and we eventually see what happens in a life behind bars which seems to only be an extension of the general state of confinement in poor urban locations. Cube's referencing 'The Message' and New York City hip hop culture is furthered by the utilization of the popular East Coast group DAS EFX on the hook for the song. However, that enhanced referencing is balanced by a sample from the song 'Deeez Nuuuts' by Dr Dre and Snoop Dogg from the landmark album *The Chronic* (1992), which cemented the

ascendancy of West Coast gangster rap on the national scene. This last reference completes a circle, as Dre and Snoop perform the refrain of their song in an idiosyncratic lyrical style that was originally popularized by DAS EFX. This web of connections demonstrates the complex and highly coded dialogue taking place within the seams of hip hop culture. In 'Check Yo Self', Cube looks back and honours the past while keeping his feet firmly planted in the present, ultimately aligning himself with the strong tradition of Los Angeles hip hop that he helped create.

At certain points this video shifts to dramatic segments devoid of any music. It seems here that the feature-length cinematic impulse is increasingly becoming a factor in the music video. In fact, though the lyrics do not present a coherent narrative flow, as they are episodic and non-linear, the visuals do tell a story in sequence that helps to ground the thematics of the verses. After he is arrested, we see Ice Cube in a holding tank waiting to be transferred to his proper destination as a prisoner. We see him call his girlfriend and learn that she is cheating on him with another man. We see him assault a fellow inmate who turns into a persecuted homosexual in something of a mini-narrative within the larger story. Finally, we see Cube befriend a female officer who ultimately helps him to escape. Throughout these narrative segments Cube is able to exercise his acting skills, demonstrating his abilities as a versatile performing artist. However, as he states in one of his lyrics, 'I make dough, but don't call me Doughboy. This ain't no fuckin' motion picture.' The reference is to the cult character he embodied in the film *Boyz n the Hood*, a violent gangbanger from a broken home. He is also warning those enemies of his not to get confused, as he represents something real and lives what he talks. This is the ultimate wager that gangster rap makes. Those that practise it must live it to the fullest or be exposed. Exposure can mean discrediting or even a death sentence. The boundaries had been blurred by this point in the evolution of hip hop, as art imitates life and life imitates art. It is no longer a question of commenting, critiquing, or reflecting – it is a question of living, and authenticity has its price. This is the message of gangster rap.

We might pause here at the junction of gangster rap and consider acting and performance strategies in hip hop culture. Indeed, the common designation (as denigration) for violent rappers that do not project an integral image that corresponds to their actual persona is 'studio gangster'.[5] In this sense the 'studio' refers to the recording studio as a 'safe' space for enacting fantasies, but also the movie studio which certain hip hop artists aspire to. The notion of cultural performance, in which there is no strong border between daily life and societal roles, begins to get to the essence of the implications surrounding the performative aspect in hip hop and can be used to elucidate the particulars of Cube's acting. Milena Dragićević-Šešić, who has written extensively on culture and art and their relation to public policy, notes that 'the essence of performance is intermediality' (2001).

Her article '*Umetnost performansa* [The Art of Performance]' explores the idea that performance is characterized by an erasure of boundaries in art. The erasing of borders is a common theme in hip hop – 'keeping it real' refers to mirroring one's life with one's art and vice versa. Very few art forms are saddled with this heavy burden of representation (2001)[6] As Boyd writes, 'hip hop is rooted in a search for the real', and this journey is an elusive one (2003). Rarely is there a boundary between life and art in hip hop and that is because hip hop is as much a way of life as it is an art form. This becomes dangerous when one considers the popularity of gangster rap music, especially in light of the performative nature of the medium of video in general.

The cultural performance that is hip hop is characterized by Richard Schechner's concept of complex acting (Jovicevic and Vujanovic 2007: 37): socially and ethnically coded acting that is realistic and anti-illusory. Complex acting means that when one performs one must create a self-effacing image that has what documentary theorists would call an indexical tie to reality. If complex acting is anti-illusory, that means it is subversive, anti-acting. However, complex acting in the Schechnerian sense also refers to performing the social and ethnic codes of everyday living, which are real but rarely anti-illusory (in the dramatic sense of the term). Life is the ultimate performing art – we construct our personas over time and play them out in various fashions and settings every day. Therefore a question arises: what is the tension between hip hop art as performing and producing social and ethnic codes or reflecting pre-existing ones? Hegemonic ideologies state that young black men in America are an endangered species; those ideologies also state that young black men are violent citizens to be engaged cautiously, which produces a social justification for their persecution. Rose writes that '[t]his hyper-investment in the fiction of full-time autobiography in hip hop, especially for those artists who have adopted gangsta personas, has been exaggerated and distorted by a powerful history of racial images of black men as "naturally" violent and criminal' (2008: 38). If the media propagates these images and this ideology while at the same time profiting from their exploitation in hip hop, an ethical conundrum immediately presents itself. We will come to a consideration of hip hop ethics tied to corporate success as the analysis of music videos continues.

According to Judith Butler, 'race is performatively constituted by the very expressions which are said to be its results' (1990: 24). To that end, there are all sorts of social tests that young black men go through in urban communities on a daily basis – and one must perform well. The result is overly complex acting, which is a tool designed to allow one to survive in a tough environment. Hip hop reflects a dichotomy of urban social reality: one is either victim or aggressor. The Northern California artist E-40 wrote a song 'Practice Lookin' Hard' (1994), in which he claimed, 'I got a mirror in my pocket and I practice lookin' hard.' Pimp C of the

pioneering Southern group UGK wrote in the song 'One Day' (1996) that 'Niggas be lookin' shife, so I look shife back. Can't show no weakness with these bitches, get your life jacked'. These lyrics[7] exemplify the desire and urgent need to perform in the urban environment, as well as the tragic cyclical and self-reflexive nature of that performance. Performing daily social roles has dire consequences for the young black male and hip hop artists alike. This is another trap, or the game that one is forced to play. Good acting can sometimes save, through the third of three functions that the writer Jon McKenzie ascribes to cultural performance: '[t]he possibility of conservation and/or transformation' (2001: 31). Through a believable transformation into a gangster, the possibility of conserving one's life is extended. This is a fundamental conceptualization of cultural performance as social efficacy. Bad acting can cause a double fate: being perceived as fake, or being dead. This is the tragic irony of the urban cultural performance – if one is successful in this transformation, one's life is still at risk due to the transgressive role and the violent implications surrounding it that have been adopted; if one is unsuccessful, or fake, then they are left at the mercy of forces far greater than them – foes who are peers that can act as judge, jury, and executioner.

To continue building links in this comparative analysis we can consider the video for the song 'Can't Nobody Hold Me Down' (1997) by Puff Daddy and Mase. The very title of this song comments on the situation depicted by Ice Cube in his video, in which a jail cell could not even hold him, triumphantly implying that the entire institutionally racist infrastructure of the United States was ineffective against him. However, we might curb notions of radical revolutionary potential in Puff's song. As Cube escapes into the night at the end of his video, Puff opens his video in the middle of a nightmare in which he is drowning. Soon enough he wakes up and finds himself in his mansion, surrounded by opulence. All is right in the world and his visions of drowning must have been referencing the obnoxious wealth all around that threatens to envelop him. We are now far away from the modest working class home in Ice Cube's video or the tough city streets in the video with Grandmaster Flash and the Furious Five.

This song and video coincides with the reemergence of East Coast hip hop after the general dominance of the West throughout most of the 1990s. As Jay-Z wrote in the song 'Money, Cash, Hoes' (1998), 'It's like New York's been soft ever since Snoop came through and crushed the buildings'. The reference here is to a song by the West Coast group Tha Dogg Pound titled 'New York, New York' (1995), particularly the video for the song which includes group members Snoop Dogg and others as giants stomping on various skyscrapers in the New York skyline. On the hook of the song Snoop levels the following critique: 'New York, New York, big city of dreams, but everything in New York ain't always what it seems.' This critique has resonance for Puff's song and video. The revitalization

of the East Coast was symbolized by the corporate turn of hip hop into big business and a generator of surplus value. As Rose wrote, 'what is important about the shift in hip hop's orientation is not its movement from precommodity to commodity but the shift in control over the scope and direction of the profit making process' (1993: 40). Many of the songs of the most profitable East Coast artists reflected this, none more so than Puff Daddy, who ran one of the more successful record labels in the history of hip hop and is still among the wealthiest entertainers in the United States. At this point hip hop had reached a celebratory stage which can clearly be seen in the video for the song 'Can't Nobody Hold Me Down', which utilizes the music from 'The Message' to deliver a different content in the service of a different ideology. As Karl Marx wrote, history repeats itself, the first time as tragedy and the second time as farce. One would be forgiven for thinking of the large and colourful clothes worn by Puff and his Bad Boy Records affiliates in this and other videos as clownish wardrobe, in which they dance for a new master.

The first sequence in this video features Puff and Mase driving a luxury convertible through an empty desert. They are at a distant remove from all social concerns, both physically and mentally. This abstract dreamscape that they move through is barren for a reason, probably because of the unhinged lyrics that transmit no message other than self-congratulation and wasteful materialism. This break with the social engagement of 'The Message' is reflected in the following verse by Mase: 'Broken glass, everywhere, if it ain't about the money Puff I just don't care.' Here, Melle Mel's original verse is repurposed to serve empty ends, like the barren desert it is set in. Broken glass has no relation to the song or the video as an objective correlative pregnant with meaning. Breaking this verse in half and suturing a concern for money to it comes as a total non-sequitur that blunts any inherent critical potential. Hip hop has been neutered here, and it is no coincidence that by this point, and with music such as this, record sales were at an all-time high. One must wonder who was really behind the scenes pulling the strings of this *danse macabre*, this 'liberated' mockery of the golden age.

The second sequence of the video takes place in a sterile white chamber suffused with bright light. This is yet another abstract dreamscape in which materialist fantasies are played out in opposition to the grounded nightmares in the videos by Cube and Flash. It should be mentioned that this scene in particular is indicative of the style that the director Hype Williams created in many of his videos. It is something of a big budget, high gloss style, a new tradition of quality in the contemporary hip hop video. Williams rose to prominence at a time when the director started to be credited in music video broadcasts, in part because his ostentatious and recognizable style was consistent and easy to market. He was the ideal director for the new era of big luxury in hip hop, and he eventually went on to direct a hip hop film titled *Belly* (1998), which is his only feature to date.

This video also has a certain large-scale cinematic impulse. Similar to Cube's video, there are dramatic scenes in which the music disappears and actors control the narrative. These sequences feature Biggie Smalls and Eddie Griffin as they sit in a car while being harassed by the police. Here we have a reclamation of 'The Message', which also finds an echo in Cube's video. However, in Puff's video these confrontations with the police are played for comedy, drawing heavily on Griffin's persona as a stand-up comic. Once again, tragedy has turned into farce. There is no attempted arrest in these scenes and the police are depicted as harmless comic foils, not to be respected and even to be disobeyed. This might be the height of fantasy as constructed in Puff's video. Any black man with half a brain and an inkling of self-preservation knows that the quickest way to meet a catastrophic fate is to disobey a policeman, much less to disrespect him to his face. In his programmatic song 'How to Survive in South Central' (1991), released as part of the soundtrack for the film *Boyz n the Hood*, Cube wrote the following lines: 'Now if you're white, you can trust the police. But if you're black they ain't nothin' but beasts. Watch out for the kill. Don't make a false move and keep your hands on the steering wheel. And don't get smart. Answer all questions. And that's your first lesson, on staying alive.' Perhaps money has the effect of engendering and allowing the foolish behaviour seen in Puff's video. If so, then the ultimate message of this song and video is that broken glass does not matter – you can just buy a new window, then celebrate when you have one in your new mansion, like in the final sequence of the video that takes place in a jubilant night club setting where the penultimate victory of Puff and mainstream corporate hip hop is toasted. As Puff rhymes in the song, 'I got a Benz that I ain't even drove yet.' This is both the price of success and its folly, its illogical futility. It also represents the end of the golden era of hip hop, or perhaps the onset of the platinum age – a shimmering detour into non-reality rap.

Throughout this study I have painted these artists and their work in broad strokes in order to achieve a survey of hip hop aesthetics and ideology. Perhaps not all of Puff's music is superficial or regressive. Certainly Ice Cube is a complex artist who has at times expressed degenerate thoughts while also writing songs meant to uplift a nation and better the human condition. The truth is rarely neat and pretty, and of course human beings, even artists, are not perfect. At its worst hip hop can offend and harm, and at its best it can change the world – and this can often occur in the space of the same lyrical verse, break beat, or graffiti mural. The form can be appreciated at its most shallow and at its most nuanced, and I believe that the virtues of hip hop outweigh its faults. Now that hip hop is an international culture in the twenty-first century, there are many messages transmitted through it in many languages. As Tony Mitchell wrote in his book *Global Noise*, 'hip hop and rap cannot be viewed simply as an expression of African

American culture; it has become a vehicle for global youth affiliations and a tool for reworking local identity all over the world' (2001: 1, 2). Hip hop music videos have proliferated as well, even after the heyday of MTV and other video channels across the globe. Of course, the Internet helps to expose new videos to more audiences than MTV ever could. Also, online channels provide a more democratic form of international hip hop exchange that is not always subject to market demands. This also means that the common language of hip hop can be shared easily with practitioners all over the world, fostering communication and mutual understanding while breaking down borders and preconceptions both physical and mental. It could be argued that the music video amplifies the effects of hip hop to multiple degrees. One can listen to songs from all parts of the world, but one cannot always understand the language or slang, or even the musical cues that are utilized. Music may be a universal language but it can only go so far. The music video helps to translate as much as transmit. When we see what an artist looks like, what she wears, where she comes from, her environment, we understand so much more. We can draw conclusions and connections that we might not normally make. One might say that hip hop did not really become, as Public Enemy's Chuck D. has often been quoted as saying, Black America's CNN until it could be seen on television. Then it became a crucial news source for all peoples, all nations.

To conclude, perhaps we should begin to consider the hip hop music video as an additional element of the culture. As Rose noted, the hip hop music video has 'developed its own style and its own genre conventions' (1993: 9, 10). Like cinema, its power comes from unifying multiple art forms. 'The Message' as *ur*text is a great unifier as well, and it will likely continue to be used as a basis for twenty-first-century hip hop, its meaning and significance absorbed in different ways by different hip hop communities. Further research questions might include a contemplation of these twenty-first-century practitioners that will develop the audiovisual language of hip hop and propel it to greater expressive heights. As critics and theorists we should also contemplate what new languages we need to employ to properly critique their works. Of continuing concern is how those of us affiliated with the art form can use those new audiovisual codes to dismantle the regimes that oppress and exploit the culture and those who practise it. We must continue to foster democratic hip hop arts that unite and uplift people. The medium may be the message, but 'The Message' remains a lasting and powerful medium.

> 'God is smiling on you, but he's frowning too. Because only God knows what you'll go through.' – Melle Mel

CHAPTER FOUR

The Boy Kept Swinging: David Bowie, Music Video, and the Star Image

Julie Lobalzo Wright

Just two days after both the release of his twenty-fifth studio album★ (pronounced *Blackstar*) and his sixty-ninth birthday, it was announced that David Bowie had died from liver cancer. The retrospectives that were released over the following days and weeks remarked about the singer's long and diverse career, notable for significant image changes, portraying iconic characters and an eclectic musical output. Although most focused on the diversity of his career, including his work as an actor, less was said about his groundbreaking work in music video. In fact, although many writers observed his importance as a music video pioneer, one of the few stars from the 1970s that appeared to fully embrace the potential of the medium even before MTV debuted in 1981, his work in music video was generally incorporated into larger retrospectives that emphasized Bowie's interest in the visual image.[1] 'Ashes to Ashes' was often cited as one of his essential videos, marking the end of one period of his career, especially through the image of a drowning Pierrot figure in the video, and the beginning of his most commercial and conservative period in the 1980s. Music video was acknowledged as part of his vast and varied career, but rarely was it recognized as a core medium in Bowie's career that presented his ever-changing star image. This may be more of a comment on the diminished role that music video plays in the rigidly canonical world of music writing

than on Bowie himself. However, it is a fact that David Bowie's music videos were not just a vital part of his own artistic output, but also important in showing the world new uses for the medium as part of the star making machinery, and in helping him explore, and revisit, certain themes across time – including the theme of mortality.

Stardom has not received much attention in music video scholarship, even though many have noted the importance of music videos as star-texts (Goodwin 1992), possibly owing to the fragmented nature of the medium. As Abigail Gardner notes in her study of PJ Harvey and music video, scholars have approached the medium as unstable, attempting to discover a 'coherent identity', but often finding the medium 'inherently and determinedly ambiguous' (2015: 24–26). Music videos tend to be non-narrative and episodic, drawing the audience's attention to the music more so than the visual (Vernallis 2004: 3). Still, it is a visual medium, therefore, an interplay occurs between the music heard and the images displayed, but there is also the third element of the star image which further informs each video. Music video has become a vital part of popular music stardom with most artists possessing a large body of work defined by their star image, but also illustrating image alterations over time. Coherence may be uncovered between videos that could, at first, appear as self-contained, especially because music videos are used as a marketing tool to promote a specific song and/or album. Furthermore, as Will Brooker has argued, some artists have produced music, videos, and films as 'episodes' that 'frequently relate directly to each other and combine into longer, more complex cycles' (2015: 95).

Although Bowie's career was noted for its transformations, he often returned to similar overarching themes throughout his fifty-year career. While this was evident in many aspects of his work, music videos acted as a particularly interesting space where the artist was able to revisit vital aspects of his star image that endured throughout his career. Bowie embraced this visual medium early in his career with the promotional film *Love You Till Tuesday* in 1969 (not released until 1984), featuring videos for songs from his first two albums (*David Bowie*, 1967, and *Space Oddity*, 1969). Although most biographies and academic writing on Bowie mention his work in music video, there have been few studies that have examined his diverse music video output and how video has always provided a space for Bowie to expand his visual image, in addition to album covers and live performances.[2]

By examining three of Bowie's music videos, namely 'Boys Keep Swinging' (1979), 'Blue Jean' (1984), and 'Thursday's Child' (1999), I will argue that although each video exists separately, the total output contributes to his oeuvre as each video displays three important elements of his star image: performance/masks, gesture/posing, and queerness/androgyny. Bowie was

an artist that utilized the medium as a significant part of his music star image and not just as a marketing tool for his latest album and visual transformation.

Performance/masks

As I have argued elsewhere, visual transformation was a key element of Bowie's work, from his character alterations to the various images presented on his album covers and the settings and environments in his music videos (Lobalzo Wright 2015: 230–244). Visual images were central to these transformations, with Bowie exposing the construction of his images, uncovering the emptiness of the image, the nothingness behind the signs and symbols. Bowie, among other glam rock performers, revealed what Iain Chambers has described as 'the "flatness" of the artifice' that became 'ironically its profoundest statement: the construction was revealed, the borrowings exposed and mocked, the style shared' (2003: 72). Reinvention and Bowie's ability to engage in 'chameleon-like poses' all signal the self-conscious construction of his surface image, the act behind the mask (Cagle 1995: 206).

Bowie has often referred to masks when discussing his portrayal of characters. In 1972, he stated he planned to play the Ziggy role for a few more months and then 'don another mask' (cited in Auslander 2006: 73). The album cover for his final release as Ziggy Stardust, the cover album *Pin-Ups* (1973) features Bowie and model Twiggy with make-up that outlines their faces as though both are wearing masks. The mask-like blank, expressionless face is replicated five years later on the cover of his album *Heroes*. Masks were also featured during the tour for *Diamond Dogs* and the 'David Bowie Is' exhibit, which debuted at the Victoria and Albert museum in 2013, used masks on the mannequins that were adorned with many of Bowie's costumes. Make-up was often utilized to convey the appearance of a mask (as the *Pin-Ups* cover displays) and Roland Barthes's famous description of 'The Face of Garbo' as having make-up with 'the snowy thickness of a mask' (2000: 56) could also be applied to Bowie and the very thick make-up he wore in photos, on stage and in his music videos.

It is not surprising that Bowie often incorporated mime, employing the white masked face, into his Ziggy Stardust performances, exploiting his body and gestures to convey a story. In 1969, he recorded a mime performance that he wrote for the film *Love You Till Tuesday*. In 'The Mask (A Mime)' Bowie enacts the story of a man who finds a mask in a junk shop, uses the disguise to impress his family and friends before becoming a famous actor, only to be strangled to death on-stage by the mask. In a voiceover, Bowie

states that the 'mask had a very strange effect on me' before attempting to remove the mask which did not come off. This early performance identifies how important masks, as a surface image as well as the ability to change masks, became in Bowie's career.

Gesture/posing

Dillane et al. (2015) have noted that Bowie has returned to the Pierrot figure throughout his career becoming a 'figure of continuity' (36) at key points in his career, especially in his 'Ashes to Ashes' video and as recently as 2013 in the 'Love is Lost' remix video. This clown figure not only presents a particular character that Bowie portrayed, but also connects his performance style to mime with its emphasis on 'posing and exaggeration' (2015: 35, 40). With the absence of voice, gesture and posing through the face and body become the central way to convey meaning in mime performances. Bowie utilized gesture and posing throughout his performances from album covers – *Heroes* is an example, but also the posed sweep of his long hair on the cover of *Hunky Dory* (1971) and the hand clasped behind his back pose on *Earthling* (1997) – to live performances and music video. On stage, especially during the Ziggy Stardust period (ca. 1972–1974), Bowie would begin songs in a highly theatrical style. This was most evident during his performance of 'Ziggy Stardust', recorded for posterity in D. A. Pennebaker's *Ziggy Stardust: The Motion Picture* (1973). At the first guitar riff, the spotlight focused on Bowie posing at the centre of the stage while two individuals pulled off his outer costume to reveal another costume below. He would then stand with his arms and legs spread before the drumbeat kicked in and he switched to a pose with his hands at his side before walking to the microphone to begin singing. The deliberateness of every movement illustrates a type of performance that is focused on gestures and single movements as opposed to frenetic activity. This performance style translates well to music video, which often displays the star performer singing with 'expressive faces' in 'heightened moments' that animate the song (Vernallis 2004: 55). This is often achieved through close-ups and as Andrew Goodwin suggests, posing, rather than acting, is desired because of the 'centrality of the voice' in popular music (1992: 109). In a medium where narrative and characterization are absent or, at the very least, reduced due to a shorter timescale, the face and body become sites where performance is conveyed, especially for the star singer who is often cast in an 'overseeing role' (Vernallis 2004: 61) and as 'overseers, dreamers, neutral observers, and participants embedded within the action of the piece' (Vernallis 2004: 57). Bowie's ability to visually transform, to (metaphorically) wear different masks, and to emphasize various gestures and poses through his bodily performance allowed him to carve out a unique position in music video history.

Queerness/androgyny

Underpinning his performance style throughout his career was the interrogation of gender and sexuality. The masks Bowie wore allowed him to create provocative images that represent a blurred gender as opposed one specific gender. The androgyny and queerness of his music image were a surface construction, but also the foundation for most of his character portrayals in the 1970s (most notably, Ziggy Stardust), and persisted until his death. Alexander Doty has argued that queerness can be defined as 'non-normative expressions of gender [and] non-straight expressions of sexuality and gender' (1998: 148). I have examined Bowie's queer image in relation to his film stardom elsewhere (Lobalzo Wright 2015: 230–244), but his interest in alien beings, science fiction, otherness, and identity has also worked to shape Bowie's star image as one which questioned many gender and sexual norms. Nick Stevenson suggests that Bowie's central quest continued 'to be connected to ideas of identity and Otherness' and his central concern was what it meant to be human (2015: 282). Bowie's own sexuality has been well-documented from his admission that he was bisexual in an interview in *Melody Maker* in 1972 (Watts 2003: 47) to the headline on the cover of *Rolling Stone* in 1984: 'David Bowie Straight', Bowie has presented a muddled sexuality, rendering a positive model 'of sexual identity outside of the heterosexist models' (Cagle 1995: 13).

Costume also assisted in presenting not only a blurred sexuality, but an ambiguously androgynous image. Stella Bruzzi contends, 'On the androgynous body is enacted ambiguity, the diminution of difference, and what is manifested is a softening of the contours – between corporeality and metaphor, male and female, straight and gay, real and imagined' (1997: 176). This applies directly to Bowie whose costumes have been extremely ambiguous, especially in relation to a dominant gender enacted through the clothing. Although most evident in the 1970s, androgyny remained, even as his career evolved, through the fabric, tailoring, and the colour of his costumes, but possibly more so, through the presentation of normalcy within his music videos, Bowie's uneasy relationship with gendered and/or sexual norms, and eventually confronting the otherness of death and the other side. I now turn to consider these reoccurring areas in relation to three David Bowie music videos that came during different periods of his career.

'Boys Keep Swinging'

'Boys Keep Swinging' was a single from the 1979 album *Lodger*, the last album in the 'Berlin trilogy', coming after *Low* (1977) and *Heroes* (1977), albums also made with Brian Eno. *Lodger* was less musically experimental than the previous albums, coming after a particularly fraught period for

Bowie, personally and professionally, in the mid-1970s. The album was released after a slippage had occurred between Bowie's drug induced paranoia, which included the star making fascist comments in the press and the portrayal of his last character, the Thin White Duke (Doggett 2012: 256). Jon Savage, writing in *Melody Maker* in May 1979, referred to *Lodger* as 'slightly faceless' and ended his piece by asking if the eighties will 'really be this boring' (2003: 160–162). However, as David Buckley has noted, although the album was a return to pop, the music also is 'an astonishing fusion of beats and ideas from Anglo-American rock and disco with musical fragments collected from Europe' (2015: 217). Thus, in this period, Bowie was beginning to shed the characters he earlier portrayed, shifting from experimental music to more pop oriented music and reduced his outward experimentation with gender and sexuality.

The 'Boys Keep Swinging' video begins with Bowie, dressed in a tight fitting black suit, white shirt, and grey and white striped tie, performing on a square stage with a backdrop of geometric shapes in pastel colours behind him. Through the first verse and chorus, the camera cuts between various shots of Bowie performing, including close-ups of his face, medium shots from the chest upwards, and long shots that show his entire body dancing. This conventional beginning focuses the audience's attention on the performance of the song, Bowie's bodily movements, and engagement with the microphone stand. The song is concerned with macho posturing and a 'male gang attitude' (Doggett 2012: 304). While first appearing as a celebration of entitled masculinity, however, it becomes evident that the song is also a criticism of the expectations placed on men.

The video begins by rendering the song and Bowie's performance as genuine before, more than fifty seconds in, cutting to Bowie in drag as three back-up singers. Their performance is coded differently from Bowie's, most notably because they are framed in a tight medium shot that does not allow for any movement beyond small gestures. Therefore, at this point in the video, the women are purely a visual spectacle, similar to what Laura Mulvey observed about classical Hollywood cinema consistently putting women on display as visual objects (1975: 6–18). The performance of Bowie as the female back-up singers appears to serve no other purpose than as a visual gag.

This, however, changes when the video dissolves from a shot of Bowie gesturing his arm downward and hanging his head to a medium long shot of a glamorous gold curtain (the same curtain that was used as the backdrop for the three singers) framed by blue bubble clouds. The curtain lifts and the first singer wearing brown hair, shaped into a bee-hive, large earrings and necklace, and a low-cut, V-neck shirt emerges after fussing with her A-line skirt. From this moment onward, the video is purely focused on these female singers walking out and onto the short catwalk, never returning to the singing, male Bowie. This prioritizes these final moments and the actions

of these women over what has come before, including the declaration of male privilege in the lyrics of the song and Bowie's own musical performance. Gestures, poses, masks, and androgyny are highlighted when each woman walks down the catwalk and then faces the camera. The woman in the A-line skirt walks out in a sassy strut, displaying her confidence and attitude as she stops at the end of the runway, places her hand on her hip, and shakes her head side to side while chewing gum. The video then cuts to a shot from another angle and she slowly lifts her hands up and rips her wig off. At this point, Bowie's face becomes angry and he takes his right hand and aggressively smears his lipstick. The 'mask' of gender is displaced as the woman becomes a man becomes performer, wiping away the illusion of femininity through deliberate gestures and poses. This is followed by the second back-up singer marked as glamorous with her flowing red hair, sleek pink column dress, and the more restrained hand caressing the hip pose at the end of the runway. Again, this points to the performative nature of gender and the importance of clothing and gestures to difference, not just between genders, but also among individuals. The camera cuts to a medium shot of Bowie, more violently than the first, ripping the wig off and smearing his lipstick. The last woman emerges, older than the first two, walking with a cane and wearing a houndstooth patterned jumper, white blouse, and black pencil skirt. Instead of following the first two, she keeps her wig on and blows a kiss to the audience before the video fades to white. This ending fixes Bowie within the character of the distinguished woman, still portraying someone else, someone who is not 'David Bowie', but, importantly, is androgynous, or at the very least, not purely masculine.

'Blue Jean'

As Sheldon Waldrep noted, from 1979 to the mid-1980s (from *Lodger* through to *Tonight* (1984)), video represented Bowie's 'most sustained effort at marketing himself and especially creating an image or character that was meant not only to complement his music, but, in some instances, to provide both a critique of it' (2004: 122). The albums *Let's Dance* and *Tonight* (the latter of which features 'Blue Jean') represent a unique period in Bowie's career when he achieved his greatest commercial success, but had rid himself of experimentation within both his music and visual image. His 1980s pop image was defined by its 'normalcy', as biographer David Buckley mused: 'He'd allowed himself to enter into someone else's vision of what a sensible, mature David Bowie should look like. The new mask of normality represented the achievement of the most extreme artifice of his career' (2005: 344, 345). The singer looked fitter and younger than he had in years, especially in comparison to the end of the 1970s when Bowie's cocaine use had caused his body to look weak and aged. It can be argued

that here Bowie had created a new character, that of the sun-kissed pop star, lacking any queer identity and instead promoting a more normative masculinity. However, I would argue that even during this commercial period, Bowie returned to many familiar themes and concerns, especially in his music videos which came to be, in the 1980s, the place where the star was able to provide his music with 'a palatable political and/or cultural backstory to make it clear [...] that he was still doing something artistic, if not avant-garde' (Waldrep 2015: 156).

The 'Blue Jean' video is part of a twenty-minute, long-form video directed by Julian Temple, *Jazzin' for Blue Jean* (1984), which tells the story of Vic, an average, socially awkward man who tries to impress a girl by taking her to see Screamin' Lord Byron. By portraying both Vic and the rock star, Bowie is able to present both a 'common' man and the rock/pop star within one piece, exposing the fabrication of a cocksure masculinity. This links the video directly with the song 'Boys Keep Swinging', especially the insinuation that men can always attain the desired girl: 'When you're a boy/Other boys check you out/You get the girl'. In 'Blue Jean', Vic wants to impress the girl, but, ultimately, she is only interested in Screamin' Lord Byron whom she already knows. The section which features the music video for 'Blue Jean' is devoid of these backstories which present the two Bowies – average Vic and rock star Lord Byron – as opposites: Vic is weak and insignificant, while Lord Byron is charismatic and arrogant. Both characters, however, are focused on winning the girl, not just the girl in the video, but also the girl in the lyrics of the song. This places the song and video in a familiar space – pop music has always had an obsession with love songs and especially boy-meets-girl scenarios- but the video considers how masculinity informs this universal story. Furthermore, Bowie returns to androgyny and masks, especially in his performance of Lord Byron.

Screamin' Lord Byron appears in the music video dressed in harem clothing and wearing make-up that contours the (screen) left side of his face (the side with Bowie's permanently dilated pupil). This mask-like make-up reminds the audience of the video for 'Look Back in Anger' from *Lodger* with Bowie overwhelmed by his painting of an angel, rubbing his hands on the painting only for the painting to reproduce itself on his own face. Again, the paint is mainly on the left side of his face, similar to the lightning bolt that covers his left eye on the cover of *Aladdin Sane* (1973). The make-up helps foreground Bowie's difference, his 'otherness' through this physical defect that assisted in allowing the artist to appear as 'a person who embraces the uncanny, the outsider and alien, and who gives those identities a platform within mainstream culture' (Hunt 2015: 191). Many have noted, including Buckley (2005: 364),[3] that Screamin' Lord Byron appears as a doppelganger for characters Bowie portrayed in the 1970s, and Vic's comments to the rock star at the end of the long-form video sounds like a summary of criticisms levelled against Bowie.[4] By presenting both Vic and Screamin' Lord Byron

as rivals for the girl's affections, the music video implies that arrogant masculinity is more desirable than a shy and insecure masculinity. This, however, is undercut by the long-form video, which displays Lord Byron's physical weakness and the ending, which reveals the video shoot with Bowie complaining to Temple that the girl leaving with the rock star is 'too obvious'.[5] Hence, the long-form video critiques performance, image, gender, and audience expectation through the two male figures, both portrayed by Bowie.

As Screamin' Lord Byron, Bowie also utilizes posing and gestures to illustrate the hypnotic power the rock star has on his audience. During the first chorus, Lord Byron sings 'Jazzin for Blue Jean' followed by a forward motion with his left hand as his body crouches down and he watches the audience repeat the motion. This gesture acts as open signal to the audience to embrace the performance, but a similar movement has been repeated in many Bowie videos, although in other videos examples, the palm of the hand faces down, indicating an ending or even the ominousness of death. In 'Ashes to Ashes' the gesture is repeated by two of the new romantics walking with Bowie's Pierrot character as a bulldozer follows behind them. Bowie said the bulldozer symbolized 'oncoming violence', but the bulldozer and gesture could also be read as 'sweeping away of the past' (Dillane et al. 2015: 44). The gesture also appears in the video for 'Fashion', another single from the *Scary Monsters (And Super Creeps)* (1980) album. In 'Fashion', Bowie gestures downward with this motion emphasized through slow motion and the repetition of the gesture three times. It is unsurprising that this gesture would be employed in two videos from *Scary Monsters (And Super Creeps)*, an album which signalled the end of the long 1970s for Bowie and the transition to a more conventional pop star. In 'Blue Jean', Bowie as pop star is gesturing towards his audience, almost like sending them a kiss as he does in drag at the end of 'Boys Keep Swinging'.

'Thursday's Child'

The late 1980s was a commercially and creatively difficult period for the star with the release of the critically panned *Tonight* and *Never Let Me Down* (1987) albums; the theatrical, gigantic, and again, critically reviled 'Glass Spider' Tour; and the two Tin Machine albums (*Tin Machine* (1989) and *Tin Machine II* (1991)) receiving mixed reviews and little commercial success. In spite of this perceived failure, Bowie has stated that working as part of a band with Tin Machine helped revive his career, and as Bethany Usher and Stephanie Fremaux put it, it 'enabled Bowie to emerge as a musician entirely on his own terms, freeing himself from the expectations of the personae from the 1970s and the commercial pressure of the 1980s' (2015: 56). The 1990s represent a point in Bowie's career where he was an artist more

than a pop star, experimenting with musical sounds and concepts, especially on the *Outside* (1995) album[6] with his focus on his own artistic desires as opposed to following commercial imperatives. Many have noted, including Naiman (2015) and Waldrep (2015), that scholars have mainly ignored this period of Bowie's career. While there are a plethora of interesting videos to consider from the 1990s, I wish to focus on one of his more mellow songs and stillest videos, 'Thursday's Child' from the album *Hours...* (1999), to illustrate that even when Bowie is 'offering a version of himself' (Usher and Fremaux 2015: 74) and flirting with authenticity, the same themes reoccur.

The video begins with Bowie looking at himself in the mirror before quietly singing lyrics from the song, 'Doing the best with what I had'. This moment already dislodges the audience's expectations to hear a pre-recorded track as opposed to 'live' singing. The video continues to disrupt the sonic seamlessness often found in music videos by having Bowie mumble/sing a few words during another section of the song, turn on the tap at the sink, and cough over the sound-tracked song. Notably, these disruptions end after a minute and forty seconds of the video, acting as the aural signal that Bowie is now purely focused on this reflective moment he is having in the mirror. It is reasonable to read this performance as 'Bowie', the individual, especially as he is not overly made up or wearing a costume and the lyrics of the song are a first person narrative of introspection. However, this can also be read as a 'performance', possibly even a performance of authenticity, indicating the real self below the star persona, with the beginning section further adding to the sense that the audience is being given a peak into reality. The slow pace of the video, the non-theatrical gestures, and the intimate interior all point to markers that hint at a truth below the surface, essential qualities, according to Richard Dyer, when determining the authenticity of a star image (1991: 133).

The song is a rumination on love, ageing, and time, but it can also be read as the separation between star and self, especially the lyrics, 'Maybe I'm born right out of my time/ Breaking my life in two'. Duality is again present in a Bowie video, as it was with the singing Bowie and the female back-up singers in 'Boys Keep Swinging' and Vic and Screamin' Lord Byron in 'Blue Jean'. In 'Thursday's Child' this dichotomy is visually revealed when the reflection in the mirror morphs from the elder Bowie into a younger Bowie, joined by the younger version of his lover, while the older lover fiddles with her contacts. The elder self, then, acts as mask shielding the younger self still present within Bowie's body, implying that the gender-bending glam rocker endures, even if only below the surface of the ageing star.

The entire fantasy scene occurs in a conventional space, a master bedroom, further linking the video to Bowie's career-long interest in the non-normative. The normality of the space where the fantasy experience, possibly even an out-of-body experience, takes place causes the space and the mundaneness within it to appear as extraordinary. The lover's continued

attention to her contact lenses (an obvious reference to Bowie's unique eyes) and disinterested glances to Bowie are striking because of the narrative focus within the video on Bowie's transformation and reckoning with his past. Similar to a later video, 'The Stars (Are Out Tonight)' from *The Next Day* (2013) which presents Bowie and Tilda Swinton as a suburban couple who have a 'nice life' before being stripped bare and reanimated by two young female stars, what is queer within 'Thursday's Child' is not sexual or gender ambiguity, but normalcy. There is an 'othering' that takes place in the video, but while Bowie recognizes the other self in the mirror, his lover does not, the boundaries between self and other are displaced with Bowie, but remain normalized with his lover.

Conclusion

Ageing is a central theme in 'Thursday's Child' and this becomes a larger part of Bowie's oeuvre as he becomes older. Both 'Thursday's Child' and 'The Stars (Are Out Tonight)' lament the 'passing of Bowie's youth' (Dixon 2013: 397). The star's interest in identity shifted from, as Nick Stevenson argues, a 'joyful exploration of who we might become and self-invention, but rather under the shadow of death we are left to ponder the emptiness, mystery or illusion of the self' (2015: 289). Tanja Stark noted that 'death has been an enduring companion to Bowie from the beginning' (2015: 61), from the rock 'n' roll suicide of Ziggy Stardust through to 'You Feel So Lonely You Could Die' from *The Next Day*. This illustrates how Bowie's star authorship has allowed the artist to explore various issues relating to identity throughout his career, but that these interests have altered and evolved. This is evident in his music, but also in his videos, which returned to the overarching themes of performance/masks, gestures/posing, and queerness/androgyny even as his star image transformed into something more 'ordinary' than at the height of his stardom in the 1970s.

The emphasis on non-normative characters, settings, and circumstances was a hallmark of David Bowie's career. It was most recently displayed in his penultimate video for 'Blackstar' which presented Bowie as a blind prophet from a post-apocalyptic planet where people appear to be motivated by a crystal skull. Even more so, the video for 'Lazarus', released the day before★, is a meditation on death, lyrically and visually, with the video ending on Bowie retreating into a closet and disappearing from sight. As with many of his videos, gestures and poses are central to 'Lazarus' from the frantic writing (an artist with a great deal still to share) to his pleading hands upward while lying in bed (embracing what is to come) and expressionless face (similar to the *Heroes'* cover) and shaking body as he withdraws into the closet (the stoic face and depleted body accepting of its fate). For many, this video acted as a 'goodbye' from the artist,[7] but the video also illustrated

the continued importance of music video to Bowie and his commitment to explore the themes of the non-normative, the unknown and the peculiarities of life and death. Thus, the fact that his final video was about death may not have been as eerily intentional as it seemed at the time of its release. It was simply a continuation of a lifelong artistic exploration.

For an artist who had such a vast and varied music career over five decades, it is not an easy task to make connections between every period, musical release, or, indeed, music video. However, Bowie's uniqueness as an artist who trained in mime and possessed a long-term fascination with the shaping of identity helped mold his legacy as a chameleon-like figure who also displayed consistencies throughout his career. As the man himself once said, 'There's a very strong continuity to the work I do' (quoted in Buckley 2015: 226) and this is nowhere more evident than in his music video oeuvre.

CHAPTER FIVE

The Perfect Kiss: New Order and the Music Video

Andrew Burke

On 26 March 1985, the members of New Order assembled at their rehearsal space just outside Manchester, England, to film the video for what would be their next single, a song titled 'The Perfect Kiss'. Unusually for the band, who had long resisted the temptation to draw singles from their LPs, 'The Perfect Kiss' was among the tracks that would feature on their third studio album, *Low-Life*, due for release in May of that year. The band was keen to avoid the conventions of the pop promo feeling that, even in the few short years that had passed since the 1981 launch of MTV in the United States had exponentially increased their production, the form had ossified into a more or less standardized set of tropes and images that revolved around mimed performance and sexualized imagery.[1] Directed by Jonathan Demme, the video for 'The Perfect Kiss' would avoid these clichés by zeroing in on the band itself as they performed the track live in the private, intimate space of their practice room. The video is remarkable for several reasons, not least its extraordinary length. Clocking in at over nine minutes, 'The Perfect Kiss' far exceeded the conventional length of the mid-1980s music video and offered no real narrative, drama, or spectacle to justify this duration. Nevertheless, it aired occasionally on both MTV in the United States and on MuchMusic in Canada. It serves as a powerful example of the possibilities of the form itself, if it could be freed from both the constraints of time and the demand that it serve above all as a vehicle for the manufacture and maintenance of pop stardom.[2]

In what follows, I look at three New Order videos from the mid-1980s to reconsider the function and significance of the music video at a historical moment when the form became both more adventurous and aspirational. I will specifically examine the role that these New Order videos – 'The Perfect Kiss' (Jonathan Demme, 1985), 'Bizarre Love Triangle' (Robert Longo, 1986), and 'True Faith' (Philippe Decouflé, 1987) – played in generating a visual image of, and identity for, the band in an era when the terms of pop identity had been transformed by the rise of the music video and the establishment of television stations dedicated to their broadcast. The video for 'The Perfect Kiss', directed by Demme with legendary French cinematographer Henri Alekan behind the camera, will be my primary focus. The clip's formal austerity and affective flatness set it apart from its contemporaries, and make it, I would argue, one of the defining music videos of the era. 'Bizarre Love Triangle', directed by the visual artist Robert Longo, departs from the static precision and careful minimalism of its predecessor and presents a torrent of seemingly unconnected images, rapidly edited together in a manner that exemplifies the kind of postmodern visual production that dominated both art galleries and MTV in the American 1980s. Finally, the video for 'True Faith', directed by French choreographer Philippe Decouflé, draws on the language of European surrealism in its creation of a visual world that firmly rejects any idea that the music video should be restricted to the documentation of a performance or the narrativization of a song's lyrical content. These three music videos identify several key questions relating to the form itself, most significantly its negotiation of a space between commerce and culture. But they also situate and affiliate New Order with a whole history of high cultural visual arts production, from the legacy of the modernist European avant-garde to the emergence of American postmodern provocateurs. These videos reveal the pop promo as a form through which band, brand, national, and cultural identity is worked through and over, and in which the visual signifiers of 1980s postmodernism converge and coalesce.

Before looking closely at the video for 'The Perfect Kiss' I want to contextualize it within the overall arc of New Order's videography and consider the ways in which the selection of Demme to direct the clip (and the key connections that led to it) fits with the group's long-standing commitment to produce interesting and innovative videos. The American Demme may initially seem an unusual or unexpected choice as director for 'The Perfect Kiss'. At the time he was perhaps best known for his film *Melvin and Howard* (1980), a Preston Sturges–inspired comedy that traces the ups and downs of everyman Melvin after a chance encounter with the billionaire Howard Hughes in the Nevada desert. It's a wry comedy, distinguished by its affection for its hapless protagonist, but hardly a film that anticipates his work on 'The Perfect Kiss'. Demme's next film, *Swing Shift*, was released in 1984, but only after much conflict with his producers

at Warner Brothers as well as with the star of the film, Goldie Hawn. It is in the context of this frustration and disappointment that Demme turned to music as a respite from Hollywood. In December 1983, just months before 'The Perfect Kiss', he filmed the Talking Heads over three nights at the Pantages Theatre in Hollywood and this footage would eventually become the concert film *Stop Making Sense* (1984). As distinct and different as the Talking Heads film is from the New Order video that Demme was working on at the very same time, both are very much characterized by a desire to capture a band playing live, but to do so without resorting to rock cliché or the basic vocabulary of pop performance that plagued so many clips in the early days of video.

Demme's connection with New Order was brokered by noted video producer Michael H. Shamberg, who had filmed a 1981 New York City concert for the band and would go on to serve as the executive producer for all of their music videos up until his death in 2014. As much as Demme's clip for 'The Perfect Kiss' is central to the development of New Order's video identity, it is nevertheless crucial to recognize Shamberg's importance as a close collaborator of the band. The first fruit borne of the connection with Shamberg was the video for 'Confusion' (1983), released the year before 'The Perfect Kiss'. This was directed by Charles Sturridge, fresh from making, oddly enough, the massively popular television adaptation of *Brideshead Revisited*. Alongside a narrative that reworks *Saturday Night Fever* in following a pizzeria server as she prepares for a night out on the town, the video documents the band's 1983 sojourn in New York. It shows them in the studio recording the track with producer Arthur Baker as well as visiting the legendary Funhouse club where they look on as resident DJ Jellybean Benitez gives the rough mix of 'Confusion' an initial spin. As Simon Reynolds notes, 'The video offered a fabulous snapshot of one corner of New York's post-disco scene, the Latin freestyle kids clustered around the Funhouse club' (2006: 262). But it also records a key moment of cultural transmission. In New York the band experienced the euphoria of garage and electro and it stirred in them a desire for the dance floor that would ultimately result in the establishment of the Haçienda club in Manchester. The founding of the Haçienda (Fac 51), in turn, sets in motion a whole history of UK electronic and dance music.

In addition to the videos directed by Sturridge, Demme, Longo, and Decouflé, Shamberg arranged for an astonishing range of film directors and video artists to make clips for the band, including Kathryn Bigelow ('Touched by the Hand of God'), William Wegman ('Blue Monday '88'), Paula Greif ('Round & Round'), and Robert Frank ('Run'). And even though it was for Electronic (Sumner's collaboration with Johnny Marr of the Smiths and Neil Tennant of the Pet Shop Boys) rather than for New Order, Shamberg also arranged for the reclusive French director Chris Marker to direct the video for their 1990 single 'Getting Away with It'.[3] New Order were by no

means alone in collaborating with filmmakers and visual artists on their music videos. These alliances between the world of cinema, the visual arts, and musicians pepper the history of the form, going back to its earliest days. Bruce Springsteen worked with both Brian De Palma ('Dancing in the Dark') and John Sayles ('Born in the U.S.A.', 'Glory Days', and 'I'm on Fire'); Brian Eno and David Byrne with Bruce Conner ('Mea Culpa' and 'America Is Waiting'); The Pet Shop Boys with Derek Jarman ('It's a Sin') and Bruce Weber ('Being Boring'); Public Enemy with Spike Lee ('Fight the Power') and Sonic Youth with Todd Haynes ('Disappearer'), to name just a few. Nevertheless, the sheer array of directors and artists that Shamberg drafted in to create a visual and video identity for the band is quite astonishing. Demme's work on 'The Perfect Kiss' is foundational in this regard, crafting an image of the band which is, as Andrew Goodwin describes, a kind of 'nonimage' (1992: 113) in its rejection of the traditional signifiers of pop stardom and conventions of the video form, and its replacement with something that veers closer to the world of independent film or the visual arts.

Having considered its position both within the trajectory of New Order's videography and alongside other videos that brought together artists, filmmakers, and musicians, I want to take a detailed look at 'The Perfect Kiss'. The power and force of the video resides in the sheer precision of its construction, something that Demme derives from the song itself. The track is a compellingly modular one, built up bit by bit from its component parts. But even before this process begins, a title screen indicates the name of the song and, in true Factory Records fashion, assigns it a catalogue number: Fac 321. It may seem a minor detail, and these opening seconds were sometimes excised from broadcast, yet this basic information, presented in a modern sans serif type, concretely connects the video to the clean, clear, and crisp modernist visual aesthetic that Factory's in-house designer Peter Saville had broadly established as both the label's house style and as New Order's specific visual identity.[4] The type, as much as the catalogue number, establishes the video as both a Factory Records product and a New Order production, an association that brought with it, at that precise historical moment, a certain amount of subcultural capital, especially in North America. This look, visually and typographically reminiscent of 1920s European modernism rather than 1980s Anglo-American postmodernism, would have contrasted profoundly with the visual identities of stations, such as MTV and MuchMusic, on which it would have appeared, as well as distinguishing the video from the others that would have surrounded it on air.[5] Furthermore, the title and catalogue number appear over the image of a monitor displaying a time code, which at once signals the liveness of the performance that follows but also, in a self-reflexive fashion, reveals something of the mechanics of music video production itself. The coming together of style and self-reflexivity in this title sequence fits with the

history and philosophy of Factory Records, as run by the iconoclastic and idiosyncratic Tony Wilson. The label was grounded in punk's suspicion of capitalism and the corporate and was, by all accounts, a fairly chaotic commercial enterprise. Yet, it aspired to produce work that was as cutting edge as it was commodifiable. The minimal modernism of the title sequence of 'The Perfect Kiss' conforms to and consolidates the identity of both band and label, as well as drawing on the subcultural capital both had already accrued in the establishment of that identity.[6]

The video proper begins with the band's keyboardist, Gillian Gilbert, stepping forward and into focus to trigger the drum sample that serves as the rhythmic backbone of the track. A sequence of close up shots cycles through the remainder of the band, all of whom to varying degrees look awkward, uncomfortable, or distractedly absorbed in the task at hand. Bernard Sumner, guitarist and vocalist, glances at his bandmates but avoids making eye contact with the camera. Stephen Morris, usually the band's drummer but on this track serving as a second keyboardist, looks furtively from side to side. Finally, Peter Hook looks down at his bass guitar, before launching into the distorted bass-line that later develops into the key melodic element of the track. There is little joy or enthusiasm visible in these shots, only nervousness, concentration and focus. The static formalism of Demme's framings accentuates this lack of affect and situates the band as part of a longer history of electronic music on film and television, most notably exemplified by Kraftwerk, in which images of technical control and sonic precision take precedence over the expression of emotion or the impulse to dance.

It's worth noting that the rise of British synthesizer-based pop music in the early years of MTV might initially appear as a kind of historical irony, given that the programming involved in electronic music production seems to lack the visual dynamism of playing drums or the electric guitar (Goodwin 1992: 31, 32). Demme himself was disappointed when he learned that the drums in 'The Perfect Kiss' were programmed rather than played. But the strength of the video for 'The Perfect Kiss' is that it does not shy away from showing the minimal gestures that trigger many of the sounds. Unlike other videos for electronically based pop from the era, which resolved this problem by either by turning away from performance entirely (Duran Duran) or by including a keyboardist dancing behind the instrument and haphazardly stabbing at it (Thompson Twins), 'The Perfect Kiss' embraces gesture. In its focus on the hands of the band members in particular, the clip reveals how these artificial and electronically generated sounds are nevertheless human in both origin and expression. Shots of Sumner playing guitar and Hook playing bass integrate seamlessly with images of Gilbert and Morris on keyboards and playing synths to evoke the sense of New Order as a live act of a new sort. Perhaps the key shot in this regard is the one of Gilbert, shot from a low angle and from behind, as she reaches up and turns on

the Voyetra-Eight analogue synthesizer to start the arpeggiated melodic sequence that persists throughout most of the track. High-angle close-up shots of Gilbert, looking impassive, frame this gesture and lend it both a weight and significance. It may initially seem a stretch to relate this moment to Giorgio Agamben's analysis of the ways in which the gestural in cinema facilitates a recovery of its ethical and political dimensions. Yet, the shot of Gilbert seems precisely that: in the first instance, the way Demme's camera dwells on the sequence of movements invites an understanding of them as a bodily condensation of several historical, cultural, and political meanings: it signals the rise of alternative electronic music and the ascent of indie in a way that reorders a cultural and geopolitical relation between the North America and the UK; it challenges the dominant phallic masculinity of rock and pop; and it opposes the hegemony and fetishization of guitar, bass, and drums. But even more than this, and following Agamben, the sequence is captivating because gesture is made visible in itself as a mode of being in the world (2000: 55). As such, its power rests not simply in the way that it condenses these cultural meanings, but in revealing gesture itself as a form of means without end, of pure mediality, to which cinema has privileged access. So, while the allure of 'The Perfect Kiss' resides in part in the way that it shows the construction of the track, and demystifies, humanizes, and even renders cool the production of electronic music in so doing, it also resides in the way that it frames and captures the looks, movements, and gestures involved in this process and which constitute it.

The studied compositions of 'The Perfect Kiss' can perhaps be attributed to the presence of legendary French cinematographer Henri Alekan. Born in 1909, Alekan was a camera operator on several French poetic realist films from the 1930s, including two by Marcel Carné, *Drôle de drame* (1937) and *Quai des brumes* (1938). He went on to serve as the director of photography on many French and Hollywood films from the 1940s to the 1960s, most notably Jean Cocteau's *Beauty and the Beast* (1946) and William Wyler's *Roman Holiday* (1953). After working infrequently throughout the 1970s, Alekan returns to prominence a decade later when Wim Wenders, seeing Alekan at work on Raúl Ruiz's film *The Territory* (1981), recognizes him as an elder statesman of the camera and has him photograph both *The State of Things* (1982) and *Wings of Desire* (1987). Alekan's work on 'The Perfect Kiss' comes in between these two assignments for Wenders and features all the hallmarks of his distinctive style. Eschewing the rich shadows of poetic realism, Alekan suffuses New Order's rehearsal studio with light yet retains his customary focus on the face not as a vehicle for the excessive expression of emotion but as a surface that communicates both the dignity and humanity of the individual.[7] For the video, Alekan used lenses and 35 mm film stock that soften the images and produce a sense of both serenity and beauty. Alekan was assisted on the shoot by Agnès Godard, who was then in the early stages of her career, but who would go on to become one

of the most important cinematographers in world cinema, most famous for her work with Claire Denis, including *Nénette et Boni* (1996), *Beau Travail* (1999), and *35 Rhums* (2008). Godard was Alekan's focus puller on 'The Perfect Kiss' and her skill in making the minute readjustments necessary as the band members nodded or bobbed in time with the music also contribute immensely to the video's sense of precision and control.

The precision with which Alekan and Godard frame the close-up shots of the band, especially in the opening sections of the track, gives shape to Demme's direction. The fragmentation that characterizes the beginning of the track, with the band members each isolated in their own section of the studio, gives way over the course of the video to a thrilling sort of integration as the band and song come together. I'll say more about the allegorical possibilities of this structure in a moment, but for now it is enough to recognize that Demme denies the viewer any kind of establishing shot that shows the band as a whole until nearly the halfway point of the track and that this generates a sense of both trauma and tension. Prior to that, the clip shows each of the band members alone and in turn as they contribute the sounds that are the building blocks of the song itself. The camera lingers longest on Sumner as he delivers the song's three verses. Sumner has an unusual pop voice, but its thinness and reediness fits well with the lyrics of 'The Perfect Kiss'. The song presents a loose narrative about reticence and regret. Sumner sings of the desire for a night out on the town, but also of the reluctance to venture out with an unstable friend whose behaviour always threatens to devolve into late night violence. The final verse tells the tale of a night gone wrong as his friend dies in the street as a result of an altercation, which prompts Sumner to contemplate the fragility of life and to deal in the aftermath with deep pangs of regret. The title comes from the final line of the song, framed as a kind of recognition or revelation about the consequence of his friend's erratic behaviour: 'Now I know the perfect kiss is the kiss of death'. Throughout these three verses, Sumner strains to reach certain notes, accentuating their emotional content and evoking vulnerability, grief, and remorse. During the verses, Demme's camera remains resolutely on Sumner, capturing each grimace as he works through the lyrics with his eyes firmly shut. Given the circumstance of New Order's formation, it is difficult not to read these lyrics allegorically, as a coded meditation on the aftereffects of the 1980 suicide of Ian Curtis. Sumner, Hook, and Morris were Curtis's bandmates in Joy Division and must have been deeply emotionally affected by their friend's death. So, even while the lyrics for 'The Perfect Kiss' do not directly invoke Curtis's suicide, his spectral presence haunts the song.

This sense of Curtis's presence is borne out in the clip's second half. 'The Perfect Kiss' has a curious structure. Once the verses are complete, the song becomes noisy, even dissonant; as Hook batters away at a drum pad, Sumner taps out a somewhat arrhythmic pattern on a cowbell, and

Morris plays an aggressively abrasive melody on the keyboard. The tension in this section of the song gives form to the self-lacerating remorsefulness evoked in the final verse, but just as it reaches a crescendo, all these elements abruptly stop, leaving only the song's basic drum pattern to soldier on programmatically as the band prepares for the track's instrumental second half. It is at this point that Demme provides a wide shot of the studio and shows the group as an integrated unit. As the song once again builds up bit-by-bit into what is a kind of variation on its opening half, Demme returns to a series of shots of the band in close-up or mid-shot. It is only after all four band members have been shown that Demme's camera offers two new perspectives on the scene. In the first, he shows Sumner slipping the strap of his guitar over his head. Visible in the background is a poster for a show Joy Division played in Berlin on 21 January 1980.[8] Second is a shot of Peter Hook playing bass. Behind him light streams through an open door and leaning against its frame, with arms crossed, is a figure clearly meant to be Ian Curtis. The saturation of the light means that he is more shadow than substance and it is impossible to discern the precise features of the figure's face. Nevertheless, the silhouette perfectly replicates Curtis's stature and bearing and nods his head in a manner instantly recognizable to anyone who has seen footage of Joy Division performing. As the song once again works its way to crescendo, Demme's camera returns several times to this figure in the doorway, whose spectral presence seems to support and sanction what is happening in the room.[9] Such a reading surely sentimentalizes what must have been a difficult process for the remaining members of Joy Division to start again after the death of a singer, bandmate, and friend who was one of the most charismatic and captivating performers of his era. Nevertheless, no matter how sentimental the idea of the late Curtis looking on approvingly as the band move forward both personally and musically may seem, the clip retains an emotional force that is rare for a music video.

There is undoubtedly more to be said about the clinical precision of 'The Perfect Kiss' and its connection to the band's tragic history, but I want to move on in order to briefly consider the two videos which followed and mark a departure from the austerity and elegiac minimalism of their predecessor. Directed by Robert Longo, the rapid editing and oversaturated colours of 'Bizarre Love Triangle' fit more comfortably alongside other examples of the music video from the period. Yet, it stands out as a particularly powerful instance of the overlap between the art gallery and music television, the convergence of video art and the music video.[10] Longo delivers an incredible array of discontinuous images, bursts of imagery that accumulate into something like a panorama of modern urban life. In this way, the video fits alongside, albeit in a less ethnographic and far more accelerated way, the films Philip Glass scored for Godfrey Reggio, *Koyaanisqatsi* (1982) and *Powaqqatsi* (1988). However, the most distinctive elements of 'Bizarre Love Triangle' depart from these quintessentially

1980s cinematic meditations on contemporary existence. First, Longo inserts images of video feedback and pixelated screens. As such, 'Bizarre Love Triangle' is at least in part a video about video as a form and medium, about the beauty of video texture and how pixel fragmentation might be used as a means and a mode of abstract visual representation. The video is caught up in the visual euphoria, the ecstasy of images, that characterized postmodern visual culture at that precise historical moment, and which is, of course, related to the rise of the music video itself. If 'The Perfect Kiss' rebels against the visual pleasures offered by kinetic editing, 'Bizarre Love Triangle' embraces them fully and explores the possibilities and limits of a video aesthetic informed and influenced by MTV, at the same time that it seeks a place on it.

Second, Longo animates the chorus of 'Bizarre Love Triangle' with images of men and women dressed in suits rising and falling through the air. Shot from a low angle, framed against an azure blue sky, and presented in slow motion, these sequences of bodies twisting and contorting in the air now almost inescapably evoke the horrors of the attack on the World Trade Centre in New York City. Yet the images originate in Longo's own work: the *Men in the Cities* series of charcoal and graphite drawings that he completed between 1979 and 1982. Based on photographs he took of men and women in business attire in free fall or in awkward poses, Longo's *Men in the Cities* series has become a kind of signifier of the aspirational 1980s and of the boom in the art market at that time, so much so that two prints from the series adorn the walls of Patrick Bateman's apartment in Mary Harron's 2000 adaptation of Bret Easton Ellis's novel *American Psycho*. But in the video itself, the images are oddly contemplative. This is, in part, because they interrupt the accelerated flow of imagery that make up the majority of the clip, but also because they accompany a chorus that evokes languor as much as longing.

Third, and in what is perhaps for many viewers the most striking and memorable aspect of the video, Longo abruptly interrupts the song during its cowbell-driven bridge to present a short, surreal scene shot in black and white that shows a man and woman having an argument, while another altogether mysterious blond woman stands in the background with her arms folded. In the scene, a clearly exasperated Asian-American woman snaps at the white man who is staring at her with a mix of rage and frustration in his eyes that 'I don't believe in reincarnation because I refuse to come back as a bug or as a rabbit'. The man's curt response, 'You know, you're a real *up* person' is both condescending and disdainful. But Longo denies the viewer anything further of the dispute and the exchange simply hangs in the air, without context that would allow the viewer to make sense of it and with explanation for its inclusion. At this point, the music kicks back in and the scene concludes with a jump cut to a close-up of the woman in the background that immediately pulls back to present a wide angle shot that

once again places her between the feuding couple. With that, Longo thrusts the viewer back into the flow of images that make up the majority of the video.

Part of the power of the scene resides in the fact that this sort of abrupt break was, at the very least highly unusual, if not wholly unprecedented, in the history of the music video. But the sheer novelty of it does not exhaust its force. Lit in film noir style, the scene fits with the period's fascination with *le mode rétro* and the evocation of older forms and styles. The chiselled good looks of the frustrated man, the exotic allure of the exasperated woman, and the sultry mystery of the blond woman in the background combine to elicit the feeling of film noir without directly referencing a specific film. Nevertheless, they do make up, as the song's title puts it, a bizarre love triangle of the sort familiar from the history of cinema. As Fredric Jameson argues, this kind of play with signification, pastiche as blank parody, was a hallmark of postmodernism (1991: 16–19). As such, the sequence in 'Bizarre Love Triangle' fits with, to use Jameson's privileged example, the Hollywood redeployment of the visual signifiers of film noir in the early 1980s in films such as Lawrence Kasdan's *Body Heat* (1981). But the recirculation of these signifiers need not be devoid of critical intent or force, as Jameson sometimes seems to imply. The work of Longo's college classmate Cindy Sherman is perhaps the best example of this. Her *Untitled Film Stills* (1977–1980) series of photographs draw on the visual vocabulary of classic Hollywood to think through the ways in which mid-century American womanhood was imagined and represented. Longo's film noir homage is so brief that it is almost impossible to assess whether he is simply indulging in the pure play of signification or whether there is a more critical edge in his restaging of such an archetypal scene. Despite this indeterminability, its presence in the midst of 'Bizarre Love Triangle' is significant precisely because it shows the way in which the music video could be a space for formal experimentation that sits somewhere between Hollywood and high art.

Given that it consists of several surreal dance sequences punctuated by the repeated image of two men, one of whom is painted blue, dressed in foam overalls slapping each other repeatedly in time with the song's rhythm, it may seem a stretch to call 'True Faith' the most conventional of the New Order videos from this period. Despite the oddness of director Philippe Decouflé's vision, 'True Faith' hardly seems as groundbreaking as Demme's ascetic vision in 'The Perfect Kiss' or Longo's visual excesses in 'Bizarre Love Triangle'. Nevertheless, the band's conscription of a French choreographer to direct resulted in a work that enjoyed both a popular and critical success. It won that year's British Phonographic Industry (BPI) award for best video, and regularly features on lists of the best of all time. As Theresa Jill Buckland notes, Decouflé drew on the work of 1920s German artist and choreographer Oskar Schlemmer for the costume design in the

video (1993: 72). Similar to several of the dancers in Schlemmer's landmark work from 1922, *Triadisches Ballet*, Decouflé's dancers wear costumes that are oddly bulbous and spongy, 'which encase and transform the human form' (1993: 72). Paul Hindemith's music for the *Triadisches Ballet* invites a few sequences in which Schlemmer's choreography becomes boldly and bracingly kinetic, but the insistent beat and faster tempo of 'True Faith' result in a work that is altogether more vigorous and violent. The dancers leap, lunge, and bounce throughout the piece as well as bumping into and rebounding off one another. This spectacle of colour and movement is alluring, but does not in any way seem illustrative of the song's lyrics. As Buckland argues, the video 'underlin[es] the band's image as serious artists, through their association with one of France's most fashionable dance choreographers', it also aligns it very much with its cultural moment in the way that signs and play are celebrated over sense:

> Torn from their seemingly once fixed *high* or *popular* contexts, images are accorded equal valence in the bricolage of music video. Such 'free-floating images' should not, however, prevent the viewer from reflecting on the role of the music video in the construction of the overall image of specific pop artists. A particular case in point is New Order's 'True Faith', where the dance appears less as an interpretive expression of the song text, than as a tangential element of design. (1993: 72)

While the everyday viewer probably would neither have known of Decouflé's reputation in the world of dance, nor recognized the video's allusion to Schlemmer's work, the video nevertheless, in its style and through its signifiers, conveys something of an identifiable modernity and Europeanness that distinguishes it from the vast majority of the clips it would have played alongside. In selecting Decouflé to direct, New Order connected themselves to a different national-cultural tradition of the music video, that of France. There are perhaps greater similarities between 'True Faith' and the more aggressively surreal, stylized, costumed, and choreographed clips by French artists from the same period than there are between it and its British or North American counterparts. The clip fits comfortably alongside French examples of the music video from the same era: Les Rita Mitsouko's 'Marcia Baila' (Philippe Gautier, 1985), Etienne Daho's 'Tombé pour la France' (Jean-Pierre Jeunet, 1985) and Niagara 'Quand la Ville Dort' (Pierre et Gilles, 1987). This French connection continues in the work of Michel Gondry. Even though Gondry selected 'The Perfect Kiss' in his 2008 selection of the top twenty-five videos of the past twenty-five years, his commitment to complex choreography and his taste for the surreal, I would argue, derives as much from 'True Faith'. This is especially visible in a video such as the one he directed for Daft Punk's 'Around the World' (1997), which combines costume,

choreography, and colour in a manner that does not directly invoke Decouflé's vision, but certainly echoes it.

New Order's contribution to the art and history of music video rests both in their refusal to submit to the music industry's limited expectations for the form and their willingness to collaborate with directors capable of forging a visual identity for the band without producing the kind of crassly illustrative or blandly performative clips that dominated, and to some extent still dominate, the genre. New Order continued to make innovative and exciting music videos well after the three that I focus on here, but I do think that these three stand as the band's most important contribution to the form. This is perhaps in part down to simple timing. The mid-1980s were a crucial moment in the history of the music video as the form ascended from emergence into dominance, from a curiosity or supplement to a cultural object or a cultural event in its own right. At the same time, the music video cross-pollinated with independent film and video art, and took its place alongside them in the effort to rethink and reimagine visual culture in the era of video and of postmodernity. 'The Perfect Kiss', 'Bizarre Love Triangle', and 'True Faith' are all at the forefront of this exploration of the form's power and possibilities.

Gender, Embodiment, and Sexual Representation

Introduction

As stated in the introduction to this collection, the music video has been a problematic and controversial media entity, for as long as the phenomenon has existed. This is no less the case when considering issues of gender, embodiment, and sexual representation. As previously discussed, the music video no longer remains yoked to the financial base of dominant music labels and with this shift, a more complex audiovisual landscape has emerged. The music video remains a space where dominant representations of gender and sexuality can be both reinforced and challenged. The chapters in this section address the complexity of these issues and take differing approaches to understanding gender, embodiment, and sexual representation at various moments in the history of the music video. While they present distinct approaches to very distinct music videos, with different emphases, they all raise related questions.

We begin with Halligan's essay 'Liquidities for the Essex Man: The Monetarist Eroticism of British Yacht Pop', where the ways in which the music video came to recalibrate the pop single as allied to the developing notion of a glamorous and enviable male lifestyle at a particular period in British pop music are examined. Halligan, through his analysis of 'yacht pop', suggests that the music video became aspirational, representing new kinds of male subjectivity which were closely linked to the pleasure of a new and enviable emerging lifestyle. He argues that the yacht as seen in the music videos of Duran Duran and George Michael, among others, replaced the cultural signifier of the British male rock star's country house and represented a novelty of *nouveau riche* acquisition indicative of the newness of pleasures on offer in 1980s Britain.

Brozzoni takes us into a different space by reflecting on the complex subjectivity of the work of Björk by examining the representations of eroticism and romantic love in her music videos. Brozzoni argues that Björk enacts a quest for her identity that unfolds throughout her entire

artistic output. By musically and visually documenting the rise and
fall of her love story, Brozzoni reflects on Björk's need to share her
experiences of the erotic side of love, where she contemplates her desires
and needs and explores the almost constant conflict between the inner
and the outer world, where the battlefield of this conflict is often the
sexualized body.

For Fairclough, the links between Björk and FKA twigs audiovisual
work are visible and she begins by examining the discursive struggles over
the meanings of feminism which are now largely staged in and through
media culture. Given that celebrity interventions into ongoing debates over
feminism have recently intensified, pop culture scholars are seeking to come
to terms with the ideological and cultural implications of these publicly
staged discursive contests. Fairclough argues that the music video has long
provided a space where these struggles are played out. Here she interrogates
the nebulous concept of celebrity feminism through an examination of the
music videos of electronic r and b pioneer FKA twigs. She explores how
twigs engages with feminist ideas in her work that complicate conventional
notions of celebrity feminism and examines how twigs's work may provide
a more open space through which celebrity feminist ideas may be played out
by presenting a deeply introspective and personal vision that lacks any sense
of aspirationalism, unlike many of her celebrity feminist contemporaries.
Fairclough suggests that twigs's willingness to engage audiences in her
own self-ambiguity and complexity presents a challenge to normative
femininity in a post-feminist regulatory environment, and in a mainstream
media culture dominated by simplistic versions of female identity and
sexuality and it is here where twigs appears to present a disruption to
the norm.

Concluding this section, Silveira presents an analysis of Nicki Minaj's
2014 music video 'Anaconda'. Here he posits that through its particular
ambience of 'wild nature', its intertextual references both musical and
cinematic, its iconography, and through the horizontal, ground-oriented
dynamics of Minaj's dance style, it evokes the notion of *anal terrorism*,
a term coined by Spanish philosopher Beatriz Preciado (Hocquenghem
and Preciado 2009). Preciado discusses the 'disappearance' of the anus
in bodily, gender, and identity performance and as also the basis for
bio-political demands and intermediations in a contemporary cultural
context. For Preciado, the anus is the damned and stigmatized organ. In
his assessment of Minaj's work 'Anaconda', Silveira argues that it presents
a new kind of anal terrorism: a 'gender anal terrorism', one which
produces erotic inflation and de-sensitization by overload. He argues
it adopts a female-empowerment approach which intensifies without
undoing or questioning the established poles of hegemonic representation.
Here transgression itself becomes a new form of over-identification with

consumerism as individual liberation, and a 'hyper-feminization through hyper-sexualization' in proximity to pornographic models and raunch culture.

The artists and music videos examined here represent only a tiny glimpse into the complexities of the spectrum of gender and sexual representations in the vast array of music videos available, but offer an insight into how complex and diffuse these representations actually are, as well as their potentials for both challenging and reinforcing dominant regimes of representation.

CHAPTER SIX

Liquidities for the Essex Man: The Monetarist Eroticism of British Yacht Pop

Benjamin Halligan

The symbolism is vivid. Roxy Music at the Birmingham Odeon on the night Margaret Thatcher was elected Prime Minister. The socialist utopia that had financed the art schools and filled them with Lennons, Keith Richards, Kinks, Hockneys, Bryan Ferry and Enos was over. We were due a season in hell.

(STEPHEN DUFFY, FORMERLY OF DURAN DURAN, RECALLS 1979, QUOTED IN MALINS 2005: 19)

I remember my first cheque for £1 million. I was only twenty-one. Fifty per cent went to Mrs Thatcher but even still.

(ANDY TAYLOR, OF DURAN DURAN, RECALLS 1982, QUOTED IN MALINS 2005: 85)

The tendency for the music video to be a kind of ambient appreciation of a single – often unsubtly visualizing or lazily dramatizing lyrical content while presenting the group/singer in a way that is sufficiently familiar to reassure fans and yet new enough to merit attention – can betray a conception, on the part of the makers, of those for whom the music video is intended, or should ideally be intended. This chapter considers the nature of the ambience of the music, in terms of how the music video came to recalibrate the pop

single as allied to the evolving idea of a glamorous and enviable lifestyle for these intended – that is, how the music video became aspirational, and what kind of new subjectivity such aspirations seemed to signal, and for which imagined constituency.

This consideration is dated to the moment of two significant cultural shifts in the early 1980s. Firstly, the birth of MTV engendered a vacuum in pop music culture, with the sudden need for videos for singles ushering in a whole new genre of music entertainment. As we have argued elsewhere (Edgar et al. 2013), this was effectively a radical remaking of pop music *per se* – demanding a doubling of output, as it were: audio now streamed with visuals. And, as has been noted of Duran Duran's career, MTV's playing of their music videos resulted in substantial sales of records in areas where the singles were not played on radio stations, and controversy later ensued when singles were first debuted on television rather than radio (see Malins 2005: 105, 124, 125 respectively). Secondly, this vacuum occurred at a point of transition in white popular music, in the British experience, from a period of punk and post-punk, and its overlapping with New Romantic subcultures to forms of music that could be considered to be more palatable as entertainment.

The success of a number of British groups at this moment, capitalizing on the imperative of making and releasing music videos, had made for a second 'British Invasion' (as journalists of that moment termed it, around 1983) of North American popular music. And that success was not a matter of revisiting and so validating aspects of North American popular music, as had been the case with a number of British 're-interpreters' of the 1970s, but of proposing and advancing a new set of concerns. From New Romanticism (and the legacy of glam rock), came a kind of post-gender-bending New Romantic 'leading man'. The tension that needed to be resolved, at the behest of the new markets opened by MTV, was over engaging with metrosexuality (as it would later be termed; see Halligan 2011) while not challenging or wrong-footing a pervasive heterosexual hegemony. The New Romantic leading man was in touch with his feminine side, but not to the freely exploratory 'excesses' that had been associated with, say, David Bowie in the previous decade. Indeed, even Bowie seemed to work to distance himself from that period with the aggressively heterosexual music video for 'China Girl' in which, as per the erotic imaginings of some ghastly cut-price package holiday, he winds up having missionary position sex on a beach with a local girl.[1] All waves of 'British Invasion' of North American pop charts seem to have been powered by marginally freer expressions of sexuality, troubling the home-grown mores of the former colonies, as with the longer hair of The Beatles, or the overt sexuality of The Yardbirds and The Rolling Stones. This is not to say that heteronormativity exerted complete domination of the Top 40 charts of the early 1980s – especially since the progressive worth of pop music, for informed commentators, and in terms of identity politics, can be identified with a more subversive glam

rock/Bowie tradition (as seen in the personae of Freddie Mercury of Queen, Boy George of Culture Club, and, later, Morrissey of The Smiths). But it is telling that one of the initial promotion challenges for Duran Duran was to dispel the potentially damaging sense that they were maybe not entirely heterosexual, as Malins notes (2005: 78). Even Andy Warhol expressed confusion, in 1981, when he first encountered the group: 'They all wore lots of makeup but they had girlfriends with them from England, pretty girls, so I guess they're all straight, but it was hard to believe' (Warhol 1992: 525).

Ambitious British pop music was remade as it came to recalibrate itself to the new musical culture associated with MTV, and the need to provide promotional video material for television programming more widely, where live performances were not possible.[2] Such a turn resulted in those now forgotten (and often long out of print) media artefacts of discographies, the Video EP and the Video Album. At their best it now seemed that the evolving and nuanced conceptual continuity once discernible across lyrics, themes, album covers, and live performances for Prog Rock groups and concept albums had been relocated to sequences of music videos. This realignment was especially true of Duran Duran, whose integration of video into their oeuvre (so that they would have been taken more as 'video stars' than 'radio stars') is perhaps the reason why there is little to no critical writing on the group, and they go unmentioned for music journalists, now tending to rewrite British 1980s pop music as essentially dissenting.[3]

Country house to yacht

The operation of music video as ambient appreciation can be seen in Roxy Music's 'Avalon' (1982, from the album of the same name; video directed by Howard Guard). In a *Country Life* magazine-style country house, the band in tuxedos (Bryan Ferry's is white; the others' are black) play to an immobile audience of ball-goers, seemingly – as the lyrics have it – 'so tired', 'now the party's over'. The music – specifically the warm synthesizer wash which introduces the first chorus – animates a super-model-like lone woman (Sophie Ward; smoky eye make-up, trussed-up blonde hair, pearl and gold earrings, silk ball gown) who entices Ferry away. They dance, and sit, and she then dances alone. Cuts associate the woman with a hooded falcon.[4] And this falcon is presented as a cypher for consideration: is the falcon the female, as enticed to earth by Ferry? Is the falcon a fleeting presence in the proceedings, akin then to the 'could have been' encounter with the woman (both as deadly, noble, and graceful?), who then seems to depart from Ferry? Or is the falcon – as suggested by a two-shot in which both Ferry and falcon simultaneously shift their gazes directly to the camera – in fact Ferry: the hunter who, flying high above social gatherings (he is first seen singing

on a balcony, crooning as he looks down on the ball), spies his prey and swoops? A further visual motif, scattered roses, seems too vague to offer sustained meaningful comment: perhaps they denote that the romance between the two dancers has gone no further, and the romantic gesture of giving roses cast aside.

The video for George Michael's 'Careless Whisper' of 1984,[5] directed by Duncan Gibbins and Andy Morahan, also dramatizes the lyrical content, and in a terribly uninspired way too: narrative tropes familiar from soap operas, with an *in flagrante delicto* climax that would seem clichéd even in a pornographic film. Michael is situated against the Miami night skyline for scenes of romantic intrigue. We see a blonde girlfriend, who looks similar to Princess Diana (and indeed both Michael and Duran Duran's Simon Le Bon then sported Diana haircuts), who then makes love with Michael in a bedroom. They both wear white towelling dressing gowns. But Michael strays to a dark-haired woman (and who is further colour-coded as bad news: black leather trousers and black stilettos seen emerging from a black car), encountered in a harbour. They sail on Michael's yacht, kiss, and make love in the same bedroom – only to be chanced upon by the blonde girlfriend, who registers anger (via a clumsy zoom in on her face), removes her ring (revealing that she was his fiancée), and departs Miami promptly, via a seaplane. Michael is seen reflecting on his misfortune as he moodily walks around the balcony of his Miami apartment and, in moments intercut with the principal music video narrative, the 'psychological' space of a darkened stage (in fact, the Lyceum Theatre, in London), which is draped with ropes and chains.

The difference in sensibility between 'Avalon' and 'Careless Whisper' can be read as the difference between two types of money, old and new (inherited and made, respectively), and so between the 'classy' and the classless. Roxy Music looks back to notions of a (white) rock aristocracy, as institutionalized during the 1970s. The country house acts as a marker of entrée into polite society, with a slight repurposing of the house to the ends of modernization and eroticism (as well as being a soft form of fortification against police raids: space to hide those things and guests that could lead to scandal).[6] One gets the sense that while models are appropriate accoutrements in these environs, there would never be anything as crude as an outright 'love scene'. George Michael's mise-en-scène, in comparison, is one of classless wealth (and even product placement, for Bridgestone tires): nouveau riche trappings, via very modern apartments, with plastic blinds filtering and diffusing the Miami sunset light, a potted bedside plant, glimpses of the leisure industry, and straight lovemaking rather than exchanges of meaningful looks.[7] A ghettoblaster is seen; Michael wears shorts, trainers, and a baseball hat – a transatlantic sartorial development, towards an 'international' Western style. His looks are metrosexual rather than matinée, even in white shirt and shoulder-padded suit. He sports

an earring, sculpted eyebrows, evenly tanned and moisturized skin with highlighted, bouffant hair. The yacht here replaces the country pile – still the status symbol, and still adorned with the desirable, silent female, but with the yacht comes access to freedom and foreign lands, the possibility of a moving bachelor seduction pad, and a newness of acquisition redolent of the understanding that the owner appreciates the newness of pleasures on offer for the 1980s. And Michael sets out into the world (and the new world at that: the Americas) rather than digs in at the inherited country pile. All these things (Miami, women, yachts, shorts, male grooming, and so on) are there for the taking for the new 1980s man.

In this respect, the discussion of yachts here can be distanced from a certain trajectory in which boats just feature as performance spaces, taking in Rod Stewart's 'Sailing' (1975), The Village People's 'In the Navy' (1978), Cher's 'If I Could Turn Back Time' (1989), and Aaliyah's 'Rock the Boat' (2002). Perhaps the yacht status speaks both of cash liquidity and the position of the boat in British post-war children's literature (and subsequent imagination), as with *Treasure Island*, the *Swallows and Amazons* books, *The Kon-Tiki Expedition: By Raft Across the South Seas,* or the *Famous Five* cycle of books and numerous films from the Children's Film Foundation. More appropriate yachting parallels could be made with what effectively seems to be an entire subgenre of rap and hip-hop videos set on boats and yachts, in terms of the melding of the space of partying and performing, and presented as evidencing wealth. But one can assume that all these boats are hired or borrowed and passed off (in the best neoliberal manner) as being possessed by the occupant, and so are just fronts, and/or are bought with an unsecured bank loan of a variable interest rate.

Classlessness, in these new respects, is understood as an essential component of nouveau riche cultures, as with Michael. The newly wealthy are to create their own modes of existence and, in so doing, challenge and reinvigorate the old modes (whose denizens now come to risk the danger of a depletion of their powers, and a flood of cultural vulgarity). Such a development occurred in defiance of what seemed to be a predominant economic trend of downward mobility in the UK in the early 1980s. During his first budget speech, in 1979, the new Conservative Chancellor of the Exchequer, Geoffrey Howe, noted, 'in the last few years, the hard facts of our relative decline have become increasingly plain, and the threat of absolute decline has gradually become very real'. The 'new beginning' that was suggested was one of allowing 'hard work, talent and ability' to be rewarded, particularly via a dismantling of the income tax structures that, for Howe, 'might have been designed to discourage innovation and punish success'.[8] Video pop stardom, and the media industries that promoted it, can be placed as a cultural and economic vanguard in this respect. Howe's meritocratic vision required an unrefined classlessness for a generation of

new money, freed from old industrial paradigms. In this respect, liquidity (in the sense of readily available, and so spendable, money) typically sought leisure status symbols for quick purchase, such as yachts.

Young Birmingham

Duran Duran may not have seemed like obvious candidates for a transfiguration of suburban wannabes into global pop stars for the first few years of the 1980s. From the outset, as York notes, there were credibility problems with these upstarts associated with the Birmingham Rum Runner club, from that quarter allied with the London Blitz club and Spandau Ballet: Duran Duran were perceived as 'hopelessly naff and provincial' (York and Jennings 1995: 36). The bluster of their debut self-shot music video, for 'Planet Earth' (1981, from the album *Duran Duran*, of the same year), confirmed as much: billowing dry ice, 1970s disco balls, and mirror-tiled walls, dancefloor 'types' (spivs and debs, furs and tinsel, women dancing slinkily in bondage gear, made-up mannequins executing robot dance moves) packed into the Birmingham Cedar Club, and the stage only discernible through a fuzzy video smog of club lighting diffused through big bobbing hair dos. But the obvious contenders for promotion may have failed to function in a sufficiently generative way: some potential options would have lacked friction and indolence (surely the lesson of punk's popularity?), which would lend character to the descent into the mainstream.[9]

Typically such a conspiratorial reading of pop stardom is one that is considered in respect to the co-option and de-fanging of what once seemed radical or dissenting. But the opposite vantage point is worth considering too: the continual need to regenerate and refresh contemporary mass culture via a modicum of radicalism or dissent – an industrial prerogative. The assimilation seems to occur around a belated reorientation of the vernaculars of pop to new movements, looks, and atmospheres. In this respect, Duran Duran, as potentially also-rans in the New Romantic phase (and lacking in the diffidence and disdain of other New Romantics, in favour of an upfront clamour for acceptance and affection, as per 'Planet Earth'), must have seemed the most malleable and so the least problematic option for elevation to stardom.

Eroticism, and only then exoticism, cut with a frisson of existential unease (the character-generating friction), would seem to have been the initial response to the need for newness from early Duran Duran and their creative team. A principal culprit in this – he freely condemns himself – was music video director Kevin Godley (formerly of the Stockport soft/art rock band 10cc), of 'Girls on Film':

It had glamour, it had polish, it had sex, it had good-looking boys, it had girls sliding on poles. It was a dirty film. In hindsight, it had the ingredients that became MTV-able. If it was influential, I'm sorry. I can only apologize. (quoted in Tannenbaum and Marks 2012: 46)

The naked models (wrestling, catwalking, flashing) gave way to a homoerotic futurist dalliance (the official 1981 'Planet Earth' music video), and then to a Eurotrashy detour (a Helmut Newton homage to fetishized models – with one such seen driven through London council estates, for 'The Chauffeur' of 1982, from *Rio* of the same year). This videography seems to chart the exit from Birmingham and to a widening of the spectrums of aspiration. The chief marker of this occurrence is the very visible presence of relatively substantial budgets for the making of music videos. For a cynic, the music videos seem to oscillate between the need for the makers to assemble a Hollywood calling card/show reel (aping what would soon be termed 'High Concept' filmmaking: music videos viscerally given over to effects, explosions, adventure) and the desire for a foreign holiday. But even these holidays, in terms of their distant locations (distant, that is, relative to Birmingham), arrived as 'high concept': developing world tourism, unspoiled beaches and teeming markets, temples and elephants – the full payload of exoticized Orientalism.

The former set of music videos (the calling cards) – around 'Hungry Like The Wolf' (1982, from *Rio*), 'Union of the Snake' (1983, from *Seven and the Ragged Tiger*, also of that year), and 'The Wild Boys' (1984, from *Arena*, also of that year) – are bombastic and arresting and yet at times fall short of their ambitions. Diegetic sonic effects, seemingly mixed willy-nilly into the full soundtrack, distract from the experience of the song. Those relatively substantial budgets still fall short, so necessitating endless cages and ropes in darkened studios, populated by dancers. And the music video narratives, which seem to revolve around a future dystopia and the band as cyberpunk/ New Romantic renegades on the run, become fragmented to the point of incomprehensibility. The latter set of music videos (the on-holiday strain) – 'Save a Prayer' and 'Rio' (both 1982, from the album *Rio* of the same year) – seem more organic in their conception. In that they are actually products of holidays the band took, it is as if the music videos seek to rise to the songs themselves, as ambient visual riffs and insights into the exalted or rarefied mindset of the band, who of course feature in these videos. These music videos seem to seek to present a mise-en-scène for an appreciation, or unpacking, of the music itself.

The songs then soundtrack the life on display. This boat is not Michael's yacht – used for getaway, privacy, and lovemaking – but a yacht that is both party venue and mobile performance platform. In this respect, the yacht enables social and professional functions, and so is indicative of a

lifestyle that capitalizes on such liminal spaces. But further complications occur: the hint of a side plot involving location photography (as one of the fantasies of the band members) seems a means merely to an end, so that the music video's unreconstructed voyeurism – of the models, as seen throughout – is given a narrative justification. The photography also cast-calls the models in the first place: 'Rio' is a movement through exotic supermodel photoshoots, intrigues, and after-parties.[10] (Even the song's name is designated as a 'her', as well as a city of relative – for the times at least – exoticism.) The models then assail the band, and are cast as day-glo sirens who disrupt their performance, and insinuate themselves into the band's affections. In turn, they are subject to drenchings, across scenes so many in number as to suggest some sort of fetishistic or obsessive liquid ritual. Water (plain and dyed) and paint are poured on women, melted cherry ice-cream splatters onto a female's hips and behind, another has champagne poured onto her midriff, and another still is covered in shampoo suds.

For 'Save a Prayer' the band has landed, and the onshore tropical existence involves sporting New Romantic variants on colonial white cotton suits, with bare feet, across scenes dominated by boats, beaches, sunsets, cocktails, surf, and deep blue skies and seas. The vantage point is sometimes that of a helicopter tour (aerial vistas of ruins and forests) and sometimes that of a snap-happy tourist (shots of the locals). As with 'Rio', the song concerns a problem associated with a desired woman who does not seem to be fully in the possession of the singer. But 'Save a Prayer' develops without resolving such a narrative of unfulfilment: the singer encourages a lonely and seemingly thrill-seeking woman to have sex with him, which involves her moving out of her comfort zone: 'so you're looking for a thrill', he asks rhetorically, and reveals that, in his opinion, she 'know[s] just what it takes and where to go'. This, it is surmised, is some sort of social event with dancing. Seemingly, she may feel sorry for him – but this empathy (the 'say[ing] of a prayer'), it is suggested, can be delayed or waylaid and so make way for a night of passion, hence 'don't say a prayer for me now/[but, rather] save it 'til the morning after'.

The key lyric, and one that has been repeatedly quoted as a matter of derision, for its clunky construction and faux-poetic conceit, comes after the moment that the dancing starts (narrativized as '[a]nd you wanted to dance/so I asked you to dance/but fear is in your soul'). The singer attempts to disarm the subject of his affections in relation to the fleeting nature of the proposed encounter: 'Some people call it a one-night stand/but we can call it paradise.' It is only with a mention of dancing that a woman first appears in the video, but she pushes Le Bon away and walks off as he sings these words: 'Some people call it a one-night stand' (extra-diegetically, as if parsing her argument); 'But we can call it paradise' (diegetically, confirming that this is his position) – returning the music video almost exclusively to frolicking

and half-clad men and boys. While the rest of the music video at first seems to hold no connection with the lyrical content, this moment dramatizes and indeed nuances the nature of the exchange. In the 'Classic Albums' documentary *Duran Duran: Rio* (George Scott 2008),[11] Le Bon offers his own interpretation of this lyric (indeed, for him, 'the most important line in [the song]'):

> This idea of let's not think about what it means, let's not think about tomorrow, just think about now, you know: that's all that matters. That feeling that now is the important time. [...] It got over the rumpled sheets aspect of it and concentrated on the [*sic*] philosophy idea a bit more.[12]

That philosophical position – on the one-night stand – takes on more of a resonance with respect to the signature synthesizer sound or hook of the song: the use of the bender to vary the note pitch. A certain pan-pipe tone suggests the space of the surroundings, with the echo of such sentiments travelling (like the helicopter) across the forests, the sand, and sea, or reverberating in the Buddhist temples. This landscape, very clearly, is presented as an Edenic paradise, and so equated with the paradise that Le Bon anticipates or promises from qualm-free, seize-the-moment sex. What he seems to suggest is a synchronizing of ecological pleasure with sexual pleasure, and with a discovery of this exotic and unsullied surrounding with a 'discovery' of the woman. And such cerebral instinctiveness on Le Bon's part seems to arise as specific to an existential and spontaneous position of living in the moment. Despite the deeply problematic (from post-colonial and feminist perspectives) realization of this thought in the music video, the guiding notion of freedom itself is indicative of a freed strata of society, unencumbered by the hardness of the working life of previous generations (for Duran Duran, the industrial Midlands), and who find psychic completeness in pleasure rather than duty.[13]

Such a preference for living in the moment, regardless of the consequences, dovetails with the idea of a new regime of life as pleasure, as also exemplified in 'Careless Whisper'. This is the dominant position of the hedonist/secular society: pleasure as available, and perhaps the movement towards such pleasure requires the rejection of stationary positions or fixed abodes (achieved via the yacht). Or, that the yacht is the getaway vehicle for pleasure – like a marauding Viking (in keeping with the given sexual politics), to be able to hastily make off with the woman found on the mainland and who is now, surrounded by the sea, imprisoned: the yacht as rape-enabling. With better manners, Ferry also isolates a precise moment and a suggestion of pleasure for a secular age: a fleeting and mysterious encounter, at the point at which the party/dance has finished but before the party-goers/dancers have dispersed (i.e. the last chance of arranging for a night of passion). The position of sexual liberation, in this new regime of life

as pleasure, is one that is more familiar from the late 1960s counterculture: the sense that women ought to be available to grasp the pleasures of the moment, rather than be hung up on bourgeois mores that puritanically and oppressively mitigate against such 'letting go'. (Early Second Wave feminist thought, reflecting back on 1968, held that this represented a continuum of exploitation: failure to be sexually promiscuous opportunistically presented as a failure to be sufficiently anti-bourgeois.) But our singers all get their comeuppance: Le Bon's philosophical argument seems to insult rather than persuade the woman he dances with; Michael's moment of passion with another woman (sex in silhouette during the impassioned saxophone solo) results in guilt, the termination of his relationships, and the promise that he will not or now cannot dance again; and Ferry winds up alone. The same problem seems to occur for Spandau Ballet, in the Hong Kong-set 'Highly Strung' (from *Parade*, both of 1984): although the exotic model appears on a variety of boats (ferries, yachts, fishing junks) for nude photoshoots with or for the band, she seems to fail to go further. Her bourgeois 'uptightness' (i.e. being 'highly strung') is doubly annoying for the singer who seems to address her as someone he once knew, seemingly when she was more available – engendering an uncomfortable frisson of the yacht/sexual assault scenario, as mentioned above.

Cultures of monetarism

What unifies such lifestyle music videos is that the protagonists all capitalize on a sense of autonomy to make headway into new landscapes of pleasure. But this is pleasure allied to 'the leisure society' (of which the yacht is a primary symbol): not pleasure as arising from de-alienation and getting back in touch with one's 'natural' inclinations (as with much 1960s West Coast pop), and not pleasure that looks to amassing sexual conquests (as with the commercial elements of disco, or 1970s 'New Man' crooners).[14] Rather, pleasure becomes the orientation of the moment, taking in new locations, new women, a new look, and an escape, and makes for the foundation of a new and enviable lifestyle. The proposer of the new mode of life for the new decade of the 1980s is the post–New Romantic leading man. The vehicle is the music video. And the implied recipients of this knowledge would seem to be the newly wealthy (or aspirationally newly wealthy), unversed in how to spend their (or others') money. Boy George noted the Thatcherite ambience in Duran Duran's music videos, and termed the 'champagne-swilling, yacht-sailing' tendencies as 'playboyeurism' (quoted in McSmith 2010). It is an apt description, not least since *Playboy* magazine, as Preciado has argued (2014) was far from a collection of nude models: its aspirations were along the lines of the construction of a lifestyle for bachelors, in respect to architecture, cuisine, luxury goods, travel, and so on.

Howe's broad intention of junking a taxation structure that 'punish[ed] success'[15] represented only half of the battle – and that half related to the initial period in office of the Conservative Party. The envisaged economic structure on the other side of this battle was monetarism, which resulted in something of a struggle for the soul of the Conservative Party between advocates of an ascendant neoliberal policy of considering market measures of economic wealth to be the index of actual well-being (in addition to determining financial policy), and the patrician, one-nation Tory moderates, who were denigrated as 'wets'. (In the context of this chapter, this political difference now emerges, in a perhaps very simple parallel, between the old and new money settings of music videos discussed.) The actual effects of this economic revolution, in the early 1980s, seemed dire: further de-industrialization, mass unemployment, race riots and immiseration, state violence and conspiracy against striking workers at home and in the former colonies, and inner city decline.

In this context, yacht pop emerges with a specific ideological role or function: a talisman to shoo away such bad news by looking beyond (or just ignoring) the immediate troubles in favour of glittering visions of what could be. Aspiration and lifestyle lie behind the proliferation of erotic imagery: adventure and freedom of (global) movement, reinvention of purpose through picaresques of pleasure, vague vistas of meaningfulness for the protagonist to navigate (unspoilt countries and sites of ancient religions, nascent capitalism in the global south, and high capitalism in the global north), and evidence of material wealth and the easy use of material wealth to pleasurable ends. Simon Le Bon, in an Antony Price suit and with the wind in his hair, and singing about Rio from the bow of his yacht as it cuts through warm waters, assumes or comes to assume just such a finessing of monetarism.

For or to whom was this assumed ideological function understood? One can only speculate about the affective ideological nature of yacht pop in terms of the sway it may have held over a certain mindset. In this, yacht pop advances a timely argument, or possesses a certain talismatic power, rather than just reinforcing or validating or verifying, albeit from a cultural quarter, the wisdom of political machinations that have occurred or are occurring. The mindset in question is one that found in Thatcherism the opportunity for betterment or enrichment: the non-aligned or now dealigned voter, perhaps early out of formal education and so seeing in the idea of a meritocratic, classless society the ways in which to ensure that a reinvigorated capitalism also spread to his corner of the world, which was typically taken to be the stockbroker belt, or the home counties and the south-east of England. This voter was now on 'the more pro-Conservative side of a broadly defined middle ground of policy preferences', and so made for the key constituency in Särlvik and Crewe's analysis of the Conservative victory in 1979 election (1983: 235). Later, such dealigned blocs would be termed

'floating voters': those with a total mobility, as if on a floating yacht at sea, and so able to move with (or find themselves moved along by) the currents of the moment. And the potentials of movement in general identifies such blocs: of physical and geographical movements into exotic climes for erotic encounters, via a sense of the liquidity (rather than staid – institutionalized/ married-off) of a spontaneous sexual picaresque; of living and movement (the sudden colonization and regeneration of commuter belts, rather than the immobility and illiquidity of the long-term mortgage near the wider family); and of the state of readiness for financial movements (a liquidity of assets, typically as banked cash). Such figures could disconcertingly and disruptively 'float' since they had unmoored themselves from elements of their class and locale.

In their discussion of the emergent 'Essex man' (as representing that strata of the newly wealthy who ditched their traditional working-class allegiance to the Labour Party in favour of voting for Thatcher's Conservatives in 1979), Biressi and Nunn (2013) track the economic and geographic case for this development. Essex man was understood as vulgar and crass, self-centred and materialistic, lacking in culture and education, and yet newly rich not in spite of but, to some measure, thanks to such personality traits. He was, in this sense, the personification of deregulation: of a freeing of the desire to make money from old mores and societal norms, and even legal restraints. The newness of these newly rich was both in the sense of breaking with previous modes of financial accumulation and in the generation of new money, and founding of a new culture. Bastions of the British Establishment reacted accordingly, and the authors note the distaste or, at best, highly guarded admiration, expressed by commentators on the right, and satire of this culture by those on the left.[16] Yacht pop, however, presents itself as directly aligned to this mindset: it intends the projection of a vision of the new capitalist horizon for those receptive to it – the aspirant nouveau riche, who felt that better was to come.

CHAPTER SEVEN

Completing the Mystery of Her Flesh: Love, Eroticism, and Identity in Björk's Videos

Vera Brozzoni

Introduction

Music, it can be argued, is often used as a means of self-expression, as a reflection on the musician's life, experiences, and choices; by matching songs with videos, the musician can delve deeper into this self-investigation and paint an even clearer picture about the motivation that informed their music in the first place.

Throughout her career, Björk has constantly used music and visual imagery to comment on her life; her recent work is inextricably linked to her love relationship with artist Matthew Barney, which spanned from 2000 to 2013. By musically and visually documenting the rise and fall of her love story, she reflects on her role in it and on the role of love and of a beloved partner in her life. By sharing her experience of the erotic side of love, she reflects on her nature, her desires and needs. In the video documentary *Inside Björk*, the singer herself confesses, 'There's always been an erotic side to what I've been doing'; further on, Icelandic poet and collaborator Sjón explains more in depth that in her work '[T]here is a constant conflict between the inner and the outer world, and the battlefield of this conflict

is the body, often the sexual body. This is something that you can see in Björk's videos' (cited in Walker 2003).

According to Georges Bataille, a writer whose work has famously inspired Björk with the imagery for the video 'Venus as a Boy' (Turim 2007: 106), 'Human eroticism [...] calls inner life into play. In human consciousness eroticism is that within man which calls his being in question' (Bataille 1962: 29). Thus, by reflecting upon her experience of eroticism and by baring her erotic self in her music and videos, Björk enacts a quest for her identity that unfolds throughout her artistic output. This chapter is an attempt to illustrate the progress of this quest by dividing it into four main phases of her recent life, represented by some of her most iconic videos.

Longing: 'All is Full of Love'

'All is Full of Love' (Chris Cunningham, 1997) is Björk's first openly erotic video, created to match an optimistic song of hope. It presents some of her recurring visual themes, such as sexual acts, physicality, surgery, and a minimal chromatic palette. 'The song, in essence, is actually about believing in love', Björk later reflected. 'Love isn't just about two persons, it's everywhere around you. Even if you're not getting love from Person A, it doesn't mean that there's not love there. Obviously, it's taking the piss too – it's the most sugary song ever' (cited in Pytlik 2003: 170). In order to convey the frozen, pristine sensuality of the song, director Chris Cunningham decided to set the action in an aseptic environment (the laboratory), drenched in an almost totally black and white palette with bluish hues, making use almost entirely of hard materials like plastic and metal; these aesthetic choices make the sudden surge of eroticism between the two main characters (the robots) unsettling: 'When I first heard the track I wrote down the words "sexual", "milk", "white porcelain", "surgery"' (*Dazed & Confused* 1999), said Cunningham about the making of 'All is Full of Love'. He actually kept each of these themes in the final video.

Surgery in this case is represented by the work that the lab machinery performs on the robots. It is both a work of assembling of the body parts (an anatomical work) and of perfecting their intelligence functions (a neurological work). It is not clear whether the intelligence that the robots are programmed for comprises of sensuality. More likely, it develops accidentally, which would explain why the machinery keeps working on them and scattering sparkles around while they get closer and finally embrace. Milk is the liquid that Cunningham used in the video to submerge

the robots, to signify a luscious white fluid that allows hi-tech machinery to work on the robots. It lubricates, smoothens, soothes. It is white, and helps a scattered creature to be assembled and to wake up to life. Given these elements and the diffused eroticism of the video, it is not out of place to see the white fluid as a symbol of sperm.

Much of the evocative and arousing power of this video, however, comes from the fact that sex actually happens between two female-shaped robots and not two human beings. Indeed, seeing two lifeless, inorganic, artificial creatures come to life in order to unite in a sensual embrace is more disturbing that simply witnessing the same embrace between two women made of flesh. However, strictly speaking, the robots are not entirely made of a hard material. Throughout the video, we see that they are able to open and close their eyes, to open their mouths, and to stretch their lips in order to sing the lyrics to the song; towards the end they stretch their lips even more to give passionate kisses to one another; from the technical point of view, Björk's facial features were tracked in 3D to match the movement with the heads of the robots. Their limbs and joints, while stiff at the beginning, are progressively moving more and more smoothly until they can perform sensual gestures, such as one robot putting an arm between the legs of the other.[1] In the primitive outline of the video Chris Cunningham stated that the robots were to be two of a series.[2] In the final version of the video, however, only two robot 'units' are shown. Therefore the physical relationship between them appears even more intimate and private; consequently it provides more intense emotions to the viewer.

Most importantly, since the robots are built the same and have the same facial features, their embrace looks as if one robot was making love with its own *Doppelgänger*. Björk loses her individuality and splits into two *alter-egos*, one being lonely and melancholic, the other trusting and passionate, both equally uncanny. This difference in attitude progressively fades until the two robots are locked in their love embrace in the same position, one mirroring the other rather than one being on top of the other. This double instance of the Freudian idea of *Unheimlich* in the robots (their human likeness, and their identical appearance) suggests that the video could be examined also from a psychoanalytical perspective: in 'All is Full of Love', despite singing about love being 'all around you', Björk is paradoxically making love not with an external partner but with herself. As the two robots embrace and stay on the same level, the two different sides of her personality (the melancholic and the passionate) equally merge in a harmonic whole. The world might be full of love, but for Björk love and eroticism are still quite a solipsistic and masturbatory affair – and this phase of her career can be read as a prelude to her subsequent, more personal, and intimate work.

FIGURE 7.1 *Björk, 'All is Full of Love' video (1997).*

Passion: 'Pagan Poetry' and 'Hidden Place'

Björk's relationship with Matthew Barney starts in 2000; her album *Vespertine* (2001) is an unashamedly romantic celebration of newfound love. The video to 'Pagan Poetry' (Nick Knight, 2001) develops and surpasses some of the themes of 'All is Full of Love', taking an even bolder stance in showing her erotic persona.

The element of white sperm reappears in a more delicate, but no less important, way. In fact the video starts showing a black screen and a white thread with pearls running across it, then suddenly the screen is flooded with a burst of a white digital liquid; again, it is not out of place to see this burst as an ejaculation that allows the rest of the video to be created. As for surgery, 'Pagan Poetry' makes explicit and human what in 'All is Full of Love' was symbolic and inorganic. The video features scenes of skin being pierced by a thick needle (sometimes with the help of a surgical tool), a pierced nipple with a string of tiny pearls running through it, pearls being sewn into the skin. The very last image shows a woman's back arrayed with six thick steel rings inserted under bleeding skin. A string of pearls hangs from the rings like a corset lacing. The concept is that of a woman 'sewing a wedding dress into her skin' (Alien Rock! 2002) and going through physical pain as a rite of passage and a proof of love. Björk seems to imply that her love is so strong that it cannot be worn on the skin, but in the flesh.

Once again it is the explicit eroticism that makes this video memorable, by showing actual bodies instead of robots performing sexual acts on camera, albeit concealed by digital image-warping effects. They are of course the bodies of Björk and Barney:

(Director Nick) Knight gave Björk a Sony Mini DV camera and asked her to shoot her own private scenes. "To try and do an honest job of documenting or presenting somebody's intimate love life, there really is no cause for me to be there whatsoever", Knight says. "She asked me to make a film about her love life, so I merely gave it back to her and said, film your love life". (Alien Rock! 2002)

The digital effects that alter and cover the original erotic footage may have been chosen for the following reasons: first of all, in order to protect the privacy of the two people involved in real-life sexual experience; secondly, because of its sheer aesthetical beauty; thirdly, because concealing the pornographic details would make the video more suitable for broadcasting on media platforms; fourthly, because it represents a 'liquefied', ambiguous state of mind in which the borders and boundaries between bodies are made loose and vague.

It is inevitable to notice a process of rarefying and liquefying of the body from its inorganic representation in 'All is Full of Love' to the organic in 'Pagan Poetry'. Originally, while working on 'All is Full of Love' Chris Cunningham had pictured the two robots to dismember, to 'unfold like strange flowers' (*Dazed & Confused* 1999). This does not happen in the final version of the video, but the viewer can imagine how the two embraced robots have evolved and have been transported into the molten, abstract world of 'Pagan Poetry', turning into the bodies of Björk and Barney. The vat of milk lubricating the joints of the robots becomes the engulfing white screen full of flowing, fluid, and ever-changing lines. Metal, plastic, and porcelain become real flesh, gently warping and swaying through a white canopy of sensuality. 'Pagan Poetry' can be seen as a logical 'filiation' of 'All is Full of Love', a step forward in developing themes that Björk feels more connected to, now that she has found the love of her life. She no longer needs to split into a *Doppelgänger* twin to make love with herself: now she has a real life partner made of flesh and, most of all, different from her.

The final sequence shows Björk belting out the coda of the song and sensually shaking, clad in a dress that leaves her breasts uncovered (which led the video to be banned by MTV). At this point, her nudity comes as a further element of visual surprise, although it represents a perfectly logical way to end the video; 'Pagan Poetry' introduces an unseen-before level of intimacy between her and the viewer that will only resurface more than ten years later with 'Mouth Mantra' (2015).

While 'Hidden Place' (Inez van Lamsweerde, Vinoodh Matadin, and M/M Paris, 2001) is visually less explicit, it is still notable for the sense of closeness and secrecy it conveys, mostly by being shot physically very close to Björk's makeup-free skin. Art duo and co-directors M/M Paris argued that this choice came from the realization that 'This is somehow taboo, to observe a pop star with no makeup from a distance of half an inch' (promo interview, 2001). The 'action' focuses on pearly fluids of various

bright colours, oozing out of some of the orifices in her face and being reabsorbed into others, in a continuous video loop. These surreal bodily fluids sometimes transform into delicate black and white drawings (in the same style that adorns the booklet to *Vespertine*).

The camera closes onto Björk's open mouth twice: one time to reveal another, smaller Björk hiding inside as a *mise en abîme*, the other to show a tiny creature in the shape of a womb and ovaries flying out of it. This analogy between throat and womb, or 'superimposition between mouth and vagina' (Guarracino 2010: 85) is especially symbolic for a female vocalist and allows Björk to equate vocal performative pleasure and sexual pleasure; it recalls the primordial 'jouissant' effect that the singing female voice has on the listener and singer alike, as Catherine Clément and Michel Poizat have examined in their seminal essays about opera. I would argue that 'if "woman" and "voice" are strong signifiers of jouissance, then their union must be even more powerful and therefore dangerous: a talking woman, or even so a singing woman, is a hypersexualised one' (Brozzoni 2015: 34). Therefore the 'Hidden Place' video and this fleeting 'throat/womb' moment in particular represent an important step in self-investigation for Björk as a musician and as an erotically charged woman.

FIGURE 7.2 *Björk, 'Hidden Place' video (2001).*

Crisis: 'Mutual Core'

Ten years of blissful love pass between *Vespertine* (2001) and *Biophilia* (2011). In the meantime Björk releases *Greatest Hits* (2002), *Medúlla* (2004), *Drawing Restraint 9* (2005), and *Volta* (2007). In the videos to these albums, eroticism isn't a great concern of hers. Avant-garde film *Drawing Restraint 9* by Matthew Barney sees her acting alongside her partner and engaging in erotic acts with him, but the project doesn't really add much to what the public already knows about them at that time: they are happy.

Then something breaks. Although the press has been reluctant to recognize this, it appears that *Biophilia* is a scientific, tech-savvy, didactic album as much as it forebodes a sentimental crisis waiting to happen; songs like 'Sacrifice' and 'Mutual Core' (Andrew Thomas Huang 2012) openly vent frustration against a relationship that is getting more and more stifling. In one interview with Italian newspaper *Corriere della Sera* (Mian 2011) does Björk open up about the subject: while acknowledging that her relationship isn't at risk, she admits, 'There were endless discussions with Matthew [...] our intellectual positions had polarized' (author's translation).

The video to 'Mutual Core' reflects the tectonic shift in her private life and spins some of the visual themes she had previously explored, in a completely unexpected way. Strikingly, the Doppelgänger trope returns: in the first half of the video it appears in the shape of two Björk-faced creatures made of rock, moss, and different layers of geological strata which appear as digitally created slabs of coloured plasticine (Huang 2012); in the second half it appears as a couple of Asian-style idols, again with Björk's facial features, made of solidified lava. This time, however, neither couple of Doppelgängers unites in lovemaking. On the contrary, the first couple strives in vain to penetrate each other's layers and to hold hands, but as they get closer they repeatedly collide and produce a destructive eruption of lava. The second couple, that is the 'mutual core' emerging from the eruption, sits petrified, inexpressive, and back-to-back like a statue of Janus (the god of beginnings, transitions, and endings); or even – like a bitter, disillusioned antithesis of the final sequence of 'All is Full of Love' that I called 'solipsistic and masturbatory'. It is no accident that Björk chose Huang to direct this video after watching his first short film 'Solipsist', which similarly featured two people sitting back-to-back and struggling to communicate (Orton 2012).

Needless to say, the song leaves hardly any space for eroticism to flourish visually. While being shot in an earthy, warm palette, the video expresses almost exclusively negative feelings: the thwarted attempts to unity of the two creatures made of layered rock are how far eroticism goes here. Moreover, both couples of Doppelgängers are shown erupting bright yellow lava from the holes in their heads; in this sense, 'Mutual Core' can be seen as the anti-'Hidden Place': the coloured bodily fluids that circulated sensually between Björk's eyes, nose, and mouth eleven years before are now an incandescent matter spurted out in rage.

FIGURE 7.3 *Björk, 'Mutual Core' video (2012).*

Mourning: 'Black Lake' and 'Mouth Mantra'

Vulnicura, Björk's latest album to date, finds her in a dire state after being abandoned by Barney. 'Black Lake' (Andrew Thomas Huang, 2015) is a sorrowful eulogy that illustrates how her confidence as a lover has crumbled and how she needs to find inner strength to face the death of eroticism in her life. Coherently, the cover art for *Vulnicura* associates the *vulva* with the *vulnus* (wound); it may seem paradoxical that a heartbreak album has such a strong focus on sexual imagery; however, it is not hard to see why a musician whose work has such a strong erotic core, would find it natural and urgent to bare her body and her personality once more, like she had done thirteen years before to celebrate the beginning of her love story. After all, losing a lover means losing a sexual partner and missing erotic satisfaction.

The trailer to 'Black Lake' is different to the final version of the video; it features Björk, naked and roughly covered by bunches of wild shrubs,[3] leaning against the wall of a dark cave; her legs are spread open, her body is cleft by a rift that goes from her heart to her genitalia. From the rift a bright blue fluid is drained out; the camera slowly zooms closer to Björk's pubis as the fluid escapes from her body and falls in the black depths of what looks like an underwater crevice (somehow reminiscent of the closing shot on 'All is Full of Love': the lab wires seem to lead to a dark abyss). The metaphor of one being 'emptied' by the loss of love is treated literally.

Going back to 'Mutual Core' it is easy to observe that the two lava-spitting idols seem to be in control of what they are doing; they spurt lava deliberately

as an expression of anger, because they want to and because they can. In the 'Black Lake' trailer, though, Björk does not appear to have any power over the fluid leaving her; she does not (possibly cannot) move, she just weakly tries to squeeze her thighs. The distance from 'Hidden Place' could not be bigger, and yet the reference to the *Vespertine* era is quite manifest: as a way of going through mourning, Björk is reflecting on her past, on the path of passion that brought her from a blissful, hidden place full of love to the dark cave of mourning, the path that turned her *vulva* into a *vulnus*.

The final version of 'Black Lake' is shot in panoramic format, which is usually used for wide exterior scenes; in this case, on the contrary, it makes the Icelandic ravine set look even more claustrophobic. The video opens with Björk wearing a tight-fitting metallic dress, down on her knees in the middle of a long, vagina-like cave, crying and swaying; as she finishes to sing the first stanza of the song, she goes down on all fours on the ground and starts to mimic the thrusting movements of a sexual act; after the second stanza, she gestures as if to smear some nonexistent liquid on her lips and tongue. At first, the viewer might infer that Björk has gone back to the masturbatory practices of 'All is Full of Love'; however, that was an optimistic situation – in 'Black Lake', pain does not allow her to have an *alter-ego* to make love with. She is inescapably alone and forced to savour her loneliness. She can only have sex with the void, with the phantasm of an absent lover that is no more, which is quite a regression from the point from where her quest (and this essay) had started. Later on in the video, as the beats fade in, she projects her frustration by turning masochistically against herself, punching her chest and abdomen to failure, biting her arm, and wildly shaking her head. The video credits indicate Erna Ómarsdóttir as a choreographer; however, it is not clear what in Björk's physical performance was scripted and what improvised; director Andrew Thomas Huang recounted that during the shooting, 'She really wasn't acting for me on camera. When she's beating herself and crying, she really is beating herself and crying' (Brumfitt 2015).

The blue fluid that pervaded the trailer is developed here as a river of blue lava, melodramatically exploding out of the surrounding rocks. It is notable that, unlike what happened in the trailer (but also in 'Hidden Place' and 'Mutual Core'), Björk never gets in touch with the lava; they only share the screen in one hallucinated sequence where a self-beating Björk is digitally superimposed on a blue lava eruption background. This separation between the protagonist of the video and one of her most frequent visual themes increases the sense of powerlessness and isolation she finds herself in. The last stanza of the song gives a glimpse of hope for distraught Björk implying that going back to native Iceland will help her going through the mourning process; the video mirrors this idea by having her clad in a voluminous cape that anti-erotically conceals her body shape, walking alone on moss-covered rounded rocks.

While 'Black Lake' reflects Björk's love pain, 'Mouth Mantra' (Jesse Kanda, 2015) illustrates her equivalent medical ordeal as she risked losing her voice due to a polyp on her vocal cords three years before (Snapes 2012). At first this song may sound out of place in a heartbreak album; however, it can be argued that, by associating the impotence in her throat to the helplessness in her love/sex life,[4] she is once again symbolically superimposing mouth and vagina – that is, Björk's two foremost means of self-expression.

The video to 'Mouth Mantra' brings the viewer back to the bare intimacy of 'Pagan Poetry' and 'Hidden Place' in that it is shot almost entirely with a micro-camera place inside her mouth. Director Jesse Kanda used 'mouth models, animatronics and Sony Action/F55 cameras in order to capture the extremely intimate inner workings of the singer's mouth, tongue and throat' (Hitchings 2015); the result is a triumph of warped, abstract, rotating shapes, at once fascinating and menacing, perfectly complementing the dramatic beats and dissonant, staccato strings in the music score. The final sequence of the video takes the viewer out of Björk's mouth and into a darkened room where she dances in a long white dress while singing cathartically about her vocal liberation following surgery. Both sequences have evident visual analogies with the two main parts of 'Pagan Poetry', although the mood of this song is completely antithetic: then there were bliss and trust, now it is time for torture and sorrow.

Conclusion

Since *Vulnicura* signifies the end of Björk's love relationship, the videos related to it present a shattered image of the artist's intimate world that will have to be patiently reconstituted in her future work. As of March 2016, she has stated that she is working on a new album described as 'paradise' and 'utopia' (Gordon 2016). As she walks away in the Icelandic landscape at the end of 'Black Lake' it is clear that the 'mystery of her flesh' hasn't been completed. Not even the perfect happiness of the *Vespertine/Medúlla/ Volta* era helped her with it, and the ecstasy of the past has come to a devastating end.

And yet one wonders, does this research even have to be completed at all? Is eroticism not too slippery, fluctuating, and ambiguous to lend itself to being univocally pinpointed? Georges Bataille points out that enduring extreme pain and enjoying extreme pleasure (considered as sensorial, physical feelings – but the same stands for spiritual and emotional ones) are both part of the erotic experience; he openly talks about 'the erotic bond that links (mankind) to death, to cadavers and to horrible physical pain' (Bataille 1997: 157) as a way to demonstrate eroticism's irreducible complexity. Even Björk's choice of words in describing her new project

involuntarily betrays the impossibility for her quest to be resolved: the word 'utopia' literally means 'nowhere';[5] utopia can be glimpsed at, but never observed; it can be reached out for, but never touched.

If and when the singer comes out of her love-mourning and finds another positive outlet for her insuppressible eroticism, she will keep using music and videos as creative tools of self-investigation like she has done so far. But as Björk's artistic output goes on, so does her quest; the mystery shall remain as such.

CHAPTER EIGHT

Soundtrack Self: FKA twigs, Music Video, and Celebrity Feminism

Kirsty Fairclough

Introduction

In the self-directed music video for 'Pendulum' by British electronic R and B artist FKA twigs, we see a close-up of twigs's mouth, and a slow zoom-out reveals her suspended in bondage ropes made of her own hair. Twigs is hanging from the ceiling staring directly into the lens of the camera. She moves to immerse her face in liquid mercury, tries to vocally express herself, but is unable to do so. Twigs moves to emerge from the liquid, unshackled and dances defiantly as a pendulum swings. These images reveal a vulnerability and self-expression that appear rarely in a context where complex emotions and nuanced manifestations of female identities, particularly related to sexuality, are rarely portrayed. 'Pendulum', released in early 2014, may offer a fresh perspective on the ways in which female artists are allowed to visually represent their own identities in audiovisual cultures. Indeed, the means by which twigs presents herself throughout her work points towards an attachment to the tenets of contemporary feminism that appears much more complex and nuanced than many other high-profile female performers who have publicly declared their attachments to feminism, such as Beyoncé, Taylor Swift, Katy Perry, and Miley Cyrus, amongst others.

FIGURE 8.1 *FKA twigs, 'Pendulum' video, directed by FKA twigs (2015).*

FIGURE 8.2 *FKA twigs, 'Pendulum' video, directed by FKA twigs (2015).*

FKA twigs first entered the music industry with the release of her 'EP1' in 2012 and 'EP2' in 2013. Her debut studio album *LP1* (2014) and third EP *M3LL155X* (2015) were released to critical acclaim, the first of which peaked at number 16 on the UK Album Chart and number 30 on the U.S. Billboard 200. Twigs self-released EP1 on Bandcamp in 2012 with videos for each song posted on her YouTube channel. In August 2013, twigs released

the video for her first single, 'Water Me', on YouTube, directed by Jesse Kanda. Twigs has consistently created imagery that challenges idealized womanhood as is routinely portrayed in the music video, particularly in a mainstream context.

This chapter will thus present an examination of the music videos of FKA twigs in order to consider the following questions: Does FKA twigs engage with feminist ideas in her music videos? And how do her music videos complicate conventional notions of celebrity feminism as presented in popular culture? It will consider FKA twigs's celebrity status alongside her feminism and explore how this sits alongside contemporary conceptions of 'celebrity feminism', a term first coined by Wicke (1994). In order to define and unpack celebrity feminism, Hamad and Taylor suggest:

> When thinking through the complicated nexus of feminism and celebrity, it is important not to simply reinscribe familiar critiques that presume this relationship to be inherently negative for feminist politics, and to recognise that there is no 'authentic' feminism that exists beyond its celebrity manifestations. Instead, 'feminist star studies' needs to attend to how feminism and celebrity culture (and media culture more broadly) necessarily intersect in ways that may be at once productive and unproductive, with constraints and possibilities. (Hamad and Taylor 2015: 124)

Indeed, as Hamad and Taylor state, feminism as presented through the vehicle of celebrity is often perceived as inherently negative. Writing in *The Guardian*, feminist commentator Roxane Gay (2014) presents the following argument when considering how feminist and celebrity intersect.

> It irks me that we more easily embrace feminism and feminist messages when delivered in the right package – one that generally includes youth, a particular kind of beauty, fame and/or self-deprecating humour. It frustrates me that the very idea of women enjoying the same inalienable rights as men is so unappealing that we require – even demand – that the person asking for these rights must embody the standards we're supposedly trying to challenge. That we require brand ambassadors and celebrity endorsements to make the world a more equitable place is infuriating. (Gay 2014)

It is through this cultural framework that a consideration of FKA twigs must begin. Music critics such as Molly Beauchemin of Pitchfork suggest, 'The furtive power and aloneness that younger female artists like FKA twigs exhibit on stage suggests something new and exciting – a more solitary, and explicitly feminist power' (Beauchemin 2014: 15). Emma Garland of Vice in a feature on International Women's Day described twigs

as 'the only British pop star changing attitudes about feminism, gender and sexuality' (Garland 2014: 42). These comments hint towards a popular assessment of twigs's work as representative of an authentic approach to the demonstration of celebrity feminist ideas through audiovisual means. Yet such statements reveal the contradictory nature of celebrity feminism. They suggest that FKA twigs embodies some kind of an authentic feminist identity, but it remains unclear what this actually means and if this authenticity may be manifest in a range of female musicians' performance and audiovisual work.

Feminism, post-feminism, and the music video

Discursive struggles over the meanings of feminism are now, perhaps more than ever, largely staged in and through media culture and given that celebrity interventions into ongoing debates over feminism have recently intensified, pop culture scholars are seeking to come to terms with the ideological and cultural implications of these publicly staged discursive contests. The music video has long provided a space where these struggles are played out and has been considered extensively by Sheila Whiteley (ed), in her seminal collection *Sexing The Groove: Popular Music and Gender* (Whiteley 1997), where she explores the textual links between sound and image in music video, notably by using a case study of Madonna's video 'Justify My Love' to examine the ways in which video images reinforce the meaning of the song and often allow little space for complex interpretations of female identities.

Within a contemporary framework, the music video is an important discursive register of the transmission and reiteration of the related concept of post-feminism, an idea that is inherently contradictory and largely operates in the mainstream media to construct feminism as an irrelevant phenomenon of the past. In this context, female artists undergo far more scrutiny than their male counterparts, particularly regarding physical appearance, weight gain or loss, ageing, cosmetic surgery, and relationship choices. Indeed, famous women are often held up as lightning rods for a whole range of cultural and societal issues; this is particularly evident in music video where women are often represented in narrow and regressive ways. Post-feminism broadly and most often encompasses a set of ideas widely disseminated through popular media, and particularly in the music video, which suggests that feminism is dated and no longer relevant. It is a term that is highly contested, often controversial, and divisive. Tasker and Negra conceive of post-feminism as a 'pastness of feminism, whether that supposed pastness is merely noted, mourned or celebrated' (Tasker and Negra 2007: 1). Much of this 'pastness' created as a result of an image-dominated society where women are still represented in narrow ways.

However, the term does not only mean that feminism as a movement is dated and does not simply speak of 'backlash' rhetoric. While we must be wary of an overtly negative association with the term, it is largely acknowledged in media and cultural studies that post-feminism is connected to a de-politicization of feminism. Indeed, it would appear that one of its primary functions may well be to render the principles of second and third wave feminism redundant and largely dated.

Post-feminism may well be indicative of a cultural moment, but it is also a lens through which many women experience culture. In many ways it promotes individualism, consumption, and beauty norms that are narrow and restrictive and promotes heightened versions of femininity that hark back to a pre-feminist era under the guise of irony, empowerment, and choice. It is intensely bound up with the perceived achievement of equality and within that, the notion of individual choice. It assumes that lifestyles, technologies, and pleasures are universally open and accessible to all women. Yet it is deeply divided along class, age, and racial lines, is also multifarious and nebulous, and any attempt to pin down a definitive meaning is deeply problematic.

Rosalind Gill's conception of post-feminism as a distinctive sensibility, made up of a number of interrelated themes, is particularly useful here. These include 'Femininity as a bodily property; the shift from objectification to subjectification; an emphasis upon self-surveillance, monitoring and self-discipline; a focus on individualism, choice and empowerment; the dominance of a makeover paradigm; and a resurgence of ideas about natural sexual difference' (Gill 2007: 149). These themes have provided the basis for analysis of cultural products by some feminist scholars and remain a useful touchstone from which to begin an analysis of post-feminism and its use of the dominant aesthetics of music video and its cultural impact.

As a counter to these kinds of ideas and ideals, celebrity feminism emerged at a point where a number of female celebrities seemingly became frustrated with being held up as examples of how these anxieties are played out in the media. Furthermore, the discourses of post-feminism played out in celebrity culture suggest that women actively encourage beauty culture, suggesting that if a woman wants 'it all', she must therefore also engage in the constant maintenance of the physical self in order to remain successful, employable, marriageable, and ultimately happy. This is a seductive and powerful discourse, which is promoted throughout celebrity culture and is one that the music video often espouses. Reacting against how famous women are encouraged to succeed in all areas of life, first and foremost in terms of image and self-presentation by publicly declaring their feminism, celebrities such as Beyoncé, Emma Watson, Lena Dunham, and Taylor Swift began to speak out against these kinds of regressive narratives that are played out in the media, and encouraged by the often misogynistic machinery of the entertainment and music industries.

The conundrum of FKA twigs

FKA twigs's work may provide a more open space through which celebrity feminist ideas may be played out. Her work presents a deeply introspective and personal vision that lacks any sense of aspirationalism, unlike many of her celebrity feminist contemporaries such as Beyoncé. Twigs's celebrity status is attached to her music, which is not considered particularly mainstream but often appears in the mainstream media because she is the partner of Hollywood actor Robert Pattinson. Their relationship has been an ongoing concern on gossip websites and in magazines since they appeared together public in 2014. The 'feminist power' twigs displays appears somewhat problematic to the mainstream media in that she possesses an image that is difficult to comprehend. She is not easy to pigeonhole. Twigs effectively presents a conundrum in that she appears complex because she presents a sense of a deeply introspective identity yet she is also an accessible celebrity. The popular media appears to find this difficult to decipher. She may be in a relationship with Hollywood star Robert Pattinson, which would have ordinarily made her instant celebrity gossip fodder, but the complexity of her music and imagery presents a disruption to the postfeminist regulatory framework that is frequently presented in popular culture, due to her exploration of her own relationship and response to reductive representations projected onto women through her visual imagery and performance style. FKA twigs's video work is concerned with obliquely critiquing the representations and misrepresentations in popular culture as well as reflecting a deeply personal perspective. Her videos interrogate issues of rape, pregnancy, female fantasy, and desire in a way that moves towards intelligent explorations of liberation and empowerment through female creativity and self-expression.

Many women in popular music have had to address their visual representations and ultimately accept mass objectification in exchange for success. Although sexual objectification is commonplace in media culture, music videos may well provide the most potent examples. From Madonna's 'Like a Prayer' in the late 1980s to Nicki Minaj's 'Anaconda' (see Silveira in this collection). The latter of which was a target from both sides of the feminist social media sphere, from those who viewed it as feminist in that she was in control of her own black female sexuality and those who thought that she was complicit in her own objectification. Minaj has a way of presenting herself in a powerfully blunt way, attracting an equal number of admirers and detractors. 'Anaconda' in particular is interesting because of how one-dimensional and transparent a commentary on female objectification it is. It only makes more explicit the sexual dynamics that exist for all female pop stars, and particularly the box Nicki Minaj will always be confined to as a mainstream black female pop star.

From Beyoncé to twigs, the complexities of female identity in *M3LL155X*

FKA twigs's work appears to challenge these discourses. Her body is still aestheticized, but what appears different is that its visual representation seems to be deeply personal and self-controlled. *M3LL155X* (a variant of Melissa, a transcendent spirit she refers to as her 'personal feminine energy') is twigs's third EP and consists of a sixteen-minute accompanying video comprised of four self-directed music videos. In this work, twigs presents often sexually charged performances and utilizes dance and performance in a way that is acutely expressive and appears to document her own feminist identity. Her performance style allows her to transform both the media-constructed horrors and fantasies that young women must negotiate in mainstream culture and remixes them in such a way that may point towards a form of resistance that may signal a feminist identity.

Music critics almost unanimously praised *M3LL155X*. Anupta Mistry of Pitchfork stated, 'As a creative package the EP is unimpeachable; a high-concept, intellectually curious project that's evocative, accessible and transgressive enough to satisfy the competing demands of a newly broadened fan-base and her existing audience of Tumblr-educated aesthetes. "M3LL155X" builds on her previous work, exploring ideas of dominance and submission and drilling down almost completely into the self' (Mistry 2015: 22). The *NME* prefaced their review by stating, 'In an age where a poor-taste Rihanna promo can launch multi-thousand-word think pieces, Twigs has conceived (and directed) a daring and provocative piece of capital-A Art' (Nicholson 2015). This is a rather reductive comparison, but there is a point worthy of investigation here in that there is a visible double-standard at the centre of mainstream feminist discussion of pop depictions of (particularly black) female sexuality. An artist such as Beyoncé routinely receives widespread praise for her work. There is little doubt that her recent visual album release *Lemonade* was seismic in terms of the representation of black feminism in the mainstream. For all of this, she has the right to be celebrated. Beyoncé has indeed facilitated a discourse that explores the place of famous women as agents of both political and monetary prowess. Yet Beyoncé's political message is also squarely a capitalist one. Her videos are meticulously constructed in order to cater to an eager fan base. In this context, the merchandising, the songs, the videos, the performances must always be considered first and foremost as an advertisement for Beyoncé's commercialized materiality. The fans are essentially buying into Beyoncé: the business, and her newfound activism, becomes a perfectly timed extension of her seemingly limitless brand. This in and of itself is impressive and her business expertise are extremely astute. Yet when it becomes bound up with emotive political statements, one cannot help but view this with

some caution. What she manages to achieve so successfully is to both represent her fans and, most crucially, inspire them to be better, to be like her while she profits from them. While she espouses the notion in her track 'Formation' that the 'best revenge is your paper', she is encouraging her fans to break through barriers of poverty and lack of opportunity, by engaging in gracious conduct and working hard to gain financial independence. Yet masquerading displays of monetary prowess as activism is not only a familiar trope within celebrity culture, but a flawed formula for agency. FKA twigs's work could be described as the opposite. *M3LL155X* presents a sense of the documentation of a deeply personal perspective on representations of women in popular culture while offering a distinct message that being a famous woman, who is the partner of a Hollywood star, does not preclude her from exploring her own subjectivity in a specific way. It appears to espouse a message that suggests she is creating work that is deeply personal and is not directly catering to a mass audience (which of course it clearly is as a product of the commercial music industry) or indeed any fan base. She often appears unconcerned with creating work that would appeal to anyone except herself. It is through her imagery that this is most apparent. Twigs's work moves well beyond the idea of female pop stars 'owning' their own sexuality and subverting conventional expectations. While her music videos are often sexually charged, twigs embodies her own celebrity feminist identity on her own terms. Her music videos often ask the audience to routinely engage with imagery that comments upon conventional representations of women in more complex ways than are often presented in mainstream music video.

'I'm Your Doll'

The video for the song 'I'm Your Doll', a key section of *M3LL155X*, is a blunt statement on rape culture. Twigs, dressed a pigtailed schoolgirl, dances in front of an older white man which leads to a situation in which she has no power. Twigs's head is attached to a blow-up sex doll which the man penetrates. The scene is constructed as a ritual rape, and one that twigs has knowingly entered into. It can be read as a commentary on the patriarchy of the music industry, where female artists must literally become detached from a manufactured body that is not really theirs to own. At the end of the sequence, her body is deflated and she is left on the bed, trapped in the same position.

Some elements of 'I'm Your Doll' and twigs's work more widely recall the work of Björk (see Brozzoni in this volume for an assessment of Björk's visual representations of eroticism) in that they present a deeply personal, erotic, and sensual sense of self that appears uncontrived and unmanufactured. Twigs's visual representations seem to emanate from a resistance to rebrand

or change for the sake of attaining mass success and widespread celebrity status. Twigs's visual commentary on the sexualization of young female pop stars is evident in 'I'm Your Doll'. Unlike other such commentaries including Lily Allen's 2013 video 'Hard out Here' which attempts to address, among other issues, the dominance of white, middle-class men in positions of power in the music industry and the sexualization of young female artists and negative representations of a feminist identity, twigs's work is far more nuanced and presents a more complex critique of the representations of women and their sexuality in the music industry. Its complexity lies in the fact that it is contextualized by mental rather than physical desire. Whereas for many female artists, artistic freedom and feminist expression must still be signed off by figures of patriarchy with endless power, it would appear that twigs has been afforded a certain amount of artistic freedom by her record label, Young Turks, allowing and encouraging her to challenge prohibitive boundaries and idealized representations. This may well be related to the fact that like Björk, twigs's work emanates from a more independent electronic musical context, rather than a mainstream pop music arena and where notions of freedom and independence appear rather more possible for female artists.

'In Time'

Here twigs wakes up from the rape scene in 'I'm Your Doll' in the middle of a sparsely lit black and white room to find herself pregnant as the sequence moves into the next track entitled 'In Time'. Here we see a black man sitting in a chair, looking down upon her from an abstract, crystalline shape floating above her head. The man appears to be a vague paternal figure, who may represent her own estranged father. In the sequence, he remains a figure out of reach, the two never meet, perhaps existing as more of an idea than a reality.

Twigs segues between presenting a fear of her own newly pregnant form and a confident sense of self as a dancer. The man looks on suspiciously and in a much less sexual way than the white man of 'I'm Your Doll'. What is clear in this section, is that the man is both fearful and wary of twigs's femininity. As the piece moves towards its conclusion, her waters break and she begins to expel rainbow liquid from her uterus, and the man appears disgusted. As the music becomes more intense and twigs stamps her feet, the man shakes his head in complete disapproval. It appears he is afraid and threatened by her expression of her feminine identity and sexuality, in all of its complexities. This sequence appears indicative of the mainstream music and popular culture's attitudes towards female sexuality in particular, that it must be contained and managed. Here twigs presents her own self-expression and sexuality as much more central to her own

sense of herself as an artist. Her image is based on exploring and expressing herself fully through visual imagery and is seemingly unconcerned with the impact that these images may have. Media coverage has tended to downplay twigs's role as a music video director and producer of her own video work, predictably preferring to focus on her physicality, image, and relationship status. Yet she resists commenting and instead uses her work to express her views on the existing reductive structures that women in music must still negotiate.

'Glass and Patron'

The last section of the video, 'Glass and Patron', is concerned with self-empowerment. It most readily resembles a music video of any of the four segments. Twigs suggests in an interview that it is a comment upon the need to step outside of digital culture in order to connect with one's sense of an authentic self. Here twigs is located in a forest with her dancers, the forest representing a reconnection with nature and the body, far away from technology. A white van is visible disrupting the tranquillity of the scene. Twigs's videos often begin with extreme close-ups. Here she is revealed upside down, singing 'hit me with your hands, double-knot my throat, mother'. The camera moves out revealing her heavily pregnant form, pulling coloured scarves from her vagina. The music changes pace, and the scarves begin to fall away to reveal her dancers, elegantly swimming through them. The camera cuts to a catwalk in the forest, twigs sat on a silver throne with her dancers voguing in front of her awaiting her approval. The video is a celebratory 2015 version of a 1990s dance fest, in which twigs's dancers are gloriously celebrating their art and their community. The voguing represents a kind of re-establishing of their connections to their bodies as a marker of their self-expression. Here, twigs is the leader of the group, and echoes Madonna's use of voguing in the 1989 'Vogue' video where a heterosexual woman appropriates a marginalized culture in order to enrich her own cultural cachet, but in a much less obvious manner. This of course is part of audiovisual culture and twigs presents the fine line between appropriation and appreciation as a knowingly blurred one. 'Glass and Patron' is ultimately celebratory and respectful of the subculture which she is utilizing.

M3LL155X, and twigs's work more generally, is attempting to marry a number of disparate cultures from high-concept performance art, to hip hop and voguing. This melding of styles is presented as a way of documenting her own explorations into more ephemeral and complex representations of female identity and moves away from universal, definitive, and rational understandings.

Conclusion

For twigs as a mixed-race female performing electronic R and B music, she routinely comes up against the rigid and static ways in which she is supposed to present herself according to the mainstream media. To counter this, twigs's feminism is much more nuanced than many claims to feminism that are presented in the media through celebrity, in that it is rooted in the substance of the work rather than in sound bites. Many celebrities have adopted feminism as a brand in order to capitalize on its current popularity. Twigs uses her music videos to present her identification with feminism as a movement, rather than solely as a vehicle to promote herself and her music. Her willingness to engage audiences in her own self-ambiguity and complexity presents a challenge to normative femininity in a post-feminist regulatory environment, and in a mainstream media culture dominated by simplistic versions of female identity and sexuality twigs appears to present a disruption to the norm. According to Priscilla Frank, 'twigs speaks to a new generation of people, of artists, of women, for whom identity operates differently' (Frank 2014: 12). Her work, while currently experiencing both critical and popular acclaim, transcends many of the boundaries of popular music, as well as the genre of R and B that her work is often placed in.

Much of what makes FKA twigs unique is the varied and complex presentations of herself put forth through her music videos. Her commitment to exploring how technology can be manipulated and used to manipulate the female form presents work that can be perceived as feminist without overtly labelling it as such. Twigs presents a contrary quality that addresses a culture where human interactions are so heavily mediated that a search for real connection is futile and redundant. Her work challenges this notion and speaks to the complexity of contemporary celebrity and digital cultures where her femininity and feminism are difficult and contradictory. Yet, this is precisely where her authenticity is written across her works so explicitly.

CHAPTER NINE

Anal Terrorism in Nicki Minaj's 'Anaconda'

Fabrício Silveira

'Anal Terror' could well be the title of a pornographic movie, a hardcore film directed by John 'Buttman' Stagliano, starring Nacho Vidal, Belladonna, and Rocco Siffredi, hidden on a porn site, age restricted but widely available. But it is not. Instead, it is the title of a lucid essay by Spanish philosopher Beatriz Preciado (Hocquenghem and Preciado 2009), discussing the general 'kidnapping' or 'disappearance' of the anus, in bodily, gender, and identity performance or as the basis for bio-political demands and intermediations in the contemporary world. For her, the anus is the damned and stigmatized organ. There is a monastic silence around it. For some of us, the mere pronunciation of its name is challenging. Its use displays, at the very least, a lack of politeness and good manners.

Gender stereotypes, modern architecture, urban dwelling (as cited in Werner 2013), and, at an extreme level, the Machine of the State itself, have their cornerstones in a kind of *anal privatization*. The anus is the first privatized organ, and is structurally excluded from public space; structurally and systematically taken apart from collective visual scrutiny. But could Beatriz Preciado's radical proposition serve as the horizon for the comprehension of a rather unique mass product? Could we invoke it, for example, in an effort to understand the controversial music video by global pop star Nicki Minaj? The video for the song 'Anaconda' seems to offer new perspectives; it seems to produce challenging instabilities within the explanatory frame held open by the Spanish author. What would they be? How do such destabilizations reverberate? How are they presented (above

all from a media-communicational point of view)? As the owner of an apparently overexposed and redundantly emphasized body, does Minaj take seriously, dissolve or realize, in the murky market of pop music, the political sturdiness implicit in Preciado's formulation as we will discuss? Taking 'Anaconda' as a curious material object, a necessary locus for reflection, how do identity tensions, roles, and social gender conventions replace and redistribute themselves through the video – released in August 2014?[1]

An opening hypothesis (vague and cautious, as it should be) suggests that the video, through its particular 'wild nature' ambience, its general iconography, and through Minaj's lascivious dance, in its horizontal and crawling, ground-oriented dynamics, can evoke the very notion of *anal terrorism*, as well as some of its correlative variations (like anal utopia, anal knowledge, and politics of anus), developed in the above-mentioned study (Hocquenghem and Preciado 2009). In the effective theoretical-conceptual 'incorporation', an intricate network of quite meaningful inversions, slipping, and dilution is manifested in the process of the work.

'Anaconda' is an act of *anal terror*, clear and concrete, unintended or not (in fact, this is a minor question), fabricated and shown in pop music's mainstream. Its sociological location, the fact that it takes place in this precise social space submitted to what Franco Berardi called *splatterkapitalismus* (in Berardi 2007),[2] however, produces a kind of specific 'counter-poison'. A 'poison-cure' is distilled, doubly effective, and responsible not only for its gaudy appeal (its controversial potential, its spectacular and medial vocation), but also for its flagrant self-annulation in its depictions of nature, and the prospect of encouraging prejudices that lie beneath the surface: it is terror and counter-terror. Pseudo-transgression. For and against Preciado.

But what is a terrorist act, in its essence? A terrorist act is a violent and excessive act. It is the unheard-of and unappealing extrapolation of a social norm or of any minimal standard of mutual reason and respect. It is a one-sided attack, an intimidation, the production of vulnerability. In the area of political science, for instance – where there is less interest in questions of intimate affairs, private life, gender, and sexuality that we are trying to highlight here, terror is comprehended in an extraordinary multiplicity of manifestations, connecting to many political systems. It is the 'terror of revolutions and counter-revolutions, of majorities against minorities, and of minorities against the majority of humankind'; it is the 'terror of plebiscite-based democracies' and modern mono-partisanship; it is the 'terror of revolutionary movements' and 'of the small groups of conspirators', says Hannah Arendt (2008: 320). In a liquid world, now using Zygmunt Bauman's familiar jargon (2006), where fear, love, mechanisms of police vigilance, modern values, and the most basic conditions of living really seem to slip through our fingers, terror is presented as a *dark axis*, the compact and scary badge of a *negative globalization* (2006: 97).

According to Bauman, we would be managing uncalculatable risks, we would be immersed in informational fluxes and networks of general interconnections, without awareness or real control of our local actions. Our responsibilities would be diffuse, as are the remote effects of our deeds. A 'market without boundaries', self-proclaimed and self-celebrated, in spite of its cynicism and its voracity – or precisely because of them – has produced an environment of 'moral displacement', galloping uncertainty, and paradoxical loyalties. Thus damages and losses, ambivalence, resentment, and vengeance have been further globalized. Terror then emerges everywhere, leaving us only three roles to play: executioners (or perpetrators), victims, and 'collateral casualties' (Bauman 2006: 98). Yet Beatriz Preciado's debate takes place elsewhere. What appears are no longer the social-historical, geopolitical, military, and/or techno-informational dimensions.[3] A continuing act enters the scene, demanding attention, strictly and clearly, as a very intense kind of '*k*ultural terrorism'. However, recognizing it as '*k*ultural' agenda, it is important to note this,[4] is not to remove it from its political consequences and meanings, as we shall demonstrate.

In this case, *Terror Anal. Apuntes sobre los primeros días de la revolución sexual* (Anal Terror. Notes on the First Days of the Sexual Revolution) was published as a kind of postscript to Guy Hocquenghem's book *Homosexual Desire* (Hocquenghem 1993), and published in France in the early 1970s. The piece is an exercise of critique, retrieval, and historical contextualization of Hocquenghem's pioneering study, which emerges there as one of the central texts (if not one of the founding texts) of Queer Theory.

According to Preciado's remarks, there is no doubt left: we would be presented with a legitimate 'terrorist text'. And what makes it that way? Guy Hocquenghem, in a gradual and sarcastic argument, sometimes one-sided, though always shocking and scathing, dislocates official discourses on homosexuality (of the time, of course: judicial, medical, psychoanalytical, and media), questioning them about their legitimacy, pointing to their limitations, and constituting a different discourse, with a revolutionary background (i.e. critical-political), contrary to the positivist prerequisite of scientific *externality* and *detachment*. The homosexual anus for the first time talks and produces a precept about itself. This precept does not come from culpability or shame, it does not aim at excusing itself or legitimizing itself, it is not a description of pathology or deficiency, but it does present itself as a way of political criticism and social transformation (Preciado in Hocquenghem and Preciado 2009: 155).[5]

There are no justifications, there are no favours sought nor excuses to be invented. There is no pleading for crumbs of respectability.[6] Following *Anti-Oedipus* (Deleuze and Guattari 2013), published few months before, it is proposed that there is no *homosexual* desire: desire is but one, polymorphic and fragmentary, the impersonal product of a 'desiring machine'. But Hocquenghem goes beyond, yet undermining the bases for

the comprehension of gender roles as being merely *political conventions* (heteronormativity as an immaterial good, capitalist primer, and agenda) and of the body as *somatic fiction*, which ultimately goes beyond anatomical certainties and dismisses biological validation.

More than just a provocative metaphor or mere rhetoric, the anus starts to be configured, no gross pun intended, as the nucleus of this new *k*ultural epistemology. In other words, it becomes the heuristic agent of de-hierarchization, the motor for a decentralization of the customary formatting of the 'male' and the 'female'. It is converted into a political standard, into a method of analysis, and into a utopia of government and social cohabitation. The anus has no gender; it does not produce surplus value. It is a 'universalizer', for it escapes the rhetoric of sexual difference and blurs the personalizing and privatizing functions of the face. It is a post-identity dermal tube. 'On the horizon of post-human sexual democracy', says Preciado (Hocquenghem and Preciado 2009: 171), 'lies the anus, as an orgasmic cavity and a non-reproductive muscle shared by all'.[7] It even contains the dimension of a portal: it is the 'biological port' responsible for the socialist distribution of pleasure.

In the medium term, one of the concrete political effects of the publication of *Homosexual Desire* was the shattering of minority movements and the complication of their inner tensions. Hocquenghem opposes not only hegemonic chauvinism and homophobic heteronormativity (with its sealed anus!), but also the male-oriented revolutionary left, Eurocentric discourses, equality-based feminism, and 'good homosexuals', the 'tame homosexuals', acclimatized to structural power games, tactically and silently identified with gender rules and their gaps, their correspondent cracks (Hocquenghem and Preciado 2009).

Once, referring to the works of Sade, Fourier, and Loyola, Roland Barthes (2005: x) said that a *terrorist text* is one which unfolds itself, 'the (liberal) repressive discourse that constantly attempts to recover it, slough itself off like an old skin'.[8] It is what allows *exceeding*, as Barthes says, 'the laws that a society, an ideology, a philosophy establish for themselves in order to agree among themselves in a fine surge of historical intelligibility' (Barthes 2005: x).[9] By trusting these words – as the Spanish philosopher did – we are led into recognizing Guy Hocquenghem's book as a legitimately *terrorist text*, with foundational and paradigmatic power. But is it possible, after all, to equate it to Nicki Minaj's hyper-sexualized figure and overflowing eroticism? May we think them jointly, one *through* the other, without depriving them of their characteristics as a whole? What improbable dialogue may happen over there, between 'Anaconda' and 'AnaKonda'?[10]

Accusations of obscenity, misogyny, and female objectification are not foreign to the universe of rap (see Gines 2006; Kellner 2001; McGrath and Tilahun 2006; Rose 1993; Shusterman 1998). In the same way, insinuations that it is crime-inducing (drug consumption, for example) and violence-

inducing, especially violence against women, are so frequent that they have essentially lost critical interpretative power with regard to gender. Such warnings are often discredited for they seem too obvious. We recognize a much more complex phenomenon – a controversial musical form, capable of inflaming, performing, that is 'presenting a theatricality'[11] while fighting, with the same accuracy and sharpness, real social problems, with polemic potential and undeniable drama. Any critique of hip hop or rap is pointless to generalize. Nicki Minaj's exuberance, her unwavering self-assured confidence, reorient our concern – an *epistemic mistrust* is produced, we could say. How can we comprehend it, therefore, in what concerns aesthetic, rhetoric, and political predominance in the repertoire accumulated in the last decades? Are the misogynistic parts of rap music confronted by this work? It is hard to tell, perhaps in a significant way.

The video for 'Anaconda' is set mostly in a stylized tropical rainforest. In the first seconds, we find ourselves in the woods; dense, closed-in, with lavish trees. It is oppressive vegetation. Sunrays can barely get through it. We hear the typical sounds of the jungle: the sleepy croaking of a frog, the chattering of monkeys, the soft roar of a tiger. Birds sing as they fly from one branch to another, through the lianas and the wild plants. It is a soundscape as recognizable as it is rowdy.[12] Obviously there are crawling snakes, almost imperceptible, moving sinuously behind the green grass, amidst wood pieces. Before the beginning of the song, Minaj appears as the leader of a wild tribe, a sort of 'queen bee' – a 'Queen Snake', to be precise – secured, in a ritual formation, by a small group of warriors: 'My Anaconda don't/My Anaconda don't/Want none unless/You got bunz, hun'. Abruptly, a male voice comes and intones the first and main chorus. It is a syncopated chant, which accentuates the rhythmic marking of the song and determines the thematic field, in an absurd hyper-focalization (*reductio ad absurdum*). Thus the 'curtain' through which Nicki Minaj's performance will get her vocal and bodily contours is created.

These shots alternate with two other sets:

(1) The rustic interior of the households, at times transformed in a female gym, at other times in a fully equipped kitchen – Minaj is the constant protagonist, be it between fresh fruit and whipped cream sprays, be it between dumbbells and work-out equipment;

(2) The interior of a filming studio, with a completely neutral, white background, where some choreographed dance pieces are presented – sometimes with nothing else around her, sometimes with the use of chairs, other scenic objects, and subtle variations of lighting, remarkably in the last minute, when a chair dance takes place.

It is a damp atmosphere. Vapour clouds go up in the air. In the last part of the video, the rapper yet appears bathing in a small lake, a natural pool.

There are chromatic patterns, balanced and regular. There are tones of childish humour and insolence. By summoning such elements, a legitimate *UrPop* ambience is depicted, in the useful expression of Eloy Fernández Porta (2008).[13] And through it, there is insistence on a mythical image, a parodic take on the permanence of an ancestry: a *preference for the primitive* is staged, a fantastical return to the forest of instincts.[14] As such, the *UrPop* aesthetic also implies a *war of eras*: the *pre-civilization paradise* is now opposed to the *totalitarian present*. There is a mutual, reversible, and complementary infusion between them both. The signs, the material goods of an era see themselves projected one into the other. They are dislocated, producing a deadlock, an anachronism, a curious temporal imprecision.

The dances and the bodily performances, in turn, are well-done and pretty sharp: they recall the twerk dance moves for which Miley Cyrus received criticism,[15] and the Tequileiras do Funk's 'Surra de Bunda' (ass bashing),[16] revealing, without modesty or embarrassment, the singer's lower spine, the buttocks, and the anus. However, there is no nudity. Technically, there is no porn, if by porn we expect a 'money shot'.[17] Nicki Minaj's anal terrorism is more conceptual than it is retinal. There are occasional focalizations on jewellery and expensive designer clothing (*Alexander McQueen* and *Balmain* are cited brands). There are brief close-ups on determined objects: a stereo, a vintage vinyl player, a champagne bottle, a beer bucket. However, it is the hip, the lower back waist ('you got bunz, hun') which are awarded the centrality of the visual focus.[18]

Beyond the fact that it is a meta-pornographic parody, 'Anaconda' is also a fantastic amalgam of semiotic components. In recent times, there have been few music videos so charged with intertextualities, subtle allusions, and explicit references to (cultural texts, after all) what had preceded it.[19] The film with the same name, starring Jennifer López, with Ice Cube, and Jon Voight, released in 1997, for example, is an unquestionable basic referent, incorporated with almost no dissimulation, as well as Sir Mix-A-Lot's song, 'Baby Got Back'. These references are merged with other media products of a diverse range and much more visceral blend of ethical and stylistic correspondences, in a true relation of consanguinity. An absolutely determining affinity is manifested among them (a 'genetic matrix', we could say, in a metaphor).

Jennifer López and Sir-Mix-A-Lot are two 'inspirations', two propelling forces: on one side, a b-movie classic from the second half of the 1990s, a low-budget non-art film, a relative popular mass entertainment success, narrating the story of a terrible monster, the infernal serpent from the depths of the Amazon rainforest,[20] on the other, a booming radio success, more or less of the same time. 'Baby Got Back' was originally released in 1992, during MTV's age of great cultural impact. However, it was banned, considered improper and offensive by the music broadcaster. Here, it is re-edited, sampled, and re-signified by the female voice.

Minaj knows how to locate her historical antecedents. She knows how to update them with impressive clarity. And out of it, she creates an insertion into a wider way of discoursing, in a reiterating structure of gender valuations which is also an enunciative platform of sexual obsessions,[21] the absolute fixation on the mountainous anatomy of the gluteal area, and 'cultural wars', whatever they may be, in ascending order: *against* white women, *against* skinny women, and *against* men's wilful, objectifying, and heteronormative desire. It is almost an indiscriminate attack on the part of Minaj. This is a risky exercise of empowerment.

But where is the risk? Part of the risk is in self-deprecation.[22] Another part – maybe more provocative – is not leaving one's own allocated place, not offering overt alternatives. 'Anaconda' only starts a new kind of anal terrorism: a 'phallocentric', pro-capitalist, and pro-female-stereotyping. It is sexist and essentialist, as opposed to Beatriz Preciado (and Guy Hocquenghem). It produces semio-erotic inflation and de-sensitization by overload. It adopts a female-empowerment tactic through hysteria and symmetric inversion, which intensifies without undoing or questioning the established poles of hegemonic representation, conservative and retrograde. Here, the 'sexual transgression', the transgression itself, primarily understood as rupture in relation to the phallocentric epistemological and juridical model, is then understood as the legitimate right to autonomy and conscious liberation of the will. Transgression is imposed as a new hyper-conformist identification and a new *ethos* for consumerism. It is a hyper-feminization through hyper-sexualization, coming closer to traditional pornography (ordinary pornography) and becoming converted into an assimilable case for what has been called 'raunch culture' (Halligan 2014; Levy 2006), or the 'culture of vulgarity'. 'You got bunz, hun'?

The Art of the Music Video

Introduction

As was already noted in the introduction, music video has been characterized by a 'commerce' between art and money, and between expression and promotion, giving rise to a heightened tension in the form. The music video, in its incarnation as a 'promo' was always both itself something and selling something else (the music track or the artist) and this tension persists in the digital, social media era, even if what is being promoted may be neither the song nor the artist, but the digital skills or cultural capital of the disseminator, whether a corporate entity like Vevo or a single individual. Even when any obvious relationship to the buying and selling of musical commodities is fractured, if not entirely broken, the music video is still a powerful affective and affecting token of digital social exchange, identity marking, and social commonality and popularity, measured more by numbers of clicks, likes, shares and comments than record sales. In this contemporary situation, the music video continues to be both itself and something other, an expression of both audiovisual creativity and commerce, even if it has become less clear what exactly this commerce is trading, beyond the music video itself as a kind of vital currency.

One way to approach this art of the music video would be to focus on art in the sense of digital video tricks and techniques as can be seen in the work of Vernallis and more recently Steven Shaviro, examining such techniques as compositing, motion control, morphing software, and other digital special effects (see Shaviro 2017; Vernallis 2004), as well as their remediation of earlier media forms such as experimental cinema or video installation to name only two. The chapters in this section, however, take different approaches, examining the art of the music video through a range of distinct yet inter-related filters namely dance, synaesthesia, philosophy, and the music video auteur. While these are distinct approaches to very distinct music video practices, with different

emphases on production, reception, and the music videos themselves, they all raise related aesthetic questions, via their different filters, as questions of sensation and affect, less that of 'what are music videos' than 'what do music videos do, what do they do to us, and what do we do with them'?

For Sarie Mairs Slee, dance is the missing element par excellence in discussion of music video which tends to focus either on the image or on music. As Slee points out, while music videos have changed in form and function over the years of their existence, 'dance and designed physical movement' remain a key if not primary element in music videos. Not only is dance a primary feature of music videos themselves but it also invites a kinaesthetic response in the viewer; a music video is as much something to dance along to as to watch, and this is frequently inscribed in the address of music videos themselves. Music videos are not only moving images but images that move us, not only affectively but physically. A focus on dance and moving bodies is therefore able to bring out aspects of the embodiment of music videos in ways that remain invisible in approaches derived from film studies or musicology. Instead, through analogies with live musical performance, Slee is able to bring out the ways in which the dance moves in music videos call for collective embodied responses, and this can be inscribed within music videos themselves; after all the musical stars of music videos 'rarely dance alone'. This communicates a range of messages to the viewer, but key among them is a participatory, embodied address that is unique to dance; by dancing with the music video, a unique access to celebrity valorization is made available via the movement of bodies on and offscreen. Slee demonstrates this through the analysis of dance in a range of music videos, focusing especially on Michael Jackson's 'Smooth Criminal' and Madonna's 'Hung Up', showing how dance operate as a powerful means of connecting star performers and their audiences via embodied participation.

Michael Goddard takes a very different approach to a very different body of work, that of first- and second-wave industrial music video. Beginning with the example of Throbbing Gristle, Goddard argues that industrial music from the very beginning was a form of 'audiovision', combining the visual and the sonic in ways that were other than and beyond being simply a new electronic genre of music. Synaesthetic combinations of sound and image accompanied music video from its beginnings, and it is hardly accidental that the groups Cabaret Voltaire, founded a video rather than a record label, 'Doubevision', to release both their own video work and that of other artists and filmmakers. If the video work of Cabaret Voltaire was at the beginning deliberately lo fi and DIY, it soon developed a complex audiovisual language in which visual and audio cut up techniques operated in parallel and complementary ways. Second-generation industrial bands

Test Dept and Laibach also incorporated film and video into their work in sophisticated ways, the former releasing video versions prior to and different from their audio recordings, and both groups incorporating film and video as essential components of live performances, as well as releasing innovative music videos. As such, industrial music video provides an alternative genealogy of music video as synaesthetic audiovisuology, enacting something more and other than merely promoting musical products. This chapter therefore presents the music videos of these groups in a larger context of industrial audiovisual practices at once artisanal and totalising.

With Paul Hegarty, we are back with dance or at least 'jumping' in the video work of Scooter, which he claims reveal 'hidden complexity [...] and reflect back on the often banal lyrics and simple music in ways that create a more critical refraction of the globalized cultural economy'. More than this, these videos of this 'happy hardcore' party band are able to resonate with the deconstructive philosophical perspectives on the contemporary world of thinkers such as Maurice Blanchot, Jacques Derrida, and Franco 'Bifo' Berardi. As such they offer a self-reflexive response to the globalization that Scooter and rave culture were products of in the first place. Not only are the videos replete with global signifiers, but for Hegarty they offer 'an engaged strategy of newly critical, perversely resistant culture, alongside the persevering glimpses of club-based party life'. Ultimately these strategies add up to a Blanchotian 'non-community' but one thoroughly mediated by global digital and social media.

Finally in this section, the concept of the music video auteur is raised through Dean Lockwood's engagement with the work of Chris Cunningham. Specifically, he engages with Cunningham's work as presenting moving bodies – the blackened puppets of the title – that also have the capacity to move viewers. However, the bodies in question here are no longer necessarily human but hybrid and monstrous entities 'which promise either to rapturously seduce or disquietingly undo those exposed to them'. Focusing especially on the videos 'All is Full of Love' (Björk) and 'Rubber Johnny' (Aphex Twin), Lockwood discerns in Cunningham's work a synaesthetic sensibility, in which the fractured rhythms both soncially and visually are largely generated in process of post-production. In Lockwood's words, these videos constitute 'a synergy of sound and vision, a "thingly" vitality encompassing both the bodies presented in the work and the bodies or machines constituted by the videos themselves'. Here the moving bodies of music video examined by Slee and in a different way by Hegarty are combined with a now post-industrial synaesthesia, in proximity to contemporary concepts of accelerationism and excommunication. However, in this Cunningham may be only one more blackened puppet and 'ultimately there is no other

auteur than mediation itself'. While having a specific meaning in relation to Lockwood's chapter, this statement also sums up this section as a whole in which the art of the music video, whatever its musical starting point, and whether circulating in commercial, independent, or underground contexts, provides a unique form for reflecting complex processes of contemporary audiovisual mediation.

CHAPTER TEN

Moving the Music: Dance, Action, and Embodied Identity

Sarie Mairs Slee

'Everybody dance now'... 'Music makes me move my body, makes me move my soul'... 'get into the groove'... 'Everybody, rock your body'... 'I've got the moves like Jagger.'[1]

Once a child of the MTV generation and now a dance artist/academic, the rhythms and lyrics of popular music seem to me a call to action to get up and get moving. And while the visual and aural norms of music videos have evolved over recent decades, dance and designed physical movement remain a regular – if not primary – element of many twenty-first-century music videos. Discourses on music videos widely examine the use of *image* within the video, along with visual animation and music consumption (Frith et al. 1993; Goodwin 1992; Whiteley 1997). But dance is something that is not only seen but done, that is not only visual but kinaesthetic. Movement, dance, and embodied action serve as constituent elements within the music videos which can move the listener/spectator from passive consumption through the ears and eyes into active participation through the body. The integration of dance within music videos seems intuitive: across histories, aesthetics, and traditions, much of popular music has sought to evoke a physical response: from moshing to the Macarena, tribal trance to twerking, the aerial aerobics of swing dance to a Saturday night boogie around your handbag. Yet the design and integration of embodied action into the music video plays a deeper role in connecting the artist featured

with his/her audience. This chapter seeks to examine the role of dance and the dancer's embodied identity within the music video. It draws from theories regarding embodiment, identity, and dance from across cultural studies, performance studies, and the social sciences. In total, it aims to explore the use of dance and embodied action in the constructed identity of the singer, the embodied experience of the song, and the methods in which video-makers support the spectator's potential to transition from passive to active.

Despite the long-standing place for dance in music videos, it has received little analytic attention outside writings specifically on dance. In an early essay on dance in music videos, Angela McRobbie highlights gaps in the analysis of dance: 'Of all the areas of popular culture, it remains the least theorised, the least subject to the scrutiny of the social critic' (1984: 130, 131). Goodwin approaches the subject stating that 'dance on music television and in music video has similarly been neglected' and suggests an initial way of analysing dance in videos is 'through its attempt to visualize music' (1992: 68). He goes onto observe that:

> [V]arious forms of pro-filmic movement – encompassing musicians, nonmusicians, professional dancers, and audience members, and ranging from full-fledged dance routines to all matters concerning gesture and the visual rhetoric of the body – may connect with synaesthesia through their efforts to visualise the music itself. Hebdige for instance, has written briefly on the links between the pace of punk rock music and style of pogo dancing that went with it. (Goodwin 1992: 69)

But, despite Goodwin's sound efforts to include dance in his analysis, the example given provides a better example of dance's work to embody music, rather than to simply visualize it. One must remember a key fact: when dancing, we cannot see ourselves dance. If it is accepted that dance in social settings is primarily participatory and only occasionally or secondarily presentational, then it is truly what is done, what is felt, and what is experienced that drives the embodied reaction to music.

This understanding of dance as a participatory action changes its role as an element within the video. In modern popular music, the musicians are the main people active in making music; even if the actions of 'singing along' in the car or in a stadium concert are acceptable, it is understood that this is an act of joining what is pivotally the musicians' role. But the same is not true for dance; from a gentle toe-tap to a full-bodied flail or flourish of torso and limbs, dance is a normalized reaction to and participation in popular music. It is something people *do,* rather than just see. Therefore, as a performative element of the music video, dance and movement hold potential for a different type of relationship with the viewer. It provides something that seems to flow from the music as 'authentic' physical response to the music –

as performed by or alongside the musician – and holds the possibility of being embodied in present or future responses to the music. Dance therefore becomes a kinaesthetic, action-based instrument that helps formulate the *embodied identity* of the song, and through the song, the artist: an identity that can be observed, experienced, consumed, extended, or transferred.

Key concepts in dance and embodied action in the music video

While rarely the focus in analysis, dance is regularly referenced in literature examining the music video. Dodds (2009) notes, 'It is hardly surprising that the dancing body is a ubiquitous presence in pop music video. In both social and performance arenas, popular dance and music are inextricably linked' (247). The 'visual' is regarded as the key additional feature of the music video that separates it from the song the original – or at least separate – artefact: 'a pop video is essentially a specific visual representation of the musical content' (Whiteley 1997: 260). Much of the theory supporting this literature arises from popular music studies, which takes the 'music' as the primary subject frame, or film studies, which prioritizes the 'image', and creates the binary frame for analysis via the eyes and ears. By incorporating the 'body' to create a triadic frame, one recognizes both the fuller sensory complexity involved in the experience of music and the symbiotic relationship triggered between dance and music videos as described by Dodds:

> Popular dance styles, both from vernacular and other screen traditions, serve as a visual illustration of the music; the music and the visuals, meanwhile, inform and influence the dance practices of the spectators who seek to embody the images that they see on screen. (2009: 248)

The incorporation of the body in the analysis of music videos also expands the consideration of the visual to both include image (noun) and action (verb). Goodwin also cautions the overreliance on film studies to read 'the visual' in music videos, but in this case for the dangers of omitting the visual elements – static and active – inherent in the music and the making of it.

> My point is that visual spectacles (dancing, gesture, the display of virtuosity, lighting, smoke bombs, dry ice, back projection, etc.) have always worked in tandem with the music itself. Performances on music television mirror many of these codes and conventions (established in more than thirty years of rock and pop concerts), yet academic theorists frequently relate this iconography to filmic, postmodernist and ... psycho-

analytic categories without taking account of its more prosaic intention – that of evoking the excitement of a live pop performance. (Goodwin 1992: 18)

To interrogate this further, consider the different states of attention when watching a film, watching television and listening/watching at a gig or concert. In film, the embodied experience is meant to be suppressed: you sit in a darkened space and the social codes of talking or laughing beyond a direct reaction to the film is frowned upon. Television is watched more casually and can serve either as a direct point of engagement or an element can be discussed, 'talked over', or ignored as desired. At a live concert or gig, audience members are on show. They can see each other and they can be seen by the musicians. Visible embodied responses are more acceptable, even expected: clapping, cheering, talking (or yelling, depending on the volume) about what is seen or heard, moving to the pulse or full-on dancing to the music. The normative spectatorship of music involves embodied response; in this, the embodied responses to the visual, aural, and kinaesthetic elements of music videos involve potential for a similarly active sensorial state of spectatorship.

Action and the embodiment of identity

As one would imagine, the body has long been a central consideration by dance academics and, more recently, an established concern within the social sciences. Introducing a volume on *The Sociology of the Body*, Cregan explains that 'the body until recently has been largely taken for granted [but] over the past two decades this has changed. The body and embodiment have become objects of direct critical reflection' (2006: 1). Sociologist John O'Neill states that '*society is never a disembodied spectacle* [as] we engage in social interaction from the very start on the basis of sensory and aesthetic expressions' (1985: 22, italics in original). Writings on embodiment and the sociology of the body have grown to identify how human action and meaning are constructed, deconstructed, subverted, parodied, etc., in a number of socially defined settings (Cregan 2006; Goffman 2005; Shilling 2007; Waskul and Vannini 2006). In this, embodied actions implicit within social rituals and the 'staging' of these interactions are central to the 'collaborative manufacture of selves' as understood in both individual and collective identities (Charon 1998: 191). The growing literature around the sociology of the body has fed into subsequent writings on dance in relation to identity, society, 'world cultures', and popular culture (Dils and Albright 2001; Dyck and Archetti 2003; Franko 2002; Grau 2008; Thomas 1993), addressing the gap highlighted via McRobbie earlier in this chapter. Albright (1997) emphasizes the extents to which 'culture is

embedded in experiences of the body and [the] body is implicated in our notions of identity' (5). In Polhemus's discussion of 'physical culture' encompassing our 'non-verbal communicative systems', he states:

> While physical culture may be viewed as a crystallisation – an embodiment – of the most deeply rooted and fundamental level of what it means to be a member of a particular society, dance might be seen as a second stage of this process – a schema, an abstraction or stylising of physical culture. (Polhemus, in Thomas ed. 1993: 7)

In an essay exploring 'movement as culture' across disco dance and contact improvisation, Cynthia Cohen Bull positions 'structured movement systems like social dance, theatre dance, sport, and ritual' as fundamental tools that 'help to articulate and create images of who people are and what their lives are like, encoding and eliciting ideas and values; they are also part of experience, of performances and actions by which people know themselves' (2001: 405). Bull's connection between 'images of who people are' and 'actions by which they know themselves' evokes both the static and active elements of identity, highlighting the role that the body (noun) moving (verb) plays in the ongoing construction of one's sense of self in relation to others.

The action of dancing is a conscious one. It involves the choice to move in ways that are kinaesthetically experienced and outwardly visible. The reasons one might choose to dance – leisure, ritual, enactment on cultural identity, self-expression, physical enjoyment, connection with others, display prowess in skills, to amuse – vary, but in the *action* of dancing, individuals draw on 'human agency' which, as outlined by Noland, is implicitly kinaesthetic and explicitly embodied:

> *embodiment* [is] the process whereby collective behaviors and beliefs, acquired through acculturation, are rendered individual and 'lived' at the level of the body. *Agency,* it follows, is the power to alter those acquired behaviors and beliefs for purposes that may be reactive (resistant) or collaborative (innovative) in kind. (2009: 9, italics in original)

When revisiting the act of dancing as conscious, kinaesthetically experienced, and outwardly visible, this concept of agency could not be more closely felt. But this power to both alter and activate one's kinaesthetic potential is not fixed. As one continually refines, expands, tests, or neglects the practices s/he has learned, the embodied agency which facilitates the choice to act changes. And therein lies the importance of both the choice and risk involved in the embodied action of dancing. On the one hand, contemporary physical culture offers such an array of embodied practices to participate in or adopt/adapt as an individual. Dodd highlights the need

'to recognize that audiences have a powerful degree of agency in deciding whether to choose any of the commodities offered [in music videos], be it the music itself, the lifestyle of the artist, the dance style, or the body image on display' (2009: 259). But the choice to acquire new behaviours leads to a potential risk, as outlined by Shilling within his concept of 'body pedagogics'. In asserting that the 'idea that social norms and social actions inhere within the deepest fibres of out bodily being', he emphasizes 'the experiences that people go through when acquiring (or failing to acquire) new skills and capacities' (2007: 13). The visibility of dance and its implicit possibility of failure when working to acquire new capacities are palpably risky. And here again, the twenty-first-century music video offers an interesting subject in considering agency, identity, and dance: widely accessible through the Internet, potential to observe or re-enact content publically or privately, the music video offers not only music to be heard and images to be observed, but also a pedagogic tool that can directly influence one's behaviours, beliefs, and the power to activate them as expression of identity.

Dance as embodied identities of music/musician

For decades preceding the advent of the music video, the role of popular music has been central in the processes of adolescence as 'a struggle of emancipation from [one's] parents' during a transfer of 'dependency to the peer group whose values are typically in conflict with those of [the] parents' (Bandura cited in Hudson 1985: 35). Whiteley highlights the core role that identity plays in popular music, in relation to both the creator and the listener, stating:

> It is arguably the case that live performance remains one of the principal constituents in notions of rock authenticity [...] In particular, the significance of live performance lies in its focus on identity, in its expression of emotions which, for examples, a listener may not be able to articulate because of personal repression or sexual taboos. This popular music locates the pleasures that are available, the sites where desire and power are invested and operationalised, and the possibilities for both determination and resistance. In turn, the power of music relies on an investment by a particular social or cultural group; its strength lies in its ability to create a feeling of belonging. (1997: xiv–xv)

Whiteley relates the key terms used in this statement (authenticity, identity, repression, pleasure, desire, power, 'a feeling of belonging') to identity within live performance, but I would argue that it is not just the flesh-and-blood

proximity which defines this live-ness. It is also the *action* fundamental to the embodiment of the song – the acts of singing, eye contact, and gesture towards the crowd, the physicality of playing an instrument, facial expression – and the dual actions of witnessing and response which further distil this connection of identity between the musician and audience.

The star identities constructed in and through these performances play important roles as 'they enable us to see that characterization, fiction, and perhaps event narrative itself exist in popular music at the point of narration…[The] creation of character identities for pop stars provides a point of identification for the listener-spectator' (Goodwin 1992: 103). This 'point of identification' is key, allowing sense of action, reaction, and interaction around the embodied identity of the star, the song, and the audience's individual and collective engagement with these identities: they are like me, I am like them, they are like us.

Simultaneously, another aspect is at play in these performances: the identity of the virtuoso. Judith Hamera draws together past descriptions of music and dance virtuosos – angels, devils, magicians, machines, geniuses, monsters – stating, 'as these images suggest, virtuosos are human but not quite: they are something else, something more than the sum of their merely human parts' (2012: 753). But she goes on to describe virtuosity as a 'relational economy', one that does more than relating the virtuoso to observing another by setting them apart from him or her. Instead she explores the connection made between the virtuoso and the audience in performance: they recognize the power and affect created while seeing the common humanity of the individual embodying this virtuosity. 'Virtuosos incarnate "plots of possibility" for audiences – seemingly mastery of one's own labour and the affective surplus it generates – even while demonstrating the audience's inability to activate these plots themselves. They are objects of both attraction and anxiety' (Hamera 2012: 753).

Virtuosity in musicianship is an obvious element within the pop star's identity, but for those stars for whom dance plays a strong (if not equal) role in their performances, the effect of virtuosic dancing can be transformative on perception of their identity. In her writings on Michael Jackson, Hamera (2012) explores 'a neglected aspect of virtuosity in dance more generally: its highly allegorical, nostalgic activation of imagined, idealized relationships between the body and work' (752). This aspect of virtuosity in dance pervades a number of dance forms; Hamera cites ballet as the pinnacle example citing ballet soloists who 'beckon spectators with the phantasmic possibility of artisanal ownership of one's own labour through efforts so exceptional and so sublime they transcend even gravity' (2012: 752). Stars like Jackson, alongside Madonna, and more recently Pink and Florence Welch (of Florence and the Machine), demonstrate both the desire and realized potential to achieve a deeper physical and creative agency that

goes beyond the charisma or presence valued in live music performance. It recognizes the risk involved in embodying such outwardly visible physical design and, when done with ease or success, can deepen the otherworldliness that Hamera speaks of as objects of 'attraction and anxiety'.

Transferable identities through dance: From solo to ensemble

The image of a pop star dancing within his or her video is familiar and, as discussed previously, elevates the perception of the star persona as virtuosic and agential in embodying a range of ideal identities: physically fit, attractive to others, and so on. But one must immediately note: *they rarely dance alone*. The pop star dancing as soloist is contextualized by the dancing and dancers that frame them, in relationship to their physical agency, social status, and identity. The role that the dancing ensemble plays in music video varies, but one thing is constant. As they are observed dancing with or alongside the star figure, members of the ensemble share an embodied agency and kinaesthetic experience with him or her. They are connected through a shared action and, therefore, share an aspect in their individual embodied identities. As this occurs through dance and dance can be learned, this shared aspect is transferrable.

> Music video is a platform both for the dilution and innovation of popular dance forms. Although, on the one hand, it operates through a form of cultural theft as it feeds off existing popular dance traditions as a means to promote its artists and attract "commodity viewers", it also serves as a pedagogical tool that circulates and distributes dance styles that audiences are keen to adopt and develop. (Dodds 2009: 258, 259)

It is worth highlighting that the reality of learning dance sequences and styles has changed with the move of music video consumption from the television to the Internet: 'In domestic settings [...] young people can respond to recorded music and dance in the privacy of their own homes' (Dodds 2009: 247). And, without the curatorial power of music television stations to choose the timing and frequency of the play of music videos, they can be watched, re-watched, played in excerpt or slow-motion. Spectators can spend time in private, exploring and rehearsing embodied behaviours before or aside from experiences dancing with their peers, in a number of settings.

In placing the solo star amidst the ensemble, dance can communicate a series of messages regarding identity. However, three messages dominate as outlined (with somewhat simplified terminology) below:

- 'I am amazing': This approach highlights the ideal identities shared between the singer and ensemble, often displaying uniform, but consistently idealized bodies dancing in ideal ways. This approach accentuates the ability to transfer the agency acquired through dance while still reinforcing the 'star identity' as central.

- 'I am just like you': This emphasizes the collective identity but with the placement of the star identity as part of a group in a flat hierarchy.

- 'You are as amazing as I am': This approach also emphasizes the collective identity but by elevating status of the dancing 'everyman', accentuating and celebrating diversity in movement.

Numerous videos use one of these messages in a singular, or at least dominant way. The first approach is perhaps the longest established and relies heavily on the presence and action of backing dancers. The identities of backing dancers have been treated in a number of ways. In some cases, backing dancers are stripped of their individual identity, by highly stylized hair and costume (as in Kylie Minogue's 'Can't Get You Out of My Head' or Michael Jackson's 'Thriller') or in showing their movement only in silhouette (as in 'Strike It Up' by Black Box). In other cases, the backing dancers are wholly on view but styled to look like the star central to the video (as seen in Beyoncé's 'Single Ladies'). Whether concealed or on show, the backing dancers represent an individual and collective idealized body, ideal both in physique and in the ability to perform movement 'endlessly and with ease' (Aalten 2007: 111). Backing dancers reinforce this idealized body as part of the star's identity, often grouped behind the singer, flanking or occasionally surrounding him or her. They serve to place dance at the forefront of the artist's viewable action, sometimes equal to the actual singing. Backing dancers are often used in more complex or difficult choreography and move in unison with the star. As a result, the collective effect of the movement is larger, often fills the majority of the screen space, and allows the 'amazing' singer to seemingly lead a chorus of skilled, moving, uniform bodies.

In the second approach, the movement is kept consciously simple and designed to be participatory (as in the Village People's 'YMCA' or more recently, Psy's 'Gangnam Style'). This power of dance is a tool for *collective* embodied identity. Tan explores the potential for this collection identity in his analysis of the Gangnam Style global dance phenomenon:

> For the non-Korean speaking listener, Psy's incomprehensible rap mutterings can be ignored when bodies, regardless of nationality, gender, class, age, and ethnicity, move and mingle to the rhythms of the music [...] The moving body, driven by the rhythm, becomes the site of the

global intercultural performative. Partaking in this Gangnam community exemplifies a mode of consumption that awards importance through a sharing of physical-virtual space. As Bauman posits, such a sharing of physical space with other actors engaged in a similar task or activity grants importance or prominence to this action through an 'approval of numbers'. (Tan 2015: 88)

The prominence of this action serves not to elevate the status of the star persona, but emphasized the non-hierarchical status between him and the other participants in the dance. McRobbie describes the activation of collective identities in the construction of song and dance numbers in *Fame* through almost ritualistic qualities: '[they] are constructed so as to seem to bind people together, uniting young and old, teachers and taught, performers and audiences in an expression of celebration' (1984: 152). While this approach is focused on a much simpler set of choreographed movement, the effect is the same: it offers the listener/spectator a low-risk possibility to participate in a collective action and therefore the opportunity to enter a celebratory, collective identity first presented and aligned with the star's and song's embodied identity.

Fluid identities through dance: Mixing messages and making connections in embodied action

In the case of some videos, the identities of the star persona as singer and dancer are presented on equal pegging and the three messages outlined previously ('I am amazing'; 'I am just like you'; 'You are as amazing as I am') are interwoven to cumulatively shape the relationship between the star and the other dances in the video, playing continuously with the hierarchies evoked. In considering the movement alone, a mix of simple and virtuosic movement is used to physically move the star's embodied identity from that of elevated to collective. But it is the relationship between these embodied actions and actors that communicates such a strong message. To explore this notion through closer analysis, I take two videos which place dance as the central action of the video: Michael Jackson's 'Smooth Criminal' and Madonna's 'Hung Up'. Each analysis will explore the ways in which these messages are mixed, elevate the connective potential of the dance, and heighten the importance of dance within the embodied identity of both the song and the singer. The analysis purposefully focuses on the physical action portrayed onscreen rather than the choices regarding framing, lighting, direction, or cuts between shots. By bringing attention specifically to the bodies and actions visible, the intent is to reframe one's analytic focus to these concepts of embodied action and identity as well.

'Smooth Criminal' (1987)

The first actions and images cement Jackson as the central and elevated figure in the video. We see his shadow – larger than life – before he appears in a darkened city backstreet. The door into the 'speakeasy' opens in silence and a blinding light pours out to illuminate Jackson's whole body. He enters into a completely still and silent club; every person, bodies tense, is transfixed on him and the music transitions from silence into music by the miraculous flip of a coin, which flies through the air across the entire room into a jukebox. Jackson's rhythmic pulse of the hips acts as a starter pistol to the song and the full ensemble immediately springs into action. His costume – white suit and fedora – catches the light in this darkened, subterranean room and he positively glows. The stage is set and, prior to the first note, Jackson's character (playing both himself and an imagined other) is well-established as other-worldly, capable of miraculous feats and holds the highest status in the room. He is 'amazing'. But actions that follow continually interrupt and reassert this dominance.

'Smooth Criminal' is marked throughout by a series of complicated dance sequences, but Jackson almost never dances alone. Instead, he dances side-by-side in tight unison movement with others (often men until final sequence). Fedoras are tipped forward to conceal all of the face but the mouth and one has to struggle to see Jackson singing. Besides the colour of his suit, there is no difference between the other men dancing. They look alike; they move alike. Jackson may be dominant but he is also like these men. A series of mime-like choreographies reassert Jackson's dominance – violently dominant, sexually dominant – but also an ambiguous moral authority: he catches cheats at card games, at the pool table, men harassing a woman in a red dress. Each narrative interaction is stylized and dancerly in its movement, but the physical action that Jackson needs to assert to recapture the upper hand is minimal. The scale of his opponent's movement is almost twice that of Jackson, reinforcing not only his dominance but the sense of 'cool' alongside it.

When Jackson does dance as a solo performer, he is a body moving in a sea of highly able bodies. The movement of the ensemble complements his solo action, relating him as a member of, but desirable within the group. In an early scene in the video Jackson dances with a woman in red dress and five women mirror her movement in unison movement, positioned in a triangle behind her. One can see that each 'desires' to be dancing with Jackson and, if not able to share proximity, can at least share in this corresponding movement. In a later scene, a solo occurs on the elevated gallery surrounding the main space and the ensemble below responds physically in a call-and-response format before he descends slowly down the stairs to join the writhing crowd below. The choreography continually loops

between messages of dominance and messages of belonging. The physical and creative agency of the group is palpably high and Jackson is both a fitting member and leader.

The narrative of the video includes other characters: three children who see Jackson in the street at the start of the film and watch the proceedings through a window. In a late part of the video, the third message is given: 'you are (or can be) as amazing as I am'. One of the little boys in the middle steps in the window and brags to his friends that he 'taught him everything he knows' and immediately performs a choreographic phrase performed by Jackson and an all-male ensemble moments earlier. It is accurate, admirable, and fully convincing. The other two children shake their heads and turn their attention back to the window, but the scene is important in three ways. First, it positions outsiders-as-observers within the video. By casting these observers as children, the video-makers cleanse them of any association with the 'sullied' aspects of the narrative: the violence and the sexually charged encounters, and instead focuses their gaze on the dancing. Finally, it demonstrates the possibility for the outsiders/observers to re-enact, embody, and therefore share this physical, danced identity. Jackson is there as a musician, obviously, but the boy in the video does not grab a pretend microphone and sing; instead, *he dances*. Jackson's embodied identity is established, exalted, and demonstrated as transferrable through dance, both by 'insiders' and 'outsiders' to the video's imagined community.

'Hung Up' (2005)

This video cuts between different sites where different people are executing a variety of dance- or movement-related actions and, through the video, people converge into one place and move together in collective dance-based or physical activity. A 'boom box' – distinct in shape and design – is a constant between the 'day' settings and while invisible in the 'night' setting, it is clear that the music in the club drives the bodies and the collective action. The video begins with Madonna entering an empty dance studio with the boom box, stripping down into a leotard and legwarmers and turning on the music (a tape, not a CD or mp3 player) before beginning to stretch and limber up. The video cuts to a group of young people – five men and one woman in T-shirts, loose jeans/trousers, and trainers – on an urban rooftop under a dawn-like sky and shows the young woman also in a deep stretch. The scenes of physical preparation continue until the chorus hits and everyone springs into action. Madonna breaks into a series of *chaîné* turns, three young people break into a run and leap between stairs and balconies. The preparation is done and it is time to practise.

A new scene is introduced: a street corner in a working class neighbourhood. A quick shot of a palm tree suggests Los Angeles. A group of four African

American teenagers bust into movement as a fifth arrives with the boom box. But this is not a shared dance; each moves as a solo, with his/her own style and physical stylistic vernacular, and are pushed out of the way to make space for another solo. This is not a 'battle' as we might understand it within breakdancing; there will be no winner. But each of the young people wants/needs to make space to try their own movement, to find their own style. Simultaneously, the video cuts back to Madonna in the studio. At times, she sings, eyes fixed to the camera and only gently undulating to the music. In scenes when she is dancing, she is fixed on her own reflection but not in a long sequence of well-executed movement. She tries a few moves, steps away from the mirror, tries some different movements, and the sequences become longer between breaks as she seemingly finds movement that 'works'. Meanwhile four of the teenagers in the street scene grab the boom box, jump in an American yellow cab, and leave the neighbourhood scene. Practice is over and it is time to dance.

These early scenes, making up a third of the video, disrupt the normative presentation of dance as virtuosity discussed earlier. Dancers do not move 'endlessly and with ease' (Aalten 2007: 111) but instead must warm up and practise, must try and fail. The *work* that Hamera highlights within virtuosity is put on show; although the settings and the people are different, this sets a flat hierarchy between our disparate characters. Watching Madonna move, the listener/spectator carries the knowledge of her past prowess as a dancer, her decades of experience. But the common ground is made explicit prior to any full-out 'dancing'.[2]

A new scene is introduced: a Chinese takeaway/restaurant at closing time. Two cooks leap over the counter into a series of inverted breakdancing acrobatics, and after a few moments, the first unison movements ensue. Meanwhile, in the dance studio, Madonna has found her groove and performs a longer sequence, aligning with the chorus of the song. But back to the restaurant where our ensemble of two grows to four and their unison movement is common with the dance phrase performed by Madonna. In both settings, the mood is light, playful, and celebratory. Work is over and it is time to dance.

The video transitions from day to night and the L.A. youths' American taxi becomes a London black cab. They tumble out, boom box on one man's shoulder, into a back street, and depart. Madonna, now in jeans and a black leather jacket, on a similar street walks towards and with the camera. Occasionally, her gaze is drawn away by passing young men, but she continues walking with purpose. The characters converge in a club. It is dark, shadowy, and the music, lights, and bodies pump to the same heavy pulse. In slow-motion, away from the dance floor, Madonna moves with a small group of men and women introduced earlier in the video. The interaction starts as one man unzips her jacket, she brushes faces with another and her hips drop as the hips of another rise to meet hers. She pivots

around a man with a leg outstretched as he descends towards her pelvis, their gazes fixed. She slides down one woman and undulates with another as the dance floor explodes into a slow-motion frenzy of unabashed, solo dances by all players. This scene continues, cut with images of Madonna (back in her leotard) continually moving over the boom box in the flashing lights of the club: a long chain of pelvic thrusts that lead to the climax of the ensemble dancing. Back in real time, the group moves together to the pulse of the music in and around a dance video game machine. It is a mix of virtuosity and community; many solo, many move in unison together in the phrase introduced earlier, many clap/smile/move in response. The group – diverse in age, nationality, style – is one: through the music and through their dance.

The second phase of the video works explicitly to exalt two messages: 'I am like you' and 'you are as amazing as I am'. The diversity of individuals' movement isn't only incorporated alongside Madonna's dancing; it is central and exalted. Considering this diversity, Dodds writes, 'Madonna [borrows] from other cultural communities, as in her video "Hung Up" (2005), in which she incorporates krumping, a bewilderingly fast style of L.A. hip-hop dance. This use of cutting-edge social dance styles is clearly a means to position herself as an innovator close to underground street culture, yet this neatly sidesteps the issue of cultural appropriation' (2009: 256). But this analysis seeks to introduce another perspective. In this layering of preparation, practice, individual dance, and collective dance, everyone's movement is aligned to their identities as presented and demonstrated: nationality, ethnicity, age, specialist skill base. Madonna's 'work' in the studio uses vernacular from jazz dance with splashes of ballet and disco. What is clear in the video's narrative is her *desire* to move with and like others, to grow her physical agency into new behaviours with new people, and, through dance, share with a diverse but equal collective. This desire is strong and unrepentantly embodied, as images of moving with others shift between abstracted, but potent, sexual intimacy, trance-like abandon on a darkened dance floor, and skilled dance sequences on the video game. Madonna's choreography does not copy the movement with others, but it embraces it and responds to it. Much could be written about the power and hierarchy implicit in a white, wealthy, mature female rock star moving within a group of people of vastly different ethnicity, age, and socio-economic standing; her status is reinforced in so many ways. But this video presents a narrative that places dance as the primary embodied identity and suspends all other aspects as secondary. It asserts, despite this diversity, the transferability of dance within danced identities and the common ground created when this shared exchange occurs. Like dance in so many music videos, 'Hung Up' employs dance to formulate the embodied identity of the song, and through the song, the artist. As a kinaesthetic, action-based instrument, it taps into the identities of the

artist – both fixed and fluid – and reinforces these identities with something that can be observed, experienced, consumed, extended, or transferred.

In both videos, the stars in their roles as singers and dancers continually renegotiate their embodied identities between ones of elevation and ones positioned within a collective. The reactions to and participation with the songs by all actors in the videos are so deeply embodied, laying groundwork for similar participation by the videos' spectators as well. By considering dance as action-based rather than simply a visual component, one can see the potential for the design and integration of dance into these music videos provide a potent tool for connection between the song, the artist featured, and his/her audience.

CHAPTER ELEVEN

Audiovision and *Gesamtkunstwerk*: The Aesthetics of First- and Second-Generation Industrial Music Video

Michael Goddard

Introduction: Industrial music, video, and audiovision

Michel Chion has famously and provocatively referred to film as a sound art (Chion 2009), developing his earlier reading of cinema in the synaesthetic audiovisual terms of audiovision (Chion 1994). Similarly, it is possible to argue that industrial music from its beginnings with groups like Throbbing Gristle (TG), Cabaret Voltaire, SPK, and others was an audiovisual artform, as much as a musical one, and never simply a generic sonic style. The visual aspects of industrial music were not necessarily limited to film and video and included such things as the development of logos and other design features on record sleeves and as concert backdrops, as well as specific uses of photography and other visual arts. These visual elements were often deployed via strategies of anonymity and ambiguity, generating meanings out of a deliberate and playful constitutive vagueness. However, whenever it was technically feasible to do so, industrial groups made use of

both film and video technologies, and in terms of the latter were pioneers in the combination of music and video, before and outside of its commercial codification.

Throbbing Gristle, for example, included in their first official album *Second Annual Report* (1977), as the whole of its second side, the soundtrack to the barely seen TG precursor Coum Transmissions' film *After Cease to Exist* (1978). The title and content of this track were inspired by Charles Manson, and the film was described in Simon Ford's book *Wreckers of Civilisation* by Genesis P-Orridge in the following terms: 'Thee [*sic*] voices are of a pathologist discussing a murdered teenager's body found at a roadside. Thee [*sic*] murder victim had been killed by a homosexual ring by Bishop Gleaves that specialised in hostels for young runaways [*sic*] boys' (P-Orridge in Ford 1999: 12.27).[1] The first and last five minutes of the fifteen-minute film were left deliberately blank to allow the audience to concentrate on the soundtrack and the visual section consisted of fetishistic scenes of Chris Carter tied to a table and apparently castrated by Cosey Fanni Tutti, a similar scene of Sue Catwoman being tied up in an iron bed, as well as some live footage of TG (Ford 1999: 7.8). Later they would compose music to accompany Derek Jarman's experimental film *In the Shadow of the Sun* (1981), and also incorporated projected film into their live performances. After all two of their members had backgrounds in music visualization, Peter Christopherson as a member of Hipgnosis designing record covers for progressive rock groups and ultimately becoming a prolific music video director in his own right, while Chris Carter, in addition to being a TV sound designer, also produced light shows for big rock groups. Even the anti-spectacle of early TG releases such as the plain white album cover of *Second Annual Report* needs to be understood as a deliberately designed anti-spectacle that would be complemented subsequently by a range of visual expressiveness from logos and paramilitary fashion, to film and video. As the group put it themselves at the time: 'Make your own TV, do your own video, your own image. It's a quick new form of communication that's all' (Dwyer and Throbbing Gristle in Vale and Juno 1982: 65). According to Nick Cope, 'A punk /D.I.Y sensibility for multimedia production was fostered by the axis of groups coalescing around Throbbing Gristle's Industrial Records label which included Clock DVA and Cabaret Voltaire from Sheffield' (Cope 2012: 27), and this sensibility further fed into the development of 'Scratch video' in the early 1980s (2012: 30–37).

Cabaret Voltaire took this audiovisual tendency even further than other industrial groups since they began as a cut-up art rather than music group, equally montaging video and sound material from the mass media, popular culture, and other sources. By the late 1970s they had established their own video production company, Doublevision, that not only released their own music videos and live performance footage but also did the same for other groups like Clock DVA. As presented in the *Industrial Culture Handbook*

(1983) 'their newest tool is video, their newest venture a video company, *Doublevision* (thanks to a high speed duplicator)' (Vale and Juno 1983: 45). In the same publication group member Stephen Mallinder stated, 'Now our visuals have video as an outlet. And the use of video means we can document a lot easier. I don't think we're neglecting the music side but you've got to be aware of the age we're in. The visual side is a much more potent form of feedback' (Vale and Juno 1983: 45). Essentially for Cabaret Voltaire at this point in their history, video enabled the articulation of a synaesthetic mode of expression, capable of expressing a sense of rhythm, not restricted to being a merely sonic phenomenon. This is especially clear in their early video work for tracks like 'This Is Entertainment' in which primitive video effects, screen text, and cut-up photographic images operate as a synaesthetic remediation of the medium of video itself.

By the time of later tracks like 'Sensoria' this video editing has become a lot more sophisticated without losing this synaesthetic rhythmic dimension, yet still remaining far removed from the now-established MTV aesthetic. As with several industrial groups, the direction they would develop in was increasingly that of creating both film soundtracks and producing audiovisual artefacts, in other words, a form of audiovisuology rather than simply visualizing music.

Even in this early period two things can be noted about the industrial music use of video. Firstly it is not seen as a mere supplement to sound and music but an integrated mode of communication, even if to begin with it was technologically primitive, and often used for quite conventional purposes such as recording live performances and making 'anti-promos' to accompany tracks that were highly unlikely to be seen on MTV. Secondly it was part of an experimentation with alternative modes of cultural media production, with the idea of circumventing the music industry in favour of network communication with enthusiasts directly via mail order and other channels. Far from music industry funded video production as the advertisement for a musical commodity based on a star persona, industrial music video was cheap, experimental and at times, as in SPK's use of autopsy footage to accompany the track 'Despair', viscerally confronting (On SPK see Vale and Juno 1983: 103, 104).

This is not to say that all industrial groups were drawn to or able to incorporate video in their work, whether for aesthetic or economic reasons. However, in the cases that will be examined in the rest of this chapter, film and video played an essential role, and were incorporated into the very functioning of the groups themselves in different ways as multimedia spectacles. Test Dept in the UK and Laibach in Slovenia both began in the early 1980s and both took industrial music in a more overtly political and collective direction than the individual expressionism of contemporaneous groups like Einstürzende Neubauten in Germany or Whitehouse in the UK. More than this, both these groups adopted a form of 'cold war poetics' expressed as much through visual elements and performance as by the

music itself. Both also had explicitly visual 'departments' including film and video production activities as an integral part of their aesthetics. It is perhaps unsurprising that they felt a mutual affinity, even if on the surface the political aesthetics that they adopted appeared to be radically different.

Program for progress: The audiovisual political mise-en-scène of Test Dept's total state machine

Test Dept, unlike some of their industrial predecessors with their arts and media backgrounds, emerged from far more proletarian origins in depressed industrial areas of south London. This perhaps accounts for their more literal interpretation of the industrial in the scavenging and reclamation of discarded industrial materials as the basis for their rhythmic percussive music. This did not, however, preclude an interest in modernist aesthetic ideas, even if they took more inspiration form Soviet avant-garde aesthetics than from mass murderers and occultists. In fact, Brett Turnbull, responsible for most of the film and video for the group, saw a direct resonance with Soviet Proletkult aesthetic practices such as the use of agit-prop trains when Test Dept took to the road during the miners' strike:

> I loved the idea of the early agit-trains going out just after the revolution. It could be a mobile film studio/laboratory/theatre. They would shoot film wherever the hell they ended up in the new Soviet Union, and edit and show it to people wherever they arrived. The purpose was to agitate; it was about propaganda but also education. (Turnbull in Test Dept 2015: 24)

Test Dept's extraordinary video work is especially evident on the video collection *Program for Progress* (1982–1984), the video elements largely though not exclusively directed by Brett Turnbull. This section will explore some of these works in relation to a number of other works and artefacts from which it seems to have drawn inspiration. These connections will be with industrial film and culture, Soviet agit prop, and Polish revisionist cinema. I will proceed by a principle of audiovisual montage, hopefully resonating with Test Dept's own procedures or those of their avant-garde constructivist forerunners.

The name 'Test Dept' is a direct reference to industry, even as they put it 'a very direct, even naïve one' (Test Dept 2015: 24); in any type of industrial production it is necessary to test the product, to know how it will behave under extreme and adverse conditions. This was especially in relation to the automotive industries as well as the military where the development of vehicles designed to go at ever greater speeds needed to be thoroughly tested to gauge at what points they would break down. This crash testing

was initially with human subjects but soon led to the fabrication of crash test dummies, whose appearance took on a significant role in contemporary industrial culture and its poetic imaginary.

In as much as industrial culture has invaded every aspect of twentieth-century life, we are all crash test dummies, with the often gruelling and toxic processes of industry being tested on our bodies and brains. However, in the case of Test Dept there is an ambiguity at work, since the group were also the experimenters and testers of new insurrectionary post-industrial possibilities for life and society, after the decay of industrial culture by making resourceful use of its abandoned materials. Finally there was another aspect of testing involved which is that of the television test pattern, used by engineers to test that a TV transmission is functioning and also appearing at moments of technical breakdown and censorship, via a usually comforting image. Test Dept would also begin some of their own videos with their own test pattern, indicating that they were presenting an alternative to television, or even an alternative form of television via their site-specific industrial audiovisual performances, in which television sets were sometimes used as significant props.

For Test Dept, the engagement with this side of industrial culture was less nihilistic than critical, ultimately opening up the radical collectivism of later projects by means of an unrelenting critique of consumerism, as one aspect of the 'unacceptable face of freedom' to cite one of their album titles. In the video for Test Dept's 'Compulsion', the obsession with car culture, spoken of so enthusiastically by J. G. Ballard in works like *Crash* (1973), ends up on the scrap-heap of the post-industrial landscape, while the consumerist desire associated with both the automotive industry and media culture is revealed is nothing other than machine-like behaviourist compulsion. All of this is given a humorous treatment as coins are extracted from a video game parlour to pay for an unusual spray painting operation applied to human subjects rather than cars.

Nevertheless, the idea of industrial testing as practised by Test Dept is rather different to that of its earlier industrial predecessors. It has to be remembered that for first-generation industrial groups, the industrial aesthetic was just a name for a certain lo fi synthetic music, as well as a satirical broadside at the mass-produced nature of contemporary music. If the results somehow contained traces of the post-industrial environment of 1970s London, this was almost aleatory, and certainly not a reflection of how the music itself was produced. Test Dept was industrial in a more literal, and direct way, firstly being based on the resourceful appropriation of discarded industrial materials and re-using these as compositional elements, a practice they shared with their German contemporaries Einstürzende Neubauten, albeit in a totally different manner and context (see Emmerling and Weh 2015: 34–46). While Neubauten was a kind of urban gang of misfits, each expressing their individuality and rejection of industrial mass conformist culture ironically via a range of expressive industrial means, Test Dept

adopted a collectivist approach, frequently evoking the state socialism of the Eastern Bloc and in this way shared more with Laibach than with Neubauten in a mode of operation utilizing numbers and anonymity. Nevertheless, while Laibach's anonymous strategies aimed to dissolve individuals into a faceless and hierarchical pseudo-institution, Test Dept were producing a nameless proletarian machinery out of the ruins of industrial culture in a quite literal way – even if both used the language of totalitarianism, propaganda, and the state, this was not at all the same state, and nor was it imagined from the same perspective. One only has to compare audiovisual documents to see how clear these differences between these second-generation industrial outfits were. In Einstürzende Neubauten's video for Armenia, for example, a ruined factory and industrial waste are only the theatrical props for the expression of an Artaudian scream, supported by some fairly, even deliberately, conventional instrumentation and compositional elements. It is Expressionism or even Romanticism deploying the machine against industrialized Cold War society.

Completely different to this is the first video off the *Program for Progress* collection, 'Cold Witness', in which abandoned industrial space is inhabited and subverted from within, via the ritualistic relocation of objects and the appropriation and burying of that supreme instrument of industrial domination, the clock. In this video there is an entire industrial poetics in which image and sound work together to embody the ideas of both survival in harsh industrial conditions and the resourceful appropriation of these elements, echoed in the sound by the 'found percussion' and use of early sampling. In terms of what we see there is a kind of industrial creature worthy of Lynch's early work, who fashions a kind of divining rod or compass leading to the discovery of the clock face that seems to be at the heart of a diabolical industrial mechanism.

This clip is noteworthy for another reason as well. The entire video for *Program for Progress* (1982–84) was produced as an audiovisual document, prior to the music being released on the *Beating the Retreat* (1984) album. While visual material had already been given prominence by industrial groups as already indicated, Test Dept had a more complex audiovisual strategy in which multiple projections were intrinsic to their often site-specific performances, slide projections complementing the screenings of films, and TV propaganda blaring from TV sets appearing as a key aspect of their mise-en-scène. To fully grasp these audiovisual strategies though, it is necessary to look at another context, that of the Cold War, the Eastern Bloc, and what Alexei Monroe in an interview with Thomas Bey William Bailey has referred to as 'cold war poetics' (Monroe in Bailey 2011: 429).

Discussions of the visual influences or perhaps rather repertoire of Test Dept often end up with Russian and Soviet referents from Malevich's Black Cross, to the cinema of Eisenstein or Vertov. In the words of one commentator on *Program for Progress*:

This was a nostalgic world of steam, engineering, the machine, functionality, David Lynch's *Eraserhead* (1977) meets *Battleship Potemkin* (1925), Tarkovsky colluding with Rodchenko. (Rimbaud in Test Dept 2015: 55)

This range of influences, of course, derive from diverse and eclectic contexts that at the time were often in contradiction and contestation with one another; for example, the well-known antagonism between Eisenstein and Vertov, over both understanding of revolutionary cinema and over the uses and effects of montage, the conflict between avant-garde montage aesthetics and the doctrine of socialist realism, not to mention the rejection of montage aesthetics by later Soviet filmmakers like Tarkovsky. Unlike the more studied appropriations of these aesthetics in post-1968 militant cinemas, this was more an available image resource that could be mined and appropriated just as Test Dept found and repurposed discarded industrial material for percussive instruments. While certain Test Dept films display montage tendencies, they are just as affected by socialist realist tropes, nowhere more evident than in their adoption of the figure of the Stakhanovite shockworker, a device used in the Soviet Union and its satellites as a tool for the realization of five-year plans and to increase production quotas.

FIGURE 11.1 *Test Dept 'Shockwork' video (Test Dept/Barclay/Delaney, 1983).*

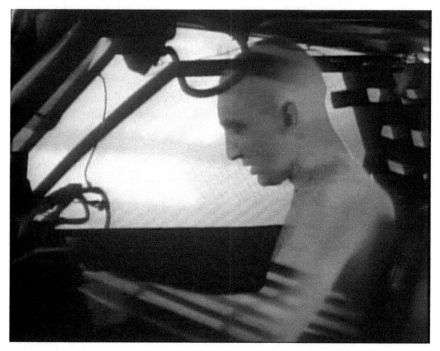

FIGURE 11.2 *Test Dept 'Compulsion' video (Test Dept/Turnbull, 1983).*

The actual Stakhanov movement, emerging through the state capture and exploitation of the working practices of dedicated communist workers like Stakhanov himself in the 1930s was, of course, less a movement than a state appropriation, designed towards the ends of supporting both the ideological and production goals of the Soviet state, which is clearly apparent in Soviet propaganda films of the time. There is certainly something of this monumental, industrial heroic tone in the Test Dept video for 'Shockwork', a direct reference to the Stalinist era and its associated representational policies of socialist realism. Combining as it does footage of South London industrial sites with that taken on a trip to Poland, the Cold War poetics mentioned above are fully evident.

This raises the question of what function this socialist realist imagery played in the aesthetics and politics of Test Dept, and their awareness of the problematic ideological functions of these figures as actually deployed in the Soviet Bloc. In fact Test Dept were far more aware of the shortcomings of Soviet style socialism than most groups, with Test Dept member Paul Jamrozy having visited Poland under martial law, and the group would also tour there in the mid-1980s, as well as maintain links with artists from several Eastern Bloc countries as well as from Yugoslavia. The use of this imagery

is both a provocation against Western values of freedom and individuality, whose despotic sides were becoming increasingly apparent in Thatcherite Britain, and the desire to reclaim the positive dimensions of discipline, collectivism, and solidarity as instruments of both art and struggle. This was both as a provocation to the West and as a critique of the corruption of these values in the East. As such they generated their own version of an 'aggressive inconsistent mixture', as Žižek famously identified in Laibach (Žižek 2009: 96), only from a very different position and also with a markedly different strategy not only to Laibach but to most industrial groups dealing in transgressive or disturbing imagery. There is no ambivalence here but rather the expression of the conflicting facets of a proletarian industrial culture, as if the figure of the Stakhanovite shock worker could be liberated both from its capture in the Soviet state machine and from its rejection in the British context where a war was going on against industrial working-class culture and communities. In this context Test Dept's 'Total State Machine' was both highly critical of both East and West existing models of states, as well as of middle-class bohemian libertarian anarchy, and also generative of revolutionary forms of industrial subjectivity based on discipline, collectivity, and solidarity, as would become abundantly clear in their participation in a range of struggles including the miners' strike

A key dimension of this strategy was clearly influenced by the Polish experience of the *Solidarność* (solidarity) union and the mass movement it gave rise to. However different the politics involved in this movement, which afterwards would be revealed to be highly reactionary, nationalist, and religious, Test Dept were able to detect in the actions of the striking Lenin shipyard workers a legacy going back to the heroic phase of the Russian revolution, to Proletcult, and even the figure of the Stakhanovite worker. Famously this figure was revisited in the Andrzej Wajda film *Man of Marble* (1976), which tellingly juxtaposed the construction of this heroic worker figure under Stalinism with media work in the present and its (supposedly) soft but nonetheless effective regimes of censorship, making it virtually impossible to address difficult subjects such as the recent political past. Whether or not Test Dept was aware of this film, highly influential on both a new era of realist cinema in Poland and arguably giving ideological support to the Solidarity Movement itself, it nevertheless constituted a key moment of revisionism in Eastern Bloc history, which would soon be replaced by a new phase of the Cold War, in Poland characterized by the period of martial law.

These Polish events as well as the artistic response to them were arguably synechdoches for Eastern European experience as a whole in a process that goes back at least to the Second World War, where Poland entered the Western imaginary, for the brutality of its Nazi occupation and subsequently the holocaust, but also acts of resistance. Later on there was a kind of leftist British love affair with Polish cinema in the 1950s, for example, on the part

of the Free Cinema movement which, however incorrectly, saw a range of Polish filmmakers, from black series documentary filmmakers to fiction filmmakers like Wajda, as a type of artistic left dissident opposition to the regime, an attitude that was revived during the pre-solidarity period of the late 1970s and the so-called Cinema of Moral Concern. Rock music had also re-imagined Poland from David Bowie's Warszawa to Joy Division's name and thematic obsessions. Test Dept both continued these traditions and challenged them, at least partially since they had direct experiences of Poland. All of this is directly embodied in the track 'Gdansk', which in its airing on the youth TV programme *Red Herring* was the first moment of contact with the group for many people who would subsequently become their fans. It is hard to imagine a stranger spectacle appearing on British TV than this and is also remarkable for the way the group were able to transform their site-specific performance work for a televisual studio setting. Again the idea of the group as providing a radical alternative to TV culture and propaganda is emphasized through incorporation of TV sets spouting propaganda, while a Stakhanovite ritual is staged live, accompanied by modernist classical music (apparently inspired by Polish composer Henryk Górecki's 'Symphony of Sorrowful Songs') in a performance that is still 'noisy' today in its absolute anomaly to television norms past and present, despite the quietness of the soundtrack. This chapter will now turn to examining another example of industrial Cold War poetics, namely Laibach, operating at first from the other side of the curtain, or rather between East and West in state socialist Yugoslavia.

'You Will See Darkness': Laibach TV, video, and audiovisuals

Laibach from its opening action of a proposed art exhibition and concert *Red Districts* in Trbovlje (which was recently recreated at the thirty years of Laibach and Neue Slovenische Kunst (NSK) symposium) has also been an essentially audiovisual phenomenon. This is perhaps so obvious as to not need stating especially for anyone who has attended a recent Laibach performance and experienced the complex interweaving of sonic, video, lighting, and textual elements, all of which are intrinsic and in no way incidental to the total performance. In fact in addition to the many other departments listed on the NSK Organigram, many of which deal with visual or audiovisual phenomena from architecture to ballet, there is clear reference to a film and photography department – associated in some instances with the name *Retrovisja* (Retrovision), which for a time produced regular NSK news bulletins, and was also adopted by some of the documentary makers working closely with Laibach.

This section will therefore track some of the audiovisual strategies in Laibach ranging from the notorious 'Bravo' TV interview, through their participation in and/or production of a number of documentaries and videos, to the use of video and lighting in their contemporary live performances. The argument will be that they can best be grasped as a form of audiovision rather than in purely either musical or visual art terms, as the mise-en-scène of a *gesamtkunstwerk* of rhythmic power, hyper-identification, and somatic intensity. In this way there is an appropriation of the concept of audiovision that Michel Chion developed in relation to cinema to emphasize the fact that cinema is essentially a synaesthetic audiovisual medium rather than a merely visual one with sound in a secondary role, that sound is as determining of cinematic perception as the usually privileged regime of visual images. In the case of Laibach, to speak of audiovision is rather to emphasize that the sonic and visual expressivity of Laibach, whether in live performances, video, documentaries, or other manifestations, is always essentially audiovisual and is never just a case of decorative imagery to accompany the music nor the sonic reflection of a privileged visual art practice, but a synaesthetic audiovisual event operating on multiple senses and via multiple media at once.

Aside from Laibach's early, and notorious, multimedia performances, the most visible conjunction of Laibach and audiovisual media was undoubtedly the 'mousetrap' situation of their appearance on Slovenian RTV, conducted as a kind of show trial by television by the host Jure Pengov, and in which almost every element of televisual discourse was effectively subverted. Everything about this TV appearance had been carefully chosen from the location in the ŠKUC gallery in Ljubljana (or, in other words, on home territory) to the costumes worn by the group, the Laibach Kunst visual works in the background of the scene, to the use of posture, gesture, and prepared statements. Every attempt on Pengov's part to individualize and humanize the group was a resounding failure, as instead of going along with this strategy at once that of state power and cliché-ridden rock journalism ('what do you do professionally, how old are you'), Laibach responded with a total absence of spontaneity, reading out prepared statements: 'We are the children of the spirit and brothers of might'. Describing themselves also as the first TV generation, they demonstrated their superior understanding of the medium as a form of collective mass communication and indoctrination by refusing at every turn to fall into the discursive traps Pengov was setting for them, responding to his 'trial by television' with enigmatic yet consistent statements at once performing and affirming collectivism, depersonalization, and fanatical devotion to art. From the first moments in which the group indulgently educated their host and audience about the historical provenance of the name Laibach, a name whose use on their part would subsequently be banned, to the final statements about the powers and potential of media manipulation via television, Laibach completely controlled the course of the

interview, even including the post-produced final statement by Pengov, as the camera scours the illuminated from below faces of Laibach: 'maybe now someone will get moving and prevent, repress these dangers, these horrible ideas and statements, right here in the middle of Ljubljana'. This not only revealed the obscene side of the state and its use of media instruments but demonstrated the effectiveness of Laibach as a collective machine, plugged into media systems, whether of television or popular music, and appropriating them as part of their own totalizing work of art. Pengov's attempted trial by television only served to intensify these operations.

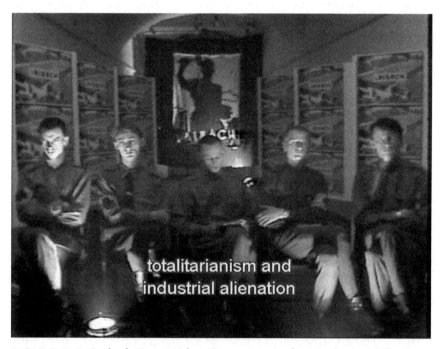

FIGURE 11.3 *Laibach 'Bravo' television appearance from* Laibach: A Film from Slovenia *(Landin and Vezjak, 2004).*

Since this early foray into state television, a quite substantial audiovisual Laibach archive has been established via several documentaries, tour films, music videos, and other works that defy straightforward classification. It will not be possible to survey this entire archive but it is worth discussing and looking at some key examples. First, however, it is necessary to underline that just as the aesthetics of Laibach and NSK is based on multiple reappropriations of what Žižek has termed an 'aggressive inconsistent mixture' of symbols and ideologies, so too is the audiovisual

archive, which consists of multiple repeated components and genres, which keep getting remixed across different works according to retro-avant-garde principles of creating the new out of the old and showing what is already old in the new. The first film to be discussed, for example, *Laibach: A Film from Slovenia* (originally entitled *Bravo*, Slovenia; UK, 1993), contains almost the entirety of the Pengov interview, several of the key Laibach music videos also almost in their entirety, as well as footage from the *Divided States of America* tour, Tito's funeral, and other newsreel footage: this reappropriation or rather 'Recapitulation' to appropriate the title of one of Laibach's first albums available in the West is typical of the audiovisual material produced by, and about, Laibach, and also reflects the NSK practice of mutual reference between the various departments of NSK such as Irwin, Novi Kollektivism, the various theatre groupings, and Laibach themselves (references to which also appear in the audiovisual archive). This dense network is perpetuated both by filmmakers with strong links to the group and relative outsiders, as a kind of totalizing effect whereby the audiovisual discourse *on* Laibach becomes inevitably *part of* the Laibach machine and likely to be subject to further reappropriations, condensations, and recapitulations.

Daniel Landin and Peter Vezjak's film, which was scripted by the UK music journalist Chris Bohm, while more or less an official account of the band made both for Slovenian TV and for release in the West via Mute Records, is not merely, however, an assembly of these various pre-existing materials. What is fascinating about the film is the way it is addressed not to the audience but to Laibach themselves, according to a quasi-masochistic and theological economy of desire and abandonment: 'Oh Laibach, why have you forsaken us in our hour of need?' Beginning with this seemingly grandiose and over-inflated call for Laibach to reappear and take charge of the specific historical moment of post-communist transition circa 1990, the film proceeds to inscribe Laibach into Slovenian, Balkan, and Cold War European history, echoing the aesthetics of Laibach themselves and gestures such as their 'Occupied Europe' tours in both the West and Warsaw Pact countries, or their appropriations of Western pop culture, reworked to bring out its totalitarian dimensions. The film in fact begins in a cosmic metaphysical realm, illustrated by the NSK theatrical manifestations of retro futurist space travel, but quickly descends into the fraught political constitution of Cold War Europe as experienced form the uniquely in-between space of Slovenia, and more specifically from the perspective of Laibach.

Another telling aspect of this and other Laibach documentaries is the strong association between Laibach and various manifestations of political theory, whether expressed by Laibach themselves (especially by Laibach member Ivan Novak) or more commonly the now well-known take of Žižek on Laibach, as directly expressing the obscene 'hidden obverse'

of state ideology, which he argues is precisely why Laibach are not, and cannot be, fascists (see Žižek 2009: 96). As it passes form archival materials presented via a poetic and enigmatic narration, to various live and video manifestations of Laibach Kunst, the film recreates the kind of aggressive inconsistent mixture that Žižek is discussing in the film, by refusing most of the standard tropes of the expository or music documentary; instead of band interviews there are militant prepared statements; instead of tour footage of the band there are highly stylized performances and confrontations with fans (especially form their US tour), and ultimately the film is posed as a series of questions to Laibach rather than any explanation of their aesthetics to an audience.

The later documentary *Predictions of Fire* (*Prerokne Ognja,* Michael Benson, 1995) repeats this focus on symbolic elements, especially fire, for example, by including an archival industrial film about the conditions under which objects will burst into flames and using this as an emblem of the explosion of ethnic conflicts in the Balkans that Laibach serve prediction and warning. Again the film makes references to the cosmos (as did the earlier *Bravo*) and it is probably the most aesthetically and politically complex of these two documentaries in its montage of different elements directly and indirectly connected to the history of Laibach. Žižek, for example, reappears but in a much more stylized setting and there are textual theoretical references not only to his work but to other philosophical perspectives like those of Deleuze and Guattari. There are also interesting sections of the film dealing with other NSK branches such as the visual arts group Irwin, especially in relation to an NSK exhibition deep within a coal mine, a type of location that Laibach themselves have recently returned to, and the Black Square/Red Square action that took place as part of the NSK State in Time embassy in Moscow project.

This account of Laibach documentaries would not be complete without mentioning some of the more recent works made by Laibach themselves, especially the one accompanying the release of *We Are Time* (2003) and included with the Mute records DVD collection of Laibach videos. Presented as a kind of state propaganda film with an amiable American accented female narrator, this film is divided into three parts: 'Past: Perfect', dealing with the history of Yugoslavia up until the appearance of Laibach; 'Past: Forward' dealing with the history of Laibach themselves, very much in the style of state propaganda established in the archival materials of the first part, and finally 'Present: Tense', a deadpan track by track commentary on some of the songs of *WAT* by the group's singer Milan Fras. What is notable here is again the repetitions and reappropriation of some of these earlier materials already mentioned, but this time as part of a propagandistic narration of the group's triumphs in the form of a state propaganda film.

Laibach's music videos present different yet related strategies to the documentaries already mentioned, perhaps unsurprisingly, given that the directors of the Bravo film, for example, also directed several of the key music videos from the 1986 'Država' (The State) to tracks from the *We are Time* album like '*Tanz mit Laibach*' (2004). Yet whereas the documentaries tended to be assembled montages of heterogeneous audiovisual materials of different provenances, each video develops a specific aesthetic concept standing as a complete work in its own right, in conjunction with the music. While clearly incorporating visual and performative ideas of their directors, they also bear the imprint of Laibach's own audiovisual strategies, which become fused together to the point of being indistinguishable from other Laibach productions and part of the total work of art of Laibach Audiovision.

The first and perhaps key Laibach video, directed by Daniel Landin, is entitled simply '*Država*' (The State). Notably the video features the dance performance of Michael Clark, who had already collaborated with post-punk groups like The Fall. The video provides via relatively simple means a kind of condensed mise-en-scène of Laibachian state aesthetics expressed via elements ranging from the backdrop with the by-now-familiar Malevich cross, to the emphatic trumpeting and military drumming of the band (which is theatrical given that these sounds are appropriated and electronically manipulated ones), to the use of quasi-military uniforms, lighting from below in stark black and white high contrast, and especially the ecstatic and abstracted expressions of the band members who seem to be caught up in a state ritual transcending and rupturing individual identity. While there are stark contrasts between the singer's almost barked vocals and stiff military posture, and the fluid expressiveness of the dancers, the overall effect is to give the sense of a state ritual, with definite references to the mise-en-scène of films by Leni Reifenstahl like *Triumph of the Will* (1936). The video also played a key role in the translation of Laibach to new audiences, signalled by the trilingual rendering of the title in Slovenian, English, and German, a linguistic strategy that would continue up to the present. As such, this video anticipates Laibach's later strategies of intervening into Western popular culture through their practices of new originals while constituting an autonomous and uncompromising aesthetic creation.

Quite different strategies are evident in the period of Laibach's 'New Originals' that make up much of the *Opus Dei* album (1987) when they were reworking key moments of Western pop culture to bring out their hidden totalitarian reverse as Žižek might put it. It is in these videos that a kind of 'blood and soil' iconography is apparent, mixing image repertoires from Slovenian and Balkan folklore with imagery with more Nazi associations, as is especially evident in the '*Opus Dei*' (Life is Life) video. A more complicated example of these multiple appropriations is evident

in Laibach's video for the Rolling Stones cover 'Sympathy for the Devil', directed by Peter Vezjak. It has to be remembered that this is a song already subject to East-West appropriations since it was inspired by the Bulgakov novel *The Master and Margherita* (arguably already appropriating universal themes of God and the Devil to a Russian context), which was then adopted by the Rolling Stones, who domesticated this transhistorical figure of the devil to little more than some bad boy rock posturing. Laibach, however, restore both the Eastern and the satanic dimensions to this track, both through their sonic treatment but also in the audiovisual mise-en-scène of the video. In this scenario, the singer's bass-processed voice suggests satanic resonances, and the song is appropriated to being about Laibach's own mythology: 'but what's puzzling you is just the nature of my game'. The game is further played out via an at-once folkloric and national socialist mise-en-scène in which the excessive enjoyment of the group at a castle banquet parodies the Western stereotypes about the East that led to the creation of mythologies such as of Dracula – the hunks of meat tossed nonchalantly at the Alsatian dogs providing the finishing touches.

FIGURE 11.4　*Laibach 'Opus Dei' Music Video (Landin, 2004).*

FIGURE 11.5 *Laibach 'Sympathy for the Devil' Music Video (Vezjak, 2004).*

As with the other Laibachian aesthetic strategies, their videos have been subject to change over time and quite soon after this adopted a quite distinct set of tropes to do with animation, cyborgs, retrofuturism, space travel, and the NSK state in time. This was already becoming apparent in the *Metropolis* like mise-en-scène of 'Wirtschaft ist Tot' from the *Kapital* (1990) album, in which the band members were covered in silver paint and futuristic outfits suggesting a post-human metamorphosis, but it reaches an apotheosis in the video for 'Final Countdown' (1994), which is entirely digitally animated and features an assemblage of both retro and futurist technologies, culminating in the establishment of the NSK embassy on Mars complete with Plečnik's never realized architectural design for a Slovenian parliament.

Before concluding this discussion of Laibachian audiovision it is worth returning to the question of Laibach's live performances which have always been an audiovisual phenomenon in which costume, staging, lighting, and increasingly complex uses of video play a vital role. In the contemporary period, Laibach perform with double screens featuring video material, some of which remixes the archive already referred to, and some of which brings in new and unexpected elements, accompanied by phrases in the three

languages already referred to. In conjunction with the lighting and other elements of staging (costume, use of megaphones, posture, and gesture) this audiovisuality is part of what makes Laibach performances uniquely intense, synaesthetic ones, rather than simply being industrial rock shows; the visual dimension also serving to communicate specific meanings such as the incorporation of reprocessed footage (in a Pop Art style) from *Deep Throat* (1972) to accompany the track 'America' from the *Volk* album (2006) (this was particularly effective when Laibach were invited to an event sponsored by the US embassy in Ljubljana and this was one of their three contributions to the evening's proceedings). A recent highpoint of this was their 'Monumental Retro-Avant-Garde' performance at the Tate Modern in April 2014, which began with a Yugoslav propaganda film, followed by the recreation of one of their earliest performances with its original line-up, before finally progressing onto their more recent material (a good deal of which is also a retro reprocessing of their early material). The rich audiovisual juxtapositions at work here worked especially well in the monumental industrial space of the Turbine Hall, far removed from the kind of spaces that Laibach would usually get to play in in the UK, and approaching their ideal of a total synaesthetic audiovisual *gesamtkunstwerk*.

Conclusion

This chapter has explored the industrial music use of film and video from first-generation industrial groups such as Throbbing Gristle and Cabaret Voltaire to the Cold War poetics of Test Dept and Laibach. It is clear from this engagement that while these groups were fundamentally audiovisual phenomena, their uses of audiovisuality did not correspond to normative ideas of music video forms, even when examining their actual production of music video rather than the wider multimedia performative strategies and experiments engaged with. As such industrial music video can perhaps best be seen less in terms of the industrial production of music video as a promotional commodity, than in terms of a complex, hybrid 'audiovisuology', to borrow the term from a recent series of German research projects investigating sound/image relationships across the history and diversity of media arts. As Dieter Daniels puts it, 'the analysis of sound/image relations can be classed as an exemplary case study for the entire field of art/technology relationships' (Daniels 2011: 10). Such an approach seems highly applicable to the synaesthetic and totalizing yet paradoxically artisanal productions of industrial music video, which seem to share more with the current digital, networked, and hybrid proliferation of heterogeneous audiovisual materials, than with the standardized production of MTV music video from their own time of the 1980s.

CHAPTER TWELVE

One. World: Self-Effacement of H. P. Baxxter in the Video Work of Scooter

Paul Hegarty

It starts with the sight of a rapidly retroing CD boombox placed on the cobbled Berlin street. As the electronically generated beats begin their monomaniacal thumping and stabs of crisp keyboard provide a counter-rhythm, two young men begin a curious type of dance, in 'jumpstyle' mode, one that in this song will transport them around a small part of the city, but will ultimately see them jumping globally. The dance is vigorous, gyroscopically challenging, when performed by the best of these 'Sheffield jumpers' (from Rotterdam). They stamp feet, swing arms lengthily, turn, turn back, turn on themselves, legs take off in jumps, circular leaps, hops. Each dance is a one-man casebook of compulsive dancing. And each dancer is in synch with his partner, or later on, many partners. As the dancers focalize areas of what by 2007 was the gentrifying heart of Cold War Europe, these shots intercut with Scooter singer H. P. Baxxter, in front of digitized shots of walls, graffiti-laden, hinting at the anarchist and often techno radicalism that had sustained underground culture in the last days of the Eastern regime. This song hints at the philosophical stance of the band Scooter, and 'The Question Is What Is the Question' seems also to beg the question as to what the answer would be. But in fact, in this respect, Scooter had changed little from their founding moment in 1993. The answer is always hardcore. The videos made to promote the songs are essential in revealing hidden complexity in the work of Scooter, and reflect back on the often banal

lyrics and simple music in ways that create a more critical refraction of the globalized cultural economy. In fact, as I will argue below, these videos offer a refreshing mode of distilling how a cosmo-homogenizing world actually functions for its users. Scooter's videos expand on the lyrics, tune and mission of this 'party band' to the extent where we can usefully call in the engaged deconstructive writings of Félix Guattari, Maurice Blanchot, and Franco 'Bifo' Berardi.

Scooter emerged as part of happy hardcore, a subroutine of rave music, and have been redefined as marginally different subgenres over the twenty plus years of their existence. Early tracks already had the solid, reliable beat, simple and insistent keyboards, lyrics about parties, having a good time. The videos were standard fare – club scenes, dancing, the band dropping in and out of the capers of the visual story, or performing on stage with female dancers on the edge of objectification, and the visuals would illustrate the music, act as backdrop for the simple yet extensive lyrics. The 2007 album *Jumping All Over the World*, from which 'The Question' springs marked a substantial change, possibly due to the influence of new arrival Michael Simon, but most particularly in the dramatic reduction of Baxxter's lyrical work in favour of a minimalized self-referential commentary. The videos of this period echo the change, with Baxxter separated off in his own temporary autonomous zone, then appearing in group shots, stage shows, driving a vintage car, but almost always set apart from the main fun. I think this setting apart, as marked visually, as stated lyrically, offers an engaged strategy of newly critical, perversely resistant culture, alongside the persevering glimpses of club-based party life. Musically, not much has changed, but everything has become cleaner, more condensed, 'gradually but constantly adjusting the winning formula', as Baxxter has it.[1] The method of taking an established song, sometimes getting it sung by a guest singer, at other times speeding up the vocals into helium hardcore mode, as punctuation for Baxxter's own writings, persists, as it has done since 2001. Scooter's music is in fact an accelerated montaging of popular musical culture, as they often use several source materials for each piece – sometimes one for the music, another for the chorus, still others for beats – which just leaves Baxxter's lyrical work, which aspires to emptiness.

But, to paraphrase Baxxter, the question is what is the punctuation that he offers in this global sound resculpting? Is he a drifting interloper in songs dominated by recognisable hook-driven songs retooled to techno beats? Or is his flow being continually dammed by the intrusions of a global culture of quotation? Either way, from 2007 on, the visual and audio elements of the songs feed off one another, establishing a structure through which Scooter's music works. Above all, this is music that needs to work, it cannot have downtime, its leisure is machinic pleasure. Félix Guattari might consider this as part of capitalist temporality, where 'time is "beaten"

by concrete assemblages of semiotization be they collective or individuated, territorialized or deterritorialized, machinic or stratified' (Guattari 2011: 107). I will argue that in fact, Baxxter's approach, mirrored in his placement in the videos, represents an undoing of this process, a radical re-beating.

In 'The Question' Baxxter gestures and poses, while making many rhymes in his trademark mix of absurd surrealism, non sequitur, love of hardcore and lines with very little sense except as part of a flow (like 'diggedy diggedy HP' or 'K nami nama/Like a hammer'). But this flow comes at the cost of meaning, logic, narrative connection, character development. In other words, it is language that strips itself down as it goes, an ultimate example of the MC art. Typically, the MC's role is to compere musical and lyrical events, toasting, boasting or even roasting the competition. Baxxter maintains the central part of the role, supplying affect, mood and impetus, and in 'The Question', fills much of his space in the song with words. Phat words. But great significance is applied to the statement of the title, which comes (at 2.54) into the song and only that once. Baxxter splits the title in two with a pause, rendering it as 'The Question Is/What Is the Question'?, at which point he is joined in shot by Rick J. Jordan on keyboards. Up until now, the group members other than the singer have been glimpsed fleetingly, but in isolation almost as marked as that of Baxxter. The pause becomes the site of the location of meaning, suggesting hedonistic loss of interest or memory/ loss of memory/aggressive rejection of the question or questioner. Further, it acts as a recursive return which questions direction and purpose. Further still it reminds me of linguistic definitions of sets where if 'the question' is the category of action or speech act, then we are still left with the question 'what is the question'? Finally, then, the question is debated as frame of itself, revealing itself as the frame of a frame as discussed by Derrida in his 'Parergon' essay in *The Truth in Painting*. All this serves to help us see that the manner of stating the query 'the question is – what is this question' opens up all kinds of philosophical questions about the nature of reflection itself, as noted by Martin Heidegger.[2]

This list is not at all exhaustive, nor are the options mutually exclusive, but much more interesting in terms of the interaction between sound and vision is that the eponymous phrase has featured up to this point as graffiti-like text on the computer-generated wall that simulates a street environment for the vocalist. At the moment of enunciation, the word goes from text to speech. This is not the achieving of a resolution or a making-real. Instead, it is the making of 'The Question Is What Is the Question' into a question, its vocal statement accreting another layer to its recursive drive, a layer that occurs visually, technically outside of language, but actually mobilizing other moments of writing. There's more, as the camera zones into close-up on Baxxter who separates out the words of the second part of the statement and barks them into the radio operator style microphone that fills his be-ringed closed fist. Baxxter also closes

the song with one of his trademark isolated slogan statements, in this case 'Can I have a light please?', following up an earlier instruction to smoke against the backdrop of the delegalization of public smoking: in 2007–08, cigarette advertising and public smoking were heavily regulated in Germany, to the point of interdiction, with the odd exception of exempt *raucherbar* locations ('Friends Turbo' [2011] ends with 'Can somebody tell me how to get off the bus?', 'Jumping All Over the World' with 'And Now all the Ladies to the VIP').

Baxxter's autonomy as MC is taken further in 'Jumping All Over the World', as he occupies a black area outside of time and space while two of the Sheffield Jumpers are transported to easily recognizable locations around the world, including Berlin again, UK, France, India, China, Japan, and a desert location. To make the identification crystal clear, the dancers may well be pictured in front of well-known monuments such as the Taj Mahal or Arc de Triomphe. Late in the song, as we cut to Scooter in concert, Baxxter lists a different set of places: England, Ireland, Scotland, India, Russia, Australia, the United States, Africa, Iceland, 'all over Europe and back to Germany, once again'. The way in which Scooter are shown in relation to this global jumping dominion is curious, though. The song announces the three members being paged as their flights are ready, but then instead of seeing Scooter travelling, or indeed jumping, all around the world, we see the Sheffield jumping duo. The concert footage extends the range of places that jumping will annex, but these are announced as a map, itinerary or log. Scooter are caught within the frame of the stage, presumably unchanging as they present their show to the fans in all these named sites. The combination of overly obvious 'world' locations and the homogenizing effect of touring leads to this video functioning as a detailed critique of top down globalization, for all that its participants revel in the spread of the hardcore message. The zones that dancing occurs in are the currency of films that aspire to global markets, and in parallel to this visual economy, the places themselves have become the currency of tourism. But two nerdish dancers jumping and twirling, synchronized as they traverse cultures and semiotic codes, unifies the sites in a way that acts as an alternative to homogenization based on mass appeal. Their improper action and mobility means they are no longer consumers of culture but responders to it. They are Scooter's emissaries as they bring the message of jumpstyle as the only way left to respond to the flattening of the world in commodification.

Another reading is of course possible, that the two dancers are part of the contemporary delocalization of labour, or even that they are forced to permanently migrate to find labour in the exploitative unity of the global economy, as 'in the universe of capitalistic refrains, everyone lives in the same rhythm and the same accelerated cadences' (Guattari 2011: 109). Ultimately, they must dance forever, wherever they are sent. But they do

seem to be believers, so perhaps we can unify cultural and economic models and conceive of them as members of a co-operative established under the Scooter brand. Whilst the dancers' journeys do not map entirely onto the list of places in the lyrics, they can also be thought of as the vanguard of the jumping movement that act as the catalyst for social change. Scooter imagine a worldwide hedonistic movement as a para-globalization, a posse that grows through its own drive towards being an elective community. Scooter's arrival consolidates the territorial gains of the Sheffield jumpers (although we have to presume their list reflects the places in which they already have most commercial success, as opposed to being their ideal set of countries they wish their message to get to). This perverse subsumption of global rhythm leads 'toward a rhizomatic mutation, deterritorializing traditional rhythms (biological and archaic), nullifying capitalistic refrains and opening the possibility of a new relation to the cosmos, time and desire' (Guattari 2011: 114).[3]

Once again, H. P. Baxxter is the facilitator, leading the charge, inspiring the dancers and anyone else who wishes to hear more about jumping all over the world, and nodding benevolently as he observes from his black box isolation. His blond hair, sparkling silver rings, shiny eyes, and paleness contrast strongly with his designated visual background, and his movements and vocal intensity make of him a permanent emergence. After the paging call to messrs Baxxter, Jordan, and Simon, the song opens with the slightly distorted vocal, through the hand held radio operator microphone, and with the words, 'hardcore hardcore'. Hardcore is so important to Scooter it crops up everywhere. Some might see it as a badge of toughness, of an attempted credibility for what is essentially an attenuated pop version of tougher styles like breakcore or gabber. Hardcore techno, like hardcore punk, represents an attempt to nail down authenticity in a genre. But with Scooter, the term is over-used to the point where even they seem fatigued and refer to 'core'. So what does hardcore mean to Baxxter, that it needs such restating? At a basic level, the use of the term indicates fidelity to a movement or style, so it speaks to those who remain faithful, who are ready to rock, jump, shuffle, or whatever else. In 'One (Always Hardcore)' from 2004, Baxxter declares that he *feels* hardcore. This leads us to the deconstructive revelation that to feel hardcore is to be it, and vice-versa.

Hardcore no longer refers to an *other* thing, it refers to itself, both one and not-one with the music termed hardcore; cause and effect, sound and affect. The double 'hardcore' that launches 'Jumping All Over the World' is that doubling – hardcore is a thing in its own right *and* demands a response that will also be 'hardcore'. It turns inward, but in a way that simply generates more hardcore, always more hardcore. Baxxter's reliance on the term is not slackness but a highly reasoned emptying of further non-identical meaning. In other words, hardcore does not represent (in any sense), nor can it be represented – it is a permanently renewable process

whose internal structure is like crystal – the same all the way down. Baxxter knows this, and trades on it from his black space booth.

Exhorting hardcore to come into being and maintain itself in the here and now and therefore always with the prospect of being forever, his rhymes are brought into a position of poetry undoing itself as a radical concretization of lyrics. These develop but without leading anywhere – as lines either do not connect or do so without narrative logic: 'Every minute, every hour/Get the power, take a shower'. Marcus Tan, writing of Psy's 'Gangnam Style', has argued that 'as a consequence of liquidity, both that which is solidly familiar and that which is foreign become liquefied; linguistic signifiers lose meaning in fluid contexts' (Tan 2015: 87). Where Tan reads 'Gangnam Style' as an unfortunate harbinger of the culture industry's reach, I take this liquidity as potential for subversive resistance, creating a site of language where meaning is meaningfully emptied.

After the verses in 'Jumping All Over the World', Baxxter gives way again to another sampled and heliumized song ('A Glass of Champagne' by Sailor (1973), one of their many forays into 1970s schmaltz pop) and the jumpers appear performing in various places, interspersed with cuts to Scooter on stage, with Baxxter offering encouraging and pithy statements. At the end, after putting in a lot of energy, doubled by the camera changing angle and distance in time with the beat, he stops, raises a hand and says 'And now all the ladies to the VIP'. Incongruous though this might seem (and/or sexist), it does at least connect to what we imagine is a vigorous club night out. But where is Baxxter? Is his black zone, where only he is to be found, the VIP area? Or is he doomed to remain separate, never to be released, as his mysterious captors force him to replay his words and gestures forever? Baxxter leads through splendid isolation, sacrificing his own pleasure and travel, in order that we all can jump, that the world jump together, in gravity-threatening and complex unison. He sacrifices the power of communicative language in favour of word sounds for effect, he rages rhythmically into his hand/microphone prosthesis, and dreams of release into 'the VIP'. This will not happen, as Baxxter must live on as a living, raving exemplar of Francis Bacon's screaming popes, blocked in their glass boxes.

The world that is to be transformed into hardcore jumping latticework is complex and far from a unified club-based utopia.[4] Instead, alienation is necessary for community to happen: Baxxter is alienated in the sense of being hived off from his own labour, condemned to not jump, so that he can issue suggestions, approval and more hardcore. For hardcore to be only hardcore, such that it can comment on itself in order to exist, Baxxter has to step outside. In so doing, he sets up a loop just as the central character does in Chris Marker's film La Jetée (1962), such that attempted extraction from the main passage of contemporaneous events leads to the deepest embedding in them.

The isolation is not total – as the jumpers clear the global stage, and Baxxter has invited all the ladies to his screaming pope glass cage VIP, we see the three Scooter men attempting the jumping dance in front of Sydney Opera House. None of them seems capable of the moves, we are not even shown their legs, and very quickly they laugh at their own ineptitude: they have sent the others out to jump for them, but they still participate in the bringing low of cultural capital/capitols. Scooter does not just look on from afar at the glories of architectural cultural display – even if it is through the flesh prostheses of the Sheffield Jumpers – it is Scooter who fuel the global jumping.

The global culture that they address is very specific – highbrow cultural monumentalism, established as the marker of cultural value and social travelling mobility. The same can be said of their appearance amid the 'classy' culture of semi-aristocratic nightlife, as presaged in the demi-monde party antics of 'Nessaja' (2002), where Scooter bring a 'real party' to the otherwise stuffy and snobbish upper class subculture of the mansion setting. As the cocktail-dressed invitees assemble in the plush interior, Baxxter, with shirt tails out and wearing jeans, shouts '3 am!', and Scooter begin a guerrilla concert to liven up the party whether the guests like it or not. 'It's not a bird, it's not a plane/It must be Dave who's on the train' is a sample lyric, amid exhortative calls of 'yeh!' and 'core!' Very quickly, the staid gathering is transformed into a rave, led by a waiter smashing a bottle. This suggestion of class conflict is submerged (though retained as avant-garde trace) as the denizens of the house let themselves go, perhaps illustrating the cross-class social revolution that Scooter can bring through their post-liberal, anarcho-minimalist critique.

In the first version of 'Friends' (1995), Scooter drive alongside a car (both classics) in Paris, as we observe a young girl breaking free of the decorum imposed by her upper-class parents. The breaking-out turns into more of a break-in after 2007. 'Ti Sento' (2009) and 'C'est Bleu' (2011) both feature quasi-operatic diva performances from singers reprising their popular anthemic pop songs. In the first, Antonella Ruggerio is cast as a dramatic singer, poised between opera and chanson. In the video, she is being protected by Scooter acting as security men, again, infiltrating the world of high culture, from a position of greater knowledge. As the song progresses, they cannot prevent the assassin from shooting the singer, even though at the last moment, Baxxter dives across her to try to 'stop' the bullet. Once more, Scooter begin and end driving a classic car. They are mobile, marginal, but also capable of deterritorializing or reterritorializing space. Whilst stars of music videos are mostly in positions of power with regard to events happening around them, Scooter are the bringers of events, managing the flow of activity. This power of deterritorializing can be heard in 'Ti Sento' in Baxxter's withdrawal. At 0.50, he says 'all right' and Ruggerio, on stage in eighteenth-century gown, wig, and powder, takes over with her song, at

1.18, he allows himself a 'get up, yes', without breaking her flow, at 1.27, there is a 'yes' and at 1.37 'come on'. His verse, when it arrives, is over in less than fifteen seconds, while he, Jordan and Simon prowl the perimeter of the concert hall. Visually and aurally, there is a ceding of space, which is the zone of opening-up, of allowing space for action, in a way that is a utopian modelling for other social activity.

'C'est Bleu' reverses the spatial polarity: Vicky Leandros, a singer of Greek origin, sings in French (what was originally the Luxembourg Eurovision song entry in 1967, and sung by her), cut with Scooter driving in Berlin and shots of their stage show. Then as we progress, we see Leandros singing in a vocal booth, while Baxxter, Jordan and Simon wait outside, enjoying the performance. A complex concordance is set up between Scooter's gig footage and them as audience to the recording. In addition, Scooter perform their own studio moves, intercut with Leandros, and with everyone chatting, in a burst of cosy formalist self-referencing familiar in pop videos 'about' making the pop video. Leandros and Baxxter both get their moments of isolation while singing, and she is even momentarily placed into a netherworld of auto-detuning and glitched video screen. The video for 'C'est Bleu' partially echoes the structure and flow of 'Ti Sento', and also expands the range of cultural reference across Europe (there are other works by Scooter that mobilize Spanish and Greek cultures and an amorphous Mediterraneanism). The presence of languages other than German or English reminds us that globalization is not just about the means of transmission and reception but also the mode of production.

Scooter sample not only songs, tunes, singers but also languages and places. This is a complex and entangled global setting, akin to the models proposed by Saskia Sassen or Homi Bhabha – neither part of a homogenizing simplicity nor a local or 'glocal' authenticity. Nor is it really much of a hybrid. Scooter's music does not change in response to external difference, it incorporates and maintains the other music, words, singer, language as other. Where Baxxter and party infiltrate cultural spaces, they simultaneously generate sonic spaces of mutual crossing in their apparently monolithic music. Without the videos, and the clarity of Baxxter's withdrawal strategies, this would not be in any way transparent. The videos play out in their own interstitial space, principally on YouTube, where Scooter garner healthy scores in the millions of views. Like Scooter, YouTube is only an apparent monolith, its fundamental structure one of permitted fragmentation.[5]

Many spaces in contemporary urban globalization control movement (plazas, stadia, *glacis* areas around any areas deemed to be subject to extra security, barriers, enclosed dwelling zones, malls), but equally, there are many spaces of flow, based around transit, and, more interesting still, spaces that are always already interstitial – delivery spaces, like the container zone in 'The Question Is What Is the Question', alleys, zones that could not be remoulded and that abut the shiny new delivery sites for higher priced

accommodation and traffic reorientations. Marc Augé glimpsed this in his 1995 book *Non-places*, but got caught in the congestion of universalizing his bafflement at the spaces of the new. A more interesting take on the new spaces that fill, line, limn, and exceed the plots of block developers is that to be found in Rem Koolhaas' article 'Junkspace'. Junkspace is both that which remains, that exists as remnant, and also the relentless empty monumentalization of office building and concept housing for the wealthy. Junkspace is what Scooter drives in, and it's where jumping takes place when not occurring in front of national monuments.

The jumpers of 'Jumping All Over the World' echo their moves in 'Jump That Rock (Whatever you Want)' (2008), with Status Quo, restaging the friendly standoff that Run DMC and Aerosmith indulged in for 'Walk This Way' (1986), with Scooter's wall ultimately knocked in by a hammer from Status Quo's section of roof. The jumpers continue in 'And No Matches', at which point, the viewer might wonder if the Sheffield team have become like the mobile serf-like international labour layer that underpins reducing prices in a global command economy. This time, there are close to twenty dancers, mostly in formation, and always jumping, like the enforced 'creative' fun of social media corporations. This all takes place in a giant warehouse, perhaps between matching packing targets and going to the dormitory, in front of two giant megaphones. Around 1.43, the dancers seem to have broken into factions, unused to this much healthy leisure, but dancing restores community and the moves from here on in are much more individually expressive, or feature duos in synch. By the end, dancers join Scooter on stage in front of a concert crowd, filmed in close-up to virtually eliminate the distance between band, dancers, and audience.

In the meantime, between the shots of dancers in the post-productive economic space of contemporary distribution systems, H. P. Baxxter is once more isolated, the camera jagged as it cuts and swerves towards and away from his singing and gesturing body. At points he is isolated between two speaker stacks, his trademark radio operator microphone dangled down to him on a long cable. At others, he returns to the black visual space of 'Jumping All Over the World'. If other songs feature extensions into language, then here it tails off from discourse entirely, with 'You Know what? I don't know either', followed by a riddle about smoking on a boat, and ending on 'Coffee, huh, isn't my cup of tea' as Baxxter's face is isolated on black, then fades away. Even in the interstitial space of the contemporary warehouse (empty of industrial goods), Baxxter eschews the sociality of the jumping, while approving, encouraging, perhaps enticing the participants towards the show. The show, like 'the club' is also a category of non-space, indefinite in its connection to external topologies, and as Scooter's show is seen over and over in the videos, albeit in brief cuts, it delineates a future model of spatial community – the rave as permaculture, the gig as endlessly

mobile but only marginally changing *ritornello*, fracturing capitalist time by parodying its regulatory beats.

Jumping is not the only psychogeographical tool at Scooter's disposal: there is also the shuffle, or more precisely, the 'Melbourne shuffle', a complex set of lower leg, ankle and foot moves, with the body following, in a kind of reconnection, at high speed, with the ground that still thrives in new habitats of carpark, flyover, linking paths, glass store fronts, and side streets. In 'J'adore Hardcore', two shufflers, Pae and Sarah, glide effortfully around such Ballardian spaces of Melbourne, while Baxxter, towards the end, is seen driving another vintage vehicle in Majorca, elegiacally framing the chrome of the car with his extensive jewellery, and shots of the Scooter live show, of course.[6] The shuffle is a way out – or through – the runnels of global capitalism – sideways instead of ahead, a counter-discipline to the enforced flow of consumer zones. The shuffle takes you off the designated path and offers a model for dwelling in the peripheral functions of the city.[7] The two dancers rise to the skyline, crossing from one area to another through footwork and video edit, and are framed by the city as their moves supply a frontal motion to its rigidity. Baxxter is again isolated, in front of a white and blue wall, something like a carpark wall, so located very much parallel to the dancers. His lyrics shuffle and slide between concepts loosely oriented around music making, dancing, and listening. Language opens up as its content is minimized, mirroring the sliding out of end-oriented travel in favour of the shuffling *dérive*.

It is the lyrical emptying of language and the visual isolation of Baxxter that complete Scooter's realization of the utopian hardcore community. The models of being an interloper combine with the occupation of the interstices to offer a paradigm of urban (and therefore social) critique through spatial occupation. This occupation is always through movement, through reiterations of Scooter's core value of community that gathers through music. Baxxter leads this communing from the strange, almost uncanny position of someone physically (visually) isolated, and lyrically diminished. If this is a leader, it is a sacrificial one, rather than a heroic controller. Baxxter becomes like the figure of the third person 'him' (il) identified by Maurice Blanchot as giving way, or stepping aside, over and over.[8] This figure is removed from social communication, and begins to move towards the unattainable community that discrete human existence drives towards. Blanchot follows Georges Bataille in seeing humans as fundamentally incomplete, their existence as individuals the product of being torn from either group existence or the flatness of pre-existing. Then they will die, with this ending always within them as lack. In *The Unavowable Community* (1988), Blanchot argues for the re-creation of community as human mission, not to fill a gap, but to reinforce the incompletion of any one individual. Only incompletion leads to openness to the other (as heard in the exhortatory calls of/in/to hardcore). The community, likewise, is also always unrealized. And

yet, the prospect of community as potential, as desire, as absence, as death, as limit, as that which is beyond limit, remains. That it cannot be realized is why we strive towards it, why our being is the striving towards it and the failure of this striving. So the way to understand this, he argues, is through accepting that community lies in self-abandonment and in abandoning community in the form of standard society. It will not be a surprise to hear that rave and subsequent communal dance events understood this very well, but we need to understand that rave does not answer the problem, instead it plays out the problem of community, community as impossibility, forever. The fusional hope of rave unity can only amount to community if we change perspective and think of it in terms of lack, of failing individuation *and* failing unity. This mutual failing is how the elective community operates as a non-functioning yet completely real community.

Baxxter's language and visual presence is what brings this 'non-community' into not-quite-being. This could be at its height when he is shown separate from the crowd and video narrative, nodding along. It is also there in his flows of not-quite aligned surrealistic lines, and even closer when he is in prime MC mode, shouting 'core', 'yeh', or launching a mysterious one liner. His separation, which is what brings the community into being and also brings him into it, is finalized in failing language, in language that comes to be the act of language and almost nothing else. Well, almost nothing at all, in fact (Blanchot 1988).[9] Baxxter can only join the community he has brought into being through his time outside of the space of language, the music and the visual narrative. Only then does his return into the stage setting carry and undo meaning. The concert footage is another way we can see the community being brought into being on the back of Baxxter's lyrical abstinence that is nonetheless full of word and gesture, from outside of semantic norms. In the Scooter concerts we see in numerous videos, in very short bursts, we see Baxxter is with his companions (mostly Jordan and Simon in the videos considered here), with the crowd where we expect it, accepting the gift of hardcore. But the hardcore that we feel ('One [Always Hardcore]') comes about through the performance of loss of meaning. Rationality and compositional skill give way to harmonious tone choices played in simple and recursive melodies, where the notes played on the keyboards percus in parallel, and, technically speaking, in sequence (i.e. through the use of sequencers), with the beats. For the audience, the effect or perhaps 'affect', is of loss of self in a heightened bodily awareness, already activated through the physical processing of the loud bass, the lightshow and relentless endurance test of living in the hardcore. But we are not at the concert, we are watching a video, probably streaming it, and the show is part of an overall visual effect that shows us the transitions between separation and community, part of the play of individual and group identities, where, through the exemplary action of H. P. Baxxter, an incomplete and process-based community begins to cohere.

It is tempting to think of this community as being some sort of network, for either recoding the world of pop music, or gathering in ways that mirror Internet communities of the most straightforward and ideologically conservative type (i.e. that have a firm belief in the individual as self-aware, full of knowledge, and capable of 'joining with' their peers and starting an elective society). This tragic repetition of Romantic nationalism is not what Scooter offer, as what they present, through an ostensibly simple hedonistic aesthetic, is a bringing-low of community, such that to join is to lose oneself without return. This is not an economy based on gain, but on a profound, categorical subversion.

In order to head further in to this non-community, this strange space of incompletion, there are two more videos to consider, both from 2012, which in different ways show a movement inward, but in both cases reinforce the power of Scooter as centripetal force, whilst showing Baxxter as privileged peripheral, deciding the exception perhaps, but sovereign through being the exception: the exception that brings the rest of the system into being, to paraphrase Carl Schmitt in *Political Theology*.[10]

In '4 AM', Scooter play in the middle of the crowded dance floor of a club. Michael Simon and Rick J. Jordan get a rare chance to share the spotlight but are cut loose from their instruments so have to join the sequence of people on the dancefloor who look directly to camera. Meanwhile, Baxxter is also shot singing in front of lights without the crowd around him. As these shots alternate with those of him singing within the crowd, the community is identified as dependent on both positions – Baxxter in the centre, Baxxter off in another chamber, black walled with bright lighting strips. How we get to the club, and the eventual replacement of Jaye Marshall's vocals with those of Baxxter is intriguing: each of the members of Scooter notices independently that it is 4 AM and time to go out. Baxxter is in a colossal scale, palatial place, where he is sipping a hot beverage from a coffee service (I am mindful of 'coffee not being his cup of tea'), Simon is on a treadmill, Jordan on the computer. The sounds he makes, while small, like clinking cup and saucer, are the result of his refined behaviour, and echo in the luxurious expanse. For once, Baxxter is not depicted as an interloper in someone else's wealth, but at home amid opulence, just relaxing and drinking in his sitting room in the dark. As he makes his way to the club, he is joined by three women, while Jordan and Simon have to make do with joining up as a duo.

The moments of Baxxter singing against the depopulated backdrop echo his house, the club dance scenes parallel his walk along the Berlin streets, flickering between recognizable communal setting and paradoxical community-enabling solitude. Baxxter's drift between these two options is almost quantum – until we observe, in any one rapidly edited cut, where he is, he is in suspension between the two. In quantum experiments, the moment of observation is of 'decoherence'. In Scooter videos, the decoherence of one moment signals the previous simultaneous existence of the preceding

multiple states, but that had, from the outset, the potential and necessity to decohere. This is another way of conceiving the model of non-subject-based community that emerges in Scooter audiovisual works. The closing shot looks out from an apartment towards Berlin's Fernsehturm, beacon of the technological media advances made under the Communist State, and now sign of a post-communist world, in the world city of transit, migration, hybdridity that is Berlin. But Scooter has gone – the girls from the club are all waking up, presumably late in the day, and Scooter's fleeting community fades back in to the normal world, remaining as residue only.

The single that came out before '4 AM' was 'It's a Biz (Ain't Nobody)'. In this video, Scooter are pushed to the edge of the narrative, whilst at the same time a substantial amount of time in the video is allocated to showing the band in the live setting. Baxxter is also shown singing in a wood-panelled house, with framed mirrors behind him. It is from this room that he launches his brief verses between the autotuned halfway hardcore singing of 'Ain't Nobody'. As in 'C'est Bleu', we see the band chilling out, in 'real footage' mode, meeting people, with the suggestion of these moments being either before or after the gig. The core narrative part of the video, though, is elsewhere: a young woman drives into and through Berlin, and heads down towards Prague, with a final destination of Brno. A re-engineered, post-Cold War Europe opens up on the road as she heads to the Scooter concert at which she will never arrive. Maybe in a way akin to Blanchot's sense of death, or subjectivity, or community (Critchley 1997: 65–68), but mainly because her car breaks down and we see a road sign indicating it is 23 km to Brno. Undaunted, she takes out her laptop, places it on the bonnet of the car, finds Scooter's Kontor channel, which is streaming the gig we have seen already, and she dances in synch with the globally connected Scooter audience, and the globally structuring work of the band. It's mostly Baxxter we see in the video on the laptop screen, and when the song ends, he looks towards the camera, reaches forward and extinguishes the image from within.

All the permutations of individual/community, distance/proximity, core, and periphery, are raised again here and supplemented by the charge of global connectivity. Baxxter is the avatar of the social possibility of Internet communities, but plays with its conventions such that this is a critical use of those disciplines and codes that otherwise constrain and regulate, as Franco Berardi notes at length in *And: Phenomenology of the End*. Baxxter's adoption of connectivity is strategic, and continually puts in play the disjunction that is at the core of coding behaviour. He is more separated than ever, *on the inside*, his screaming pope glass box transduced into a desktop window. It is through the videos that this element is achieved, enriching but also darkening the 'party' atmosphere. The videos push the lyrical conceits, the pose of the MC and the relentless minimal pounding of the beat beyond absurdity into a new level of hyper-reality from which the processes of globalization become visible and audible.

Ever visually further from community, Baxxter's entrapment in code (core), his wilful estrangement from language, his subversion of social media participation models all make 'It's a Biz' a richly subversive ending to the quest for re-spatializing global cultural production as a radically absent community. The use Scooter and its audience make of YouTube in particular is echoed here, and Baxxter is responding, from an inside that is other to the interiority we as individuals presume to own, a within that is without. A margin, a subversion, moving from periphery to centre, and back, over and over. In repeating we breach the singular. The core.

CHAPTER THIRTEEN

Blackened Puppets: Chris Cunningham's Weird Anatomies

Dean Lockwood

In this chapter, I shall suggest that music videos constitute moving bodies – puppets, if you will – which in turn have the power to move viewers, in fact to enlist their viewers into a process of metamorphosis. My focus is the work of the director, Chris Cunningham, who has demonstrated a particular propensity for affectively gripping audiences with a mixing table aesthetic which promotes a synaesthetic mutuality of music and image. This auteur's videos, I will claim, experimentally explore a kind of sonic anatomy. They flesh out the music that inspires them as humanly impossible puppet-bodies which promise either to rapturously seduce or disquietingly undo those exposed to them. In relation to the former, I will begin by reflecting upon Cunningham's video for Björk's 'All is Full of Love' (1999). I will then move on to discuss the more horrific mutational potential of his 2005 video, 'Rubber Johnny'. Ultimately, I propose, the director can himself be considered a puppet, inevitably strung to the dark and alien materiality of his medium, ceding auteurship to the weird, fracturing power of mediation itself.

A white heaven

A sequence of extraordinary events. It begins as if with the initialization of a computerized system or process. The camera ascends from a dark realm of entangled cabling and we emerge into the space which the cables

serve, a dimly lit and minimalistic white panelled room which evokes an industrial laboratory. On a platform, lying on its side, is an android wearing Björk's facial features. Lights come on and robotic arms move over the platform as the music gets into its stride, a slow electronic beat with shimmering waves of strings. The Björk android opens her eyes, gazing to camera. As she sings of love gifted from unexpected sources – from all around if one can only relax, open up, be willing to connect and receive – the robotic arms, like handmaidens in attendance, gently manipulate and penetrate parts of her mechanism, inspecting, testing, and adjusting. Their ministrations are lubricated by a milky liquid which pools on the platform, reminding some of us of the very similar fluid which is gruesomely revealed to be coursing through the body of the android, Ash, in Ridley Scott's *Alien* (1979), and into which fairy-dust-like sparks alight as they shower from some engineering taking place inside her head. Björk, now seated, looks up and, in reverse shot, we see she greets a second android, also bearing her features. Both now sing and then they are together on the platform, kissing and gently caressing each other as the robotic arms continue their work of succour. Lights flick off, shadows grow and the milky lubricant is pulled back into the machinery. Light returns, the androids gazing at one another with half smiles. The camera descends back amongst the cabling beneath the floor, into darkness as the music fades and the system shuts down.

Chris Cunningham's celebrated 1999 video for Björk's 'All is Full of Love' (exhibited in, amongst other places, New York's Museum of Modern Art) was not released as part of a promotional schedule – the album from which the track was taken was released two years earlier – and was intended as an artist's film as much as a music video. It adopts a science fictional scenario suggested by Björk herself. Interviewed for the 'Making of …' film featured on Palm Pictures' Directors Label collection, *The Work of Director Chris Cunningham* (2003), she recalls how she specified a white setting of hard surfaces, a kind of 'heaven', initially as if frozen, but then gradually melting. It was to be a 'clean' space, but not sterile. Rather there should be some intimation of 'lust'.

Björk's feeling that the music would best be visualized by means of a process of deliquescence seems perfectly tailored not only to the music video as medium but also to Cunningham's own formal predilections. Laura Frahm argues that music videos are 'premised on the idea of *transformation*' linked to 'medial movement' (2010: 155). Music and spatial movement render 'genuinely "moving spaces"' (2010: 159). Cunningham's sensibility, for Frahm, hinges upon his repeatedly and reflexively dwelling upon medial movement as process, emphasizing fluidity in a video's moving elements: 'His video works can be conceived as a permanent reflection about a world that is in a state of endless flux. He creates unique settings that are ever shifting and ever changing, relentlessly reshaping our conceptions of space

in foregrounding its potential of transformation, while, at the same time, most precisely orchestrating the movements according to the music' (2010: 164). Fluid motion, in Cunningham's work, is a matter of 'becoming', a vision of a 'liquid cosmos' (2010: 167). Moreover, this medial movement can be conceived as self-reflexive in a way which approaches the uncanny. In science fictional mode, it is almost as if the process initialized in 'All is Full of Love' is not only dawning awareness and erotic encounter on the part of the androids depicted but also the coming to sentience of the video itself.

Steven Shaviro views Cunningham's video for Björk as a eulogy to the post-human, working against the grain of a certain phobic imaginary which deplores alleged consequences of disembodiment such as, at the time of his writing, was *de rigueur* in the wake of bleak of dystopias like *The Matrix* (1999). In the Björk androids the post-human is rhapsodized precisely for its promise of bodily transfiguration. This can be apprehended in the way in which 'faciality' is downplayed – Björk's features are a minimal sketch – and in the 'double movement' presented by Björk's vocal performance – peculiarly 'toneless', delicate and otherworldly, it strikes, on the one hand, as a machine-like, nonhuman voice, but, on the other hand, indicates vitality in the machine (Shaviro 2002: 8–11). In fact rather than vitality we might say 'lifeness', a term used by Sarah Kember and Joanna Zylinska to indicate 'the possibility of emergence of forms always new' (2012: xvii). Crucially, this is not explicitly thematized in the video, but is expressed by means of sensorial relay, a mutual responsiveness of sound and image resulting from the 'synaesthetic sensibility' which Cunningham has cultivated in his work (2002: 3). Although Cunningham's music videos frequently feature narrative and can be conducive to a hunt for meaning, non-representational, affectively attuned orchestration of time, rhythm, and light appears, on the whole, to be much more important to his endeavour. In the video, Shaviro notes (curiously choosing to ignore the black, occulted infrastructural realm beneath the white heaven) almost everything in the space is light and whiteness. Eschewing a dualistic opposition of light and dark, the video works through fluid 'modulations of light, degrees of whiteness and luminosity' (2002: 6). Similarly, time is pulled into this flux and rendered modulatory: 'time becomes elastic. It seems to have lost its forward thrust. It no longer moves at a fixed rate. It dilates and contracts irregularly, following the contours of (Björk's) voice' (2002: 10). Here we have a fantasy of inhuman perception, and inhuman logic of sensation, the 'erotic life' of blossoming machines, opening up, vital, and in flux. But, more than a fantasy, the viewer/listener is herself conscripted into this synaesthetic flux, taking part in its disassembly and reassembly of the senses, its 'calmly distanced rapture' (2002: 15).

Far from a jettisoning of the body, here is an epiphany of the body, an 'affective mapping' of the new modulatory body of the post-human, to borrow the terminology of Shaviro's book, *Post-Cinematic Affect* (2010).

Here, 'a new sort of life emerges', attuned to the erotic capacities of the machine, the machine which is infinitely more responsive than the human (Shaviro 2002: 11). Mathias Korsgaard, building on Shaviro's ideas, conceptualizes a 'signaletic body' (2012: 12). In signaletic modulation, images are treated as manipulable signals rather than representational signs. In music video, the synaesthetic sound-image is an unstable, fluctuating signaletic body, producing 'an affective and ever transforming materiality' (2012: 2). Certainly, this conceptualization fits well with Cunningham's music videos. In 'All is Full of Love', the affective tone generated in this softening silky, milky world is of a piece with a sense of openness and vulnerability, an invitation to metamorphosis. In Cunningham's later video, 'Rubber Johnny', as I will shortly discuss, the invitation to metamorphosis remains, though the milk is now a latex which has toughened into an invulnerable elastic body fitting for the collisions of a more cartoonish rubbery world of bouncy, snapping, popping, and squashy mutation. Extending Frahm's intimation of a self-reflexivity inherent to the transformational properties of the music video as form, it will be instructive to pursue Cunningham's work not simply as being *about* post-human machinic becomings, but in terms of the becomings *of*, in Shaviro's words, 'the machine that the video itself is' (2002: 12).

Auteur of the abhuman

'All is Full of Love', rapturous flux notwithstanding, indulges a slightly sardonic tone, not least in the presence, on androids and robot arms, of logos for a fictional Japanese corporation (Yamtaijika) which appear to symbolize two intertwined bodies. Who is pulling the strings? Corporate capitalism sponsors this post-human bliss. As Björk herself acknowledges in the Palm collection DVD interview, the omnipresent love of which she sings can be taken in more than one way; the phrase 'You'll be taken care of' comes across as aggressively smothering as much as succouring. Isn't there something rather horrific about the events in this room?

In this respect, it will be enlightening to consider the video in the light of Chris Cunningham's earlier work, which exhibits a good degree of consistency. Cunningham has been granted the privilege of auteur status, rare in music video. This was cemented by his being lionized, somewhat transparently, in a 2003 novel, *Pattern Recognition*, by science fiction writer, William Gibson. Gibson's protagonist, Cayce, is staying in the Camden Town flat of her friend, Damien, 'director of music videos and commercials' (2003: 2). Parts of models and props litter the apartment, notably sexualized robot girls: 'Dreamlike things in the dawn half-light, their small breasts gleaming, white plastic shining faint as old marble. Personally fetishistic, though; she knows he'd had them molded from a body cast of his last girlfriend'

(2003: 5). Cunningham's auteur status is attributable, at least partly, to his association, as here, with science fiction, but we will see that his involvement with the horror genre is just as pertinent.

In 2003, as well as getting the name check by Gibson, Cunningham's work, as already noted, was the focus of one of Palm Pictures' influential Directors Label DVD collections. Carol Vernallis suggests that these collections, which also included entries on the work of Spike Jonze and Michel Gondry, 'enhance our sensitivity to music video directors as auteurs: we intuit that music video constitutes a significant realm for directors to develop style and technique and to discover a means to communicate ways of experiencing music' (2013: 263–264). Specifically, of all the collections, the Cunningham collection, which assembles a selection of his music videos from the first, 'Second Bad Vilbel' (for Autechre), through to 'All is Full of Love', in addition to commercials and video installations, 'projects the greatest faith in music's powers to alter our experience and modify the material world' (2013: 274).

Our 'sensitivity' to auteurship in music video production typically remains undeveloped, of course, because the medium has been so closely connected to the imperatives of promotion within the music industry. Nevertheless, as with the Palm directors, some individuals have achieved cult status, associated with thematic and stylistic consistency and a creative vision which lifts their work from the commercial sphere into art (Railton and Watson 2011: 66–67). Auteurism is an analytical model originating within Film Studies and, Railton and Watson remind us, it is 'based on exclusivity' (2011: 70). Music videos are less conducive than arthouse films to being treated as a 'minority phenomenon' (2011: 70). Perhaps, more importantly, though, a film studies perspective will inevitably lead to a downplaying of the music aspect of music videos and certain issues around music – especially, as Railton and Watson point out, the centrality of the ascription of authenticity as criterion for evaluation by those who appreciate popular music (2011: 71). '[The] discourse of authenticity', they write, 'is the primary means of marking a product's difference from that deemed crudely commercial' (2011: 73). The focus on authorship follows on from a prior ascription of authenticity, of original, singular talent. This evaluative process is conditioned by expectations of various kinds about skill, character and credentials. Cunningham became known for virtuosity in editing coupled with a widespread perception of his integrity, autonomy and seriousness. Although a number of his earliest music videos (for the likes of Placebo, Holy Barbarians, and Dubstar) are efficient but rather forgettable, his first video, the aforementioned 'Second Bad Vilbel' (1995), instigated a rapport with Warp, an iconic independent record company known for promoting so-called Intelligent Dance Music, coloured by drum and bass and house styles, and, more pertinently, for its association with cutting edge music video. He resumed his relationship

with Warp in 1997 for his breakthrough music video for Aphex Twin's 'Come to Daddy', and continued it with later work made for and with Aphex Twin ('Windowlicker', 'Rubber Johnny') and Squarepusher ('Come On My Selector'). In this alliance with Warp, Cunningham aligned himself with artists willing to 'break the rules' in terms of musical composition and artist 'image'. Richard D. James (aka Aphex Twin), for example, put his face prominently on the cover of his album 'I Care Because You Do' precisely because the 'unwritten rule' in techno is that anonymity is preserved (Hoffmann n.d.: 6) – and Cunningham's music videos for Aphex Twin notoriously featured ubiquitous masks bearing James's facial features. Autechre, for their part, 'dispense(d) with conventions such as constant time signatures, resolving chord sequences and the normal ebb and flow of song structure', claiming in interview, 'we don't know anything about music, we still don't understand what music is really' (Holder 1997). This post-punk disavowal of standard compositional craft, essentially a credential of an attitude of experimentality, is to some extent mirrored in Cunningham's inclination to speculatively open out the music video as form to the influences of artists' film and video and the installation milieu. Moreover, this attitude, as already indicated in my earlier reference to the work of William Gibson, shares a great deal with cyberpunk, a variety of science fiction (see Gibson's *Neuromancer* (1984), for example, a novel which Cunningham was, for some time, engaged in attempting to adapt for film), which takes social disintegration for its setting and features alienated but talented mavericks surviving in the interstices of predatory control structures. Cyberpunk typically emphasizes the transformative impact of new technical media upon the human body, echoed in some forms of electronic dance music such as drum and bass, which can be understood as provoking an anticipative, even paranoid, visceral state (Chapman 2003).

Cunningham's preoccupations with the structure and movement of the body – in effect, his music videos index what might be thought of as a study of sonic anatomy – have often been noted, both by Cunningham himself and by commentators on his work. The sinister robot around which 'Second Bad Vilbel' is organized was constructed with aircraft parts from the hangar in which he was building an animatronic boy for Stanley Kubrick's film, *A.I.* (2001). The video, intended as an exercise in abstraction ('although it feels like it's trying to say something, it isn't', Durston 2009), works viscerally, affectively, rather than as representation or narrative. As Vernallis notes, his videos 'work by encouraging us to inhabit on-screen bodies who possess something strange. As viewers we may bind to the musculature or mechanical structure of the figure and feel different' (2013: 274, 275). She conceives his videos as 'opportunities to reorient our bodies', to become sufficiently malleable, as it were, that we might experience our physical immediacy in new, perhaps post-human, ways (2013: 275).

If this is the case, the condition Cunningham aspires to is by no means always the rapturous post-human merging with the machine conjured in the Björk video. His work may also be considered in relation to the *abhuman* or *unhuman*. Dylan Trigg, in his book, *The Thing*, evokes Merleau-Ponty's notion of the 'alien materiality' of the human body (2014: 77), and asks, 'if the human body is foreshadowed at all times by an alien subjectivity, then can it be said that I "possess" my body?' (2014: 65). In the abhuman condition described by writers of weird fiction, the body is unstable, metamorphic, 'turning away' from the human and becoming almost indescribable. There is something occulted and dark about the body which is grist to the mill of writers of horror and the weird such as William Hope Hodgson, H. P. Lovecraft and Thomas Ligotti. The abhuman body is conceived in terms of its thinghood: 'A site of loss, recuperation, transformation, dissolution, the abhuman signifies the locus of the Thing in all its ambivalence. If horror marks a limit the beyond of which humanity must ab-ject, it also opens a hole in which it is consumed' (Botting 2008: 174).

Cunningham's claim to geekish authenticity can be associated with his affiliations with the horror genre as much as with science fiction. Under the name Chris Halls, he was a member of the special effects crew, Image Animation, responsible for designing the demon, Pinhead, for Clive Barker's *Hellraiser* (1987), and was listed as a 'creature technician' for Barker's follow-up film, *Nightbreed* (1990). Science fiction and horror film director, Richard Stanley, writing in 2002 on the prospects of British horror cinema, suggested that Cunningham 'may well prove to be one of the most important genre figures of the generation to come' (187). This promise is abundantly indicated in music videos such as 'Come to Daddy' (1997), in which a demon forces its way through an abandoned television set to terrorize a desolate council estate in league with a host of malicious children (all of whom bear the face of Aphex Twin), and 'Sheena Is a Parasite' (2006), for which a strobe-illuminated Samantha Morton performs a deranged and furious dance, flinging visceral or tentacular bodily extrusions at the camera from beneath her dress and whipping slimy membranes across her face.

We might take Cunningham at his word in his occasional insistence that his music videos do not 'say' anything, do not communicate a message as such. His work can in fact be understood, as I will suggest, after Galloway, Thacker, and Wark (2014), in relation to a concept of *ex*communication. It is not so much a playground of possibilities for post-human bodies – all too often the bodies and selves imagined in post-humanist discourse offer transformations that enhance without fundamentally threatening the human condition (Thacker 2003: 74) – but rather of bodies which mediate some ab-human ambivalence or materiality. More radically, the machine that is the video is here disclosed as an unhuman mediation that threatens to undo both auteur and viewer.

Night vision

By means of a night vision camera, we see, in close-up, the face and glowing eyes (typical with infra-red light) of what we might initially take to be an infant, albeit malformed, with a bulging, perhaps hydrocephalic head. This is Rubber Johnny, the eponymous focus of a six minute music video-cum-short film, the DVD distributed by Warp Films in 2005 in an elaborate package with a 42-page book of Cunningham's photographs and drawings. Johnny flicks his tongue rapidly in a disquieting intimation of cunnilingus. As, off-camera, a doctor seeks to reassure him, Johnny darts glances into the darkness. 'Are you seeing something'? the doctor asks. 'What do you see over there'? 'Mama', Johnny responds, and begins to struggle, hyperventilating and frantic to the point the doctor administers a sedative. After the doctor's departure, a Chihuahua, whose bulbous head echoes Johnny's, laps at a bowl of water but is disconcerted by the blinking of an ominously malfunctioning neon strip light. The dog looks at Johnny, who is – we now see – an emaciated adolescent, naked and slumped in a wheelchair, huge head unsupported and tipped back, hands and wrists spastically twisted. There is something alien about Johnny. His appearance evokes the so-called Starchild skull (allegedly that of an alien, found in 1930 in a mine near Chihuahua, Mexico), as much as it evokes associations with ordinary human medical conditions or disability. The camera closes in again onto his face as the on-off of the strip light rouses him. 'Aphex', he slurs twice in a trancelike, machinic voice. And, indeed, the music of Aphex Twin can now be heard, specifically a remix of the track, 'afx 237 v7', from the album, *drukqs*, for which the video was initially intended as a short commercial (but which, for Cunningham, patently warranted a much more expansive treatment pushing it beyond the usual expectations for a promotional music video). The youth's hands move jerkily, fingers touching bright, short beams of light like tracer bullets fired towards Johnny from close by the camera's position. Johnny rocks back on his wheelchair and enters into a high speed and labile kinetic performance entailed by his attempts to avoid, deflect, and ward off the projectiles of light now coming increasingly thick and fast (originating and ricocheting, perhaps, from the glitchy strip light). Johnny's contortions synchronize closely with the remarkable, complex syncopation of Aphex Twin's nervous and skittering drum and bass. In the glare of sudden flashes of light, Johnny's shadow is cast against the rear walls of the small, featureless and empty box-like room, but his frenetic movement, impossible bodily reconfiguration, stretching and smearing head, and odd gestures and hand signals, begin to suggest illimitable space. With preternatural dexterity, he manipulates his wheelchair, spinning around and partially lifting himself from the chair to bring his buttocks into play. The performance is punctuated by close-up shots of wheels spinning, feet crossed on the footrests. Suddenly, the door of

the room opens and music and movement stops. As if nothing has happened, Johnny sits inert as his father, who does not enter the room, berates him: 'Great twot, you'! No sooner has the door been closed again than Johnny lunges to snort an immense line of coke. Matters immediately become considerably more intense, as does Aphex Twin's resumed breakbeat. It is unclear whether the light beams – now thicker bolts – strike, or are emitted from, Johnny's mouth and eyes and (momentarily shattered) forehead. A rapid fire edit of shots of his head suggest he is morphing into an unstable hybrid of human and wheelchair parts. Pulling a lever on his chair, he recommences his dance, faster, his body more incredible in its topological manoeuvres, sometimes seeming to squash and flow like a rubber SuperBall and sometimes to rigidify like bone or the carapace of the xenomorph in Ridley Scott's *Alien*. The nature of the space clearly changes. Johnny appears at times to recede into the immense reaches of a black void, a far-off flapping and twisting white thing, only to lurch forwards, smashing into and pulping his head against a glass frame very close to the camera, glorious, abject displays resolved by Johnny's snapping back again into the dance. Perplexingly, a flat round object – Frisbee or vinyl record – ricochets around the room. Johnny, having possibly fully assimilated the wheelchair into his body, hides in hitherto unsuspected alcoves, then pelts and tumbles behind pillars on all fours or on his back, pausing to thrust out footrest components as temporary shields against the bolts of light. Everything stops as the door is shoved open once again with further complaints from Johnny's dad. Johnny slumps again now, exhausted and breathing stertorously. The dog, having looked on throughout the proceedings with as much consternation as, no doubt, ourselves, barks. Cut to the credits, and another Aphex Twin track from *drukqs*, 'gwarek2'. A shot of a night train; life goes on, other people with ordinary destinations, unaware of the extraordinary events in this small dark room.

We have identified a synaesthetic sensibility as a particular source of Chris Cunningham's authenticity as an auteur. His music videos have consistently effected a synergy of sound and vision, a 'thingly' vitality encompassing both the bodies presented in the work and the bodies or machines constituted by the videos themselves. Cunningham's reputation has been built on his ability to inhabit or surrender to the music which provides the occasion for his videos. As he has said, 'my style is synchronized to the music and dependent on the music for its tone'. And, further: 'I listen to a piece of music and really get inside it and let it suggest a little universe to create' (Dombal 2005). This is not merely illustrative or a matter of theme and meaning but rather an affective attunement. The 'universes' he evokes typically involve attunement with monstrous, nonhuman, or cyborg bodies. Cunningham's anatomical preoccupations entail the building and shooting of various models, but he places greatest emphasis on digital sculpture in post-production. It is at the stage of post-production that his talents for

manipulation of sound and image are most intensively practiced. He is, we might say, a stellar proponent of the 'art of the mixing table' (Fetveit 2011: 181), auteur of the 'audiovisual turn' announced by Vernallis (2013) which Fetveit associates with a 'new mutability in audiovisual culture' (2011: 182) or, alternatively, Vernallis associates with a new audiovisual aesthetics which maps and feeds into an accelerationist twenty-first-century media delirium related to 'socioeconomic and cultural factors like capital flows, work speedup, and just-in-time labor' (2013: 13).

Johnny's monstrous body is humanly impossible. The account of the video with which I opened this section was only possible with multiple viewings and liberal use of frame by frame playback. The universe of elasticity conjured by Cunningham here owes a great deal to the frenetic drum and bass style of Aphex Twin. Drum and bass rhythms can be so stupendously complex and rapid that they exceed the capacity of any human drummer and are only realizable as a cyborg accomplishment. Drum and bass artists, already practising a kind of sonic anatomy, 'dissect and fragment breakbeats into their smallest components, reassemble them into intricate, asymmetrical patterns and then set them at a rapid tempo' (Chapman 2003: 3–4). This is a laborious, minutely detailed (re)constructive surgery of rhythm. It involves quite a different sensibility to the electronic dance music styles from which it was developed. It is both an intensification and destabilization of rhythm, an aesthetic rapture which places a premium on discontinuity (2003: 15). Drum and bass prompts a heightened awareness of contingency; to listen and dance to this music demands ceaseless vigilance with regard to 'how the present is reconfigured in each moment' (2003: 4). Johnny dances on a knife's edge, facing obliteration. Akin to a martial art (and, indeed, Johnny's dance is a combat with light), to dance is here to take up the 'fractal-like complexity of the rhythms' and embody abstraction (2003: 7). Chapman aligns the rapture of this cyborg dance, which is also a paranoia or terror, with the aesthetics of the sublime. This music, he argues, prefigures increasing instability in the world, a near future in which 'our own technological infrastructure is turned against us' (2003: 15).

The full-tilt paranoid, martial aesthetics of 'Rubber Johnny' might indeed be seen as symptomatic of a mediatic mutation fomented by contemporary technocapitalism. To briefly take one account, social theorist Franco Berardi has, in a somewhat paranoiac mode, attributed electronic communication in the new 'semiocapitalism' with a 'connective mutation' (2009: 86). In networked existence, we, as subjects, face a storm of signs which demands accelerated responses with, in his view, deleterious consequences. We undergo a mutation in our sense of time as our activity is 'fractalized'. Living labour, Berardi insists, is translated into 'an infinite brain-sprawl, an ever-changing mosaic of fractal cells of available nervous energy' (2011: 130). Relationships shift from a basis in empathy to a basis in connection and compatibility of algorithmic

functions, entailing a facility for rapid pattern recognition. Fractalization engenders a generalized psychopathological epidemic of paranoia and fear. Music video could be seen, along the lines Vernallis suggests, as a pedagogy for semiocapitalism, a reschooling of labour to enable it to render paranoia and terror productive, to nervously recognize, mirror, and respond to patterns presented (2013: 278). Like the vigilant dancer to drum and bass, we must embrace the malleability of mind and body necessary to survive at the twenty-first-century workstation. Much of what Vernallis describes as Cunningham's 'faith in music's powers to alter our experience and modify the material world' (2013: 274) is of a paranoid, accelerationist tenor in his more recent work, from 'Rubber Johnny', through to 'Sheena Is a Parasite', and including the video installations, 'Flex' and 'Monkey Drummer' (both featuring Aphex Twin's drum and bass music). It is as if Cunningham responds to the demands made by contemporary accelerationist thinkers that emancipation from the yoke of capitalism hinges upon fuelling and provoking its tendencies to speed and excess in order to push its dynamic to breaking point (see Mackay and Avanessian 2014).

As Cunningham explains when interviewed for the Palm collection, the initial results of the shooting stage of his production process are typically 'ramshackle'. It is only when this material is experimented with and worked over with computer graphics that he actualizes what he considers to be his vision. In Fetveit's terms, the temporality of the profilmic performance is 'partly overruled and controlled in the post-production process' (2011: 161). The mutability of temporality – accelerate and rupture – is a key aspect of Cunningham's synaesthetic anatomical sensibility. The human body, and the body which is the video itself, becomes a 'malleable "puppet" body open to control by another performer' (2011: 166). As Fetveit puts it, with reference to an earlier Cunningham video, 'Only You' (for Portishead), but also relevant here, 'Cunningham, in effect, *dances* the bodies to the music by means of adjusting the speed of the footage in post-production', always bearing in mind that '[if] the puppet answers to the master puppeteer, he again answers to the rhythmic pulse of the music itself' (2011: 166). Cunningham sees something in the music, much like Johnny sees something in the darkness, translating music into anatomy, gesture, but equally, rendering perceptible impersonal affective forces, performing (and performed by) the 'inner pulse of life' in the present (2011: 171).

Johnny is a seer of sorts, sensing something which, unassisted, we do not but which he will make visible in his ruptural dance. A force in the darkness animates him. Perhaps, *pace* Chapman, it would make better sense to understand this in terms of the experience of the *weird* rather than the sublime. Music video is nothing if not quotidian media. Whereas the sublime is always a matter of encountering the extraordinary as from a distance, the weird, by one definition, is a name for the insinuation of that which is outside the ordinary directly into the everyday, undermining and

throwing it askew. The weirding of the quotidian occurs with, as China Miéville suggests, the 'puncturing' of the 'membrane' separating the world from outside forces, such that the outside miasmatically 'swills' in: 'the weird is a radicalized sublime backwash' (2009: 511). Cunningham's music video anatomies constitute an accelerationist aesthetic of everyday fractal weirdness.

A secret too terrible to know

Earlier, I noted a sardonic intimation in 'All is Full of Love', an intimation that all is not what it seems and that some unknown agency pulls the strings. Let us consider this in the light of the notion of the 'blackened puppet'. Described in Kenneth Gross's *Puppet: An Essay on Uncanny Life*, the blackened puppet is the thing that is, as it were, torn from the base material of the earth, a material that clings ineradicably to the extracted thing, in fact, to all puppets: 'within or alongside all working, moving, and painted puppets there is always a blackened puppet' (2011: 114). Taking up any puppet, the puppeteer gives himself or herself over to 'this charged, blind, and silent material object' (2011: 114). The puppet is bound to a secret blackness, becoming visible only as it crosses the threshold of a space hidden offstage (2011: 116). Gross describes a nineteenth-century puppeteer's account of the puppet, Shallaballah, 'Grand Turk of Sinoa': 'Sinoa is nowhere, for he's only a substance yer know. I can't find Sinoa, although I've tried, and thinks it's at the bottom of the sea where the black fish lays' (2011: 117). As Gross comments, 'Shadowing the visible puppet is the blackness of that unknown fish which lies in wait, or lays eggs, eggs that will hatch in the darkness, and find their way up to the light' (2011: 117). This is an inhuman, abyssal realm to which – as perhaps via the cabling beneath Yamtaijika's android factory in 'All is Full of Love' – the puppeteer, never entirely himself or herself, is also strung. The puppeteer masters the puppet through mediating technology but is in doing so mastered, registering and penetrated by impulses and vectors emanating 'from the puppet suspended below' (2011: 122). The process of mediation described here is peculiar. The medium is, we might say, rendered weird, 'a control with nothing to control' (2011: 122).

We might take a lesson from weird fiction. In the motif of the puppet, as in Thomas Ligotti's horror stories, we are presented with a paradox made flesh. The puppet behaves in ways it should not, shedding its strings, becoming self-moving. In the puppet is reflected that *we* are puppets, a *secret too terrible to know* (Ligotti 2010: 18; emphasis in original). In the encounter with the puppet we reflexively and convulsively grasp our own conscious existence as a kind of supernatural animation. We neither master the world nor are masters of ourselves and the suspicion grows that

'*we are not from here*' (2010: 221; emphasis in original). The weird is our 'secret quarter' (2010: 222).

I would like to conclude by suggesting that Cunningham's videos might be understood as firmly placed within this 'secret quarter;' they are, in sum, a performative, accelerationist horror show. His sculptural, anatomical synaesthesia (synaesthesis) invokes a black, base materialism, the media object 'thingified', emerging, everting, a 'blind spot' articulated as impossible life form (Thacker 2011: 9). As music video, a demon pushes through into the world, just like the demon thrusting through the television set in 'Come to Daddy', just like Sheena flinging alien extrusions as she dances in 'Sheena Is a Parasite'. Here is not simply the evocation of 'a sense of threat through the fracture, transformation, or faulty workings of machines and bodies' described in Vernallis's discussion of Cunningham's work (2013: 225), but, more radically, an intimation of the fracturing, dispossessing power of the medium and of mediation more broadly. Ultimately there is no other auteur than mediation itself. The blackened puppet is object, auteur and viewer, all danced, all transformed together. In its immediacy, mediation is nothing, yet we persist in seeing something there, just as we persist in 'finding nothing in each something', each thing constituted by mediation (Thacker 2014: 85). Galloway, Thacker, and Wark (2014) have written of the imperative inaccessibility of that 'excommunication', which is both constitutive of and exceeds communication. Similarly, Grusin has theorized 'radical mediation', which, in its affective, embodied immediacy cannot be seen, cannot be 'made into something one could paint or draw or re-present, or something that needed mediation' (2015: 232). No distance from it can be achieved, since we are part of it (2015: 132). Maybe what Johnny 'sees' in his tenebrous basement is his own blackness, a blackness which also dances and re-anatomizes us in the music video.

Digital Media and Mutations

Introduction

Mackenzie and Wajcman observe that 'the history of technology is a path-dependent history, one in which past events exercise continuing influences' (1999: 19). This is certainly true when we consider the development of the music video: that its past is still evident within its latest digital incarnations. Even music video's use of 'video' is but a remnant from a bygone age: from when the term would be closely associated with television and, later, alongside the introduction of recording machines that could capably recapture the audio visual broadcast. Subsequently, when exploring the impact of digital media within the subject area of the music video, it becomes essential to also examine the continued influence of pre-digital technologies and, in fact, preceding media forms.

Within his chapter, José Cláudio Siqueira Castanheira examines this path-dependent field of music video in relationship to what are long established cinematic conventions with the subsequent analysis considering whether the music video can be situated alongside a comprehensive story-driven framework (similar to film and TV productions) or aligned with conceptions that simply defy narrative norms. Yet arguing for the format as operating as a postmodern pastiche, he asserts that the music video ably shifts some of the creative energy that would otherwise be invested into a more formal cinematic rhetoric towards a greater focus on aspects of the song. It is then possible to perceive this as the reconciliation of two structures – the musical structure and the filmic structure – with the intersection of these resulting in quite unconventional narratives. Yet, as Castanheira's chapter highlights, this interplay appears to have further, lasting consequences for both music video and feature film given the continued experimentation by directors who will work across both formats; vanguards who have identified new aesthetics and championed non-standardized story arcs.

If that space between the music video and the feature film subsequently becomes blurred by the interventions of these new auteurs, the consequent

compiling as marketed products (including the Palm Pictures compendiums of music promos of Spike Jonze, Michel Gondry, Chris Cunningham, and so on) have made use of film's once preferred physical embodiment: the DVD. Jaap Kooijman makes his own assessment of this particular format at a time when music video has transitioned from television to the internet: a point where the DVD's contribution to our understanding of music dissemination could be argued as irrelevant. Yet this chapter makes the case for a reappraisal of DVD – a successor to VHS and Laserdisc – as a playable media that has demanded active involvement from the viewer due to the addition of elaborate on-screen menus. In turn, these options are novel due to how they disrupt the way that we might otherwise analyse music videos by placing them in what might be a predetermined (often chronological) sequence and while bypassing a more accurate chronology by linking what are otherwise disparate works that may be drawn from across a musician's career. As perhaps the embodiment of the time-skewed videography, Kooijman's main focus is the Greatest Hits DVD: packages that, like their musical 'Best of' counterparts, distort perceptions of a musician's output (and the success of that output) through the exclusive sequencing of hit after hit. Such collections, he argues, should be viewed as contributors to the performer's 'star text:' products that reinforce suggestions of artistic advancement as they play through each successive video.

By comparison, viewers may never have the opportunity to experience a Greatest Hits DVD from South Korean pop star, Psy. Still, with global ubiquity through his 2012 viral track 'Gangnam Style', his music video will already be familiar. Gina Arnold notes how the omnipresence of this particular video signified the worldwide adoption of broadband internet. The song could then be assumed to be a soundtrack for McLuhan's 'global village:' an anthem heralding a new, international homogeny. Yet, as the chapter examines, 'Gangnam Style' may be comprehended as signaling a new Asia: where its dominance on YouTube is a likely precursor to the similarly unstoppable ascendance of the Asian economies and the affirmation of South Korea as a modern, global power.

The impact of YouTube alongside other video content sites such as Vimeo, are considered in this book's final chapter. Completing this section on Digital Media and Mutations, it specifically draws on the development of the 'unofficial video' as a fan-oriented pastime that stays true to the original user-generated intentions behind these platforms. Pulling from interviews with three makers of this kind of content – who are all united due to each having incorporated (or responded to) compositions from electronic music producer Burial – it brings to light digital media's further blurring of another distinction: that of the amateur and professional. In the cases that are described, a further dimension is uncovered through Burial's own reluctance to engage in the practice of music videos which sits alongside the 'anonymous' musician's reticence to be interviewed, photographed and

reveal biographical detail. Then unlike the kind of music video parody that will also populate YouTube, this bootleg-like material seemingly validates the construction of the unofficial version due to the non-existence of any official version. Interestingly here, even areas of music that could be perceived as rejecting nostalgia (in Burial's case, those built around the 'dubstep' axis), still raise phantom-like sonic apparitions from the past. Similarly, the almost synaesthetic responses as music videos will, in turn, pull from an established visual legacy.

These retro undercurrent manifestations – elements of period style – are intriguing. Music dissemination has altered drastically in the twenty-first century and we are at the stage where music doesn't *need* to be physical or even visible. And with electronic media's benefits for distribution, the newer electronic devices that inhabit our homes and pockets have allowed musicians an opportunity to investigate interactivity as almost a replacement for physicality. The band Arcade Fire, for example, developed an app to accompany, album, 'The Suburbs' that took the buyer through a series of visual album artworks. Yet, considering the amount of new releases, this is one of a relatively small number of innovative alternatives. While there is evidence of some mutations triggered by these outputs moving to digital platforms, it is notable that the capabilities for more revolutionary transfiguration has largely been ignored in favour of what might be described as a commitment to a 'traditional' music video format and its influential ancestors.

CHAPTER FOURTEEN

Timeline Philosophy: Technological Hedonism and Formal Aspects of Films and Music Videos

José Cláudio Siqueira Castanheira

Music and narrative structures

Whenever we talk of music videos and especially their relationship with cinema, Michael Jackson's 'Thriller' (1983) is usually mentioned as an important reference point. Considered to be one of the most influential videos of pop culture and a milestone for the music industry, the film directed by John Landis attracted attention precisely because of the large-scale assimilation of the narrative techniques of classical cinema. Jackson's choice of director here was not random. Landis had already gained recognition in the horror genre with his 1981 film *An American Werewolf in London*. The scenes of metamorphosis employed within that earlier film were considered, at that time, to be of an unusual realism; using techniques that were transferred to 'Thriller' part of its symbolic capital. In the case of 'Thriller', it is necessary to draw attention to some of the strategies which make an almost unrestricted association with an established artistic/industrial activity. 'Thriller' opened the doors to new dimensions in terms of what music videos were able to achieve. The business model of film looked promising and brought together the aesthetic premises upon which it was laid. At this point, the linear organization of a perfectly

understandable narrative flow was presented as a novelty compared to other videos made from collages of excerpts from concerts or of edited old movies. Commercial aspects were also decisive in its history:

> At issue was not only the innovative character with which it was seen; but, mainly, his role as representative of music video in the home video market and the certainty that, from then on, this would be a way of business for record companies. (Holzbach 2013: 115)

Despite the great success of the 'Thriller' music video and album of the same name, the promised financial returns for both the music industry and the video industry were not as big as expected. Investments as made in Michael Jackson's video should then remain as exceptions within the complicated system that articulated interests of different actors in the music market. However, the association between music video and narratives seemed to solidify from the 'Thriller' initiative.

The relationship between music and classical narrative cinema was consolidated at the cost of fading a great part of music's internal logic because codes of representation of images and internal narrative structures of film needed to be strengthened. From the period where the industrial establishment of film industry took place, the standardization of musical accompaniment, as Altman (1995) indicates, was an important step for the development of solid connections between music, cinema and market. Films abandoned external 'narrators', 'lecturers', and 'impersonators' when creating specific codes for a new form of representation. The public was getting more and more used to a cinematic experience and films were increasingly self-explanatory. Musical codes inherited from the Classical and Romantic periods helped to emotionally situate the audience. Adorno and Eisler (1989) refer to the persistence of these empirically acquired codes as 'bad habits'. They argue that the incorporation of such practices hindered the progress of music for films.

At the height of the talkies, the composition of original scores for films had already developed a sophisticated apparatus. Take the particular study Claudia Gorbman (1987) makes of music in films from the 1930s and 1940s and, specifically, of Max Steiner as paradigmatic example. Steiner came to Hollywood in 1929 and exerted great influence on the way of composing for films and on the use of musical elements from the classical repertoire, working along with specifically cinematic conventions to create or emphasize dramatic and psychological effects. His European formal education brings to American cinema an already widespread rhetoric, mainly from nineteenth-century music, the leitmotif being his favourite technique. The strict hierarchy between cinema and music was not necessarily egalitarian. Gorbman points to the conflicting relationship between the internal structures of film and music:

There might be something inherently paradoxical about the presence of music in films, even as our experience as spectators seems to affirm that music quite 'naturally' belongs on the soundtrack. The problem might be posed in this way: is not the rhetoric of filmic discourse (representational, 'naturalistic', rhythmically irregular) incommensurate with the rhetoric of musical discourse (nonrepresentational, 'lyrical', rhythmically regular)? (Gorbman 1987: 13)

In the field of composition for films, Gorbman observes a group of basic principles applied in a disseminated form in composition, mixing, and editing processes. What these principles actually did was help to unify sound context, subjecting it to narrative conventions.

Technological hedonism

Bordwell (2006) identifies a new style of filmmaking emerging in the 1990s. This style is characterized by camera work and editing strategies working within an intensely sensorial lexicon made possible by the sophistication of new technologies. This 'intensified continuity' uses features such as close shots, fast editing, shorter average shot length (ASL), energetic movements of camera, and bipolar extreme lengths of lenses. The materialities of film and of its various technical components come forward, producing effects of presence (Gumbrecht 2004), highlighting the asymmetry between human and machinic perceptions. In the early days of industrial cinema, the parity between vision and hearing of the spectator and those of cameras and microphones, at least in theory, was something to be looked for. Within the logic of 'intensified continuity', that equality seems something of lesser importance. Instead, film seemed willing to destabilize a certain conservative bias in order to explore new repertoires offered by technical apparatuses.

Vernallis (2008) points out many similarities between this type of film and formal experiences that music videos had been exploring since at least a decade before. In this sense, many of the mainstream contemporary cinema practices are better understood through the study of what would be commonly considered as a 'minor art'. Undoubtedly, the experimental nature of many music videos (maybe most of them, to a greater or lesser degree) creates difficulties for a generalization or even for a precise categorization of types or styles. Experimentation and a sort of lack of experience or even an intentional disregard for consolidated conventions of previous media can be seen as linked in a way. The distance these new cultural objects took from classical cinema – and hence from film studies – makes difficult the adequacy of existing theoretical tools to the field of music videos. However, for purposes of this analysis, one can start from the premise that the features mentioned before try, to some extent, to make evident certain musical

structures the narrative classic film laid aside. From this observation, I am especially interested in the amount of practices and processes of the universe of music production that starts permeating the film industry. The conversation between film and music was taking different contours.

The 'processual and fluid' nature of music can be translated in terms of images from the equally fluid use of cinematic devices. This refers not only to technology but also to a set of practices ranging from acting to lighting, from special effects to costumes. All these elements, at least the most technical ones, refer to simultaneous processes, with a less evident hierarchy and obeying a flow without a rigorous logic of beginning, middle, and end. 'Music videos foreground unpredictable teleology and ambiguous endings' (Vernallis 2008: 277). These great unpredictability and flexibility are related also to the increasingly heterodox training of directors. Names like David Fincher, Spike Jonze, and Michel Gondry can be mentioned as filmmakers who moved easily between music videos and narrative cinema realms. It is true that this diversity of learning (not necessarily in formal schools of cinema) and even the experience as musicians – as in the case of Gondry – lead to dealing with music not only as an accessory but as part of a discourse that is not mostly visual. The experimentation is also due to the use of new technologies, not yet fully co-opted by traditional ways of producing films, and, mainly, to a certain indiscrimination with which these new tools deal with images and sounds. It is possible to infer some of these practices from material characteristics of old and new audiovisual production technologies.

Talking about analogue technologies and of how traditional film production was articulated, there is a clear distinction between sound and image universes. The moviola was the basis on which the two materials were edited – rough cut film for images and perforated magnetic film for sound. Nevertheless, different procedures were required for each of them. All methods were well differentiated. It is as if the analogue editing confirmed the sense that the two elements inhabited the same realm fortuitously. They were worlds apart that functioned by different rules, observing specific natures: different performances. Although it can be argued that in modern editing software sound and image still have their own specificities such as channel addressing, EQ or colour correction, they are presented in a much more similar way. Every intervention on any kind of material in the timeline seems to follow similar procedures. Actions of cut and paste – functions that, in fact, are common to the many different softwares – homogenized tasks in a way that fewer professionals can handle almost every step in production and post-production stages of a film. Sound and vision establish a more friendly dialogue exactly because of the facility of handling both through the same logic. Any imperfection in sync or any difference in tempos can be easily revised. A set of digital tools and their somewhat undirected potency

allows us to consider what once were irreconcilable dynamics as close and sometimes indistinct ones. Manovich (2013), analysing some of the effects available in Photoshop menus, points to those which, originating from analogue models, undergo an adaptation to digital media – what would require also an update of the very concept of media – and those which were already born in a digital reality. Digital native functions or effects transcend the traditional differences between sound and image, proposing new ways to assemble both.

Manovich himself deals with a database of sounds, images, graphics, and 3D models in his work *Soft Cinema*, giving the software the autonomy to arrange random combinations of all these elements. The network arrangement and, even more symptomatic of new media settings, the constitution and inevitable reference to increasingly complex and ubiquitous databases, transform cinematic experience from something linear and organized according to a syntagmatic logic to something diffused and unfinished, from a paradigmatic order (Manovich 2001). In his conception, the linearity of narration is opposite to the way of building knowledge through databases. By identifying the software as the 'engine' of contemporary societies, Manovich proposes that audiovisual experience cannot be contained within interpretative models inherited from literature.

On the side of professional music production, the desire to offer a wider repertoire of possible actions on images and sounds and, on the other hand, to escape a limited audiovisual grammar produced some of music videos landmarks during the 1980s and 1990s. The song 'Leave It', from the English band Yes, released in 1983, gave origin to a video that, besides being one of the first to use computer-generated images, is also remembered for having been originally designed to be presented in several different versions. In 1984, MTV came to broadcast a documentary on the making of the eighteen video variations. MTV also transmitted all the different versions randomly, each of them with an identifying mark. The base image for the video is quite simple: a front view full body shot of the five members of the band upside-down. They remain immobile while singing. The differences between the versions are in the effects applied by computer. At times, the bodies are distorted, swinging like pendulums or melting down the steps of a staircase like a Dali's surrealist picture. Occasionally, their heads become detached from the bodies and rotate independently. Then, the bodies turn and are viewed from the back, confirming the flatness of a two-dimensional image. There is even a version in which nothing happens: it shows just the musicians singing without any applied effect.

What 'Leave It' reveals is, first, a less definitive nature of the audiovisual product. The 'final cut' of videos no longer possesses the weight of products

associated with the film industry. In addition, the convenience of digital editing makes room for multiple versions. The formal exercise of image manipulation acquires a degree of autonomy in relation to other music video practices, especially with regard to narrative demands. Technological excess is taken as a virtue, almost like a second nature of music videos. Finally, it highlights the intersection between visual and musical procedures, resulting in, for example, carrying out different possible variants of the same product. This type of practice became quite common throughout the 1980s and 1990s, with the release of remix or extended versions of songs, as well as the production of different cuts for each video. The very term 'official video' denotes the multiplication of versions made to supply the need of a market avid for novelties.

Another video usually cited as an important point in the use of digital imaging technology is 'Money for Nothing', from the band Dire Straits. The song is part of the album *Brothers in Arms*, released in 1985 and features Sting on vocals. The video is one of the first to use computer-generated 3D animation, presenting it as an aesthetic element as well as symbolic capital. The computer, seen at that moment as a prime example of technological advancement, helped build an imaginary of omnipotence in terms of manipulation of sounds and images, but equally related with marketing issues. In the video, the characters are employees of an appliance store that make sarcastic and unflattering comments about pop music stars seen on TV. In the final part of the song, the voice of Sting repeatedly sings 'I want my MTV' as an allusion to the type of massive musical production that would become hegemonic and articulate market, digital technologies, and an increasing segmentation of media. The space to be occupied by music videos seemed more promising than that which had been dominated by cinema in previous decades.

The dialogue between technology and market seems to set music videos free from maintaining the legacy of cinematic model. It becomes a platform where to show/sell things: the artists included. One of its purposes is to make visible eminently audible structures, revealing a hidden world containing new layers of meaning. It functions as a cabinet of curiosities in which music, notwithstanding being the main issue, shares the space with the wonderment provided by other elements present in videos: one of them is the performance of technical devices. Some of these techniques, although not being new, were still able to arouse great interest. A second version of the music video 'Take on Me' (1985), from Norwegian band A-ha, mixed scenes of traditional animation with rotoscoping: a technique known since the first decade of the twentieth century. It tells the story of an impossible love between a girl of flesh and blood and a drawing on a sheet of paper. In spite of this, much of the interest that the clip raised was the very use of animation techniques themselves. The video is still remembered with nostalgia by synthpop music fans.

The interest in material aspects of music video production processes overflows, contaminating other fetishist instances. The music video 'Freedom! '90' (1990), from George Michael's homonymous song, has the participation of five well-known top models who do not interpret any characters with defined roles within the 'story'. In 'Freedom! '90', the models dub the song, as if they were alter egos of George Michael himself. Lip-sync becomes an element of fascination, not just by shifting the function of the singer from protagonist of a short story, but, likewise, by pulverizing this character into multiple personas. The character/singer is replaced by a succession of possible bodies: bodies that are objectified and depersonalized. To achieve this, the direction of David Fincher explores a grim and sensual ambience, reinforcing the musical elements that accentuate this mood. The constant use of close shots, highlighting the face and the articulation of the lyrics by the models, which act as if in an advertising campaign, not only confirms the attraction of lip sync but also evokes the hypnotic power of those perfect visages framed by diffused light and other scenographic elements. Any nostalgic remembrance of that video works, without fail, by evoking these feelings, regardless perhaps of the very existence of the male character that appears at the beginning as a 'counterpoint' to the women's determining presence. Narrative models can hardly define the atmosphere of latent sensuality. Indeed, the very notion of atmosphere or ambience (Stimmung), as Gumbrecht defines it, although connected to a specific historical and cultural environment, is something only 'accessible from the rare and subjective experience' (2014: 22). The video is subject to ineffable structures that need a deeper exploration.

Like virtually all sectors of artistic production, cinema also found itself tempted to take digital technologies as a way to facilitate filming, post-production, and commercial issues. The practicality and efficiency of the new tools were very tempting. However, Hollywood was unable to realize how much they meant a deeper reworking of aesthetic premises. As it incorporated the computer as the basis of the entire production chain, American cinema of the 1990s went through one of its most anachronistic phases. It promoted a high-tech image: appropriating futuristic themes, possibly reissuing an imaginary legacy from the 1950s; using technology as a marketing strategy; investing in platforms to expand the market. However, 1990s films followed the same formal structures and narrative techniques of ancient productions. The 'cyberfilm', that is, the one about or dependent on technology, perpetuated a worn modus operandi.

As a cycle, cyberfilms – implicitly or explicitly – contain an odd paradox in terms of subject and form. On one hand, digital technology comes wrapped in a utopian veil of endless visual possibilities. [...] On the other hand, cyberfilms themselves are often thematically reactionary and anti-technological. (Faden 2001: 79)

Categories

It may prove useful an attempt to propose an initial categorization of some of the specificities of music videos when compared to traditional narrative film. The proposal made here is not to be taken as a definitive one but as a sort of speculation on more fruitful ways of identifying new relations amidst the two universes. For this, I will take examples from both sides, analyzing music usages and different post-production steps. Michel Gondry stands out for being a prolific director of music videos for artists such as Björk, Daft Punk, White Stripes, and so on, as well as being able to establish a very personal style in realizing his feature films.

Besides the work of Gondry, I cite other filmmakers who also directed music videos, trying to analyse the specific ways they articulate music and image, namely Spike Jonze, Gaspar Noé, and Marco Brambilla.

Circularity

In the 2007 music video, 'Declare Independence', directed by Michel Gondry, Björk sings into a megaphone-like device from which several cables emerge. On leaving the device, these wires entwine a group of soldiers who, while bound to Björk's performance, are lost in a hypnotic trance. However, these cables are revealed as already being channeled so that they can be played as a bass by another soldier before they even reach the singer; a configuration that allows them to emit a deep melodic line. After a few repetitions, red paint dyes the threads in their way to the megaphone, producing a colouring effect that gradually transforms the space. The inkjets are synchronized with the first beat of each measure of the music. Along with the jet, we hear a distorted note on medium/high register. The red strings pass through the group of soldiers. Shortly after, another note, a lower one, stresses the third beat. Another inkjet, again, as in response to what already occurs in the first beat of measures, becomes part of this flow of events. Then, the jet of the third beat becomes blue. The thread is constantly changing colours. Throughout the video, other changes in musical and visual elements succeed, synchronized or as mutual responses: always in a repeating, circular motion.

Circular movements, literally speaking, are also seen in duo Daft Punk's video, 'Around the World' (1997). Five groups of characters are attributed to a musical element from the track. They perform repetitive actions on a round platform, emphasizing or translating melodic and rhythmic events into the form of choreographic movements. Thus, four robots/aliens begin to mechanically walk around the structure that resembles a vinyl record when a vocoder-modified voice begins to sing the lyrics containing just three words. Four women in stylized vintage bathing suits go up and down

the stairs following the line played by the keyboard; four figures with false heads imitate the bass line – accelerating and slowing down the steps on another staircase; four skeletons dance to the rhythm guitar; four mummies move in sync with the beats of the drum machine. At a certain moment, a fluidity of relations between each group and the roles originally played begins. Still, each performance follows an autonomous logic, which can occasionally dialogue with other elements but never leaving its own inner musical coherence. Musical themes made visible.

Motifs

Recurrence and circularity of actions or of objects can also be seen in the Michel Gondry feature film, *Eternal Sunshine of the Spotless Mind* (2004). Carol Vernallis (2008) points to the peculiar way filmmakers with previous experience in the direction of music videos can deal with less rigid relationships between sounds and images in their films.

Eternal Sunshine presents a simple narrative line. Joel (Jim Carrey), after some disappointments with Clem (Kate Winslet), decides to delete her from his memory. This is done, literally, with the help of a specialized company (Lacuna). However, traces of those memories persist and Joel fights, in a psychological/ surrealist terrain, to maintain them. Despite the unusual premise (the dispute within the character's own mind), the film maintains a proximity with Hollywood representational models using its social archetypes and romantic clichés. The clear difference of Gondry's style in the film is in the way he organizes the various narrative and non-narrative elements to ultimately present a multiple and overflowing array of nuances. There are indentifiable groups of images, sounds and situations that are repeated throughout the film, helping to build autonomous processes that may seem often arbitrary. *Eternal Sunshine* disperses many of his motifs along the narrative that, in fact, is not eliminated, but becomes vague, diffused, and incomprehensible at various times. The motifs compose a tangle of seemingly unconnected events. This network resembles the threads in the aforementioned music video, 'Declare Independence': each one of a different colour, crossing or mixing sometimes, but always independent.

Some of the motifs in *Eternal Sunshine* are: blurred faces, planes, skeletons, and spots. They are sometimes just vague traces, not always easily perceptible. Sounds are also used as significant particles disjointed of a previously given diegesis. Voices infiltrating unexpectedly, as in the words 'tape recorder' heard on a montage sequence – without an identifiable source – strengthen or weaken possible dramatic effects. The murmur in the library seems to belong to an airport, disconnecting the characters from their most obvious space. Noises such as a scratched disk repeat several times, collages of sounds build environments rich in details. 'Gondry seems to be moved by the ideal of reducing dialogue, music, sound and image to their

smallest possible units, which can then interchange with one another – an ideal of erasing the differences between media' (Vernallis 2008: 283).

The familiarity Gondry has with musical practices (he's a drummer) ends up favouring a 'translation' of narrative framework processes into the non-narrative structures and vice versa. To Vernallis, this is essential for expanding the limits of cinematographic 'language'. The organization of film material demonstrates obvious analogies with the organization of musical material:

> As with many of his videos, *Eternal Sunshine* organizes its material in this way: a motif is introduced and extended by repetitions and other processes, such as looping. These threads work differently than do motifs in most films. A typical narrative film might feature between five and seven motifs (a music video likewise). *Eternal Sunshine*, deploying music video's techniques on a feature film's scale, has over thirty. (Vernallis 2008: 280)

Similarly, the 'motifs' may be treated as recurring events endowed with an internal coherence and easily grouped into larger structures. Although it is not a strange expedient to conventional feature films, the way motifs are concatenated in this case is much more complex than in most of cinema productions. Gondry's film adopts a peculiar logic in the organization of these themes, closer to a genuine musical way of thinking cinema.

Self-referential flows

Music videos usually inhabit a world of their own, describing processes that are, one way or another, about creating or performing songs. The recurrence to use band components themselves – specially the vocalist – as characters in music videos is just one of the features that reinforce that relation between fictional and non-fictional spaces.

Those processes are not so usual (at least not as the main articulation of images and sounds) in narrative feature films, but they can be detected in the work of directors like Spike Jonze, as in the case of *Being John Malkovich* (1999). By entering a particular passage in his office, Craig Schwartz (John Cusack) can penetrate the mind of actor John Malkovich (played by himself). The fantastic plot and, as in the case of *Eternal Sunshine*, the development of much of the action within an 'inner world', allows a freedom of representation and a detachment from any verisimilitude or intention of realism. The repetition of motifs reaches its climax when the real Malkovich enters his own mind. All the characters inhabiting this surreal space are John Malkovich and express themselves only by saying the word 'Malkovich' in a narcissistic exhibition seldom seen in cinema.

The work of screenwriter Charlie Kaufman in both films is obviously a defining factor for the way they are structured.

Another feature film of Jonze that was written by Kaufman, *Adaptation* (2002), is a great metalinguistic exercise in which the classical narrative form is subjected to an intense process of deconstruction. The film mocks this kind of pragmatism and predictability of traditional script when presenting as one of his characters the very author of a popular manual of how to write for films, Robert McKee himself. The character, within the narrative, is a famous screenwriter who teaches the protagonist Charlie Kaufman (who, despite being the real screenwriter of the film, is played here by Nicolas Cage) how to write a script. At first, Jonze wanted the real McKee to interpret himself, but that was not possible. In fact, *Adaptation* tells the 'story' of a script (which is the film we are actually watching) being written by a writer (which is, consequently, the writer of the film we see). He should adapt a novel by a writer named Susan Orlean (Meryl Streep) who is also part of the plot as a character in Kaufman's script. The circular processes get narrower and narrower until it is not possible to tell where one story/reality ends and where another starts. There are several overlaps and self-references, the most ambitious of them being the initial sequence in which Kaufman tells us his personal biography: starting with the emergence of life on Earth.

Material affectation/production of presence

Certain material characteristics of sounds and images, along with their sensory affectations, are of great importance for films such as *Enter the Void* (Gaspar Noé, 2009). As with Jonze, Noé already had experience in music videos, having directed works for bands like Placebo. *Enter the Void* tells the story of a drug dealer (Oscar) who, when killed, enters an astral projection, witnessing past events or reviving false memories. The psychedelic tone, the strong colours, the undefined and volatile sounds, and the discontinuity of space and time, accentuate the sensation of existential emptiness. Notwithstanding, it can also be seen as the perception of cinematic experience itself.

At several moments, the film seems to assume a lysergic travel contour, never making clear what would be reality and what would be delirium. Realism codes are gradually left behind. In fact, from the beginning, the film has no intention to present itself as 'real'. Even procedures that in classical cinema would be considered as 'realistic', as the use of direct sound, seem to assume a stylized tone. The film is presented through the subjective listening and vision of Oscar. The camera works uninterruptedly with a point-of-view shot (simulating even eye blinks). Similarly, all the sounds are conditioned to character's point-of-audition. These devices, which might

seem initially as maintainers of a realistic perspective, end up having the opposite effect, producing a stylized and allegorical perception of images and causing an estrangement when suggesting a subjective perception of sounds even in moments of delirium/astral projection. There is no naturalism when we put ourselves to listen through the ears of a 'spirit'. There is an exaggerated stylization of audible and visual elements as if the state of 'projection/delirium' could broaden our sensory ability and open the 'doors of perception'. Cameras with abrupt and inaccurate movements also collaborate in this destabilization of the spectator.

In fact, sounds and images, especially in moments of dream/hallucination or death, refer to themselves. They draw attention to their construction, to their fabric, to physical ways of invading and bewildering our senses. In the opening credits, the film shows vivid colours that, at first, refer to the hyper stimulated universe of Tokyo (the city where the film takes place). However, it is not just that. Sound and imagetic elements are living processes that are noticed long before any narrative element. Musical accompaniment is not required. The film has a musical impact on its very organization.

Sync

A final example of filmic construction from musical parameters: in the episode 'Sync', directed by Marco Brambilla, from the film *Destricted* (2006, several directors), hundreds of very short shots (one or two frames per image) are organized in sync with a drum solo. The film is only around two minutes long while the speed in which the shots are used is dizzying; leaving little possibility of identifying each of them individually. What is clear is the erotic nature of the images and their organization by affinity: there are images arranged by categories as kissing, hugging, having sex in different positions, body details as breasts, buttocks, and so on. Despite the fact that the images have the most varied origins, it is relatively easy to propose a common identity to each group, as if, when displaying them in sequence, we configured a single movement. Moreover, the movement within each image is replaced by an inter-images movement, producing the feeling of continuity from the juxtaposition of different shots (and objects): an exacerbation (and a displacement) of the retinal persistence effect. The accuracy of editing is so great that moments like a roll on the snare drum, or the more evident beats during the solo, are synchronized with groups of frames, producing a single image/sound rhythm. One element can only be understood in its relationship to the other.

Importantly, in Brambilla's film the images lose their specificity, being treated as patterns. You cannot take just one frame of the film as representative of a scene or a sequence. It is not reducible to a single image. It becomes evident the recurrence of the same type of image archetype

through the significant repetition of these. The actions shown in such a disorientating manner reveal a limited repertoire of representations. There are hundreds of different films from which the images were taken, but the frames are equivalent, producing scenes that are inscribed in a kind of cinematic collective unconscious that feeds on its own repetition. In this case, the unpredictable element is the drum solo.

This type of collage is possible with the use of specific functions of editing software (the film was edited using Final Cut). The arrangement of images is automatically made from sync points set on the timeline. Assigning each point to nearly every drum solo detail (it would be, roughly, like identifying each beat as an event), there would be hundreds of these points. From a bank of images separated by motifs, the software takes care of synchronizing sound and image following the parameters set by the editor. More than a technological 'ease', this kind of feature modifies the relationship between the editor and the edited material.

The inflexible adjustment to a grid or to a timeline is a common feature in many different types of digital editing. The 'snap' function would be one of those which, following the categorization of Manovich (2013), would blur the ontological limits of the set of audiovisual elements on the desktop. It ensures (visually) that the different objects (sound and image clips) are precisely placed. It is a sort of certification that is not so much guided by subjective evaluation criteria, but by the microscopic objectivity of the timeline. Visual and audio performances are forced to adapt to the logic of editing software. As music category, however, the notion of rhythm seems to overflow and contaminate the traditional cinematic thinking. Effective inseparability of sound and image, linked to new ways of post producing films, entails the emergence of new models of seeing and hearing.

Voices

The concept of 'voices' may be another one of great interest for this speculation on music videos, to the extent that it relativizes the role of the different sound elements, coming, almost, to set aside their differences. Although voice can be thought of as a kind of film body manifestation, that is, an expressive and perceptive view of the apparatus, its most obvious meanings would be, on the one hand, the speech of each of the characters, on the other hand the discourse implicit in film narrative. Either there is almost as natural, the relationship of this voice with a human dimension, on a textual or a discursive level (what the film or the director wanted to say).

Thinking of a quality less tied to human facts and more conditioned to the form of film or music, one might think voice as the element that, despite working autonomously, can only be understood from its relation

to other voices. The role of a voice is not specifically in itself. Thus, it is not possible to pre-determine the function of each of them individually but within a structure. It is clear that musical polyphony is constructed from a series of rigid conventions. Musical discourse, if aligned with Adorno's (1989) categorization, comprises a refined logic that only an *expert listener* would be able to understand. However, beyond this possibility of intellectual musical 'understanding', polyphony introduces us to the difficulty of apprehending the whole, at least at once. The phenomenon that Langkær (1997) identifies as a 'cognitive overload' can and should be thought outside the strict sense of musical context. The superposition of relatively independent sound layers can produce effects that are beyond the rational. Music video logic, by promoting a sort of representational 'polyphony', seeks to produce that sense of 'presence', of a sensory impact not reducible to textual categories or even to conscious apprehension.

Conclusion

The common identification of images and sounds as 'clips' on a timeline allows an approximation of procedures and hence a conceptual identification. Categories such as rhythm, motifs, and voices come to meet both universes. The discussion on how the material characteristics of different technologies can effectively result in new forms of experience may point to different conclusions. Anyway, it is good to be aware that musical experience, commonly defined as 'subjective', is linked to formal structures not directly translatable into images and that it is conditioned by the different technical procedures used for its realization.

If songs are thought of as affectations beyond the rational field, observed from their material features, the growing distance between music videos and the traditional film narrative model can be considered as quite promising. Music videos stick to material issues not just concerning recording processes but also related to the various media to which they are attached. Many of the effects available to video technologies during the 1990s were considered tasteless, as if they were not good enough to be considered as part of an established 'cinematographic language'. They were seen as excessive. The availability of these 'kitsch' possibilities of video means, on closer inspection, that the experimentation was something deeply attached to electronic image technologies. Moreover, the 'amateurism' of many of these first 'videomakers' has proven beneficial in many ways. Furthermore, the relationship with the new electronic and, subsequently, digital resources, eventually contaminated the film industry itself.

The material conditions that new digital tools provide for sound and image editing certainly play an important role in building new logics. The timeline philosophy makes the boundaries between sound and image more fluid. This new organization should be thought of in aesthetic terms, of course, but not as that alone. Both in narrative feature films like Gondry's or in data based algorithmic experiences such as Manovich's *Soft Cinema*, what is at issue is a change of consciousness about cinematic experience.

CHAPTER FIFTEEN

The Boxed Aesthetic and Metanarratives of Stardom: Analysing Music Videos on DVD Compilations

Jaap Kooijman

When one puts *Whitney: The Greatest Hits* (BMG Video, 2000) into the DVD player, before the main menu is shown, the star herself appears in medium shot, standing in front of a pink and white backdrop and addressing the viewer directly: 'Hi! I'm Whitney Houston. Welcome to my DVD. I hope you enjoy watching it. Have fun! Bye!' Whitney subsequently pops up again on the main menu, spreading her arms in a welcoming gesture, while simultaneously pointing out the different menu options offered to the viewer (Figure 15.1). In retrospect, more than fifteen years later, this personal welcome seems rather frivolous. However, back in 2000, it signified the innovative character of the DVD format, which only had been commercially available since three years earlier. Whitney's presence highlighted that, in comparison to music video compilations released on Laserdisc and VHS, the DVD format promised an improved viewing experience, enabling viewers to select individual music videos to watch as well as offering special features and bonus material, such as interviews and 'behind-the-scenes' footage.

The music video on DVD has received little attention in the academic literature, which tends to focus instead on the music video's shift from traditional television to Internet, from the analogue era of the MTV 1980s

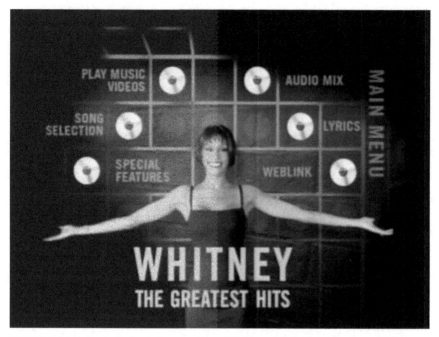

FIGURE 15.1 *Image of DVD menu from* Whitney: The Greatest Hits *(2000).*

to the current digital era of YouTube and VEVO (Beebe and Middleton 2007; Keazor and Wübbena 2010). A notable exception is Carol Vernallis, who devotes a chapter in *Unruly Media* to the *Directors Label* series (Palm Pictures, 2003–2005), consisting of DVDs that each focuses on the work of one individual director of music videos. Vernallis does mention DVD music video compilations by 'megastars' Michael Jackson and Madonna, only to conclude that 'these have sold poorly and provide few aesthetic pleasures', explaining her preference for the director-based compilations over the star-based ones with the argument that the former 'enhance our sensitivity to music video directors as auteurs' (Vernallis 2013: 262, 263). The *Directors Label* series is indeed exceptional in the extensive way each DVD gives insight in the process of music video making and also invites the viewer to recognize common themes that make the collection of music videos a unified body of work. However, by placing a sole focus on the director and by suggesting that star-based compilations are less aesthetically pleasurable, Vernallis ignores the added value that star-based DVD compilations can offer in the study of the music video as part a performer's 'total star text' (Dyer 1991) and 'metanarrative of stardom' (Goodwin 1992). Whereas the director-based DVD compilation invites an analysis of the collection of music videos as a demarcated oeuvre with a recognizable 'signature' of the director as auteur, the star-based DVD compilation similarly invites an

analysis of the collection of music videos as a defined body of work that highlights the star's commercial and artistic development.

As by now popular music videos are easily accessible online or can be purchased through iTunes or Amazon, the music video DVD compilation as format has become archaic in a relatively short period of time. Moreover, Vernallis's claim that the star-based music video compilation on DVD is less aesthetically pleasurable does make sense when comparing it to the star-based audio greatest hits collection; for the average user, watching a compilation of music videos from beginning to end seems less common than the repeated listening to a CD collection of songs. For the media studies scholar, however, the music video DVD not only has an archival function but also challenges one to rethink the music video as an audiovisual text and object of study. In this chapter, I take two star-based DVD compilations as starting point to explore how they can contribute to the analysis of music videos as part of the total star text and the metanarrative of stardom: the posthumously released three-disc box set *Michael Jackson's Vision* (Epic, Legacy, MJJ Productions, 2010) and Madonna's two-disc box set *Celebration: The Video Collection* (Warner Bros., 2009). Without a doubt, Michael Jackson and Madonna – MTV's 'Two M's' – are the quintessential music video pop artists of the MTV 1980s (Austerlitz 2007: 37–40, 45–47; Marks and Tannenbaum 2011: 189). They were also among the firsts – and, to my knowledge, Jackson the first – to release music video compilations on DVD: Michael Jackson's *HIStory on Film: Volume II* (Sony, 1997) and Madonna's *The Immaculate Collection* (Warner Bros., 1999; originally released on Laserdisc and VHS in 1990) and *The Video Collection 93:99* (Warner Bros., 1999). Isolated from both the televisual flow and the Internet, the two DVD compilations present the music videos of Michael Jackson and Madonna as unified audiovisual overviews of work, suggesting that the individual videos should be analysed as part of a collective.

The chapter's second part presents a case study of the music video 'Come into My World' (2002), starring Australian-born pop diva Kylie Minogue and directed by French film director Michel Gondry. 'Come into My World' has been released on both a star-based and a director-based DVD compilation: the single-disc *Ultimate Kylie* (EMI-Warner, 2004) and the double-sided single-disc *The Work of Director Michel Gondry: A Collection of Music Videos, Short Films, Documentaries and Stories* (Palm Pictures, 2003), the third DVD that was released in the aforementioned *Directors Label* series. By analysing the music video within these two different contexts, the distinction between star-based and director-based DVD compilation can be made explicit, showing how the analysis of a music video is not only steered by the music video itself but also by the way it is distributed. Such a double analysis enables us to perceive the music video as being part of both the performer's metanarrative of stardom as well as the oeuvre of the director as auteur.

Metanarratives of stardom:
Michael Jackson and Madonna

The introduction of the VCR and DVD has changed the viewing experience of film and television, as well as the way these media can be analysed. The possibility to pause, select, and replay enables a delayed viewing practice that encourages a pensive spectatorship (Mulvey 2006: 192). This is particularly significant in the study of television, as the conventional television text was part of a larger broadcast, often interrupted by commercials, resulting in a fleeting viewing experience. Television on DVD, on the contrary, invites a more attentive viewership and enables the media scholar to pay more attention to television's formal textual qualities (Walters 2008: 79). According to Jason Mittell, the introduction of the DVD has enhanced the notion that television can be studied as an autonomous text: 'We might consider this drive toward unity and complexity as fulfilled by bound volumes such as DVD sets as a *boxed aesthetic*, tight together as a complete whole comparable to similarly unified forms such as novels and films' (Mittell 2015: 40, emphasis in original). Although Mittell is specifically referring to fictional television series, the notion of the boxed aesthetic can also be applied to music videos. Individual music videos have been perceived in several different ways: as commercials to promote a song or artist; as short films in which the song functions as soundtrack; as part of the audiovisual flow of music television; as artistic expressions by the performer or the director. When presented collectively within the boxed aesthetic of the DVD compilation, however, the music videos become a complete whole as one collection that can be analysed as a text on its own.

Released one year after his death, the DVD *Michael Jackson's Vision* provides a chronological overview of Michael Jackson's post-Motown solo career, ranging from 'Don't Stop 'Til You Get Enough' (1979) to 'Liberian Girl' (1989) on the first disc and from 'Black or White' (1991) to 'Cry' (2001) on the second. The third 'bonus' disc consists of seven music videos that explicitly are not considered to be part of his core body of work. As its title *Michael Jackson's Vision* emphasizes, the DVD frames the collection of music videos as the artistic expression of the performer, presenting Jackson as a cinematic auteur rather than a pop megastar. This notion is reinforced by the promotional text on the DVD's back cover:

> Throughout his illustrious career, Michael Jackson not only changed the way music sounded, he changed the way it looked. Breaking through barriers of all kinds – including the preconceived notion of a 'promotional music video', Michael created cinematic short films with universal appeal that brought his songs to life to the point where the premiere of a new Michael Jackson video became a worldwide television event. Working

with such acclaimed film directors as John Landis, John Singleton, Spike Lee, David Fincher, and Martin Scorsese as well as special effects legend Stan Winston, *Michael Jackson's Vision* was realized on the 35 ground-breaking short films on this 2-DVD set, collected here for the first time.

I quote the text at length, as it shows how Jackson is transformed from a music video performer to an auteur of 'cinematic short films', a notion that is enhanced by the sixty-page golden-coloured DVD booklet that features pictures of Jackson at work on location at the different music video shoots rather than the conventional glamour pop star photography. Even though the text mentions the 'acclaimed film directors' who worked with Jackson, they are not presented as the actual directors of the music videos but instead as mere contributors to 'Michael Jackson's vision' and as such reinforce Jackson's credibility as film auteur.

Whereas *Michael Jackson's Vision* downplays Jackson's pop star image in favour of his cinematic auteurship, the DVD compilation *Celebration: The Video Collection* emphasizes the image of Madonna as pop megastar (Figure 15.2). Released in 2009 to 'celebrate' the twenty-fifth anniversary of her first global hit single 'Holiday', the DVD presents the music videos in chronological order on two discs, from her 1983 second single 'Burning Up' to the then-current single 'Celebration', inviting the viewer to recognize a development in Madonna's body of work. In contrast, the songs on the accompanying double-disc CD compilation, also entitled *Celebration*, are in seemingly random order. The DVD cover features a portrait of Madonna

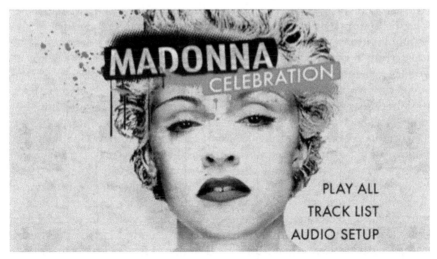

FIGURE 15.2 *Image of DVD menu from Madonna,* Celebration: The Video Collection *(2009).*

made by Mr Brainwash (pseudonym of the French artist Thierry Guetta), clearly inspired by Andy Warhol's famous Marilyn Monroe portraits. Instead of a booklet with text, the DVD includes a foldup poster with, on one side, another version of the faux-Warhol portrait, and on the other, a collage of vintage television sets with pictures of Madonna from different phases of her career as well as the necessary credits (including the names of the music video directors) in small print. The art design has a double function. On the one hand, Madonna is explicitly connected to the historical connotations of stardom as embodied by Marilyn Monroe and Andy Warhol, including the pop art aesthetic of the endless reproduction of commercial images. On the other hand, the design by Mr Brainwash reaffirms the notion that Madonna successfully keeps up with cultural trends to appropriate them for a mainstream audience; Mr Brainwash became widely known one year later, when he was the subject of the documentary *Exit through the Gift Shop* (Banksy, 2010).

To understand the relation between the music video as text and the star image of its performer, it is productive to revisit an early essay on Michael Jackson's 1983 'Thriller' (the sixth music video on the first disc of *Michael Jackson's Vision*), directed by John Landis. In 'Monster Metaphors', originally published in *Screen* (1986), Kobena Mercer first presents a formal analysis of 'Thriller' as a short film text, focusing on how the music video uses the genre conventions of the horror film to move from the 1950s B-movie imagery into the then-contemporary dance sequences. However, Mercer then argues that 'Thriller' should not just be perceived as a self-contained short film text but also as a text that reflects on – and as such becomes a part of the construction of – Michael Jackson's evolving star image, particularly his transformation into a 'monster:' 'The metamorphosis could thus be seen as an accelerated allegory of the morphological transformation of Jackson's facial features: from child to adult, from boyfriend to monster, from star to superstar – the sense of wonder generated by the video's special effects forms an allegory for the fascination with which the world beholds this star-as-image' (Mercer 1993: 105). In this way, Mercer convincingly shows how the music video not only presents a short story but is also part of its performer's total star text.

Without explicitly referring to Mercer's essay, Andrew Goodwin has made a similar distinction between the music video's 'visual narrative' and the 'metanarrative of stardom' of its performer (Goodwin 1992: 98–101). As main example, he uses Madonna's 1984 'Material Girl' (the fifth music video on the first disc of *Celebration*), directed by Mary Lambert, which is one of the most often analysed music videos in the academic literature (Fiske 1987; Kaplan 1987; Tetzlaff 1993). In 'Material Girl', Madonna performs a visual pastiche of Marilyn Monroe's 'Diamonds Are a Girl's Best Friend' from the Hollywood movie *Gentlemen Prefer Blondes* (Howard Hawks, 1953), prompting the fictional film producer featured in the music video

to exclaim: 'She's fantastic...I knew she would be a star...she is a star!' The music video's visual narrative presents a 'classic' Hollywood love story of an actress, played by Madonna, as impersonating a material girl rather than being one, and who is successfully wooed by the film producer giving her flowers instead of diamonds. When perceived as part of metanarrative of stardom, however, the music video introduces the 'real' Madonna as the material girl – 'She is a star!' – a 'real' start just like Marilyn Monroe. As Goodwin argues, the 'Material Girl' music video 'served the function of shifting Madonna's image from that of a disco-bimbo to "authentic" star', and therefore the analysis of music videos should be made 'at the level of the star-text, not within the discursive world of the fiction acted out by the pop star' (Goodwin 1992: 100, 101). Not the rather trivial love story told by the music video, but its presentation of Madonna as star makes 'Material Girl' significant. By connecting her to Monroe and Hollywood, as well as explicitly stating that she is a star, the music video positions Madonna within the realm of movie stardom, which was subsequently confirmed by her starring role in *Desperately Seeking Susan* (Susan Seidelman, 1985).

Even though one does not need to watch these music videos on DVD to recognize these metanarratives of stardom, the box aesthetic of the DVD compilation invites a reading of the music videos from such a perspective. Moreover, viewed within this context, the way the metanarratives of stardom develop over time becomes highlighted. Both Jackson's 'Thriller' and Madonna's 'Material Girl' are featured relatively early on in the chronological overviews as presented on the DVD compilations, released three decades later. In the case of 'Thriller', the DVD literally shows the 'morphological transformation of Jackson's facial features' that Mercer identified as Jackson's metanarrative of stardom, as one witnesses the continuous change of his body and face from 'Bad' (1987) and the aptly titled '[It Doesn't Matter if You're] Black or White' (1991) to the also aptly titled 'Ghost' (1997) and 'You Rock My World' (2001). As I have also argued elsewhere, instead of a shift from 'black' to white', Jackson's physical transformation can be perceived as a shift from 'full' to 'blank', in which Jackson's star image is reduced to an empty logo (Kooijman 2013: 166). Jeremy Gilbert speaks of 'the real abstraction of Michael Jackson', suggesting that Michael Jackson's shift from a Black disco-soul singer into a global megastar has made him a sign representing nothing but commodified culture (Gilbert 2009: 148). In spite of its explicit aim to solidify Jackson's legacy as cinematic auteur, the DVD most of all shows how Jackson's star image has evolved into a 'real abstraction', which tellingly is visualized by the DVD's transparent plastic slipcase featuring a golden-coloured silhouette of Michael Jackson in one of his trademark dance poses as an easily recognizable logo.

In the case of Madonna's 'Material Girl', the *Celebration* DVD compilation too highlights the metanarrative of stardom that Goodwin

identified. Although in retrospect it is difficult to imagine the need to position Madonna as a 'real' star, the compilation of music videos from the early 1980s to 2009 reinforces Madonna's stardom, showing, on the one hand, how her star image continuously has been reinvented (or indeed, how Madonna continuously has reinvented herself) to connect to current fashion trends, while, on the other, Madonna as 'material girl', the 'real' star as introduced in the 'Material Girl' music video, remains a consistent element of her star image. Madonna's established and retained stardom is emphasized by the repetition of Madonna impersonating Marilyn Monroe, first in the 'Material Girl' music video, then in the faux-Warhol portrait on the DVD's cover, connecting her to the mythical Hollywood stardom that Monroe embodies. While Michael Jackson's metanarrative of stardom reveals a transformation into abstraction, in which the Jackson star image becomes increasingly crystalized into an empty sign, the one of Madonna reveals a continuous re-inscription of the sign, repeatedly reaffirming the Madonna star image. By viewing 'Thriller' and 'Material Girl' in the context of the respective DVD compilations, the metanarratives of stardom – already identified in the individual music videos but incessantly evolving during the subsequent decades – are brought to the foreground.

Come into My World: Kylie Minogue and Michel Gondry

By the end of the 2000s, pop music magazines and websites published lists of the decade's best music videos. Kylie Minogue's 2002 music video 'Come into My World', directed by Michael Gondry, could be found on many of them, including as 'the most re-watchable video of the decade' (number 14) on the top fifty of the Pitchfork website and the number one of 'The 50 Best Music Videos of the Aughts' published by *Slant* magazine (Gonzalez 2010; Plagenhoef 2009). 'Come into My World' is the fourth and final single and music video from Minogue's popular 2001 album *Fever*. Although not as commercially successful as the album's lead single and music video 'Can't Get You Out Of My Head' (directed by Dawn Shadforth), which is Kylie Minogue's biggest global hit to date, the music video 'Come into My World' has been critically acclaimed. In addition to being on the best of the 2000s lists, 'Come into My World' has been included in the 'canon' of music video art that has been exhibited at museums such as the MAKK contemporary art museum in Cologne, Germany, the Museum of Contemporary Art Tokyo, Japan, and the Australian Centre for the Moving Image in Melbourne, though its inclusion is primarily based on the artistry of director Gondry rather than of performing artist Minogue (Aust and Kothenschulte 2011: 185).

'Come into My World' is the twenty-seventh music video out of thirty-one featured on the 2004 DVD compilation *Ultimate Kylie*, which is in chronological order, starting with the 1987 hit single 'I Should Be So Lucky' up to Minogue's then-current single 'I Believe In You'. Similar to Madonna's *Celebration*, the songs on the accompanying double-disc CD *Ultimate Kylie* are in random order (although the first disc includes only songs up to 1992 and the second disc songs from 1994 on). The music video looks deceivingly simple, presenting a long take of Minogue in everyday clothes – faded blue jeans and a pink top – exiting the drycleaners and lip-synching to the song as she walks along a Parisian crossroad. The music video mirrors the song's monotonous and repetitive structure, starting with the chorus, followed by the first verse. When the second chorus begins, Kylie is back at the drycleaners, where the same round begins again, this time with two Kylies. Not only Kylie doubles but also all the other pedestrians and several objects such as the blue Volvo and the window cleaner's ladder. This layering is repeated with each chorus, only to fade out by the time the fifth Kylie appears. The visual narrative of 'Come into My World' could be summarized as telling a story of the mundaneness of everyday life and the repetitiveness of daily chores. Far more relevant, however, is how the music video relates to Kylie Minogue's metanarrative of stardom, as also argued by Ed Gonzalez of *Slant* magazine, who explains why 'Come into My World' tops its list of the decade's best music videos. Comparing the music video to Zbigniew Rybczynski's short film *Tango*, Gonzalez argues – in tongue-and-cheek academic jargon – that 'Come into My World' is a 'remarkable deconstruction of artistic identity and technique', as the 'Kylie multiplying on screen in unison as one more buttery, Minnie Moused version of herself' highlights how the music video's 'subject is the negotiation of space but also a consideration of how the self is refracted through media' (Gonzalez 2010: n.p.).

In the academic literature, Minogue's evolving star image is often compared to the one of Madonna, as both pop stars rely heavily on music videos in the continuous reinvention of their star images, with each new music video presenting a new 'Kylie' and 'Madonna', while simultaneously staying 'themselves' to such extent that their core audiences are not alienated (Barron 2008: 47; Gauntlett 2004: 172; Shuker 2001: 164–165). In his pastiche of Roland Barthes's essay 'The Face of Garbo', Sunil Manghani describes how 'Kylie' remains at the centre of the pop singer's different incarnations: 'In spite of its singular beauty, the body Kylie…acts out a succession of feminine forms (yet always *as* Kylie), from girl-next-door to disco diva, from Barbie doll to Hollywood chic, from magazine cover girl, and comeback queen to indie chick' (Manghani 2013: 64, emphasis in original). When viewing 'Come into My World' in the context of *Ultimate Kylie*, this notion of 'Kylie' as the main point of focus becomes prominent, particularly as the DVD's cover features an extreme close-up of Minogue in

conventional pin-up style, looking seductively into the camera. This look is repeated in the accompanying ten-page booklet, which includes three double-paged collages of pin-up-style photographs showing Minogue throughout different phases of her career. The booklet also features a two-page list of credits, which includes the names of the music video directors, yet the list is printed so small that the names are hardly readable, suggesting that the music videos should be perceived as showcases of the Kylie Minogue star image rather than as artistic work made by the individual directors.

Kylie Minogue's metanarrative of stardom is explicitly presented in the DVD booklet with a two-page biographical overview entitled 'From lucky lucky lucky to la la la', which expresses both progression as well as repetition – the title refers to the hit singles 'I Should Be So Lucky' (1987) and 'Can't Get You Out Of My Head' (2001), respectively. The overview describes Minogue's artistic and commercial development in three phases: first, a young soap opera actress 'almost accidentally' (direct quotation) turns teen-pop singer under guidance of the Stock-Aitken-Waterman production team; second, in search of artistic freedom, the pop star signs with an independent label to produce her own music, releasing commercially less successful yet critically acclaimed pop albums; and third, the pop star makes a commercial comeback as a fully developed artist who is able to combine her artistic vision with commercial success, while being credited for a critical self-reflection on the construction of her star image. 'Come into My World' then fits the third 'commercially and artistically successful' phase, in which working with renowned director Michel Gondry enhances Minogue's artistic credibility, as well as the critical self-reflection. A productive comparison can be made to Minogue's 1997 music video 'Did It Again' (directed by Pedro Romanhi) from the second 'independent yet less commercially successful' phase and also included on the *Ultimate Kylie* DVD. 'Did It Again' features four different Kylies – 'Cute Kylie,' 'Dance Kylie,' 'Sex Kylie,' and 'Indie Kylie' – getting into a catfight over which Kylie should be in the forefront. The Kylies in 'Did It Again' represent four distinctive parts of the Kylie star image, whereas 'Come into My World' multiplies one 'plain' Kylie. However, with such playful multiplication, both music videos explicitly recognize that 'Kylie' is a construction, an image that can be repeated over and over again.

When viewing 'Come into My World' in the context of *The Work of Director Michel Gondry* DVD, the focus shifts – obviously – to the oeuvre of Michel Gondry as auteur. Gondry founded the *Director's Label* series together with Chris Cunningham and Spike Jonze, whose works are featured on the other two DVD compilations of the first series. As Saul Austerlitz has argued, Jonze and Gondry can be seen as the 'two filmmakers who would come to dominate the [music video] form as no directors before them had done' (Austerlitz 2007: 163), prompting MTV in the mid-1990s to feature the director's name in addition to the performer's name on the music video's

credits. Like the DVD's title, the DVD's cover emphasizes the focus on the director's work, featuring a still from the 2002 LEGO animation music video 'Fell In Love With A Girl' that Gondry directed for the White Stripes rather than an image of the director himself. This does not mean, however, that Michel Gondry is visually absent; he is prominently present, including on the DVD's menu and in the 52-page booklet. Remarkably similar to Whitney Houston's introduction, the DVD opens with a medium shot of Gondry, standing in front of a classroom, exclaiming: 'Hello! Welcome into [sic] my DVD'. Moreover, the DVD includes a 75-minute autobiographical documentary *I've Been 12 Forever*, in which Gondry provides personal commentary on his own work.

Like the *Ultimate Kylie* DVD, the Michel Gondry DVD is in chronological order, except in reverse, starting with his latest work and going back into time: side A from 2003 to 1996 and side B from 1995 to 1987, thereby not only inviting the viewer to trace Gondry's artistic development back to its origin but also emphasizing the return to a childhood world of fantasy and innocence as a main trope in Gondry's work. 'Come into My World' is the second music video on side A and stands out because it is the only music video that stars such an overtly commercial pop star, compared to the relatively 'artistically acclaimed' artists such as Björk, (the pre-'Get Lucky') Daft Punk, Foo Fighters, the White Stripes, and Oui Oui. A statement inside the DVD cover emphasizes this exception: 'The Licensee Fee otherwise payable to Kylie Minogue and EMI/Parlophone in relation to the inclusion of "Come into My World" on this DVD will be donated to [charity]'. Surprisingly, the 1997 music video 'Feel It' that Gondry directed for Neneh Cherry is not included, also not on the sequel *Michel Gondry 2: More Videos (Before and After DVD 1)*, released in 2009. Although less visually and technically advanced as 'Come into My World', 'Feel It' shares similar elements, such as Neneh (like Kylie, dressed in pink) lip-synching while she walks along a crossroad and a multiplication of the singer into three identical Nenehs.

Although the inclusion of 'Feel It' would have connected 'Come into My World' more explicitly to Gondry's earlier work, the music video befits Gondry's signature as auteur, including his 'exceedingly personal iconography, often linked to childhood or dreams' as well as his fascination with 'visual cannons, palindromes, and complex graphic schema' (Vernallis 2013: 268, 269). When discussing the making of 'Come into My World' in the *I've Been 12 Forever* documentary, Gondry literally returns to his childhood by explaining that the music video's visual technique was inspired by a magic trick performed by a illusionist he had seen on television when he was a young boy. Yet, the music video's visual trick is not just a reference to Gondry's childhood, but also fits the techniques he has used in his other work. Similar to the 1997 'Around the World' music video that Gondry directed for Daft Punk, 'Come into My World' visualizes the song's musical structure.

Scholars have identified this 'circular repetition', combined with the 'optical effect [of] multiple exposures', as a 'clear visible leitmotiv' that is easily recognized as a defining element of Gondry's oeuvre (Gabrielli 2010: 97; White 2009: 98). Such an auteur perspective focuses on how the music video contains the director's artistic signature, in which 'Kylie' merely functions as a prop in Gondry's trademark visual trickery. In this way, the analysis moves from merely the visual narrative to the level of the metanarrative, yet not the one of the star performer but to the one of the director, which I would define as the metanarrative of authorship. This does not mean, however, that the metanarrative of stardom is completely absent, as the music video, also at the level of the metanarrative of authorship, does rely on the Minogue star image. 'Come into My World' works because the prop is 'Kylie' – Michel Gondry's 'number one pin-up', as he reveals in the DVD's booklet – rather than just an anonymous woman. Here the music video presented on a star-based as well as director-based DVD compilation comes together, as analysing 'Come into My World' within these two different contexts shows how the metanarratives of stardom and authorship complement rather than contradict each other.

Welcome in/to my DVD

At the beginning of this chapter, I referred to Carol Vernallis's argument that director-based DVD compilations 'enhance our sensitivity to music video directors as auteurs' (Vernallis 2013: 263), to which I would add that star-based DVD compilations enhance our sensitivity to music video performers as stars. The box aesthetic of the DVD invites the media scholar to view individual videos as part of a larger body of work, highlighting the metanarratives of stardom and authorship. The comparison of four different music video DVD compilations featuring the work of, respectively, Michael Jackson, Madonna, Kylie Minogue, and Michel Gondry, as discussed in this chapter, does raise the question of authorship. While the Gondry DVD presents the music video compilation as the body of work of a cinematic auteur, and the *Michael Jackson's Vision* DVD positions Michael Jackson as a cinematic auteur rather than a pop star, the Madonna's *Celebration: The Video Collection* and *Ultimate Kylie* DVDs both emphasize the central role the pop star plays as a spectacle to-be-looked-at, the object of the (male) gaze. Here one cannot fail to notice the gendered distinction between these specific examples, in which the cinematic auteur is connected to male artists and the spectacle to-be-looked-at to female artists. Such a distinction is emphasized by the box aesthetic of the DVD compilations; while the Gondry and Michael Jackson DVD compilations are relatively deluxe editions of the DVD box set with extensive DVD booklets, mirroring the 'Collective

Works' book editions of literary authors, the music video DVD compilations of Madonna and Kylie Minogue are released in plain DVD cases.

In the end, however, the similarities between these four DVD compilations challenge these gendered distinctions. The *Michael Jackson's Vision* DVD may aim to present Jackson as a cinematic auteur, but highlights his star image as pop spectacle instead. Even the Michel Gondry DVD, focused specifically on the director's work, ends up celebrating his stardom: not just his auteur signature but also his visible presence as star director is a common thread throughout the DVD, specifically – but not limited to – the autobiographical documentary, suggesting there is a thin line between the metanarratives of authorship and stardom. In the cases of the Madonna and Kylie Minogue DVDs, as well as the one of Michael Jackson, the role of the different directors of the individual music videos is downplayed to such an extent that the star remains the common thread, implying that not the individual music video's director but the star is the 'auteur' of her own metanarrative of stardom. These issues are raised when Whitney Houston and Michel Gondry, or Michael Jackson, Madonna, and Kylie Minogue, welcome us to their DVDs, to come into their worlds. Analysing music videos on DVD compilations encourages interpretations beyond the individual music video, inviting the media studies scholar to recognize the metanarratives of stardom and authorship.

CHAPTER SIXTEEN

Why Psy? Music Videos and the Global Market

Gina Arnold

In the summer of 2012, a new colour made an appearance on the planet, a shimmering shade of neon green which Nike, its biggest proponent and the maker of a signature pair of trainers in it, called *volt*. Although it seemed as if it emerged from the London Olympics as a sort of visual synecdoche for the flying feet of Jamaican sprinter Usain Bolt, the colour is one that by rights should be associated more closely with South Korea. A full year before Bolt made volt famous, the neighbourhood of Seoul called Gangnam was full of the eye shattering hue, it having made its first appearance in the South Korean city of Daegu at the World Track and Field Championships. Directly after that event, volt-coloured trainers, bags, warm-ups, and umbrellas were available for purchase all over Gangnam, the most ostentatious shopping neighbourhood in Seoul, so it isn't surprising that the video for 'Gangnam Style', the surprise viral hit of 2012, was also awash with it. It's most obvious appearance in the video is on a full, formal tuxedo worn by guest-star comedian Yoo Jae-Suk, who emerges from a yellow Porsche to dance briefly with the song's singer Psy (Park Jae-Song). But nary a frame goes by without some dash of it elsewhere: as a necklace on a dancer, as a life preserver on a person on a boat, as an accent, even, in one frame, as the hue of Psy's visage.

To me, volt is the colour of Gangnam, of K-pop, of Korea itself: bright, catchy, inescapable, and loud, loud, loud. It belongs in 'Gangnam Style' the same way that 'Gangnam Style', the song, belongs in any short list of important pop hits of the twenty-first century, that is to say, alongside the work of more lasting and/or revered pop hits of the era by Taylor Swift, Beyoncé, Kanye West, and Drake. The song 'Gangnam Style' is often mentioned alongside

other flash-in-the-pan joke songs, like LMFAO's 'Party Rock Anthem'. But it distinguishes itself from those in part by being one of only a handful of songs sung in a language other than English to ever succeed in America (Nena's '99 Luftballoons', from 1983, sung in German, and the Spanish group Mocedades' 'Eres Tu', from 1974, are the others). More importantly, it is one of the most viewed videos ever. As of this writing, the number of people who had watched it – over 1 billion – exceeded the populations of all but three countries on the planet. Unlike other wildly popular viral videos like 'All Your Base Belong To Us', 'Kofi 2012', and 'David At Dentist', Psy's video occupies a different role in the *zeitgeist*, signifying a global turn in both the reach and the significance of music videos. Much like Nike's faddish colour volt, 'Gangnam Style' brought a new visual energy to the world of cultural artefacts.

The success of 'Gangnam Style' has some obvious implications, such as an uptick in the penetration of YouTube as a platform for dissemination and (the possibly linked) fact that Western and non-Western video standards are now blending into a mushy stew of standardized 'pop' sounds and images that have nothing to do with their countries of origin. But I wish to contend here that the implications surrounding the success of 'Gangnam Style' go beyond cultural ubiquity, linguistic novelty, and aesthetic considerations. They also raise questions about the space that music videos, as a form, occupy in the global imagination. This chapter will argue first, that the imagined spaces music videos delineate have much to tell us about the eras they emerge from, and second, that Psy's video in particular is relating a story both to Western and non-Western audiences about global urban culture, helping to orient us towards a new Asia. Aspects of the video, which at core is merely a humorous comment on a specific over the top consumer-ridden neighbourhood of Seoul, are, like early rap videos, really an expression of both what Marcialana Morgan calls 'the extreme local' and a new global urban contemporary space. In addition, the video shares commonalities with what theorist Manuel Castells has called 'the space of flows'. The fact that this space has been visualized and then caught up and popularized worldwide speaks to the important new role of music videos play in shaping the social imaginary.

Why Sigh?

In the 1980s, when MTV began circulating music videos to promote music, the medium was maligned as a form of marketing. It was seen by critics as destroying listener imagination, forcing consumers to understand songs as having a single meaning, and finally, as being subject to as many (if not more) corporate and economic restrictions than popular music. As Will Straw puts it in the *Sound and Vision* reader:

The advent of the music video era evoked two fears, 1, that the image would become more important than the experience of music itself, with effects that were to be feared (for example, the potential difficulties on artists with poor images, the risk that theatricality and spectacle would take precedence over intrinsically musical values, etc.); 2, that the music video would result in diminishing interpretive liberty of the individual music listener [...] in what would amount to semantic and affective impoverishment of the musical experience. (Straw, in Frith 1993: 2)

In addition, videos were costly to make and even more costly to distribute. Not only did they require investment from major labels, but the prohibitive expense meant that relatively few acts would be supported in this way.

Few would argue that all these effects came to pass. What wasn't taken into account was that, as Neil Postman has said, 'It is a mistake to suppose that every technology has a one-sided effect. Every technological innovation is both a blessing and burden...not either-or, but this-and-that' (Postman 1992: 4). For all the losses incurred by the introduction of music videos into music promotion, there have been many gains as well. Moreover, early criticism of music video was in part due to the primitive nature of the product. To begin, music videos were not only expensive to shoot but also unimaginatively conceived. Many consisted of roleplaying, wherein the singer or a singer-substitute acted out the actions of the lyrics, while lip-synching along with the action. Later, less literal scenes would be interspersed with live shots of the band or singer performing the song.[1] Some videos, led by popular clips by Pat Benatar and Michael Jackson, relied heavily on a regimented, formation dancing, while rap videos evolved their own set of cliché's, mostly resting on naked women, jewellery, cars, and track shoes.

But the days are long past when music video was seen as a shallow, hollow, vehicle for music promotion. By the turn of the century, music videos had become an art form in their own right, often utilizing respected art house film directors like Spike Jonze (Beastie Boys), Anton Corbijn (Nirvana), and Michel Gondry (Kylie Minogue), among others. Gondry's video for Minogue's song 'Come into My World' (2002), for example, used sophisticated one-shot camera technique combined with studio trickery to simulate many Minogues walking by shops at a French intersection.

The elevation of video to an artform may not have saved the musical experience from impoverishment that Straw et al. feared. But it added a dimension they may not have considered, as did the invention of both cheap and easy video software and social media sharing sites that wildly enhanced the importance of videos in music promotion, while at the same time decimating the role that MTV had once played in circulation. Chief among these changes is the introduction of YouTube, circa 2005. In the new world of viral video, videos are of supreme importance for the circulation of music,

replacing radio as a mainstream source of music discovery. And alongside the vastly greater number of developers and listeners – consumers and creators, if you will – comes a concomitant change in the imagined space in which these songs take place. Literalness in narrative is no longer necessary to music, just as objects (vinyl, CDs, stereos) are no longer necessary to play the music. Now, cyberspace is often presented as limitless space of freedom – 'the wild west' is the cliché'd term used by many – and many, if not most, videos enact this in their narratives. Indeed, videos allow artists to reimagine both the world and their songs in both utopian and dystopian spaces. In both cases, artists emerge victorious. In a utopian video, like Lady Gaga's 'Born this Way' (2011), or Beyoncé's 'Run the World (Girls)' (2011), the stars plop themselves down in scenarios where the usual roles of women are reversed and romanticized. In the Nicki Minaj video 'Fly' (2011), Minaj and guest singer Rihanna rise from the smoking ashes of a downed jetliner wearing wild space-age skin suits and otherworldly hairdos, as they rap about overcoming misfortune, poverty, haters, and triumph.

These are high-end videos, however; high-end, and high stakes. For hip hop performers like Minaj and Rihanna – American women of colour – an elaborate visual portrayal of their aspirations are the only way to map themselves onto the pop consciousness. But that route is a fairly narrow one. Luckily, thanks to increasingly cheap video cameras and easy to access video platforms, smaller artists – outsider artists, so to speak – have become able to utilize the form to increasingly good effect. In 2006, for example, OK Go's video for their song 'Here It Goes Again' was credited with being the first viral video, hitting 50 million views in a single month. The video, which featured the band members doing a synchronized dance routine on four exercise treadmills, was shot at the singer's sister's place of work, and cost essentially nothing to make. The same is true, only more so, for Baauer's dance track 'Harlem Shake'. The song was released in 2012; in 2013, a YouTube comedian named Filthy Frank created his own 30-second long video for it which somehow spawned literally thousands of copycat videos, more than seventy of which have over one million views each (Mason). In both cases, the artists invested essentially no cash for a return of millions of dollars. The almost magical economic transaction that these viral videos represent has three crucial pieces: an extremely simple dance routine, an incitement to audience participation, and humour.

Why Psy?

Psy's video for 'Gangnam Style' has all three elements. But few things have less ability to travel across continents and languages than humour, and it came from a very different place than most popular music heard in the United States: Seoul, South Korea. Korea has its own highly successful, regional

music market, for what's called K-pop, and although Psy's music doesn't fit with the vast majority of this music (which is written by committee, and performed by highly trained and choreographed girl and boy groups), he did initially have the power of his label, YG, behind his work. In fact, at the time of 'Gangnam Style's release, Psy had been making music for twelve years, some of which had been nominally banned in Korea for 'inappropriate content' (as is the case in the United States and the UK, such a ban only made him more popular). Still, his success with this particular song took everyone by surprise. His label, YG, and its rival labels, S. M. and J. Y. P., had spent millions of dollars promoting other K-pop groups in America. But he had no ambitions there himself. 'My motto is "be funny but not stupid"', Psy told Korea's Yonhap News Agency in 2012. 'I think the humour targeted for social outsiders reflected throughout the song, dance and music video really hit the bull's eye. I didn't make this for foreign countries', he said. 'This was always for local fans' (Yang 2012: online).

That word, 'local', is confusing. On first thought, it seems as if it means 'Gangnam' – a neighbourhood which takes up some fifteen square miles of Seoul, but which, according to the *Atlantic* represents 7 per cent of the entire country's GDP. Perhaps by 'local' he meant residents of Seoul, in which case it swells to 25 million. Korean speakers? 80 million. Whatever way you parse it, in Psy's case, 'local' is a large number. But localness isn't really about numbers – nor can its appeal, in pop, be overstated. Rap music initially was made exclusively for, by and about residents of the South Bronx. Punk rock had a very small footprint of fans when it began in lower Manhattan. So did the folk revival of the fifties, which was concentrated in Greenwich Village and Cambridge Mass. The original grunge scene: teeny-tiny. Locality is a keyword to almost every really successful musical movement. The Liverpool Sound. Motown. Topanga Canyon. Madchester. Soca. Guyville. Brooklyn. Portlandia. Each of these spaces has created a distinctive sound that describes something unique to itself, yet at the same time universally appealing. As Bruce Pavitt, the head of Sub Pop records once said:

> The one thing that gives music its potency is its context. You have to look at the artists' community at large, where they're coming from, who they were speaking to in the first place. Look at San Francisco in the sixties: Haight Ashbury, Owsley, Ginsburg. That's what made the Grateful Dead and the Jefferson Airplane more than just bands: that's what made them resonant and important [...] the context is the whole story. (Arnold 1993: 160)

Pavitt was talking about music of an earlier era, pre-music video, pre-YouTube, pre-internet. It may seem odd to apply his words to the post-MP3 world, and particularly to Korea, but in fact, context adds dimensionality to everything. On its surface, 'Gangnam Style' may have appealed to video

viewers who were merely attracted to what Susan Kang, in the *Wall Street Journal*, calls 'its wacky Asianness'. Kids confronted for the first time with the clip in the video 'Teens React to Gangnam Style' use words like 'random', 'hilarious', 'awesome' and 'swag', and speculate it's called 'Asians gone wild;' they like the dance and the emotion it evokes, which they describe as happy and funny (Teens React to Gangnam Style 2012: online). But these are all words and emotions that could apply to countless videos. Given its appeal to *one billion* people, however, it's worth considering what the song was *about* that made its humour cross borders. According to Psy and other Koreans who have written about it, 'Gangnam Style' is a critique of consumerism. It is even, according to some, subversive. According to Sukjong Hong:

> Psy does something in his video that few other artists, Korean or otherwise, do: he parodies the wealthiest, most powerful neighbourhood in South Korea. Sure, he uses physical humour to make it seemingly about him, a man who wants to project glamour but keeps falling short. All of his mannerisms, from the curled upper lip to a sinister neck-stretching move, come from the repertoire of a rich playboy, and in his hands, they become a little laughable. But ultimately, by declaring 'Oppa [essentially, "big brother"] is Gangnam Style', he turns the lens on Gangnam, getting specific about power and privilege in a country where a single district has long dominated in almost every arena. (cited in Yang 2012: online)

After it took the world by storm, experts began weighing in on the meaning of 'Gangnam Style'. Hong, a Korean pop culture commentator, told the *Atlantic* that the song's subtext referred in part to Korea's staggering debt: 'The neighbourhood in Gangnam is not just a nice town or nice neighbourhood. The kids that he's talking about are not Silicon Valley self-made millionaires. They're overwhelmingly trust-fund babies and princelings' (cited in Fisher 2012: online). Blogger Jea Kim concurs. 'Psy is making fun of people that are so vain and materialistic, but at the same time he's making a mockery of where he's really from, that is, Gang Nam. It's like he's shouting, "Look at me! I'm a true Gangnamese but don't I look really tacky and pathetic?"' (Kim 2012: online).[2]

In scene after scene, Psy shows himself doing something a wealthy person would do – then undercuts it with 'reality' – he rides a horse that turns out to be on a merry go round; he goes to a beach that turns out to be on the shore of the river, he goes to a nightclub that turns out to be an old person's party bus, he sits on a throne that is – you guessed it – a toilet. Kim claims part of the appeal of the video in Korea is just this knowing wink on his part: 'Most Koreans are fed up with all those *nouveaux riches* in Gangnam who became rich because their real estate values skyrocketed overnight. The haves in Gangnam are so materialist and philistine that they hardly have a real organic relationship with the world outside of Gangnam, much

less a sense of noblesse oblige' (Kim 2012: online). At one point in the song, Psy references a 'Gangnam guy' gulping down coffee – a reference to the myriad of fancy coffee shops that line the main street selling cappuccinos for 6,000 won.[3]

In short, 'Gangnam Style' is a critique of wealth and inequality, with specific points addressed at economic disparities that most neighbourhoods the world over are currently experiencing: it is also, incidentally, as message that both crosses and complicates the underpinnings of early rap music, a point that is underlined by the fact that it is performed *as a rap*. Conspicuous consumption enacted by the newly rich in grotesquely ritzy neighbourhoods that have become unmoored from their historic underpinnings is something that has its equivalent in almost every American state and European country. 'Gangnam Style' lampoons this idea in the gentlest of fashions, in words that aren't legible to most Western listeners. But language notwithstanding, it's difficult to believe that some part of the message isn't being transmuted – and isn't incredibly welcome.

Sci Fi

Like most video phenomena, the success of 'Gangnam Style' is partly sheer luck. And surely its popularity can be attributed as much to its beat as to its understanding of global economic disparities. But that said, it is a surprisingly accurate visualization of global urban theory. In *The Network Society* Manuel Castells discusses how social forms of space and time are 'being transformed under the combined effect of the information technology paradigm and [...] the current process of historical change' (2009: 407). Castells's analysis begins by showing how the concentration of 'advanced services' in the information and financial sectors – concentrations of power and skills – have created what he calls 'nodes' across the globe. Globalization, he argues, stimulates regionalization, as local markets glom onto the nodes nearest them (2009: 415). One of the fundamental dichotomies of our era is the continued existence, and even growth, of the city. Despite having been voided of their functional necessity by the invention of the internet, Castells argues that global cities have become increasingly important as places of opportunity for personal enhancement, social status and individual self-gratification; of increasing one's cultural capital via conspicuous consumption and art and entertainment (2009: 416).

Castells analyses various city forms – the American business park (Irvine), the European capital (Madrid) and a newer form which he says can be found all over the globe but particularly in Asia. Seoul – with a metropolitan area that reaches to Incheon and includes about 30 million of Korea's 50 million population – is one of the latter, which Castells calls a

'mega city': that is, a region that 'articulates the global economy, links up the informational networks, and concentrates the world's power' (2009: 435). These mega cities connect externally to global networks, while internally disconnecting local populations that are either functionally unnecessary, or socially disruptive (2009: 436). But all three of these types of urban centres are dwarfed by a more modern form of space, which Castells calls 'the space of flows'.

According to Castells, the 'space of flows' is the dominant spatial form of the new network society we live in. This space is created not only by electronic pulses that make up our communication network but also by simultaneity of social practices without territorial contiguity (2009: 415). It is, in other words, a 'real' place, occupied by real people, who share time at a distance, and one of its feature is a flattening out of culture that can be one of the signifying features of globalization. According to Castells, the space of flows requires secluded spaces for cultural elites: VIP lounges and luxury hotels, first-class flights and private access to online networks, as well as the practice of homogenous lifestyles that incorporate spas, jogging, and meals featuring salad and salmon. In addition, he argues that, because the space of flows has become the dominant spatial form of the new network society we exist in, city architecture is becoming increasingly ahistoric, blurring the relationship between society and (visible) space.

Thanks to the space of flows itself, Castells's insights are already somewhat dated, but they can also be usefully applied to video, which thanks to YouTube, has created a time sharing social practice that mimics the qualities he describes. And here is where Psy's video come in. 'Gangnam Style' is the megacity made visible – but also, the mega city being mocked. Certain aspects that Castells has specifically singled out as being necessary for cultural elites to – the jogging, for example; the spa treatments, and the VIP life – are highlighted here. Although a specific local neighbourhood in Seoul is named again and again in the song, the parts of the city the video shows are interchangeable not only with many parts of Seoul but also with many parts of other megacities, especially in Asia. The buildings seen from the so-called beach; the underground parking garage, the inside of an elevator…these could all be anywhere. And even the few buildings that are shown are not the gaudy glass high rises of Apkujeong but completely banal skyscrapers. The architecture revealed, as Castells has suggested that it will be, is bland and ahistoric, wiped of regional interest or of anything remotely Korean. Not only that, but the characters in the video seemingly celebrate this lack of Korean-ness with abandon – dancing in a garage, in an elevator, in a toilet, and finally, on a tour bus full of old Koreans, that is, the 'functionally unnecessary' visitors from the space outside the megacity.

Another way that the space of flows is applicable to video is that watching them consists of 'time sharing social practice', with 'sharing' being

the operative word: the sharing of videos is the sole cause of their virality. 'The space of places' – that is, the industrialized economy's old idea about locale – conforms to the olde worlde idea of music videos as advertisements, made by corporations and then shown on corporatized television station to a passive set of viewers. Conversely, within the space of flows – that is, the post-industrial economy's more fluid notion of location as 'a time sharing social practice' – video consumption is a two-way practice. In this way, it becomes a bridge between two spatial logics, a form of communication that links flow with place.

Conclusion: Wi-Fi

In attempting to explain 'why Psy?' I have perhaps invoked a theory about the post-digital world that could apply to any number of other videos. That being the case, perhaps this hasn't answered the question: that is, in a world full of videos about every conceivable subject, videos about wealth and poverty, immigration and politics, and sex and drugs, videos with nudity, beauty, synchronicity, and pulchritude, videos about everything under the sun, what on earth caused *this* video – one sung in a language other than English – to become the most watched video of all time? Once again, with feeling: why Psy?

There's no definitive answer, but one can make a few guesses. To begin, although the space of flows exists everywhere and all at once, it only seems right and proper that the first ever billion-hit music video should hail from Asia, where the wi-fi is better – Seoul has both the fastest download speeds and best wireless penetration of any country on earth[4] – and where there are simply more young people (not to mention people) than in the West. Its nearest rival, Justin Bieber's 'Baby', holds no interest whatsoever to vast swathes of the world's population: to most men, for example. Second, 'Gangnam Style', like all fluke hits, owes some of its success to timing. It enjoyed its heyday during the months just after the London Olympics and before the American Presidential election, a time when media saturation is at its highest and may have therefore included people not usually attuned to popular culture, such as occasional fans of strange sports or clued out voters. Third, visually, 'Gangnam Style' is bright and cheerful. In the age old words of the television dance programme *American Bandstand*, it also has a good beat and you can dance to it. Plus, songs that are accompanied by easy dance moves traditionally have a long, long shelf life: The Twist, The Locomotion, The Macarena, and The Dougie all come to mind.

Most importantly, however, capitalism thrives on innovation and new markets, and 'Gangnam Style' invokes both those elements with ease. Singing in Korean is an innovation. And its mere existence has made South

Korea visible as a new market, as a space of pleasure and playfulness, and incidentally, as a new global power that does not need to be reckoned with so much as conjoined. Rather than consign it to the long list of jokesy videos that it seems to fit into at first glance, 'Gangnam Style' should be remembered for having made room for itself on a platform that seldom glances offshore, and for making Asia – and Asian pop – as blindingly noticeable as the Nike colour volt.

CHAPTER SEVENTEEN

Vimeo Killed the Video Star: Burial and the User-Generated Music Video

Daniel Cookney

The title I have used here does indeed allude to 'Video Killed the Radio Star:' the 1979 hit single by The Buggles that may very well lurk in the background of other sections within this book. With regard to this chapter's content, the implication might be an obvious kinship: where – as with the video's role within The Buggles song – user-generated content platforms such as Vimeo are seen as propagating media that are capable of usurping more established formats or channels. However, the unofficial music video – the precise focus of this chapter – almost corrects a misunderstanding that is the central premise of 'Video Killed the Radio Star:' the supposition that the visual music promo is a technological development that obliterates the simple pleasures of audio. After all, without the actual music, there really is no music video: it is a format that is responsive to and also incorporates an existing music recording. Despite this, the video content of music video has been perceived as relegating the aural component to secondary place via the kind of argument that insists that the world is somehow becoming increasingly visual.

The idea of technological developments within the music industry as destructive and therefore untrustworthy is certainly not a new one. For example, it can be traced back to the campaign against canned music within 1930s theatres and the Keep Music Live slogan of The Musicians' Union through to 'Video Killed the Radio Star' and later critiques of music video's

importance to what is often negated as a banal and passive MTV generation. In each case, there has arguably been a survivalist imperative at work where warnings are issued by individuals or organizations with investments in an area that suddenly feels threatened with extinction. This may similarly apply to the popularity of user-generated content given suggestions that it has the capabilities to dismantle established media institutions. Gauntlett, for example, observes how 'for centuries people have liked to make things, and share them with others, in order to communicate, to be part of the conversation, and to receive support or recognition; but the internet has given us a forum where people can do this without gatekeepers' (2011: 107). Yet this may not be entirely true. There remains a substantial amount of interposing between audiences and online content and many established, so-called 'traditional' organizations are still involved in this mediation having more than adapted to find their online entry point to fully capitalize on the web's communicative potential and assure further growth in global markets. As Jennings says: 'one of the predictions made in the early days of the World Wide Web was that it would bring about the end of intermediaries who got in the way of direct links between creators and consumers. But rather than being obliterated, these intermediaries are being transformed' (2007: 197). This relates to the time-honoured major media corporations whose influence is still felt online but, at the same time, it remains significant with regards to the development of user content-based media platforms such as Youtube and Vimeo: newer media spaces that aggregate and approve content rather than produce it (Burgess and Green 2009: 4). While these particular platforms may still occupy a role as a go-between, they notably allow contributors to occupy a similar role within their own personal channels. At this personal user/producer level, it can be argued that the transformation of the intermediary has been even more revolutionary given that it contributes to what Gauntlett describes as a culture of 'making and doing' (2011: 11). Ultimately, this new breed of intermediary then fulfils the optimistic view of Web 2.0 as a participatory environment that fosters collaboration and involvement over passivity. Importantly, this can be 'amongst everyday users, rather than elite professionals' (Gauntlett 2011: 90) and is said to then offer the 'immediacy and authenticity we don't get from more mass-scale professional media' (Jennings 2007: 146). Gauntlett notes that amateur music videos were amongst the earliest contributions to YouTube (2011: 89) but, while highlighting even more nuance and complexity within this area, I have chosen to discuss three user-generated uploads here that will traverse the professional/amateur divide: a trio of music videos that respectively incorporate a piece of music by UK electronic music producer, Burial, that as audio visual works, can be viewed as an extension of each creator's own professional practice.

Signed to London-based record label Hyperdub, Burial – real name Will Bevan – has never actually issued an official music video. Other Hyperdub

signings such as Kode9, DJ Rashad, Jessy Lanza and DVA *have* worked with video makers to produce visual treatments for selected recordings yet, despite Burial's popularity and some profile-raising collaborations with musicians such as Thom Yorke, Four Tet and Massive Attack, he maintains a distanced relationship with what might be described as music's more visual and promotional aspects. As Hancox identifies:

> Burial doesn't do DJ gigs, live performances or radio shows, and only a few photos exist of him, taken by the photographer Georgina Cook, and obscured to conceal his identity. 'Only about five people outside of my family know I make tunes, I think. I hope', he says. (2007)

This position of 'deliberate self-marginalisation' (Gilbert and Pearson 1999: 161) can be aligned with concepts such as underground – particularly within electronic dance music where the proliferation of niche scenes assists with participants' self-identification as being distanced from supposedly mainstream commercial concerns. As such, Burial is not the only producer who chooses to see himself as operating on the margins of the music industry as – to varying degrees – Kraftwerk, Daft Punk, Zomby, and Aphex Twin have all actively sought to avoid the tropes associated with the fame-based methods of distribution that have become commonplace in the twentieth and twenty-first centuries. Again, this itself is barely a new concept. In 1930, McColvin questions the focus on performing artists rather than the compositions within 'announcements of concerts, gramophone companies, or wireless companies' (317). Concerned by an emphasis on 'personalities', he states that 'it is fairly certain that a stranger to music would believe, after surveying our present conditions, that the performer was far more important than the music he performed' (McColvin 1930: 317). So, for at least eighty-five years, there has demonstrably been reticence regarding whether attention should be placed on the individual rather than their musical output. The music video subsequently occupies an awkward position within this kind of underground ideology. While able to be recognized as a creative endeavour in its own right, the music video is tied to its definition as a promo: a promotional device or advertisement for the music recording and, indeed, the performer. For Burial, the preferred method of communicating his underground-aligned recordings would be similarly grassroots and, further eschewing mass-scale professional media, pirate radio is cited as a particular influence on his work. As an alternative outlet to video channels, Williams does state that, even via commercial stations, the concept of a song played on radio 'as an advertisement is rendered mute [...] radio airplay is considered as entertainment and authentic artist expression, not advertising' (Williams 2003: 52).

Recounting the theme of 'Video Killed the Radio Star' once again, it is possible to subsequently perceive the radio transmission as concentrating

on the recording whilst its video counterpart presents external elements that
may actually distract from the composition. The former, it could be argued,
then gives attention to 'the music itself' (Hesmondhalgh 1998: 234) – an
idea that definitely has currency within underground scenes. As Burial has
discussed:

> Old underground producers – their releases had a mystery to them.
> When all you've got is a logo, track name and music, it makes you focus
> more on what's important. I'm not some full time music person and it's
> a laugh making music, but all I want is to make tunes – nothing else.
> (Murray 2012)

What is then important for Burial is the music – as he says, 'nothing else:'
'the art as an ideal, not the ego' (Hazlitt 1930, quoted in Ferry 2002: 198).
His self-marginalization and employment of anonymity is then part of
'an attempt to move focus away from the identity of the author or artist,
and onto the work itself' (anon #4 2013: online) and such practices have
been echoed elsewhere with – as one example – Swedish production duo
Skudge quoted as saying: 'we choose to be anonymous because we want
the listeners to put focus on our music and not our personalities. For us
the music speaks for itself' (Brophy 2010: online). The use of 'the music
itself' therefore suggests links to processes that are devoid of image or
the influence of biography: often used with an assumed inflection of a
purer and less mediated music experience that can be unhindered by the
external influences surrounding celebrity and personality. It results in music
that suits what Jennings describes as 'insiders' (2007: 33): those that 'see
themselves as the "true" fans of music for music's sake and set themselves
apart from anything that smacks of hype and commercialism, which they
view as polluting the pure musical instinct' (Jennings 2007: 33). Yet there
are additional factors to consider with regard to Burial's reluctance to have
his music portrayed within an official music video: that of the auteur and
creative control. 'Everything Burial does is 100% him', states director Ben
Dawkins following his own experience of making a Burial-approved, yet
still unofficial, video. 'The music, the graphics [...] everything. The word I
got back from him was that "if I have a video, it will have to be done by me.
Everything's mine"' (2015: interview with the author).

On 22 June 2008, Søren Severin uploaded a file to YouTube with the
description 'Unofficial Video. A visual interpretation of the tune Ghost
Hardware by UK dubstep artist Burial'. Severin notes how 'at the time,
dubstep was very hot in Copenhagen' (2015: interview with the author).
While Clark states that the genre 'used to be a niche concern, often dismissed
as a dark UK garage mutation from the South London margins of Croydon,
Streatham and Norwood' (2007: 65), he observes how it had gained more
international recognition in 2006. Reynolds says that, in its early stages,

dubstep was a development or 'mutation' of the earlier UK garage genre that had notably 'dropped the songs and pop-fizzy euphoria in favour of [...] empty space' (2013: 641). Yet by 2008, its sound had further fragmented due to the number of disparate music producers exploring its possibilities, yet dubstep – as a term – was increasingly being associated with a harder, more abrasive and overtly bass-heavy definition. While still experimenting with low frequencies, Burial's output was less obvious: arguably more introspective, perhaps even cinematic. For Severin, 'Burial was one of the most interesting artist to come out of the scene' (2015: interview with the author). Actually developed as part of Severin's animation and video-making coursework at The Royal Danish Academy of Fine Arts (then named The Danish School of Design), the imagery for his video for Burial's 'Ghost Hardware' was captured with a relatively cheap handheld Hi8 camcorder while travelling around by 'train, bus, car or even by bike' (2013: 641) before being edited with Final Cut Pro and undergoing some basic post-production in Adobe After Effects. However, the aesthetic inspiration for the video did not come from any specific source.

> It was basically my own visual interpretation of the mood and feel of the music. I used to listen to Burial on the train or bus, riding through Copenhagen, and the repetitive rhythmic patterns of the music seamlessly fitted together with the city lights and buildings passing by. As far as I remember, it was wintertime, so the light and mood of the city also seemed perfect for the music. (Søren Severin 2015: interview with the author)

Presented in black and white, it begins with footage of the sun seemingly struggling to break through a bank of cloud. While this, as implied by Severin, is responsive to the video maker's own interpretation, it is interesting that similar visual metaphors can also be found elsewhere within the discussion of Burial's music. One comment on another video upload that actually relates to Burial's music rather than any visual component (in this case for the track 'Fostercare') claims that 'you're at the bottom of the pit of life, you can't go any lower, and just when you're wondering if this darkness that surrounds and entombs you will dissipate, a single beam of light shines upon your skin once more, reminding you of a time you had almost forgotten' (RellyAlexander 2015: online). Elsewhere, an upload of Burial's 'Forgive' prompts a related assessment:

> Haunting and humble, full of pain and experience, yet hopeful and beautiful. It's so simple but so incredibly powerful. When I hear this I picture someone's soul drifting off into the clouds, as they look back at their life. All of the things that gave them trouble are completely insignificant. All of the pain and suffering wiped clean. All that's left is beauty. (WreckingFox Mashups 2014)

Conceivable as somewhat overwrought, these kinds of readings add a fascinating dynamic to Burial's work. The absence of the performer has not only meant that Burial has often avoided the need to justify his music, his reluctance to engage beyond making music has allowed (or maybe even encouraged) his audience to independently interpret the work. As Sumner insists, the withdrawal of the composer 'creates space between the artist and the listener' (Church 2009: online) and subsequently 'leaves it wide open for anyone listening to put whatever they want in that empty space' (Blanning 2011: 41). In Burial's case, it has infamously prompted what has been described as a deluge of 'metaphor, dodgy poetry and urban imagery' (anon #5 2012: online) including the instigation of prose such as 'his recordings ask similar questions of their audience as a broken toy in an abandoned house might: who did these traces belong to? Who were they? Where are they now? And are these things left behind signifiers of happiness or sadness?' (anon #5 2012: online). The fervour to decipher Burial's ambiguous intentions has therefore generated an extensive, if speculative, discourse that has arguably come to describe those musical texts and what is an otherwise unknown author. Severin also acknowledges this allure – stating how he was intrigued by the fact that Burial's identity was, at that point, unknown and how this factor actually warrants the creation of a video:

> I think I felt that the anonymity made it more legitimate and exiting to do a fan video [...] I saw an opportunity in the empty space and was interested to explore it. (2015: interview with the author)

Severin's consequently self-justified exploration involves that journey through Copenhagen's cityscape. Still, the way it is captured by the lens means it could almost almost be any other urban environment. Throughout, Burial's music seemingly conducts the the visuals: determining the action with footage depicting the rigidity of the man-made environment – corresponding with the compositions more machine-like musical elements – but eventually giving way to a beat-less section where the human voice (a brief sample of Christina Aguilera from a live performance of 'Beautiful' – just one of a number of vocal fragments that briefly emanate from Burial's otherwise hiss and echo-ridden soundscape) offers some respite. As Burial says of this kind of arrangement:

> I like putting uplifting elements in something that's moody as fuck. Make them appear for a moment, and then take them away. That's the sound I love…like embers in the tune…little glowing bits of vocals…they appear for a second, then fade away and you're left with an empty, sort of air-duct sound…something that's eerie and empty. (Kek-W 2012: online)

Visually, Severin represents this change of pace by correlating the introduction of the voice with a visual detail that, contrastingly, is natural. Specifically, the camera fixes its gaze on rainfall generating almost cymatic patterns as it collects on the street. This rain is especially noteworthy as a recurring motif within Burial's work. In interview he has stated how 'I love rain, like being out in it. Sometimes you just go out in the cold, there's a light in the rain, and you've got this little haven, and you're hanging round like a moth' (Fisher 2012: online). Additionally, it is the sound of rainfall that introduces his remixes of Bloc Party's 'Where is Home?' and – perhaps most appropriately – Thom Yorke's 'And It Rained All Night'. The producer, however, can be self-effacing about the role of these additions within his productions when insisting that, like his incorporation of vinyl crackle on other tracks, 'I partly use the rain to cover up the lameness of my tunes' (Fisher 2012: online). Yet, as described, that is only 'partly' the reason. Burial has also expanded through his own poetic explanation to indicate how his music tries to emulate the sensory experiences associated with such elements:

> What I want is that feeling when you're in the rain, or a storm. It's a shiver at the edge of your mind, an atmosphere of hearing a sad, distant sound, but it seems closer – like it's just for you. Like hearing rain or a whale-song, a cry in the dark, the far cry. (Hancox 2007: online)

Karl Kliem's video for Burial's 'Prayer', on the other hand, makes no concessions to the natural world. A real-time visualization, captured two years prior to its uploading on 24 March 2011, it showcases a sound reactive device that had already been used within a number of 2008 live concerts for, musicians, Jen Jelinek and Sleeparchive. Here, Kliem's utilization of the self-built 'Rasterdeck' involves the sequencing of four fluorescent tubes – each evenly spaced within a square gridded ceiling element (seemingly the kind of standard lighting unit that might be installed in a corporate office block). In this case, the diffuser that would commonly be used to reduce glare has been removed to reveal the tubes and their connections (see Figure 17.1). The visual result is that of a stark and industrial monochromatic experiment where lights blink harshly in accordance to the sharp snaps of Burial's snare drums; the immediate space around the tube is then temporarily illuminated but beyond, just a couple of centimetres, is nothing but pitch black: perhaps the embodiment of that aforementioned 'cry in the dark' (Hancox 2007: online).

However where it has an immediate connection to Søren Severin's treatment for 'Ghost Hardware' is through the use of the object as musical signifier. Severin's own five minutes of captured and rearranged motion is dominated by streetlights and cables (plus trees and stacked shipping

FIGURE 17.1 *Karl Kliem's video for Burial's 'Prayer' (2010).*

containers) that will shift through the various various frames in time with
Burial's skeletal rhythms. Within the 'Ghost Hardware' video, objects will
jerk nervously at points: disjointed within the editing process to ensure
that their erratically repeated forms provide a visual referent for clattering
percussive arrangements. This broken montage then offers a visual referent
for what might be best described as Burial's 'scuttling, sidewinding, 2step
shuffles, treble and bass scattered with woodblocks and rim shots, often
completely snare-less drum patterns, with accents in all kinds of strange
positions' (Goodman 2001, online). In response to this, Severin's work
notably, but accidentally, evokes the approach that Michel Gondry chose for
his Chemical Brothers – 'Star Guitar' video: presenting a moving landscape
as viewed from a window where elements are carefully organized and
cued by the soundtrack (the maker of the 'Ghost Hardware' video wasn't
aware of this reference at the time that it was produced but, more recently,
has been startled by the similarities). He elaborates further on the process

with regards to the incorporation of this 'rhythmic repetition' (Gilbert and Pearson 1999: 73):

> One specific thing I looked for was objects that are naturally recurring in a rhythmic series and are evenly aligned and spaced – such as lamp posts, street lights on wires, stacked containers or trees in a row. This allowed for naturally looking repetitions to sync with the beats, and also saved some editing and repeated use of the same motif. (Søren Severin 2015: interview with the author)

What is portrayed within the videos for both 'Ghost Hardware' and 'Prayer' is a synaesthetic account: a cross-sensory interplay that culminates in an approximation of seen sounds or heard images. As Williams says: 'That cross-sensual communication becomes the perceptual foundation of music video style; its "logic" of video production' (2003: 11). This interplay may, more usually, be represented through the practice of dance within more pop-oriented videos but, while Burial is a musician whose work is still located within the realms of dance music, the frivolity often associated with choreography could be observed as having a difficult relationship with such brooding output. As Kliem notes of 'Prayer:' 'The beats were unprecedentedly tricky: very dark, full of noisy details and deeply melancholic (2015: interview with the author). In fact, this piece of music – the 11th track on Burial's eponymous first album from 2006 – derives its beat from a sample of Massive Attack's 'Teardrop' (itself, initially lifted from Les McCann's 'Sometimes I Cry'): a piece of trivia that may indicate a desolate or despondent lineage. In turn, Kliem's moody and monochrome visual interpretation could also be seen as akin to the bleak, jagged visual and sonic aesthetics that typify Massive Attack's *Mezzanine* long-player. 'The sporadically flashing tubes disrupt the mostly dark and unknown, the sinister, that is inherent to the music,' Kliem explains (2015: interview with the author). 'The large reverberations evoke a deepness, while, frequency-wise, the razor-sharp beats build a contrast' (2003: 11). So the electronic pulse of fluorescent lights then defines what is an atypical audio visual connection but, at the same time, it 'teaches us about stimulation and rhythmic pulsation, and presents to us a musicality of the world [...] a mutual interpenetration of sights and sounds' (Williams 2003: 99).

Ben Dawkins's 'Dealer' video is something of an anomaly when considered alongside the other Burial videos that are found on Vimeo and YouTube. As already highlighted, it might be seen as curious as, while still an unofficial video (i.e. one that was not commissioned by Burial's Will Bevan and the Hyperdub label), permission has been granted to use copyrighted music. Yet the main reason why it remains distanced from the user-generated content elsewhere and, indeed, many music videos is due

to its reliance on narrative. As Williams observes, 'the video logic of music video is less narrative than musical [as it] rejects traditional narrative, condenses images into stimulating pulses, and rejects prose and writing' (2003: 98, 99). Certainly, this has been addressed by Søren Severin with regards to his own 'Ghost Hardware' video where, aligning the work with his role as a graphic designer, he admits how 'I think in shapes and colours, and not so much in narrative' (2015: interview with the author). The structuring of music video then more often fits with variations of the synaesthetic approach as explored by Severin and Karl Kliem although, more generally, this is less likely to involve such stark and potentially abstract results. A more widespread approach would be to develop a video treatment that 'acts-out' the music as with the practice of dance: thus culminating in an audio visual format that is distinctly removed from that of TV and film. Music videos, as Williams expresses, mostly follow this kind of convention where:

> Dialog [sic] and sound effects (prominent in television sound) are, for the most part, used sparingly, if at all, and their function (in terms of sound and vision relations) appears (at this time) less important than the relationship between musical track and visual presentation. (Williams 2003: 62)

Interestingly, Williams inserts a caveat within his observation of 'at this time:' then offering the slightest suggestion that his own analyses are located in a particular moment. Yet even more than ten years later, the majority of music videos are underpinned exclusively by the music recording. As Williams goes on to discuss, the consideration of the diegetic and non-diegetic is then largely useless: the assembled performers in the music video tend to exist within a post-diegesis filmic environment where each sound element is heard by those on screen. There are some rare exceptions with Ben Dawkins specifically citing Jonathan Glazer's treatment for UNKLE's 'Rabbit in Your Headlights:' a video where traffic and the actors' speech punctures, rather than punctuates, the soundtrack. The surreal promo for Daft Punk's 'Da Funk' is also notable for its use of dialogue in the music video yet in this case, all of the presented sonic elements exist within the internal world framed by, director, Spike Jonze. For the video for 'Dealer', the effect is completely disjunctive: the performers do not respond to the accompanying music and it plays as a score that is seemingly only heard by the viewer: then soundtracking the action rather than insisting that the performance should illustrate or amplify the music track. No person or object dances to Burial's music here. Instead, there is the suggestion that the meanings behind the recording are being further explored and explained only via the kind of narrative that would arguably position it closer to the format of a short film. It opens on a domestic scene with accompanying

dialogue and more than a minute of footage transpires before Burial's music is even introduced. Still, there is an obvious connection to Burial that reveals itself through Dawkins's exploration of the London cityscape. As the director has stated in an interview with Thump: 'Burial's sound is 100% London. I couldn't see the film being made anywhere else' (Roper 2014: online). The grittiness of 'Dealer' as the story of Curtis, a drug dealer operating within the capital, may then be responsive to and incorporative of music from Burial's 'Rival Dealer EP', but it also employs a cinematic aesthetic that would be likely to meet with the approval of the musician given an earlier comment that 'I love this film called *Nil By Mouth* by Gary Oldman because it's the only film I've ever seen anyone get London properly in it, which is just distant lights, down the end of your road' (Clark 2006: online). While Dawkins has a healthy career making advertisements/commercials – an area that may be seen as furthering slick, mainstream visual material – there is definitely a raw quality to the narrative of 'Dealer' that could link it to a film project such as *Nil By Mouth*. In both cases, what is offered is not picture postcard London, nor is it an image of the gleaming modern metropolis that will connote success and economic power. This is London's underbelly: an uneasy, pressured, sprawling environment that Burial's seemingly nocturnal Will Bevan is also said to stalk:

> London's weird, it's home, but sometimes you're walking along and it's deserted. You can turn a corner and there's no one. Sometimes you're in a place where it's not even designed for people: you'll be standing in the middle of a fucking motorway and there's not even a pavement, and then you get across and there's a fence that you can't get past. You'll find yourself in a weird car park with no cars in it, where there's no way out, nothing. It's odd. (Hennings 2007: online)

It is perhaps the kind of environment that Dawkins understands having spent fifteen years living in the capital. As he says 'I know what it's like to sit on a bus and hear the rain and the street sounds and the random conversations' (2015: interview with the author). Musically even, Burial can be observed as rooted in the city with that largely London-centric sound of UK garage found within his own productions' DNA. And after explicitly titling a track 'South London Boroughs' and featuring aerial photography of the Wandsworth area on the cover of his debut album, there is no mistaking his preferred place of residence. His interviews, while few, also repeatedly return to the theme of the capital city and, particularly, a tension that exists between Burial's uncertainty and fascination with it. 'London's part of me,' he has confirmed, 'I'm proud of it but it can be dark, sometimes recently I don't even recognize it' (Fisher 2012: online). It is this same tension that Dawkins captures – the juxtaposition of the safe and familiar with the unsettling unpredictability of an inescapable inner city.

Conclusion

The Hyperdub label's founder Steve 'Kode9' Goodman has acknowledged how Burial's music 'has a weird, intoxicating, obsessive effect on his fans' (Blanning 2013: online) and it may be argued that this is partly due to the space – or void – that he leaves around the work. With this anonymity working in conjunction with an underground ideology, he does avoid many of the visual/visible aspects that may be viewed as anathema to grassroots activity. Yet, as Kliem notes, his rumoured indifference to fame hasn't exactly 'hurt the myth surrounding him' (2015: interview with the author). Burial has also revealed his own consideration of maintaining a low profile and its association with creating allure or even myth:

> Everyone goes on about themselves [...] they reveal everything and give it away. It's an obsession in London, people and the media are too blatant, trying to project this image, prove themselves and trying to be something. They should just hold back a bit, it's sexier. (Fisher 2012)

Shuker observes that in more committed, fanatical circles 'metaphors of desire and the hunt are present' with 'emphases on the thrill of the chase' (2004: 317). However, through the introduction of the platforms and tools associated with Web 2.0, committed fans need not solely consume what they avidly pursue. They are now also equipped to develop creative responses to the material that thrills, entices and intrigues. Critics might see the consequent output negatively – stating that it equates to 'free labour and exploitation' (Andrejevic 2009: 416–420) – but other commentators will frame such endeavours as pointing to the emergence of a socially conscious 'gift economy' (Gauntlett 2011: 95). The latter also has its links to Illich's 'Conviviality' (1973): a concept that includes the reassessment of made materials as those defined as communicative ephemera that can build and strengthen connections (rather than just an indication of the manufacturing of products as part of industrial production). And this is where the makers of the three discussed Burial videos find their creative endeavours sitting most comfortably: where the work is not driven primarily by financial gain. Yet there are arguably benefits for a graphic designer, a maker of live music visuals and a director of commercials to both explore and further communicate their creative approach with Burial as their muse. The opportunities are of course facilitated by the producer with his music working as 'the seed' for that creativity; reminding practitioners that 'what we perceive, at a given cultural moment, is transformed, amplified, diminished or augmented by acts of expression' (Williams 2003: 7). The ambiguity that surrounds the individual and his work arguably drives that need for that expression as an additional commentator clearly highlights:

Burial lets me travel to the dark and shadowy cathedrals in my head! He lets my soul stand on imaginary mountain tops [sic] while it is storming up there! [...] Because he sets free my imagination, creating worlds inside my head. He does inspire with creation, a mystery I wish I'd met. (CowXxXPow 2015)

To this end, the user-generated music video – as hosted on websites such as Vimeo or YouTube – has an undoubted relationship to the Barthesian 'Death of the Author' (1977). As Peters and Seier suggest, the user-generated music platform then 'does not seem to be killing the video star, but [is] rather preserving and multiplying this phenomenon' (2009: 190). Subsequently any perceived eradication of the original author (or, indeed, the 'video star') is coupled with creation: in this instance, subsequent interpretations and expansions of the original music text that can arguably aid distribution when giving rise to new creative voices and a spate of original, interpretive audio visual forms.

NOTES

Chapter 1

1 There are definite distinctions to be made between the vlogger as someone who offers regular video diaries and the YouTuber as someone who offers a regular video 'programme'. A younger audience engaged in the consumption of these materials is generally highly literate about these distinctions, and the differing merits associated with the online performers. In writing this chapter I am greatly indebted to the insights and clarifications offered by Luli Fukukawa.

2 The term 'metapicture' is evoked here with reference to W. J. T. Mitchell's *Picture Theory* (1994: 35–82), in which he defines metapictures as 'pictures that refer to themselves or to other pictures', which is to say they are 'pictures that are used to show what a picture is' (35).

3 From 'Jennifer Lopez – L'Oréal Paris Elvive Triple Resist Commercial 2011 Making', YouTube: https://www.youtube.com/watch?v=5pjSXTUz8eE

4 If one takes the time to watch a series of music videos – however one might access them – it is soon evident that very little has changed. The music video is carnivalesque. It gives the appearance of change and disruption, but this is fleeting, and generally only a masquerade. Rife with cliché and repetitious rhetorical forms, music videos remain largely tethered to the 'male gaze', with narrow definitions of gender and cultures; even where stereotypes are seemingly being overturned, there is little escaping dominant binary logics. Around the time of writing this chapter, various high-profile examples could be cited: Major Lazer's video for 'Lean On' (2015) was filmed in India for no apparent reason, with the singers seemingly parachuted into scenes that play out all manners of stereotypes of dress, dance, and quasi-religious motifs; the video for Katy Perry's 'Darkhorse' (2013) (which received over a billion views on Vevo) had to be re-edited as one sequence was claimed to offend Muslims (the image in question showed a man being burned wearing a pendant forming the word 'Allah'); and Taylor Swift was accused of racism with her video for 'Wildest Dreams' (2014), which, filmed at an undisclosed location in Africa with a largely white cast, was cuttingly described as 'African colonial fantasy'.

Chapter 2

1 The empire's official name, headquartered in Walt Disney Studios, Burbank, California. Hereafter sometimes referred to simply as 'Disney' or 'the Company'.

2 One recent YouTube post, 'Top 10 Decade Defining Music Videos of All Time', illustrates changes in MTV material from the wildly imaginary stories that accompanied early videos to the more strictly performance-oriented videos of the past decade. See Anonymous 2015: an audiovisual conflation that unfortunately lacks a posted script.

3 Available online at https://www.youtube.com/watch?v=XJIpp2Jj8AQ (accessed 15 October 2016).

4 One example must suffice: the 2015 'Official Jeep Renegade Commercial', originally broadcast on MTV2, includes footage of X Ambassadors performing their hit song 'Renegades'. Yet, despite its plausible 'rock video' style, the substance is automobile advertising. The discussion that follows the online post (see 'Official Jeep Renegade Commercial') reveals ambiguous viewer responses: was the ad more successful *because of* the music, or was the music more successful *because of* its televisual audience outreach and appeal?

5 Of 222 regular episodes, only four lack music – one of them the pilot, entitled 'Rollercoaster' (2007; Season 1, episode 1). Even 'Rollercoaster', however, includes the series' familiar opening music, performed by Bowling for Soup, a band that later makes several virtual on-screen appearances.

6 Edwards also recorded 'When You Wish Upon a Star' for Disney's *Pinocchio* (1940).

7 Revised and televised versions of the same show – one of them containing a song initially intended for *South Pacific* (1949), another Rodgers and Hammerstein musical – were initially broadcast in 1965 and 1997, starring (respectively) Julie Andrews and Leslie Ann Warren.

8 According to WorldCat online, which can be used to identify library holdings. No location is given for 'The Disney Company' as publisher of these and other volumes.

9 For an 'official' example of a Disney-generated *Phineas and Ferb* Web post, go to http://www.youtube.com/watch?v=0nKG_O0Ei_o. The post re-presents 'Squirrels in My Pants' from 'Comet Kermilian' (2008; Season 1, episode 35), one of the series' most popular songs; by April 2013 the 'Squirrels' clip had received more than 2,500,000 hits. For a technologically primitive re-recording of the same musical material, go to http://www.youtube.com/watch?v=qWeDS7bLIU0. This amateurish clip, posted to YouTube by 'dapockercat' on 15 August 2008, appears to have been manufactured using a hand-held digital camera pointed at a TV set; nevertheless, by April 2013 dapockercat's clip had itself received more than 191,000 hits. For a high-quality, user-generated re-creation of the same material – this one posted by 'pbryan_999' to Dailymotion, another venue for online audiovisual posts – go to http://www.dailymotion.com/video/ xlapwi_phineas-and-ferb-squirrels-in-my-pants_music#.UXqnMoIyGdM. Unfortunately, Dailymotion reported neither the hits pbryan_999's post received nor the date it was posted.

10 Both Povenmire and Marsh worked on *The Simpsons* earlier in their careers, and both 'appear' as *Phineas and Ferb* characters, with Povenmire voicing Dr Doofenshmirtz and Marsh voicing Major Monogram, who 'runs' Perry as an animal spy. Furthermore, Jack McBrayer, who plays Kenneth Parcell (also

known as Kenneth the Page) in *30 Rock*, voices Irving, one of Phineas's and Ferb's occasional friends. Alyson Stoner, who voices Isabella, has appeared in a number of other Disney productions.

11 I would like to thank Virginia Polytechnic Institute and State University, especially the College of Liberal Arts and Human Sciences, for support that contributed to the completion of this article and to partial presentations of its contents at 'Intertextuality in Music Since 1900' (a conference held at FCSH – Universidade Nova de Lisboa, Lisbon, Portugal; March 2015); and at the annual conference of the Literature and Film Association (University of Kansas; October 2013). I would also like to thank Chelsea Gillenwater (see Gillenwater and Alvarez), who introduced me to *Phineas and Ferb* and raised some of the issues discussed above during a class presentation.

Chapter 3

1 The first feature-length hip hop film was *Wild Style*, written and directed by Charlie Ahearn in 1983.

2 I analyse the disastrous codes and the dubious performative strategies hip hop citizens use to negotiate them in the essay 'Performing hip-hop: ethics, complex acting and Tupac Shakur in *Juice*', published in *Kultura* #127 (Belgrade, June 2010).

3 The ghetto as 'the trap' came into currency as slang derived from the city of Atlanta, most notably evoked in the album *Trap Muzik* (2003) by T. I. and the mixtapes *Trap or Die* (2005) by Young Jeezy and DJ Drama and *Trap or Die II: By Any Means Necessary* (2010) by Young Jeezy and Don Cannon.

4 It is very common for some urban areas to be called the 'jungle' as metaphoric slang. California has at least two jungles: a section of low-income housing developments in South Central Los Angeles that is notorious for gang activity; also Marin City in the North Bay Area, which is a small city racked by crime and poverty in the mostly middle-class Marin County. Marin City is significant for hip hop culture, as it is where Tupac Shakur spent his formative years before he became the most popular hip hop artist of all. South Central's jungle was memorably depicted as a danger zone in the hip hop film *Training Day* (Antoine Fuqua, 2001).

5 This term was likely first heard in the song 'Real Muthaphucckin G's' (1993) by Eazy-E featuring Dresta and B.G. Knocc Out. The song was meant as an affront to Dr Dre in the aftermath of the dramatic break-up of NWA.

6 'Representing' is another powerfully evocative colloquialism in hip hop culture, used to mean exactly what it signifies in its dictionary definition: 'To act the part or role of.'

7 'Hard' is hip hop slang for 'mean' or 'tough'; 'shife' means the same thing, with an added undertone of connivance. 'Jacked' is hip hop slang for something stolen. And note the subtle reference to mirroring in this lyric, with two men coming face-to-face, looking at each other with the same dangerous expression, recognizing their common fate in each other's eyes, holding each other's destiny in their hands.

Chapter 4

1 There were, also, many lists published online that ranked many of Bowie's best or most significant videos. These lists, however, existed separate to retrospectives, in effect, marginalizing his music video oeuvre.

2 See Dillane et al. (2015) for an examination of Bowie's 'Ashes to Ashes' video.

3 Buckley referred to Screamin' Lord Byron as a 'lighthearted piss-take of Bowie's 1970s alter egos' (2005: 364).

4 'You conniving, randy, bogus, oriental, old Queen. Your record sleeves are better than your songs'.

5 When Screamin' Lord Byron first appears at the music venue, he is dragged in my bodyguards and using oxygen to breathe. He, also, cowers in the corner of his dressing room when the puny Vic barges in, begging Vic to leave.

6 *Outside* was a concept album about a dystopian future in 1999 where the presentation of murdered and mutilated bodies became an underground art craze.

7 Producer Tony Visconti released a statement after Bowie's death that the ★ album was 'deliberately created and timed as a "parting gift" for his fans' with many interpreting the 'Lazarus' video as a major part of a 'carefully planned finale' (Furness).

Chapter 5

1 The formative studies of the music video remain E. Ann Kaplan's *Rocking Around the Clock: Music Television, Postmodernism, and Consumer Culture* (1988) and Andrew Goodwin's *Dancing in the Distraction Factory* (1992). In addition to these book-length studies, Will Straw's 'Music Video in Its Contexts: Popular Music and Post-Modernism in the 1980s' is particularly acute in identifying the common tropes not simply of music videos themselves but of the critical discourse about them that emerged along with them.

2 Day-by-day playlist details for both MTV and MuchMusic are not readily available and this, obviously, presents clear difficulties in the historical studies of the music video. As a result, I am relying here on anecdotal evidence and personal memory here rather than archival records. For a fuller consideration of the methodological difficulties in studying broadcast history and the music video in both the American and Canadian context, see Pegley (2008).

3 For more on Chris Marker's music video work, see Ian Balfour's 'Chris Marker's Only Music Video (Almost, Still)' in which he speculates that Marker's willingness to direct 'Getting Away With It' might have derived, at least in part, from the fact that 'New Order [...] had refrained from many clichés of the video genre, opting sometimes for decidedly low-key, deadpan shots in an MTV world that thrived on very rapid eye movement' (171–172).

4 For an overview of Saville's work that includes examples drawn from the Factory catalog and New Order's discography, see Saville (2003).

5 In addition to broadcast on music video stations, 'The Perfect Kiss' was also shown in cinemas. As Shamberg recalls, 'In New York "The Perfect Kiss" played

as a short before Demme's *Stop Making Sense*. In London it played with Nicolas Roeg's film *Insignificance*. It also played in international film festivals' (n.d.).

6 It is increasingly difficult to separate out the mythologies that surround the founding and operation Factory Records from the actual history of the label. Michael Winterbottom's film *24 Hour Party People* (2002) plays its part in the blurring of fact and fiction, but there are a few sources which do confirm some elements of Winterbottom's representation while contradicting others, perhaps most significantly John Robb's *The North Will Rise Again: Manchester Music City 1976–1996* (2010).

7 While sadly not available in English translation, Alekan's *Des lumières et des ombres* ([1979] 1997) details the technical innovations he brought to cinematography as well as the philosophy of the image that lies behind them.

8 Elsewhere in the studio and visible in another shot is a poster that the American conceptual artist Lawrence Weiner, at the invitation of Shamberg, designed for a concert New Order played at New York's Paradise Garage on 7 July 1983. Shamberg later arranged for Barbara Kruger to design a poster to promote the cinema and festival screenings of Demme's video for 'The Perfect Kiss'. As such, New Order's visual identity does not just connect with a remarkable range of film and video artists, but also with two of the most important and influential graphic and text-based contemporary artists.

9 The presence of a doorframe connects Demme's 'The Perfect Kiss' to the clip for Joy Division's 'Love Will Tear Us Apart', which is the only video the band filmed while active. Like 'The Perfect Kiss' the video for 'Love Will Tear Us Apart' was recorded on a single day, 28 April 1980 at a former rehearsal space. In its original form, the sound was recorded live, but this was later replaced with a recording of the track. The video begins and ends with the opening and closing of a door, with 'Ian C.' etched into it, to reveal an empty room.

10 For more, see Javier Panera's *This Is Not a Love Song* (2013), which is a catalogue from a 2013 exhibition at Loop in Barcelona that traced the tangled history of video art and the music video from the 1950s to the present day.

Chapter 6

1 For those in the know, the sequence pays homage to the film *From Here to Eternity* (Zinnemann, 1953). Bowie rerecorded the song he first wrote with and for Iggy Pop, and which appeared on the Bowie-produced Pop album *The Idiot* (1977), for his *Let's Dance* album of 1983. The video was directed by David Mallet and circulated in both censored and uncensored versions. This heterosexual gambit was triumphant: the video was awarded MTV's Best Male Video.

2 It is these ambitious groups and singers who, rejecting the miserabilism of the music of the years associated with punk and post-punk, were then in a position to elevate themselves globally with and through a bold use of music videos. Ironically, in doing so and having to absent themselves from the usual routes of local pop promotion in order to do so (that is, not appearing on the BBC's *Top of the Pops* or being able to engage with the music press), it seems that they may have made way for more progressive chart music. Howard Jones

recalled (Royal Northern College of Music concert, 18 February 2016) that the expected competition from Duran Duran and Spandau Ballet had vanished in November 1983. He took them to all be abroad, shooting music videos. In Jones's recollection this allowed his single 'What is Love?' to chart at number 2 in the UK, and so introduce his relatively 'difficult' debut album of that year, *Human's Lib* (which opens with a consideration of false consciousness and closes by advocating a radical refusal of work, and bisexuality), to the record buying public.

3 See, for example, Stanley (2015). And, while it is difficult to cite a comparable strain to Duran Duran's videos at this time in chart music (which other groups were seen as so consistently partying with models, around the world, in their videos?), their influence seems to have been extended to the entirety of music video production. The Duran Duran video EP, termed a 'Video 45', was released in 1983 with the cut version of 'Girls on Film' (1981) on VHS and uncut version on Betamax, as well as a B-side equivalent of another video. A video album, called *Duran Duran*, was released later in 1983 and included videos for album songs that had not been released as singles. The uncut 'Girls on Film' was originally intended for play on video screens in nightclubs, although perhaps strip clubs then proved to be a more receptive or appropriate destination. The cover of the album *Rio* was eventually provided by Patrick Nagel, whose graphic work was first seen by the band's manger in *Playboy* magazine.

4 This association recalls the Peter Saville-designed cover of the album: model Lucy Helmore hidden beneath a Medieval helmet, and with a falcon perched on her hand.

5 The single was also released as by Wham! 'featuring George Michael' in some countries, and then appeared on the 1984 Wham! album *Make It Big*, although in the UK at least the single was intended to represent Michael's post-Wham! solo debut. Michael's Wham! colleague, Andrew Ridgeley, is credited as co-writer of the song.

6 The erotic ambience of the music video recalls stories of the modernizing Alexander Thynn, the Seventh Marquess of Bath, and his country house in Wiltshire, Longleat. Thynn's psychosexual novel *The Carry-Cot* became the erotic horror film *Blue Blood* (Andrew Sinclair, 1973), starring his model/ actress wife and shot in and around Longleat. In this, a sophisticated hedonism becomes a force of modernization for the old aristocracy, and their haunts. This strain is quite different to the British anti-Establishment take on the upper classes and sexual promiscuity, as found in, say, the films of Joseph Losey of the 1960s (particularly *The Servant, Accident,* and *The Go-Between* of 1963, 1967, and 1971, respectively). This take found unchecked predatory and exploitative passions and stratagems in operation, undercutting the sense of an equitable and patrician ruling class. A threat to the continued existence of the country house and estate was indeed a theme for British Conservatives (of the one-nation, patrician type) across the 1970s, particularly as articulated through the Victoria and Albert Museum's 1974 exhibition The Destruction of the Country House 1875–1975, overseen by Roy Strong; see (Strong, Binney and Harris, 1974) and, on its political effectiveness, (Adams, 2013). So such impulses of modernisation would have been understood as an considered response from the old aristocracy, keen to be seen to be conceding ground to upstarts, even if only to safeguard their own positions.

7 The Miami elements of the video recall aspects of the look of *The Conformist* (Bernardo Bertolucci, 1970) and, in the shot of the women reflected in mirrors, a recurring visual motif in the films of Max Ophüls. But more generally the video shares something of the presentation of Miami for the opening credit sequence of the *Miami Vice* television series (1984–1989) and the film *Scarface* (Brian De Palma, 1983): beaches, cars, boats, sun, models in bikinis, designer suits, new apartment buildings. One could argue that Miami was the ideal neoliberal city in that such a regime of pleasure (along the lines of new wealth, deregulation, and libertarianism) is understood to be a cultural front of the anti-Castro aspect of the Cold War.

8 Hansard record of 1979 budget speech; available at: http://www. margaretthatcher.org/document/109497 (accessed February 2016). The importance of this speech is central Jenkins's thesis in respect to Thatcher's rise to power, as the definitive break from the 'socialism' of the Labour Party of the 1970s (Jenkins 1988; Jenkins also discusses the speech specifically, 48, 49).

9 At any rate, a number of candidates can be disqualified, in terms of a pop culture transition from post-punk to the New Romantics: too incapacitated, too posh, 'too' gay (in the sense of 'too' far out of the closet), or overly associated with radical political formations, or within the orbit of subcultures and formations around paedophilic preferences. Duran Duran's association with the Rum Runner seems to have been essentially innocuous, whereas other breeding grounds for new pop and youth cultures (such as the Thames Valley disco the Walton Hop) were considerably murkier. In addition, the gossipy and back-stabbing social strata around the Blitz Club was probably just too much for music company scouts looking to sign new bands, and even Duran Duran members clocked the two very different 'vibes' (see Malins 2005, 55; for a fuller discussion of the Blitz ambience, see 54–57).

10 In the nouveau riche/'trophy wife' manner, Duran Duran's John Taylor clarified (or reassured himself and his public?) that these were 'high-class models' and not 'the kind who do stripteases', as well as recording his sexual successes with them (quoted in Malins 2005, 90 and 63, respectively). Malins opens his book by noting that Le Bon '[chose] his future wife from a model agency portfolio' and that '[n]ow in 2005, [the band members'] beautiful wives from the 1980s have maintained their looks ...' (vii, viii, respectively). In these terms as well as the use of the models in the music videos, it is as if one is pushed to read their presence in terms of financial assets – albeit without the liquidity of yachts.

11 The DVD documentary was made and released by Eagle Vision/Naïve Vision.

12 There is a continuity in Le Bon's writing in this respect; the 2010 Duran Duran single 'All You Need is Now' revisits the theme of living in the moment as equated with a time of youth, and the urging that such a philosophical position enables a rejuvenating reacquaintance with one's younger years: 'You sway in the moon/the way you did when you were younger/and we told everybody/all you need is now.'

13 This question of what actually constitutes freedom in terms of demanding pleasure, to turn to Frank Zappa, is one that he critiques as indicative of post-1968 muddle-headedness on the part of rebarbative youth – whose articulations of as much he mimics as '[f]ree is when you don't have to pay for nothing/or do nothing/we want to be free/free as the wind'. For a fuller discussion of Zappa's take on the legacy of the counterculture across the 1970s, see Halligan (2013).

14 As with, for example, Rod Stewart's 'Do Ya Think I'm Sexy?' of 1978, the video for which involves Stewart impressing a girl in a bar by showing her a video of himself performing the titular song, and who reciprocates by intimating fellatio with her drinking straw. Stewart then has sex with her in a bedroom while his video continues to play on a television set in the background, as if some sort of erectile aid.

15 Hansard record of 1979 budget speech; available at: http://www.margaretthatcher.org/document/109497 (accessed February 2016).

16 On the left, and from around this moment of emergence, *Abigail's Party* (a television film, Mike Leigh, 1977) and *The Long Good Friday* (John Mackenzie, 1979/1980) are frequently noted. *Abigail's Party* details the paucity of the middle-class aspirations of those who saw in Thatcher a chance to realize their goal, and *The Long Good Friday* sees the redevelopment of the Docklands area of East London as an entrenchment and legitimization of criminal cultures.

Chapter 7

1 It is not clear if and when the robots are expected to be ready to leave the laboratory, while it can be inferred that at the end of the video they still need adjustments. Perhaps they will never leave and both their improvement and their embrace are going to last forever.

2 A comparison can be made with the beginning of the music video 'Cocoon' (2001) directed by Japanese fashion and costume designer Eiko Ishioka. In the opening sequence, a series of Björk-like white porcelain dolls are shown standing still with their eyes shut, until one of them comes to life and starts to perform the song.

3 The cover was possibly conceived to avoid censorship, although sheer nudity would have been consistent with the subject of the video. This work was commissioned by MoMA as part of a Björk-dedicated public exhibition, which might have influenced artistic choices.

4 One can even wonder whether the polyp might have been indirectly triggered by the stress of her relationship deteriorating.

5 More precisely, it comes from the Greek *ou* 'not' + *topos* 'place'.

Chapter 9

1 'Anaconda' is a track off Nicki Minaj's third Studio album, *The Pinkprint* (2014). It was composed by Minaj, with Jamal Jones, James Strife, Jonathan Solone-Myvett, Ernest Clark, Marcos Palacios, and Anthony Ray. It was released on 4 August 2014 as the second single for album. It reached no. 2 in the *Billboard Top 100*.

2 Roberto Saviano's (2009) book *Gomorra. A história real de um jornalista infiltrado na violenta máfia napolitana* is a great model. The situations narrated there are seen as typical of *splatterkapitalismus*. The expression

'splatter', as we know, designs a subgenre of horror cinema, characterized by the clear exposure of violent deaths, guts, and diverse atrocities. According to Berardi, the capitalist system has become a criminal system, in which the acceptance of crime makes for a competitive principle. Without practising it, there is no way of survival. 'Crime', says the Italian author, 'is not a sideline function of the capitalist system anymore, but the decisive factor to win in a deregulated competitive scenario. Blackmailing, violence, physical elimination of opponents, torture, homicide, underage-people exploitation, induction to prostitution, production of instruments for mass destruction, criminal use of handicapped people, have become irreplaceable techniques for the economic competence' (Berardi 2007: 126). *Splatterkapitalismus* represents the end of bourgeois hegemony in its association to the illuminist universality of Jurisprudence. All quotes in this text, originally from languages other than English, were translated by me. Berardi's, originally in Spanish, follows here:

> El crimen no es más una función marginal del sistema capitalista, sino el factor decisivo para vencer en un cuadro de competición desregulada. El chantaje, la violencia, la eliminación física de los adversários, la tortura, el homicidio, la explotación de menores, la inducción a la prostitución, la producción de instrumentos para la destrucción masiva, la utilización delictiva de discapacitados se han vuelto técnicas insustituibles para la competencia económica.

3 In Brazil, in the field of Communications, some good studies have already explored distinct aspects of the relation between media and terrorism (as in Argolo 2012; Domingues 2013; Wainberg 2005). But this chapter will not approach them nor discuss this issue more widely, bearing in mind the nature of our empirical object and the conceptual definition through which we operate. For the time being, it is enough to mention them and suggest that the interested reader consult them on their own.

4 Beatriz Preciado is quite emphatic: 'ANAL TERRORISM = KULTURAL TERRORISM' (Hocquenghem and Preciado 2009, 144). It is worth noticing the way which the expression 'cultural' is spelled – in capitals, with 'K' – suggesting differentiated power and semantic weight. Italian anthropologist Massimo Canevacci, around 2005, had already noted, the 'letter K is an indicator of youth countercultures of an antagonistic kind that developed in the 1970s' (Canevacci 2005: 41). Through the above-mentioned typographic alteration, at the same time a declared opposition and a well-defined enemy are marked, inscribed on an authoritarian and dominant matrix, usually associated with hegemonic North American culture. It is the 'K' of John Kennedy, Henry Kissinger, and Calvin Klein being confronted by the 'K' of the oKupas and the BlacK Panthers. K ≠ K. 'Anaconda' *versus* 'AnaKonda'. [Canevacci's quote, originally in Portuguese: 'letra K é um indicador das contraculturas juvenis de tipo antagônico que se desenvolveram nos anos 1970'.]

5 Original quote: 'El ano homosexual habla y produce por primera vez un saber sobre sí mismo. Este saber no precede de la culpabilidad o de la vergüenza, no busca excusarse o legitimarse, no es descripción de la patología o de la

deficiencia, sino que se presenta como una forma de crítica política y de transformación social'.

6 The first sentence of the book, already in the introduction, is very representative: 'what makes the problem is not homosexual desire but the fear of homosexuality; it is necessary to explain why the same word touches off escape and hatred' [in Spanish: 'lo que causa el problema no es el deseo homosexual sino el miedo a la homosexualidad; hay que explicar por qué la misma palavra desencadena las huidas y los odios' (Hocquenghem *in* Hocquenghem and Preciado 2009, 21)].

7 From the original, in Spanish: 'En el horizonte de la democracia sexual posthumana, está el ano, como cavidad orgásmica y músculo no-reproductivo, compartido por todos'.

8 The original quote, in Portuguese: 'como uma pele ruim, o sentido recebido, o discurso repressivo (liberal) que quer sempre encobri-lo'.

9 The original quote, in Portuguese: 'as leis que uma sociedade, uma ideologia, uma filosofia se dão para pôr-se de acordo consigo mesmas'.

10 In his most recent book, Massimo Canevacci (2013) returned to agonistic power, the confrontational symbology of the '*K*'.

11 In the documentary *Nicki Minaj: Pink Planet* (2013), available on Netflix, the theatricality of the singer's work is highlighted. In the early 1990s, still using her birth name, Onika Tanya Maraj enrolled at the La Guardia High School, in New York.

12 All of the audio design is quite rich and qualified. Not only for the inclusion of extra-musical elements which give references and collaborate for the apprehension of a macro-thematic context (it is actually even difficult to isolate such elements, and perceive them separately), but also for the exploration of some of these sonorous objects 'within' the song, arranging them along with the music, yet along with 'special effects' (Auto-Tune tuning, insertion of laughter, and many vocal emissions made by Minaj). In this manner, a coherent and creative plot of non-musical and musical sonorities is produced. Such sonic fashion is an important subtext to be considered, for it aggregates meaning and substantiates critical capacity and meta-linguistic conscience with regard to the objective content exposed in the lyrics. It is an acoustic approach that simultaneously 'naturalizes' and 'de-naturalizes' the theme, as well as the language of the composition. It is an *afterpop* irony (as in Silveira 2013).

13 *UrPop* is a rather fertile aesthetic category, however still vague. When Fernández Porta employs it, he tries to understand media products that would be promoting the emerging of primitive emotions, representations, and values in the ultra-modern and hyper-technological space in which we live, well into the twenty-first century. *UrPop* is the repressed unconscious, the mythical memory, the natural history, lived as *intensity*, not as *objective chronology* of pop culture (as in Fernández Porta 2008).

14 The image of a serpent is very rich in meaning: it recalls both religious and scientific imagery. A serpent is an ambiguous symbolization: anal and phallic (a serpent is a digestive tube).

15 'Do you know how to twerk? (Or even what it is?)', as in http://www.smh. com.au/data-point/do-you-know-how-to-twerk-or-even-what-it-is-20121213-

2bbrp.html#ixzz3S6i3C4dX, For further details and extra clarification, check https://www.youtube.com/watch?v=NgoyVRO0A0E (accessed 15 June 2015).

16　As in https://www.youtube.com/watch?v=ypX2hFsteJU (accessed 16 July 2015).

17　Porn films have established a series of points of view and recurrent audiovisual acting techniques. 'Money shot' is the male ejaculation scene.

18　Beatriz Preciado (2009) refers to *Playboy*'s impressario Hugh Hefner as a 'horizontal worker', who converted the rotary bed into an office, a conference room, immortalized in many pictures, wearing robes and silk pajamas. The same principle applies to (or could also be applied, up to some extent and maneuvers) Nicki Minaj, pop singer and horizontal performer.

19　There is an infinity of other cultural goods that could still be correlated and discussed, very pertinently, with no interpretative exaggeration. One of them is the movie *Black Venus*, directed by Abdellatif Kechiche, which tells us the story of Saartjie Baartman, the 'Hottentot Venus', forced to expose her body in London, in the turn of the century in the 1800s.

20　Informal narratives recount that *Anaconda*, the movie, became a public phenomenon in the city of Porto Velho, northern Brazil. The information that it had been shot in Amazon, in authentic locations, contributed significantly for box-office success. In the capital of Rondônia, for example, the movie was on at theatres for months and months.

21　In *I Must Not Think Bad Thoughts*, Mark Dery (2010) made an inventory of some of American fetishes and strangest sexual manias. If we consider jointly the music videos of 'Booty', of Jennifer López and Iggy Azalea, Miley Cirus's 'We Can't Stop', and 'The Motherload' by the band Mastodon, we can see that Nicki Minaj is only conforming to a bit part in the range of the predilections catalogued by Dery.

22　As Gines (2006: 108) said, 'this attempt to revert sexual *status* reinforces, instead of weakening, the distorted prevailing image of black sexuality'. Obviously, Gines is not talking about Nicki Minaj. However, he is recognizing the operativeness (and the boundaries, for sure) of a certain rhetoric-critical pattern which embodies more or less frequent cases in the contemporary hip hop scenario. [Gines's quote in Portuguese: 'essa tentativa de reversão do *status* sexual reforça, em vez de enfraquecer, a imagem distorcida prevalecente da sexualidade negra'].

Chapter 10

1　The lyrics referenced come from (in order of citation): 'Everybody Dance Now' by C+C Music Factory (1990), 'Dr. Beat' by the Miami Sound Machine (1984), 'Into the Groove' by Madonna (1984), 'Everybody' by The Backstreet Boys (1996), and 'Moves Like Jagger' by Maroon 5 (2010).

2　The term 'full-out' is used in dance to denote dance activity that uses the maximum movement range, energy, and performance quality possible in its execution. It stands aside from other activity in dance, such as the term 'marking' which refers to dance in a smaller scale which may be more

focused on experimentation, building muscle memory for movement order, or conserving energy in a rehearsal setting.

Chapter 11

1 Ford's book departs from standard pagination, so page numbers are given as indicated.

Chapter 12

1 '"Popularity Is a Currency of Its Own": H. P. Baxxter Meets Albert Oehlen', http://www.electronicbeats.net/h-p-baxxter-meets-albert-oehlen/, 2 (accessed 5 April 2016).
2 On the question of 'the question' as the principal question for philosophy, see Derrida (1989: 7–13).
3 Guattari derives this potential from the processes of capital itself (2011: 113, 114).
4 Carter F. Hanson notes the value of seemingly aimless self-referentiality in club music as part of what makes the space of 'the club' a utopian location (Hanson 2014: 398 and passim).
5 On viewing as something subject to alteration through YouTube practice and reception, see Vernallis (2013).
6 The use of classic cars in Scooter videos would be worth further reflection: the car offers a safe space in hypermodernity, and also acts as a vector for transversal globalization. The vintage car is a perverse statement of both machine and ecology, as no newly made car could be as ecologically friendly as a car that already exists. This is all before we get to the signification and histories of the individual cars, and Baxxter's own dedication to the classic car.
7 The juxtaposition of ice hockey action and UK street shuffling in 'Stuck on Replay' (2010) should also be noted here.
8 See Blanchot (1973: 13), where he writes 's'effaçant et s'effaçant encore'. My translation.
9 See also Critchley (1997).
10 'Sovereign is he who decides the exception' (Schmitt 1985: 5).

Chapter 16

1 For an interesting gloss on this, see the 'literal' versions of videos like 'Total Eclipse of the Heart' and A-ha's 'Take On Me'.
2 As Kim (2015) and most Koreans know, Psy is the privileged son of one of Korea's wealthiest industrialists. Early in the decade, he was implicated in a scandal due to evasion of mandatory military service. And in a strange twist

of fate, his father's semi-conductor company DI Corporation experienced a huge bump in investment the months after 'Gangnam Style' came out, which researchers Andy Kim and Ho Sung Jung explain is related to the 'investor recognition hypothesis'.

3 Here is a short and incomplete list of some of the cafés I've seen on Seocho, the main drag of Gangnam on a recent trip to Korea: Starbucks, Tous Les Jours, Pascuccis, Delispresso, Presso Design Coffee, Bellacaffe, Paris Baguette, Angel In Us Coffee, Apgujeong Roasting Company, and A Twosome Place.

4 McDonald (2011).

VIDEOGRAPHY

The below is an alphabetical list of music videos discussed within this book, organized according to artists. Other audiovisual works such as feature films and television programmes are listed in the general list of works cited.

The videos listed below can be found on the companion playlist to the book at: https://www.youtube.com/playlist?list=PLcRRb4LnhT2c_l1UcInR5gZcg7WPD1-ju

A-ha (1985), 'Take On Me' [Music Video], dir. Steve Barron.
Allen, L. (2013), 'Hard Out Here' [Music Video], dir. Chris Sweeney.
Aphex Twin (1997), 'Come to Daddy' [Music Video], dir. Chris Cunningham.
Autechre (1995), 'Second Bad Vilbel' [Music Video], dir. Chris Cunningham.
Baauer (2013), 'Harlem Shake' [Music Video], dir. Maxime Quoilin.
Beyoncé (2016), 'Formation' [Music Video], dir. Melina Matsoukas.
Beyonce (2016), 'Lemonade' [Music Video], dir. Jonas Åkerlund, Beyoncé, Kahlil Joseph, Melina Matsoukas, Dikayl Rimmasch, Mark Romanek, Todd Tours.
Björk (1999), 'All is Full of Love' [Music Video], dir. Chris Cunningham.
Björk (2001), 'Hidden Place' [Music Video], dir. Inez van Lamsweerde, Vinoodh Matadin and M/M.
Björk (2001), 'Pagan Poetry' [Music Video], dir. Nick Knight.
Björk (2002), 'Cocoon' [Music Video], dir. Eiko Ishioka.
Björk (2007), 'Declare Independence' [Music Video], dir. Michel Gondry.
Björk (2012), 'Mutual Core' [Music Video], dir. Andrew Thomas Huang.
Björk (2015), 'Black Lake' [Music Video], dir. Andrew Thomas Huang.
Björk (2015), 'Mouth Mantra' [Music Video], dir. Jesse Kanda.
The Boomtown Rats (1979), 'I Don't Like Mondays' [Music Video], dir. David Mallet.
Bowie, D. (1979), 'Boys Keep Swinging' [Music Video], dir. David Mallet.
Bowie, D. (1979), 'Look Back in Anger' [Music Video], dir. David Mallet.
Bowie, D. (1980), 'Ashes to Ashes' [Music Video], dir. David Mallet.
Bowie, D. (1980), 'Fashion' [Music Video], dir. David Mallet.
Bowie, D. (1983), 'China Girl' [Music Video], dir. David Mallet.
Bowie, D. (1999), 'Thursday's Child' [Music Video], dir. Walter Stern.
Bowie, D. (1999), 'The Stars (Are Out Tonight)' [Music Video], dir. Fiona Sigismondi.
Bowie, D. (2015), 'Blackstar' [Music Video], dir. Johan Renck.
Bowie, D. (2016), 'Lazarus' [Music Video], dir. Johan Renck.
The Buggles (1979), 'Video Killed the Radio Star' [Music Video], dir. Russell Mulcahy.
Cabaret Voltaire (1980), 'This Is Entertainment' [Music Video], dir. Doublevision.
Cabaret Voltaire (1984), 'Sensoria' [Music Video], dir. Peter Care.

The Chemical Brothers (2002), 'Star Guitar' [Music Video], dir. Michel Gondry.

Cherry, N. (1997), 'Feel It' [Music Video], dir. Michel Gondry.

Cyrus, M. (2013), 'Wrecking Ball' [Music Video], dir. Terry Richardson.

Daft Punk (1996), 'Da Funk' [Music Video], dir. Spike Jonze.

Daft Punk (1997), 'Around the World' [Music Video], dir. Michel Gondry.

Dire Straits (1985), 'Money for Nothing' [Music Video], dir. Steve Barron.

Duran Duran (1981), 'Planet Earth' [Music Video], dir. Russell Mulcahy.

Duran Duran (1981), 'Girls on Film' [Music Video], dir. Godley and Creme.

Duran Duran (1982), 'Rio' [Music Video], dir. Russell Mulcahy.

Duran Duran (1982), 'Save a Prayer' [Music Video], dir. Russell Mulcahy.

Einstürzende Neubauten (1985), 'Armenia' [Music Video], dir. Sohgo Ishii.

FKA twigs (2013), 'Water Me' [Music Video], dir. Jesse Kanda.

FKA twigs. (2015), 'Glass and Patron' [Music Video], dir. FKA twigs.

FKA twigs (2015), 'M3LL155X' [Music Video], dir. FKA twigs.

FKA twigs (2015), 'Pendulum' [Music Video], dir. FKA twigs.

Grandmaster Flash and the Furious Five (1982), 'The Message' [Music Video], dir. not credited.

The Horrors (2006), 'Sheena Is a Parasite' [Music Video], dir. Chris Cunningham.

Ice Cube (1993), 'Check Yo Self (The Message Remix)' [Music Video], dir. F. Gary Gray

Jackson, M. (1983), 'Thriller' [Music Video], dir. John Landis.

Jackson, M. (1987), 'Smooth Criminal' [Music Video], dir. Colin Chilvers.

Jackson, M. (2001), 'Black or White' [Music Video], dir. John Landis.

Laibach (1987), 'Opus Dei' [Music Video], dir. Daniel Landin.

Laibach (1988), 'Sympathy for the Devil' [Music Video], dir. Peter Vezjak.

Laibach (1992), 'Wirtschaft ist Tot' [Music Video], dir. Peter Vezjak.

Laibach (1994), 'Final Countdown' [Music Video], dir. Laibach.

Madonna (1984), 'Material Girl' [Music Video], dir. Mary Lambert.

Madonna (1989), 'Like A Prayer' [Music Video], dir. Mary Lambert.

Madonna (1990), 'Vogue' [Music Video], dir. David Fincher.

Madonna (2005), 'Hung Up' [Music Video], dir. Johan Renck.

Michael, G. (1984), 'Careless Whisper' [Music Video], dir. Duncan Gibbins and Andy Morahan.

Michael, G. (1990), 'Freedom! '90' [Music Video], dir. David Fincher.

Minaj, N. (2014,) 'Anaconda' [Music Video], dir. Colin Tilley.

Minaj, N. ft. Rihanna (2011), 'Fly' [Music Video], dir. Saana Hamri.

Minogue, K. (1998), 'Did It Again' [Music Video], dir. Petro Romanhi.

Minogue, K. (2002), 'Come into My World' [Music Video], dir. Michel Gondry.

New Order (1983), 'Confusion' [Music Video], dir. Charles Sturridge.

New Order (1985), 'The Perfect Kiss' [Music Video], dir. Jonathan Demme.

New Order (1986), 'Bizarre Love Triangle' [Music Video], dir. Robert Longo.

New Order (1987), 'True Faith' [Music Video], dir. Philippe Decouflé.

OK Go (2006), 'Here It Goes Again' [Music Video], dir. Trish Sie and OK Go.

Psy (2012), 'Gangnam Style' [Music Video], dir. Cho Soo-hyun.

Puff Daddy and Mase (1997), 'Can't Nobody Hold Me Down' [Music Video], dir. Hype Williams.

Roxy Music (1982), 'Avalon' [Music Video], dir. Howard Guard.

Scooter (1995), 'Friends' [Music Video], dir. not credited.

Scooter (2007), 'The Question Is What Is the Question?' [Music Video], dir. not credited.

Scooter (2007), 'Jumping All Over the World' [Music Video], dir. not credited.

Scooter (2009), 'Ti Sento' [Music Video], dir. Oliver Sommer.

Scooter (2011), 'C'est Bleu' [Music Video], dir. Mark Feuerstake.

Scooter (2011), 'It's a Biz (Ain't Nobody)' [Music Video], dir. Mark Feuerstake.

Scooter (2012), '4 AM' [Music Video], dir. Mark Feuerstake.

Spandau Ballet (1984), 'Highly Strung' [Music Video], dir. not credited.

Test Dept (1983), 'Compulsion' [Music Video], dir. Brett Turnbull.

Test Dept (1983), 'Shockwork' [Music Video], dir. Brett Turnbull.

UNKLE feat. Thom Yorke (1998), 'Rabbit in Your Headlights' [Music Video], dir. Jonathan Glazer.

Yes (1983), 'Leave It' [Music Video], dir. Godley and Creme.

Yuki (2003), 'Sentimental Journey' [Music Video], dir. Nagi Noda.

Yuki (2005), 'Joy' [Music Video], dir. not credited.

WORKS CITED

30 Rock (2006–2013), [television series], created by Tina Fey. Broadcast on NBC.

Aalten, A. (2007), 'Listening to the Dancer's Body', in C. Shilling (ed), *Embodying Sociology: Retrospect, Progress and Prospects*, 109–125, Oxford: Blackwell Publishing.

Adams, R. (March 2013), 'The V&A, The Destruction of the Country House and the Creation of "English Heritage"', *Museum and Society* 11 (1): 1–18.

Adorno, T. W. (1989), *Introduction to the Sociology of Music*, New York: Continuum.

Adorno, T. W. and H. Eisler (2005), *Composing for the Films*, London: Continuum.

Agamben, G. (2000), *Means Without End: Notes on Politics*, trans. V. Binetti and C. Casarino, Minneapolis: University of Minnesota Press.

Aladdin (1992), [film], produced by Walt Disney Feature Animation.

Albright, A. C. (1997), *Choreographing Difference: The Body and Identity in Contemporary Dance*, London: University Press of New England.

Alekan, H. (1997), *Des Lumières et Des Ombres*, Paris: Éditions du Collectionneur.

Alien Rock! (2002), 'The Light of Love – The Making of the Pagan Poetry Video', (sic), *Xah Lee Web*, n.d. Available online: http://xahlee.org/music/bjork__pagen_ poetry__the_light_of_love.htm (accessed: 2 December 2015).

Allan, B. (1990), 'Musical Cinema, Music Video, Music Television', *Film Quarterly* 43(3): 2–14.

Altman, R. (1995), 'Nascimento da Recepção Clássica: A Campanha Para Padronizar o Som', *Imagens* Campinas: Unicamp, (5), Agosto/Dezembro: 41–47.

Andrejevic, M. (2009), 'Exploiting YouTube: Contradictions of User-Generated Labor', in P. Snickars and P. Vonderau (eds), *The YouTube Reader*, 406–423, Stockholm: National Library of Sweden.

Anon. #1. (2009), 'Cable Ratings: NFL, Heisman The Closer, Men of a Certain Age and Phineas and Ferb top weekly cable charts', TV by the Numbers, 15 December. Available online: http://tvbythenumbers.zap2it.com/2009/12/15/ cable-ratings-nfl-heisman-the-closer-men-of-a-certain-age-and-phineas-and-ferb-top-weekly-cable-charts/36244/ (accessed: 1 February 2016).

Anon. #2. (2010), 'Phineas and Ferb [sic] Music, Mischief, and the Endless Summer Vacation', Variety 411, n.d. Available online: http://variety411.com/ article/phineas-and-ferb-music-mischief-and-the-endless-summer-vacation-3941815/#?search=&category=0 (accessed: 1 February 2016).

Anon. #3. (2015), 'Top 10 Decade Defining Videos of All Time', YouTube, 15 November. Available online: https://www.youtube.com/watch?v=DSj9h3yzvGk (accessed: 1 February 2015).

Anon. #4. (2013), 'I Am Burial: Anonymity, Gaze and the (Un)True Self', *Everyday Analysis*, 20 June. Available online: http://www.everydayanalysis.com/ post/53440895040/i-am-burial-anonymity-gaze-and-the-un-true (accessed: 10 October 2014).

Anon. #5. (2012), 'Burial: A Quietus Pseuds Corner', *The Quietus*, 15 February. Available online: http://thequietus.com/articles/07997-burial-pseud-quotes (accessed: 22 April 2013).

Anything Goes (1934), [musical comedy], book by Guy Bolton and P. G. Wodehouse; lyrics and music by Cole Porter.

Arendt, H. (2008), *Compreender. Formação, exílio e totalitarismo*, São Paulo: Cia. das Letras; Belo Horizonte: Editora da UFMG.

Argolo, J. (2012), *Terrorismo e Mídia*, Rio de Janeiro: E-Papers.

Arnold, G. (1993), *Route 666: On the Road to Nirvana*, New York: St. Martin's.

Aufderheide, P. (1986), 'Music Videos: The Look of the Sound', *Journal of Communication* 36(1): 57–78.

Augé, M. (1995), *Non-Places: Introduction to an Anthropology of Supermodernity*, New York: Verso.

Auslander, P. (2006), 'Watch That Man, David Bowie: Hammersmith Odeon, London, July 3, 1973', in I. Inglis (ed), *Performance and Popular Music: History, Place and Time*, 70–80, Hampshire: Ashgate Publishing.

Aust, M. P. and D. Kothenschulte (eds) (2011), *The Art of Pop Video*, Berlin: Distanz.

Austerlitz, S. (2007), *Money for Nothing: A History of the Music Video from the Beatles to the White Stripes*, New York: Continuum.

Autodesk (2015), 'Black Lake in Iceland', YouTube, 2 April. Available online: http://www.youtube.com/watch?v=YcVECJ_FckM (accessed: 6 December 2015).

Bailey, T. B. W. (2011), *Unofficial Release*, unpublished MS.

Balfour, I. (2011), 'Chris Marker's Only Music Video (Almost, Still)', *Public* 44: 171–175.

Banfield, S. (2005), 'Popular Musical Theatre (and Film)', in M. Cooke (ed), *The Cambridge Companion to Twentieth-century Opera*, 291–305. New York: Cambridge University Press.

Barron, L. (2008), 'The Seven Ages of Kylie Minogue: Postmodernism, Identity, and Performative Mimicry', *Nebula* 5(4): 46–63.

Barthes, R. (1975), *The Pleasure of the Text*, trans. R. Miller, New York: Hill and Wang.

Barthes, R. (1977), *Image, Music, Text*, trans. S. Heath, London: Fontana.

Barthes, R. (2000), *Mythologies*, London: Vintage.

Barthes, R. (2005), *Sade, Fourier, Loyola*, São Paulo: Martins Fontes.

Bataille, G. (1962), *Eroticism*, trans. M. Dalwood, London: Marion Boyars.

Bataille, G. (1997), *The Bataille Reader*, F. Botting and S. Wilson (eds), Oxford: Blackwell.

Baudrillard, J. (1996), *The System of Objects*, London: Verso.

Bauman, Z. (2006), *Liquid Fear*. London: Polity.

Baxter, R. L., et al. (1985), 'A Content Analysis of Music Videos', *Journal of Broadcasting & Electronic Media* 29(3): 333–340.

Baxxter, H. P. and A. Oehlen (2014), 'Popularity Is a Currency of Its Own: H. P. Baxxter Meets Albert Oehlen', *Electronic Beats*, 25 November. Available online: http://www.electronicbeats.net/h-p-baxxter-meets-albert-oehlen/ (accessed: 3 May 2016).

Beauchemin, M. (2014), 'FKA twigs, Lorde, and the New Feminist (Dance) Movement'. *Pitchfork*, 12 November. Available online: http://pitchfork.com/thepitch/550-fka-twigs-lorde-and-the-new-feminist-dance-movement/ (accessed: 9 May 2016).

Beebe, R. and J. Middleton (eds) (2007), *Medium Cool: Music Videos from Soundies to Cellphones*, London: Duke University Press.

Beller, J. L. (2006), *The Cinematic Mode of Production: Attention Economy and the Society of the Spectacle*. Lebanon: Dartmouth College Press.

Benjamin, W. (1969), *Illuminations*, trans. Harry Zohn, New York: Schocken Books.

Berardi, F. 'Bifo' (2007), *Generación Post-Alfa*. Patologías e imaginarios en el semiocapitalismo, Buenos Aires: Tinta Limón.

Berardi, F. 'Bifo' (2009), *Precarious Rhapsody: Semiocapitalism and the Pathologies of the Post-alpha Generation*, London: Minor Compositions.

Berardi, F. 'Bifo' (2011), *After the Future*, Edinburgh: AK Press.

Berardi, F. 'Bifo' (2015), *And: Phenomenology of the End*, Los Angeles: Semiotext[e].

Bergen, L. (2009), *Phineas and Ferb: Runaway Hit*, New York: Disney Press.

Bey, H. (1991), *T.A.Z.: The Temporary Autonomous Zone, Ontological Anarchy, Poetic Terrorism*, New York: Autonomedia.

Biressa, A. and H. Nunn (2013), *Class and Contemporary British Culture*, London: Palgrave Macmillan.

Blanchot, M. (1973), *Le Pas au-delà*, Paris: Gallimard.

Blanchot, M. (1988), *The Unavowable Community*, Barrytown: Station Hill Press.

Blanning, L. (2011), 'Don't Stop the Rush (Zomby feature)', *The Wire* (330), August 2011, 36–41.

Blanning, L. (2013), 'Revolution9: An Interview with Kode9', *Electronic Beats*, 14 May. Available online: http://www.electronicbeats.net/revolution9-an-interview-with-kode9/ (accessed: 13 August 2015).

Bolter, J. D. and R. Grusin (2000), *Remediation: Understanding New Media*. Cambridge: MIT Press.

The Book of Mormon (2011–), [musical comedy]. Book, lyrics, and music by Trey Parker, Robert Lopez and Matt Stone.

Bordwell, D. (2006), *The Way Hollywood Tells It: Story and Style in Modern Movies*, Berkeley: University of California Press.

Botting, F. (2008), *Limits of Horror: Technology, Bodies, Gothic*, Manchester: Manchester University Press.

Boyd, T. (2003), *The New H.N.I.C.: The Death of Civil Rights and the Reign of Hip Hop*, New York: New York University Press.

Brayton, R. (n.d.), 'The History of MTV' (video script). *Watch Mojo*, n.d. Available online: http://www.watchmojo.com/video/id/9782/ (accessed: 1 February 2016).

Brennan, M. (2007), 'The Best Pop Princess: Kylie Minogue', in A. McKee (ed), *Beautiful Things in Popular Culture*, 178–192, Oxford: Blackwell.

Brooker, W. (2015), 'Time Again: The David Bowie Chrontope', in T. Cinque, C. Moore and S. Redmond (eds), *Enchanting David Bowie: Space Time Body Memory*, 87–102, New York: Bloomsbury.

Brophy, R. (2010), 'Anonymous Techno', *PlayGround*, 25 October. Available online: http://www.playgroundmag.net/articulos/reportajes/Anonymous-techno_5_538196176.html (accessed: 12 September 2012).

Brozzoni, V. (2015), *A Cry of (Little) Death: A Polyphonic Account of Mysticism, Sex and Self-dissolution*, PhD thesis, Newcastle upon Tyne: Newcastle University.

Brumfitt, S. (2015), 'Bjork's Black Lake Director on Iceland, Special Effects and Facing Criticism' (sic), *i-D*, 9 March. Available online: https://i-d.vice.com/en_gb/article/bjorks-black-lake-director-on-iceland-special-effects-and-facing-criticism (accessed: 9 March 2015).

Bruzzi, S. (1997), *Undressing Cinema: Clothing and Identity in the Movies*, London: Routledge.

Buckland, T. and E. Stewart (1993), 'Some Preliminary Observations: 3. Dance & Music Video', in S. Jordan and D. Allen (eds), *Parallel Lines: Media Representations Dance*, 50–79, Luton: University of Luton Press.

Buckley, D. (2005), *Strange Fascination: David Bowie, The Definitive Story*, London: Virgin Books.

Buckley, D. (2015), 'Revisiting Bowie's Berlin', in A. Dillane, E. Devereux and M. J. Power (eds), *David Bowie: Critical Perspectives*, 215–229, New York: Routledge, 404–413.

Bull, C. J. C. (2001), 'Looking at Movement as Culture: Contact Improvisation to Disco', in A. Dils and A. C. Albright (eds), *Moving History/Dancing Cultures: A Dance History Reader*, Middleton: Wesleyan University Press.

Burgess, J. and J. Green (2009), *YouTube: Online Video and Participatory Culture*, Cambridge: Polity.

Butler, J. (1990), *Gender Trouble: Feminism and the Subversion of Identity*, New York: Routledge.

Butler, J. G. (2010), *Television Style*, New York: Routledge.

Bye Bye Birdie (1960), [musical comedy], book by Michael Stewart, lyrics by Lee Adams and music by Charles Strouse.

Bye Bye Birdie (1963), [film], dir. George Sidney, USA: Columbia Pictures.

Cagle, V. M. (1995), *Reconstructing Pop/Subculture: Art, Rock, and Andy Warhol*, London: Sage Publications.

Canevacci, M. (2005), *Culturas eXtremas*. Mutações juvenis nos corpos das metrópoles, Rio de Janeiro: DP&A.

Canevacci, M. (2013), *Sincrétika*. Explorações etnográficas sobre artes contemporâneas, São Paulo: Studio Nobel.

Castells, M. (2009), *The Rise of the Network Society, Pt. 1*, New York: Wiley & Blackwell.

Cats (1982), [musical comedy], composed by Andrew Lloyd Webber.

Certeau, M. (1984), *The Practice of Everyday Life*, trans. S. Rendall, Berkeley: University of California Press.

Certeau, M. (1988), *The Writing of History*, New York: Columbia University Press.

Chambers, I. (2003), 'Among the Fragments', in E. Thompson and D. Gutman (eds), *The Bowie Companion*, 67–76, London: Macmillan.

Chapman, D. (2003), 'Hermeneutics of Suspicion: Paranoia and the Technological Sublime in Drum and Bass Music', *ECHO: A Music-Centered Journal* 5(2): 1–18 (Available online: http://www.echo.ucla.edu/volume5-issue2/chapman/chapman.pdf).

Charon, J. M. (1998), *Symbolic Interactionism: An Introduction, an Interpretation, an Integration*, 6th edn., Upper Saddle River: Prentice-Hall Inc.

Chion, M. (1994), *Audio-Vision: Sound on Screen*, trans C. Gorbman, New York: Columbia University Press.

Chion, M. (2009), *Film: A Sound Art*, trans. C. Gorbman, New York: Columbia University Press.

Church, T. (2009), 'The Function of Identity in Techno', *Beatport*, n.d. Available online: http://news.beatport.com/the-function-of-identity-in-techno/ (accessed: 20 February 2012).

Cinderella (1950), [film]. Produced by Walt Disney, USA.

Cinderella (1957), [television program]. Book and lyrics by Oscar Hammerstein II, music by Richard Rodgers. CBS, 31 March 1957. (Staged on Broadway 2014).

Clark, M. (2006), 'Blackdown: Soundboy Burial', *Blackdown*, 21 March. Available online: http://blackdownsoundboy.blogspot.co.uk/2006/03/soundboy-burial.html (accessed: 19 August 2015).

Clark, M. (2007), 'Mediate on Bass Weight (DMZ Feature)', *Dummy Magazine*, Autumn 2007, 65–71.

Clément, C. (1988), *Opera or the Undoing of Women*, trans. B. Wing, Minneapolis: University of Minnesota Press.

Cope, N. (2012), *Northern Industrial Scratch: The History and Contexts of a Visual Music Practice*, unpublished critical commentary, Sunderland: University of Sunderland.

CowXxXPow (2015), Comment on 'Burial – Rough Sleeper', YouTube, 14 December. Available online: https://www.youtube.com/watch?v=N4_dzevyFK8 (accessed: 27 November 2015).

Crazy Ex Girlfriend (2015–), [television series], created by Rachel Bloom and Aline Brosh McKenna. Broadcast on CW.

Cregan, K. (2006), *The Sociology of the Body*, London: Sage Publications.

Critchley, S. (1997), *Very Little ... Almost Nothing: Death, Philosophy, Literature*, London: Routledge.

Cubitt, S. (1991), *Timeshift: On Video Culture*, London: Routledge.

Cubitt, S. (1993), *Videography: Video Media as Art and Culture*, New York: St. Martins Press.

Daniels, D. (2011) 'Prologue: Hybrids of Art, Science, Technology, Perception, Entertainment and Commerce at the Interface of Sound and Vision', in D. Daniels and S. Naumann (eds), *Audiovisuology 2 Essays: Histories and Theories of Audiovisual Media and Art*, Linz: Ludwig Boltzmann Institute.

Dawkins, B. (2014), 'DEALER', *Vimeo*, 2 May. Available online: https://vimeo.com/93600325 (accessed: 15 September 2015).

Deakin, F. (2010), 'What Is the Future of Music?', *Grafik* (185): 54, 55.

Deleuze, G. and F. Guattari. (2013), *Anti-Oedipus: Capital and Schizophrenia*, trans. R. Hurley, M. Seem and H. R. Lane, London: Bloomsbury Academic.

Derrida, J. (1987), *The Truth in Painting*, Chicago: Chicago University Press.

Derrida, J. (1989), *Of Spirit: Heidegger and the Question*, Chicago: Chicago University Press.

Dery, M. (2014), *I Must Not Think Bad Thoughts: Drive-by Essays on American Dread, American Dreams*. Minneapolis: University of Minnesota Press.

Dillane, A., E. Devereux and M. J. Power (2015), 'Culminating Sounds and (En)visions: *Ashes to Ashes* and the Case of Pierrot', in A. Dillane, E. Devereux and M. J. Power (eds), *David Bowie: Critical Perspectives*, 35–55, New York and London: Routledge.

Dils, A. and A. C. Albright (eds) (2001), *Moving History/Dancing Cultures: A Dance History Reader*, Middleton: Wesleyan University Press.

Dixon, I. (2013), 'The Return of the Thin White Repressed: Uses of Narcissism in The Stars (are Out Tonight)', *Celebrity Studies*, 4(3): 397–400.

Dodds, S. (2009), 'From Busby Berkeley to Madonna: Music Video and Popular Dance', in J. Malnig (ed), *Ballroom, Boogie, Shimmy Sham, Shake: A Social and Popular Dance Reader*, Chicago: University of Illinois Press.

Doggett, P. (2012), *The Man Who Sold the World: David Bowie and the 1970s*, London: Vintage Books.

Dombal, R. (2005), 'Interview: Chris Cunningham', *Pitchfork*, 31 July. Available online: http://pitchfork.com/features/interviews/6103-chris-cunningham/ (accessed: 21 December 2015).

Domingues, I. (2013), *Terrorismo de Marca*, Rio de Janeiro: Confraria do Vento.

Doty, A. (1998), 'Queer Theory', in J. Hill and P. Church Gibson (eds), *The Oxford Guide to Film Studies*, 148–157, Oxford: Oxford University Press.

Dragićević-Šeši, M. (2001), *Umetnost Performansa/The Art of Performance*, Belgrade: Fabrika Knjiga.

Durston, T. (2009), 'Chris Cunningham: In Focus', *Inverted Audio*, 19 April. Available online: http://inverted-audio.com/visual/chris-cunningham-in-focus/ (accessed: 21 December 2015).

Dyck, N. and E. P. Archetti (2003), *Sport, Dance and Embodied Identities*, New York: Berg.

Dyer, R. (1991), 'A Star Is Born and the Construction of Authenticity', in C. Gledhill (ed), *Stardom: Industry of Desire*, 132–140, New York: Routledge.

Edgar, R., K. Fairclough-Isaacs, and B. Halligan (2013), 'Introduction: Music Seen', in R. Edgar, K. Fairclough-Isaacs and B. Halligan (eds), *The Music Documentary: Acid Rock to Electropop*, 1–21, London: Routledge.

Emmerling, L. and M. Weh (eds) (2015), *Geniale Dilettanten: Subkultur Der 1980er-Jahre in Deutschland/Brilliant Dilettantes: Subculture in Germany in the 1980s*, Ostfildern: Hatje Cantz Verlag.

Enter the Void (2009), [film], dir: Gaspar Noé; France, USA, Fidélité Films, Wild Bunch.

Faden, E. S. (2001), 'The Cyberfilm: Hollywood and Computer Technology', in *Strategies: Journal of Theory, Culture & Politics* 14(1): 77–90. Available online: http://www.informaworld.com/smpp/title~db=all~content=g713447029 (accessed: 12 July 2012).

Fame (1980), [film], dir: Alan Parker; USA, Metro-Goldwyn-Mayer.

Family Guy (1999–), [television series], created by Seth McFarlane. Broadcast on FOX.

Fanon, F. (1986), *Black Skin, White Masks*, London: Pluto.

Fernández Porta, E. (2008), *Homo Sampler*. Tiempo y consumo en la Era Afterpop, Barcelona: Editorial Anagrama.

Ferry, A. (2002), 'Anonymity: The History of a Word', *New Literary History* 33(2): Anonymity (Spring, 2002), 193–214.

Fetveit, A. (2011), 'Mutable Temporality in and beyond the Music Video: An Aesthetic of Post-Production', in E. Røssack (ed), *Between Stillness and Motion: Film, Photography, Algorithms*, 159–186, Amsterdam: Amsterdam University Press.

Fiddler on the Roof (1964), [musical comedy], book by Joseph Stein, lyrics by Sheldon Harnick, and music by Jerry Bock.

Fidler, T. (2007), 'The Imaginary Body in Chris Cunningham's Music Videos: Portishead's *Only You* and Leftfield's *Afrika Shox*', in J. Wall (ed), *Music, Metamorphosis and Capitalism: Self, Poetics and Politics, 77–88*, Newcastle: Cambridge Scholars Publishing.

Fine Brothers Entertainment (2012), 'Teens React to Gangnam Style', YouTube, 19 August. https://www.youtube.com/watch?v=uYFmxgzPP3Q (accessed: 30 November 2015).

Fisher, Mark (2012), 'Burial: Unedited Transcript', *The Wire*, n.d. Available online: http://www.thewire.co.uk/in-writing/interviews/burial_unedited-transcript (accessed: 13 August 2015).

Fisher, Max (2012), 'Gangnam Style Dissected: The Subversive Message within South Korea's Video Sensation', *Atlantic*, 23 August. Available online: http://www.theatlantic.com/international/archive/2012/08/gangnam-style-dissected-the-subversive-message-within-south-koreas-music-video-sensation/261462/ (accessed: 30 November 2015).

Fiske, J. (1986), 'MTV: Post Structural Post Modern', *Journal of Communication Inquiry* 10(1): 74–79.

Fiske, J. (1987), 'British Cultural Studies and Television', in R. C. Allen (ed), *Channels of Discourse: Television and Contemporary Criticism, 254–289*, Chapel Hill: The University of North Carolina Press.

FKA Twigs Is the Only British Popstar Changing Attitudes About Sexuality. Available online: https://noisey.vice.com/en_us/article/fka-twigs-is-the-only-pop-star-who-knows-what-sex-isEmma Garland (accessed: 5 September 2014).

Flight of the Conchords (2007–2009), [television series], created by James Bobin, Jermaine Clement, and Bret McKenzie. Broadcast on HBO.

Flusser, V. (2011), *Writings*, Minneapolis: University of Minnesota.

Follies (1971), [musical comedy], book by James Goldman, lyrics and music by Stephen Sondheim.

Ford, S. (1999), *Wreckers of Civilisation: The Story of Coum Transmissions and Throbbing Gristle*. London: Black Dog.

Frahm, L. (2010), 'Liquid Cosmos. Movement and Mediality in Music Video', in H. Keazor and T. Wübbena (eds), *Rewind – Play – Fast Forward: The Past, Present and Future of the Music Video, 155–178*, Bielefeld: Transcript Verlag.

Frank, P. (2014), 'Who Is FKA twigs?', *The Huffington Post*,18 August. 2014. http://www.huffingtonpost.com/priscilla-frank/who-is-fka-twigs_b_5682311.html (accessed: 10 June 2016).

Franko, M. (2002), *The Work of Dance: Labour, Movement and Identity in the 1930s*, Middleton: Wesleyan University Press.

Freud, S. (1919), 'The Uncanny', *MIT*, n.d. Available online: http://web.mit.edu/allanmc/www/freud1.pdf (accessed: 15 November 2015).

Freund, K. (2011), *Veni, Vivi, Vids!: Audiences, Gender, and Community in Fan Vidding*, PhD thesis, Wollongong: University of Wollongong.

Frith, S., A. Goodwin and L. Grossberg (1993), *Sound and Vision: The Music Video Reader*, London: Routledge.

Fuchs, C. (2007), 'The Death of Jay-Z', in R. Beebe and J. Middleton (eds), *Medium Cool: Music Videos from Soundies to Cellphones*, 290–302, Durham: Duke University Press.

Furness, H. (2016), 'David Bowie's Last Release, Lazarus, Was "Parting Gift" for Fans in Carefully Planned Finale', *The Telegraph*, 13 January. Available online: http://www.telegraph.co.uk/news/celebritynews/12092542/Bowies-last-album-was-parting-gift-for-fans-in-carefully-planned-finale.html (accessed: 14 February 2016).

Gabrielli, G. (2010), 'An Analysis of the Relation between Music and Image: The Contribution of Michel Gondry', in H. Keazor and T. Wübbena (eds), *Rewind, Play, Fast Forward: The Past, Present and Future of the Music Video*, 89–109, Bielefeld: Transcript.

Gardner, A. (2015), *P.J. Harvey and Music Video Performance*, Burlington: Ashgate.

Gauntlett, D. (2004), 'Madonna's Daughters: Girl Power and the Empowered Girl-Pop Breakthrough', in S. Fouz-Hernandez and F. Jarman-Ivens (eds), *Madonna's Drowned Worlds: New Approaches to Her Cultural Transformations, 1983–2003*, 161–176, Aldershot: Ashgate.

Gauntlett, D. (2011), *Making Is Connecting*, Cambridge: Polity.

Gay, R. (2014), 'Emma Watson? Jennifer Lawrence? These Aren't the Feminists You're Looking For', *The Guardian*, 10 October. Available online: http://www.theguardian.com/commentisfree/2014/oct/10/-sp-jennifer-lawrence-emma-watson-feminists-celebrity (accessed: 24 October 2014).

Gibson, W. (2003), *Pattern Recognition*, London: Viking.

Gilbert, J. (2009), 'The Real Abstraction of Michael Jackson', in M. Fisher (ed), *The Resistible Demise of Michael Jackson*, 137–149, Washington: 0 Books.

Gilbert, J. and Pearson, E. (1999), *Discographies: Dance Music, Culture and the Politics of Sound*, London: Routledge.

Gill, R. (2007), 'Postfeminist Media Culture: Elements of a Sensibility', *European Journal of Cultural Studies* 2007(10): 147–166.

Gillenwater, C. and P. Alvarez (2013), 'Music and TV', *Philologia: The Virginia Tech Undergraduate Research Journal for the College of Liberal Arts and Human Sciences* (5): 88–89. Available online: http://www.philologia.clahs.vt.edu/Journal2013.html (accessed: May 1 2016).

Gines, K. (2006), 'Abelhas-rainhas e grandes cafetões: sexo e sexualidade no hip hop', in D. Darby and T. Shelby (orgs.), *Hip Hop e a Filosofia*, 101–112, São Paulo: Madras.

Glee (2009–2015), [television series], broadcast on FOX.

Goffman, E. (2005), *Interaction Ritual: Essays on Face-to-Face Behaviour*, New Brunswick: Aldine Transaction.

Gonzalez, E. (2010), '1: Kylie Minogue, "Come into My World" (Michel Gondry)', *Slant*, 20 January. Available online: http://www.slantmagazine.com/features/article/best-of-the-aughts-music-videos/P5 (accessed: 30 July 2016).

Goodman, S. (2001), '21st Century Skank: The Haunting of UK Garage', *Riddim Dot Ca*, 29 November. Available online: http://www.riddim.ca/?p=80 (accessed: 22 December 2014).

Goodwin, A. (1992), *Dancing in the Distraction Factory: Music Television and Popular Culture*, Minneapolis: University of Minnesota Press.

Gorbman, C. (1987), *Unheard Melodies: Narrative Film Music*, Bloomington: Indiana University Press.

Gordon, J. (2016), 'Björk and Arca at Work on New Björk Album', *Pitchfork*, 7 March. Available online: http://pitchfork.com/news/63984-bjork-and-arca-at-work-on-new-bjork-album/ (accessed: 7 March 2016).

Grant, Mark N. (2004), *The Rise and Fall of the Broadway Musical*, Boston: Northeastern University Press.

Grau, A. (2008), 'Dance, Identity, and Identification Processes in the Postcolonial World', in S. Franko and M. Nordera (eds), *Dance Discourses: Keywords in Dance Research*, 404–413, London: Routledge.

Grease (1971), [musical comedy]. Book, lyrics, and music by Jim Jacobs and Warren Casey with additional songs by John Farrar.

Griffin, Sean (2005), 'Curiouser and Curiouser: Gay Days at the Disney Theme Parks', in Mike Budd and Max H. Kirsch (eds), *Rethinking Disney: Private Control, Public Dimensions*, Middletown, CT: Wesleyan University Press, 125–150.

Gross, K. (2011), *Puppet: An Essay on Uncanny Life*, Chicago: University of Chicago Press.

Grusin, R. (2015), 'Radical Mediation', *Critical Inquiry* 42(1): 124–148.

Guarracino, S. (2010), *La Primadonna all'Opera*, Trento: Tangram Edizioni Scientifiche.

Guattari, F. (2011), *Machinic Unconscious*, Los Angeles: Semiotext[e].

Gumbrecht, H. U. (2004), *Production of Presence: What Meaning Cannot Convey*, Stanford: Stanford University Press.

Gumbrecht, H. U. (2014), *Atmosfera, Ambiência, Stimmung: Sobre um Potencial Oculto da Literatura*, Rio de Janeiro: Contraponto.

Gwynne, J. and N. Muller (2013), *Postfeminism and Contemporary Hollywood Cinema*, London: Palgrave Macmillan.

Halligan, B. (2011), 'Metrosexuality', in D. Southern (ed), *The Encyclopaedia of Consumer Culture*, 968–970, London: Sage.

Halligan, B. (2013), 'From Countercultures to Suburban Cultures: Frank Zappa after 1968', in S. Whiteley and J. Sklower (eds), *Countercultures and Popular Music*, 187–202, Surrey: Ashgate.

Halligan, B. (2014), '"({})": Raunch Culture, Third Wave Feminism and The Vagina Monologues', *Theory & Event* 17(01).

Hamera, J. (2012) 'The Labors of Michael Jackson: Virtuosity, Deindustrialization, and Dancing Work', *PMLA*, 127(4): 751–765.

Hamad. H. and A. Taylor (2015), 'Introduction: Feminism and Contemporary Celebrity Culture', *Celebrity Studies* 6(1): 124–127.

Hamilton (2015), [musical comedy], book, lyrics and music by Lin-Manuel Miranda.

Hancox, D. (2007), 'Elusive Dubstep Star Burial Gives a Rare Interview', *The Guardian*, 26 October. Available online: http://www.theguardian.com/music/2007/oct/26/urban (accessed: 13 August 2015).

Hannah Montana (2006–2011), [television series], created by Michael Poryes, Rich Correll, and Barry O'Brien; broadcast on Disney and Disney XD.

Hanson, C. F. (2014), 'Pop Goes Utopia: An Examination of Utopianism in Recent Electronic Dance Pop', *Utopian Studies* 25(2): 384–413.

Harrison, J. (2012), 'The Television Musical: *Glee*'s New Directions', in M. Ames (ed), *Time in Television Narrative: Exploring Temporality in Twenty-first Century Programming*, 257–269, Jackson: University of Mississippi Press.

Harvey, D. (1989), *The Condition of Postmodernity: An Enquiry into the Origins of Cultural Change*, Cambridge: Blackwell.

Hebdige, D. (1988), *Subculture: The Meaning of Style*, London: Routledge.

Hennings, E. (2007), 'Burial Interview by Emmy Hennings', *Cyclic Defrost*, 24 November. Available online: http://www.cyclicdefrost.com/2007/11/burial-interview-by-emmy-hennings/ (accessed: 13 August 2015).

Hesmondhalgh, D. (1998), 'The British Dance Music Industry: A Case Study of Independent Cultural Production', *British Journal of Sociology* 49(2): 234–251.

High School Musical (2006), [made-for-television musical comedy], produced by Disney.

High School Musical 2 (2007), [made-for-television musical comedy], produced by Disney.

High School Musical 3: Senior Year (2008), [made-for-television musical comedy], produced by Disney.

Hitchings, C. (2015), 'Bjork's "Mouth Mantra" Is One of This Year's Craziest Videos', *Gigwise*, 7 December. Available online: http://www.gigwise.com/news/104306/bjork-films-bizarre-new-mouth-mantra-youtube-video-inside-her-mouth (accessed: 7 December 2015).

Hocquenghem, G. (1993), *Homosexual Desire*, Durham: Duke University Press.

Hocquenghem, G. and B. Preciado (2009), *El Deseo Homosexual* (followed by *Terror Anal*), Barcelona: Melusina.

Hoffmann, H. (n.d.), 'Aphex Twin Interview', *The Aphex Twin Community v4*, n.d. Available at: http://www.aphextwin.nu/images/interviewsarticles/afx_interview_by_heiko.pdf (accessed: 21 December 2015).

Holder, C. (1997), 'Autechre: Techno-logical', *Sound on Sound*, n.d. Available online: http://www.soundonsound.com/sos/1997_articles/nov97/autechre.html (accessed: 21 December 2015).

Holzbach, A. (2013), *Smells Like Teen Spirit: A Consolidação do Videoclipe Como Gênero Audio-Visual*, PhD thesis, Niterói: Universidade Federal Fluminense,

Hong, S. (2012), 'Beyond The Horse Dance', *Open City*, 12 December. Available online: http://opencitymag.com/beyond-the-horse-dance-viral-vid-gangnam-style-critiques-koreas-extreme-inequality/ (accessed: 30 November 2015).

hooks, b. (2014), Transgression: Whose Booty Is This?, YouTube/*The New School*, 7 October. Available online: https://www.youtube.com/watch?v=QJZ4x04CI8c (accessed: 10 June 2016).

Houplain, L. (2010), 'What Is the Future of Music?', *Grafik* (185): 56–57.

Huang, A. T. (2012a), 'Solipsist', *Vimeo*, 3 March. Available at: https://vimeo.com/37848135 (accessed: 6 December 2015)

Huang, A. T. (2012b), 'The Making of Björk – "Mutual Core" - Art + Music – MOCAtv', *Andrew Thomas Huang (Tumblr)*, 14 November. Available online: http://andrewthomashuang.tumblr.com/post/35698325832 (accessed: 1 December 2015).

Hudson, B. (1985), 'Femininity and Adolescence', in A. McRobbie and M. Nava (eds), *Gender and Generation*, 31–53, London: Macmillan Education Ltd.

Hunt, K. J. (2015), 'The Eyes of David Bowie', in T. Cinque, C. Moore and S. Redmond (eds), *Enchanting David Bowie: Space Time Body Memory*, 175–195, New York: Bloomsbury.

Illich, I. (1973), *Tools for Conviviality*, London: Marion Boyars. Available online: http://www.preservenet.com/theory/Illich/IllichTools.html (accessed: 22 November 2015).

Inside Björk (2003), [video documentary], dir. Christopher Walker, UK: One Little Indian/Wellhart Productions.

Into the Woods (1987), [musical comedy]. Book by James Lapine, lyrics and music by Stephen Sondheim.

Into the Woods (2014), [film], dir. Rob Marshall; USA, Disney.

Jameson, F. (1991), *Postmodernism, or, The Cultural Logic of Late Capitalism*, Durham: Duke University Press.

Jazzin' for Blue Jean (1984), [film], dir. Julian Temple, UK: Sony Video.

Jeep (2015), 'Official Jeep Renegade Commercial ft. X Ambassadors "Renegades"', YouTube, 16 April. Available online: https://www.youtube.com/watch?v=YM-th85hRUU (accessed: 1 May 2016).

Jenkins, P. (1988), *Mrs. Thatcher's Revolution: The Ending of the Socialist Era*, Cambridge: Harvard University Press.

Jennings, D. (2007), *Net, Blogs and Rock 'n' Roll*, London: Nicholas Brealey.

Jersey Boys (2005-), [musical comedy], book by Marshall Brickman and Rick Elice, lyrics by Bob Crewe, and music by Bob Gaudio.

Jersey Boys (2014), [film], dir. Clint Eastwood, USA: Malpaso Productions.

Jones, J. (2009), *Speed Demons* [Phineas and Ferb Novelizations #1], New York: Disney Press.

Jovićević, A. and A. Vujanović (2007), *Uvod u Studije Performansa/Introduction to Performance Studies*, Belgrade: Fabrika Knjiga.

Kaplan, E. A. (1987), 'Feminist Criticism and Television', in R. C. Allen (ed), *Channels of Discourse: Television and Contemporary Criticism*, 211–253, Chapel Hill: The University of North Carolina Press.

Kaplan, E. A.(1988), *Rocking Around the Clock: Music Television, Postmodernism, and Consumer Culture*, London: Routledge.

Keazor, H. and T. Wübbena (eds) (2010), *Rewind, Play, Fast Forward: The Past, Present and Future of the Music Video*, Bielefeld: Transcript.

Kek-W (2012), 'Burial: It's Quite a Simple Thing I Want to Do', *FACT*, n.d. Available online: http://www.factmag.com/2012/07/01/interview-burial/ (accessed: 13 August 2015).

Kellner, D. (2001), *A Cultura da Mídia*. Estudos culturais: identidade e política entre o moderno e o pós-moderno, Bauru: EDUSC.

Kember, S. and J. Zylinska (2012), *Life after New Media: Mediation as a Vital Process*, Cambridge: MIT Press.

Kim, J. (2012), 'Psy's Music: Gangnam Style and Gangnam Oppa in Architecture 101', *My Dear Korea*, 9 August. Available online: http://mydearkorea.blogspot.co.uk/2012/08/korean-music-psys-gangnam-style-and.html (accessed: 30 November 2015).

Kim, Y. H. and H. Jung (2015), 'Investor PSY-chology Surrounding Gangnam Style', *SSRN*, 13 March. Available online: http://ssrn.com/abstract=2292577 (accessed: 30 November 2015).

Kinder, M. (1984), 'Music Video and the Spectator: Television, Ideology, and Dream', *Film Quarterly* 38(1): 2–15.

Kiss Me Kate (1948), [musical comedy]. Book by Samuel and Bella Spewack, lyrics and music by Cole Porter.

Kliem, K. (2011), 'Burial – Prayer on Vimeo', *Vimeo*, 18 November. Available online: https://vimeo.com/16967871 (accessed: 14 September 2015).

Kooijman, J. (2013), *Fabricating the Absolute Fake: America in Contemporary Pop Culture*, 2nd edn., Amsterdam: Amsterdam University Press.

Koolhaas, R. (2002), 'Junkspace', *October* 100: 175–190.

Korsgaard, M. B. (2012), 'Creation and Erasure: Music Video as a Signaletic Form of Practice', *Journal of Aesthetics & Culture* 4. Available online: http://www.aestheticsandculture.net/index.php/jac/article/view/18151/22823 (accessed: 23 November 2015).

Lakin, C. (ed) (1993), *The Guinness Encyclopedia of Popular Music*, concise ed, London: Guinness Publishing.

Langkær, B. (1997), 'Spatial Perception and Technologies of Cinema Sound', *Convergence: The International Journal of Research into New Media Technologies* 3: 92–107. Available online: http://con.sagepub.com/cgi/content/abstract/3/4/92 (accessed: 12 December 2009).

Les Misérables (1980), [musical comedy]. French lyrics by Alain Boublil and Jean-Marc Natel, music by Claude-Michel Schönberg. Originally produced in France; later translated into English and produced in both London and New York.

Les Misérables (2012), [film], dir. Tom Hooper; USA, Universal.

Levy, A. (2006), *Female Chauvinist Pigs: Women and the Rise of Raunch Culture*, New York: Simon & Schuster.

Ligotti, T. (2010), *The Conspiracy against the Human Race*, New York: Hippocampus Press.

The Little Mermaid (1989), [film]. Produced by Walt Disney Feature Animation.

Lobalzo Wright, J. (2015), 'David Bowie: The Extraordinary Rock Star as Film Star', in A. Dillane, E. Devereux and M. J. Power (eds), *David Bowie: Critical Perspectives*, 230–244, New York: Routledge.

Louro, G. (2013), *Um Corpo Estranho*. Ensaios sobre sexualidade e teoria queer, Belo Horizonte: Editora Autêntica.

Love You Till Tuesday (1984), [film], dir. Malcolm J. Thompson, UK: Polygram.

Lury, C. (2000), 'The United Colors of Diversity: Essential and Inessential Culture', in S. Franklin, C. Lury and J. Stacey (eds), *Global Nature, Global Culture*, 146–287, London: Sage.

Mackay, R. and A. Avanessian (eds) (2014), *#Accelerate: The Accelerationist Reader*, Falmouth: Urbanomic.

MacKenzie, D. and J. Wajcman (eds) (1999), *The Social Shaping of Technology*, Buckingham: Open University Press.

Malins, S. (2005), *Duran Duran: Notorious*, London: Andre Deutsch/Carlton Publishing Group.

Manghani, S. (2013), 'Kylie *Écriture*', in P. Bennett and J. McDougall (eds), *Barthes' 'Mythologies' Today: Readings of Contemporary Culture*, 64–65, New York: Routledge.

Manovich, L. (2001), *The Language of New Media*, Cambridge: The MIT Press.

Manovich, L. (2013), *Software Takes Command*, New York: Bloomsbury.

Marks, C. and R. Tannenbaum (2011), *I Want My MTV: The Uncensored Story of the Music Video Revolution*, New York: Dutton.

Mary Poppins (1964), [film], dir. Robert Stevenson, with songs by the Sherman Brothers.

Mason, K. (2013), 'Baauer's Harlem Shake', *Billboard*, 22 February. Available online: http://www.billboard.com/articles/news/1549748/baauers-harlem-shake-billboard-cover-story (accessed: 30 November 2015).

Mayer, H. (2009), *Phineas and Ferb #3: Wild Surprise*, New York: Disney Press.

McColvin, L. (1930), 'Anonymity in Music', *The Musical Times* 71(1046): (1 April), 317, 318. Available online: http://www.jstor.org/stable/914492 (accessed: 12 March 2014).

McDonald, M. (2011), 'Home Internet May Get Even Faster in South Korea', *New York Times*, 21 February. Available online: http://www.nytimes.com/2011/02/22/technology/22iht-broadband22.html?_r=0 (accessed: 30 November 2015).

McDonald, P. (1997), 'Feeling and Fun: Romance, Dance and the performing Male body in Take That Videos', in S. Whiteley (ed), *Sexing the Groove: Popular Music and Gender*, 259–276, London: Routledge.

McFarlane, S. (n.d.), Seth McFarlane Biography [interview extract], *Bio*, n.d. Available online: http://www.biography.com/people/seth-macfarlane-20624525 (accessed: 1 February 2016).

McGrath, S. and L. Tilahun. (2006), A garota tem 99 problemas: o hip hop é um deles? in D. Darby and T. Shelby (orgs.), *Hip Hop e a Filosofia*, 138–149, São Paulo: Madras.

McKenzie, J. (2001), *Perform or Else: From Discipline to Performance*, London: Routledge.

McLuhan, M. (1967), *The Medium Is the Message*, London: Penguin.

McRobbie, A. (1984), 'Dance and Social Fantasy', in A. McRobbie and M. Nava (eds), *Gender and Generation*, 130–161, London: Macmillan Education Ltd.

McRobbie, A. (2004), 'Postfeminism and Popular Culture', *Feminist Media Studies* 4(3): 255–264.

McSmith, A. (2010), 'The Eighties: Another Country', *The Independent*, 13 September. Available online: http://www.independent.co.uk/news/uk/home-news/the-eighties-another-country-2078407.html (accessed: 6 February 2016).

Mercer, K. (1993), 'Monster Metaphors: On Michael Jackson's *Thriller*', in S. Frith, A. Goodwin and L. Grossberg (eds), *Sound & Vision: The Music Video Reader*, 93–108, New York: Routledge.

Mian, M. G. (2011), 'Björk e il nuovo album: «Ho fatto i soldi con la musica, ora salvo l'ambiente»', *Corriere Della Sera*, 18 August. Available online: http://www.corriere.it/spettacoli/11_agosto_18/byork_salva_ambiente_cb3d5afa-c9a5-11e0-a66c-10701cdb9ebd.shtml (accessed: 2 December 2015).

The Mickey Mouse Club, (originally 1955–1959), [television program]. Created by Walt Disney. Broadcast on ABC.

Miéville, C. (2009), 'Weird Fiction', in M. Bould, A. M. Butler, A. Roberts and S. Vint (eds), *The Routledge Companion to Science Fiction*, 510–515, London: Routledge.

Miller, M. (2000), 'Of Tunes and Toons: The Movie Musical of the 1990's', in Wheeler Winston Dixon (ed), *Film Genre 2000: New Critical Essays*, 45–62, Albany: State University of New York Press.

Mirzoeff, N. (2009), *An Introduction to Visual Culture*, 2nd edn., London: Routledge.

Mistry, A. (2015), 'FKA twigs – M3LL155X review', *Pitchfork*, 19 August. Available online: http://pitchfork.com/reviews/albums/20985-m3ll155x/ (accessed: 11 June 2016).

Mitchell, T. (2001), *Global Noise: Rap and Hip-hop Outside the USA*, Middletown: Wesleyan University Press.

Mitchell, W. J. T. (1994), *Picture Theory: Essays on Verbal and Visual Representation*, Chicago: University of Chicago Press.

Mittell, J. (2015), *Complex TV: The Poetics of Contemporary Television Storytelling*, New York: New York University Press.

Moca TV (2012), 'The Making of Björk – Mutual Core', YouTube, 13 November. Available online: http://www.youtube.com/watch?v=LmyiYxtsImw (accessed: 4 December 2015).

MoMA (2015), 'Black Lake Trailer', YouTube, 13 February. Available online: http://www.youtube.com/watch?v=EiXQ5qaUGDI (accessed: 6 December 2015).

Morgan, R. (2009), 'Dustin McLean, Literal Video Mastermind', *Wall Street Journal*, 28 July. Available online: http://blogs.wsj.com/speakeasy/2009/07/28/dustin-mclean-literal-video-mastermind-on-writing-legal-woes-and-his-go-to-karoke-song/ (accessed: 30 November 2015).

Mulvey, L. (1975), 'Visual Pleasure and Narrative Cinema', *Screen* 16(3): 6–18.

Mulvey, L. (2006), *Death 24x a Second: Stillness and the Moving Image*, London: Reaktion Books.

Murray, R. (2012), 'Untrue: Burial I Features I Clash Magazine', *Clash* 16 February. Available online: http://www.clashmusic.com/feature/untrue-burial (accessed: 13 August 2015).

The Music Man (1957), [musical comedy], book, lyrics, and music by Meredith Wilson.

The Music Man (1962), [film], dir. Morton DaCosta. USA: Walt Disney.

My Fair Lady (1956), [musical comedy], book and lyrics by Alan Jay Lerner, music by Frederick Loewe.

Naiman, T. (2015), 'Art's Filthy Lesson', in A. Dillane, E. Devereux and M. J. Power (eds), *David Bowie: Critical Perspectives*, 178–195, New York: Routledge.

Nussbaum, Emily. (2012). 'It's Good Enough for Me.' *The New Yorker* 88 (1): 110–115.

Negra, D. (2009), *What a Girl Wants: Fantasising the Reclamation of Self in Postfeminism*, London: Routledge.

Negra, D and S. Holmes (2008), 'Going Cheap? Female Celebrity in Reality, Tabloid and Scandal Genres', *Genders Special Issue* 48.

Nicholson, B. (2015), 'FKA Twigs – 'M3LL155X' Review'. *NME*, 14 August 14. Available online: http://www.nme.com/reviews/fka-twigs/16215 (accessed: 23 July 2016).

Nicki Minaj: Pink Planet (2013), [DVD], dir: Tom O'Dowd. USA: EUA.

Niles, J. (2014), "Scrubs" Creator Has Broadway Musical Based on Hospital Comedy in the Works', *Mstars News*, 14 February. Available online: http://www.mstarz.com/articles/26256/20140214/scrubs-creator-broadway-musical-based-hospital-comedy-works.htm (accessed: 1 February 2016).

Noland, C. (2009), *Agency and Embodiment: Performing Gestures/Producing Culture*, Cambridge, Mass: Harvard University Press.

Oklahoma! (Broadway 1943; filmed 1955), [musical comedy], book and lyrics by Oscar Hammerstein II, music by Richard Rodgers.

O'Neill, J. (1985), *Five Bodies: The Human Shape of Modern Society*, Ithaca, NY: Cornell University Press.

Orton, K. (2012), 'Björk Selects Andrew Thomas Huang', *Bjork.fr*, 1 September. Available online: http://www.bjork.fr/Dazed-Confused-4236 (accessed: 2 December 2015).

Padnick, S. (2012), 'Phineas and Ferb Is the Best Science Fiction on Television', Tor.com, 17 May. Available online: http://www.tor.com/2012/05/17/phineas-and-ferb-is-the-best-science-fiction-on-television/ (accessed: 1 February 2016).

Panera, J. (2013), *This Is Not a Love Song: Cruce des Caminos Entre Videocreación y Música Pop*, Barcelona: Lunwerg.

Pegley, K. (2008), *Coming to You Wherever You Are: MuchMusic, MTV, and Youth Identities*, Middletown: Wesleyan University Press.

Peters, K. and A. Seier (2009), 'Home Dance: Mediacy and Aesthetics of the Self on YouTube', in P. Snickars and P. Vonderau (eds), *The YouTube Reader*, 187–203, Stockholm: National Library of Sweden.

Phantom of the Opera, The (London 1986; Broadway 1988), [musical comedy], book and lyrics by Charles Hart with Richard Stilgoe, music by Andrew Lloyd Webber.

Phili, S (2013), 'Robin Thicke on That Banned Video, Collaborating with 2 Chainz and Kendrick Lamar, and His New Film'. GQ Magazine, May, 2013. http://www.gq.com/story/robin-thicke-interview-blurred-lines-music-video-collaborating-with-2-chainz-and-kendrick-lamar-mercy#ixzz2ZrNJyLLe (accessed: 1 November, 2016).

Phineas and Ferb (2007–2015), [television series], produced by The Disney Company.

PhineasFan11 (2012), 'Phineas and Ferb – You're Going Down Extended Music Video with Lyrics', YouTube, 19 February. Available online: https://www.youtube.com/watch?v=1bNf5BDiFKs (accessed: February 1, 2016).

Plagenhoef, S. (2009), 'The Top 50 Music Videos of the 2000s', *Pitchfork*, 31 August. Available online: http://pitchfork.com/features/staff-lists/7695-the-top-50-music-videos-of-the-2000s/4/ (accessed 30 July 2016).

Poizat, M. (1992), *The Angel's Cry. Beyond the Pleasure Principle in Opera*, trans. A. Denner, London: Cornell University Press.

Polhemus, T. (1993) 'Dance, Gender and Culture', in Thomas, H. (ed) Dance, Gender and Culture, London: Macmillan, 3–15.

Postman, N. (1992), *Technopoly: The Surrender of Culture to Technology*, New York: Knopf.

Preciado, B. (2014), *Pornotopia: An Essay on Playboy's Architecture & Biopolitics*, New York: Zone Books.

Prince, D. and N. Martin (2012), 'The Tween Consumer Marketing Model: Significant Variables and Recommended Research Hypotheses', *Academy of Marketing Studies Journal* 16 (2), July. Available online: https://www.questia.com/library/journal/1G1-289620955/the-tween-consumer-marketing-model-significant-variables (accessed: 1 February 2016).

Pytlik, M. (2003), *Björk: Wow and Flutter*, Toronto: ECW Press.

Railton, D. and P. Watson (2011), *Music Video and the Politics of Representation*, Edinburgh: Edinburgh University Press.

RellyAlexander (2015), Comment on 'Burial – Fostercare', YouTube, 15 May. Available online: https://www.youtube.com/watch?v=vTs7KXqZRmA (accessed: 27 November 2015).

Reynolds, S. (2006), *Rip It Up and Start Again: Postpunk 1978–84*, New York: Penguin.

Reynolds, S. (2013), *Energy Flash: A Journey through Rave Music and Dance Culture*, New and Revised edn., London: Faber and Faber.

Richardson, J., C. Gorbman and C. Vernallis eds. (2015), *The Oxford Handbook of New Audiovisual Aesthetics*, Oxford: Oxford university Press.

Robb, J. (2010), *The North Will Rise Again: Manchester Music City 1976–1996*, London: Aurum Press.

Roper, T. (2014), 'We Spoke to the Director of the Burial-Inspired Short Film, Dealer', *Thump*, 30 May. Available online: https://thump.vice.com/en_uk/article/we-spoke-to-the-director-of-the-burial-inspired-short-film-rival-dealer (accessed: 20 October 2015).

Rose, T. (1993), *Black Noise: Rap Music & Black Cultural Resistance in Contemporary American Popular Culture*, Middletown: Wesleyan University Press.

Rose, T. (2008), *The Hip Hop Wars: What We Talk about When We Talk about Hip Hop – and Why It Matters*, New York: BasicCivitas.

Särlvik, B. and I. Crewe with the assistance of N. Day and R. MacDermid (1983), *Decade of Dealignment: The Conservative Victory of 1979 and Electoral Trends in the 1970s*, London: Cambridge University Press.

Savage, J. (2003), 'Avant-AOR', in E. Thompson and D. Gutman (eds), *The Bowie Companion*, 160–162, London: Macmillan.

Saviano, R. (2009), *Gomorra*. A história real de um jornalista infiltrado na violenta máfia napolitana, Rio de Janeiro: Bertrand Brasil.

Saville, P. (2003), *Designed by Peter Saville*, Princeton: Princeton Architectural Press.

Schatz, T. (1981), *Hollywood Genres: Formulas, Filmmaking, and the Studio System*, Philadelphia: Temple University Press.

Schmitt, C. (1985), *Political Theology: Four Chapters on the Concept of Sovereignty*, Chicago: Chicago University Press.

Schwartz, M. (2008), 'Michel Gondry Selects 25 Classic Music Videos', *Entertainment Weekly*, 10 July. Available online: http://www.ew.com/gallery/michel-gondry-picks-25-classic-music-videos (accessed: 29 November 2015).

Scrubs (2001–2010), [television series], broadcast on NBC and ABC.

Seidman, R. (2009), 'Disney Channel is TV's No. 1 Network in Total Day [sic] Among Tweens 9–14 for the Sixth Time in 7 Weeks', *TV by the Numbers*. 28 May. Available online: http://tvbythenumbers.zap2it.com/2009/05/27/disney-channel-is-tvs-no-1-network-in-total-day-among-tweens-9-14-for-the-sixth-time-in-7-weeks/ (accessed: 1 February 2016).

Severin, S. (2008), 'Burial – Ghost Hardware – YouTube', YouTube, 22 June. Available online: https://www.youtube.com/watch?v=EPwbqb6DZ9g (accessed: 18 September 2015).

Shamberg, M. (n.d.), 'The Perfect Kiss 1985', *Kinoteca*, n.d. Available online: http://www.kinoteca.net/Text/ThePerfectKiss.htm (accessed: 29 November 2015).

Sharpay's Fabulous Adventure (2011), [direct-to-disc musical comedy]. Produced by Disney.

Shaviro, S. (2002), 'The Erotic Life of Machines'. Available online: http://www. shaviro.com/Othertexts/Bjork.pdf (accessed: 23 November 2015).

Shaviro, S. (2010), *Post-Cinematic Affect*, Winchester: Zero Books.

Shaviro, S. (2017), *Digital Music Videos*, Quick Takes: Movies and Popular Culture Series, New Brunswick: Rutgers University Press.

Shilling, C. (2007), *Embodying Sociology: Retrospect, Progress and Prospects*, Oxford: Blackwell Publishing.

Shuker, R. (2001), *Understanding Popular Music*, 2nd edn., New York: Routledge.

Shuker, R. (2004), 'Beyond the "High Fidelity" Stereotype: Defining the Contemporary Record Collector', *Popular Music* 23(3): 311–330.

Shuker, R. (2013), *Understanding Popular Music Studies*, 4th edn., New York: Routledge.

Shusterman, R. (1998), *Vivendo a Arte*. O pensamento pragmatista e a estética popular, São Paulo: Ed. 34.

Sibilla, G. (2010), 'It's the End of Music Videos As We Know Them (But We Feel Fine): Death and Resurrection of Music Videos in the YouTube Age', in H. Keaor and T. Wübbena (eds), *Rewind, Play, Fast Forward: The Past, Present, and Future of the Music Video*, Bielefeld: Transcript.

Silveira, F. (2013), *Rupturas Instáveis*. Entrar e sair da música pop, Porto Alegre: Editora Libretos.

The Simpsons (1989–), [television series], created by Matt Groening. Broadcast on FOX.

Singer, B. (2004), *Ever After: The Last Years of Musical Theater and Beyond*, New York: Applause.

Singin' in the Rain (1952), [film], dir. Gene Kelly and Stanley Donen; USA, Metro-Goldwyn-Mayer.

Snapes, L. (2012), 'Björk Undergoes Successful Laser Treatment for Vocal Cord Nodules', *Pitchfork*, 21 November. Available online: http://pitchfork.com/news/48675-bjork-undergoes-successful-lazer-treatment-for-vocal-cord-nodules/ (accessed: 3 December 2015).

South Park (1997–), [television series], created by Trey Parker and Matt Stone. Broadcast on Comedy Central.

Stanley, B. (2015), 'Forget 1966, Because 1981 Was Pop's Year of Revolution', *The Guardian*, 17 December. Available online: http://www.theguardian.com/music/musicblog/2015/dec/17/1981-pop-year-of-revolution (accessed: 14 January 2016).

Stanley, R. (2002), 'Dying Light: An Obituary for the Great British Horror Movie', in S. Chibnall and J. Petley (eds), *British Horror Cinema*, 183–195, London: Routledge.

Stark, Tanja 'Confronting Bowie's Mysterious Corpses', in Tonjia Cinque, Christopher Moore and Sean Redmond (eds), *Enchanting David Bowie: Space Time Body Memory*, 61–77, New York and London: Bloomsbury.

Stempel, L. (2010), *Showtime: A History of the Broadway Theater*, New York: W. W. Norton.

Stevenson, N. (2015), 'David Bowie Now and Then: Questions of Fandom and Late Style', in A. Dillane, E. Devereux and M. J. Power (eds), *David Bowie: Critical Perspectives*, 280–294, New York and London: Routledge.

Stoever, J. (Forthcoming), 'How Bam Heard Hip Hop: Black Women's Record Collecting and Living Room Selecting in the 1960s and 70s Bronx', in J. Burton and J. L. Oakes (eds), *The Oxford Handbook of Hip Hop Music Studies*, Oxford: Oxford University Press: Spring 2018.

Straw, W. (1988), 'Music Video in Its Contexts: Popular Music and Post-Modernism in the 1980s', *Popular Music* 7(3): 247–266.

Straw, W. (1993), 'Pop Music and Postmodernism in the 1980s', in S. Frith, A. Goodwin and L. Grossberg (eds), *Sound and Vision: The Music Video Reader*, 2nd edn., 3–21, London: Routledge.

Strong, R., M. Binney and J. Harris (eds) (1974), *The Destruction of the Country House: 1875–1975*, London: Thames and Hudson.

Tan, M. (2015), 'K-Contagion: Sound, Speed and Space in "Gangnam Style"', *The Drama Review* 59(1): 83–96.

Tannenbaum, R. and C. Marks (2012), *I Want My MTV: The Uncensored Story of the Music Video Revolution*, revised edn., London: Plume/Penguin.

Tasker, Y. and Negra, D. (2007), *Interrogating Post Feminism: Gender and the Politics of Popular Culture*, Durham: Duke University Press.

Teen Beach 2 (2015), [film], dir. Jeffrey Hornaday, USA: Disney.

Teen Beach Movie (2013), [film], dir. Jeffrey Hornaday, USA: Disney,

Telotte, J. P. (2004), *Disney TV*, Detroit: Wayne State University Press.

Test Dept (2015), *Total State Machine*, A. Monroe and P. Webb (eds), London: PC-Press.

Tetzlaff, D. (1993), 'Metatextual Girl: → patriarchy → postmodernism → power → money → Madonna', in C. Swichtenberg (ed), *The Madonna Connection: Representational Politics, Subcultural Identities, and Cultural Theory*, 239–263, Boulder: Westview Press.

Thacker, E. (2003), 'Data Made Flesh: Biotechnology and the Discourse of the Posthuman', *Cultural Critique* 53: 72–97.

Thacker, E. (2011), *In The Dust of This Planet*, Winchester: Zero Books.

Thacker, E. (2014), 'Dark Media', in A. Galloway, E. Thacker and M. Wark, *Excommunication: Three Inquiries in Media and Mediation*, 77–149, Chicago: University of Chicago Press.

Thoman, H., ed. (1993), *Dance, Gender and Culture*, London: Macmillan Press.

Trigg, D. (2014), *The Thing: A Phenomenology of Horror*, Winchester: Zero Books.

Turim, M. (2007), 'Art/Music/Video.com', in R. Beebe and J. Middleton (eds), *Medium Cool: Music Videos from Soundies to Cellphones*, Durham: Duke University Press.

Unbreakable Kimmy Schmidt (2015–), [Television series], created by Tina Fey and Robert Carlock. Broadcast online by Netflix.

Usher, B. and S. Fremaux (2015), 'Turn Myself to Face Me: David Bowie in the 1990s and Discovery of Authentic Self', in A. Dillane, E. Devereux and M. J. Power (eds), *David Bowie: Critical Perspectives*, 56–81, New York: Routledge.

Vale V. and A. Juno (eds) (1982), *William S. Burroughs/Throbbing Gristle/Brion Gysin. RE: Search*: 4/5, Special Book Issue.

Vale V. and A. Juno (eds) (1983), *Industrial Culture Handbook. RE: Search*: 6/7, Special Book Issue.

Vaughan, D. (1990), 'Merce Cunningham', in *Cage, Cunningham, Johns: Dancers on a Plane* [exhibition catalogue], 81–87, Anthony d'Offay: Thames and Hudson.

Vênus Negra (2010), [DVD], dir: Abdellatif Kechiche.

Vernallis, C. (2004), *Experiencing Music Video: Aesthetics and Cultural Context*, New York: Columbia University Press.

Vernallis, C. (2008), 'Music Videos, Songs, Sounds: Experience, Technique and Emotion in Eternal Sunshine of the Spotless Mind', *Screen* 49(3): 277–297.

Vernallis, C. (2013), *Unruly Media: YouTube, Music Video, and the New Digital Cinema*, Oxford: Oxford University Press.

Wainberg, J. (2005), *Mídia e Terror*, São Paulo: Editora Paulus.

Waldrep, S. (2004), *The Aesthetics of Self-Invention: Oscar Wilde to David Bowie*, Minneapolis: University of Minnesota Press.

Waldrep, S. (2015), 'The "China Girl" Problem: Reconsidering David Bowie in the 1980s', in A. Dillane, E. Devereux and M. J. Power (eds), *David Bowie: Critical Perspectives*, 147–159, New York and London: Routledge.

Walters, J. (2008), 'Repeat Viewings: Television Analysis in the DVD Age', in J. Bennett and T. Brown (eds), *Film and Television After DVD*, 63–80, New York: Routledge.

Warhol, A. and P. Hackett (eds) (1992), *The Andy Warhol Diaries*, London: Pan Books.

Warner, T. (2003), *Pop Music – Technology and Creativity: Trevor Horn and the Digital Revolution*, Aldershot: Ashgate.

Wasko, J. (2001), *Understanding Disney: The Manufacture of Fantasy*, Cambridge: Polity.

Waskul, D. and P. Vannini (2006), *Body/Embodiment*, Padstow: Ashgate Publishing House.

Watts, M. (2003), 'Oh You Pretty Things', in E. Thompson and D. Gutman (eds), *The Bowie Companion*, 47–51, London: Macmillan.

Werner, F. (2013), *La Materia Oscura. Historia cultural de la mierda*, Buenos Aires: Tusquets Editorial.

White, S. L. (2009), 'Michel Gondry and the Phenomenology of Visual Perception', in C. Grau (ed), *Eternal Sunshine of the Spotless Mind*, 94–110, New York: Routledge.

Whiteley, S. (1997), *Sexing the Groove: Popular Music and Gender*, London: Routledge.

Wicke, J. (1994), 'Celebrity Feminism: Materialist Feminism and the Culture of Celebrity', *South Atlantic Quarterly* 93(4): 751–778.

Williams, K. (2003), *Why I (Still) Want My MTV: Music Video and Aesthetic Communication*, Cresskill: Hampton Press.

WreckingFox Mashups (2014), Comment on 'Burial – Forgive (music video)', YouTube, 27 July. Available online: https://www.youtube.com/watch?v=DxrHNQZhvKw (accessed: 27 November 2015).

Yang, J. (2012), 'Gangnam Style's U.S. Popularity Has Koreans Puzzled', *Wall Street Journal*, 28 August. Available online: http://blogs.wsj.com/speakeasy/2012/08/28/gangnam-style-viral-popularity-in-u-s-has-koreans-puzzled-gratified/ (accessed: 30 November 2015).

Yatanis (1999), 'Brush Up Your Shakespeare', YouTube, uploaded 9 August 2008. Available online: https://www.youtube.com/watch?v=XJIpp2Jj8AQ (accessed: 1 February 2016).

York, P. and C. Jennings (1995), *Peter York's Eighties*, London: BBC Books.

Zak, Newton (2011), 'Comment on "Burial – Ghost Hardware – YouTube"', YouTube, 7 September. Available online: https://www.youtube.com/watch?v=_MigURCQQA0 (accessed: 27 November 2015).

Ziggy Stardust: The Motion Picture (1973), [film], dir. D.A. Pennebaker, UK: 20th Century Fox.

Žižek, S. (2009), 'Why Are Laibach and NSK Not Fascists?', in N. Henig and W. Skok (eds), *Ausstellung Laibach Kunst: Rekapitulacja/Recapitulation*, Łódź: Muzeum Sztuki.

Zuckerman, E. (2015), 'From the Theme Song to "Peeno Noir": Jeff Richmond on the Music of *Unbreakable Kimmy Schmidt*', *Entertainment Weekly*, 12 March. Available online: http://www.ew.com/article/2015/03/12/unbreakable-kimmy-schmidt-composer-jeff-richmond-sitcoms-music (accessed: 1 May 2016).

INDEX

9 781501 313912